BRITISH MUSLIM WOMEN IN THE CULTURAL AND CREATIVE INDUSTRIES

BRITISH MUSLIM WOMEN IN THE CULTURAL AND CREATIVE INDUSTRIES

Saskia Warren

EDINBURGH
University Press

Edinburgh University Press is one of the leading university presses in the UK.
We publish academic books and journals in our selected subject areas across the
humanities and social sciences, combining cutting-edge scholarship with high
editorial and production values to produce academic works of lasting importance.
For more information visit our website: edinburghuniversitypress.com

Edinburgh University Press Ltd
The Tun – Holyrood Road
12(2f) Jackson's Entry
Edinburgh EH8 8PJ

Typeset in 11/15 Adobe Garamond by
Cheshire Typesetting Ltd, Cuddington, Cheshire, and
printed and bound in Great Britain

A CIP record for this book is available from the British Library

ISBN 978 1 4744 5931 0 (hardback)
ISBN 978 1 4744 5932 7 (paperback)
ISBN 978 1 4744 5934 1 (webready PDF)
ISBN 978 1 4744 5933 4 (epub)

CONTENTS

FIGURES

ACKNOWLEDGEMENTS

Much of this book was written during the Covid-19 pandemic and the various intensities of lockdown, after I had returned to research following a period of maternity leave. I am sure that my husband, Aidan, and son, Seamus, would agree the book was a shared challenge. First and foremost, then, I give thanks to Aidan and Seamus for their support and patience, and for their welcome distractions that offered some useful perspective. I dedicate this book to Seamus and our newest arrival, Amaia.

Crucial to the book is of course the stories of the women featured within it. I offer sincere thanks and gratitude for your time and sharing your lives with me. I hope I have done your stories, insights and reflections some justice. Most of the women in the book are anonymised therefore I cannot thank them by name personally, but there are so many who enriched the book, challenged me and opened up new lines of thinking. I would also like to warmly thank the women who helped organise focus groups and who participated in them. I would like to thank the Muslim Heritage Centre and Oldham Library for helping to support the research by hosting focus groups, and to those members of the public who attended and provided their points of view. Thank you to the artists Sara Choudhrey, Zarah Hussain and Azraa Motala for allowing me to reproduce their artwork.

I would like to take some space to also thank the many people who kindly agreed to comment on different chapters of the book. It was such a generous act especially during this difficult period of the pandemic. Reading and talking through your intelligent and perceptive comments in relation to the chapters was one of the highlights of my entire fellowship, a deeply rewarding process, and pushed me forward. So sincere thanks to Karen Patel, Bridget Byrne, Saira Hassan, Jana Wendler, Katie Higgins, Fran Lloyd, Paul Long, Tariq Jazeel and Fiona Hackney. Any flaws and errors in the finished work are mine alone.

I would particularly like to thank Bridget Byrne for her mentorship during the Arts and Humanities Research Council Fellowship and continued support throughout the twists and turns of the exhibition and book writing. And my becoming a mother for the first time in the middle of it all. Your guidance has been invaluable.

Deep thanks to Uma Kothari who supported the development of the grant proposal, and also to the late Claire Dwyer who gave her time to discussing the ideas at a formative stage. Claire's work inspired the work in so many ways, and the loss to the field is still felt.

I would like to thank the five artists who helped to co-curate the *Beyond Faith* exhibition, and who showed their wonderful artwork: Fatimah Fagihassan, Usarae Gul, Robina Akhter Allah, Aida Foroutan and Shabana Baig. I would like to thank Saira Hassan for acting as Research Assistant for the youth workshops and sincere thanks to Jana Wendler for project managing the exhibition film, exhibition brochure, events and evaluation. Many thanks to Ricardo Viela for creatively and thoughtfully shooting the exhibition films. Thank you more widely to The Whitworth and to Alistair Hudson, Esme Ward, Maria Balshaw for variously supporting the ideas for the exhibition and the exhibition launch. Particular thanks to Uthra Rajgopol and Andrew Vaughn for co-curating the exhibition. Also thanks to the audiences of the exhibition, especially those who left feedback in the visitor book, visitor cards or feedback sheets – there were so many fantastic, incisive, rewarding comments that everyone involved relished reading.

I would further like to thank my colleagues in Geography at the University of Manchester for supporting me during the process of the research and book writing. A special thank you to Aurora Fredriksen for her insights on work and life, and their imbrications. Also within Geography I would particularly like to thank the Cities, Politics and Economies Group. Many of the ideas for the book and its discussions were strengthened through audience feedback in various talks and presentations I gave, and by reviewer comments on articles and chapters. So I offer my gratitude to all the people who engaged with this research at various stages of its development.

Funding

This research was generously supported by the University of Manchester SEED small grant and UKRI Arts and Humanities Research Council [Grant reference number AH/P014828/1].

Parts of Chapter 5 and Chapter 8 have been published in other formats. Some passages of Chapter 5 are reworked from: Warren, 'Placing faith in creative labour: Muslim women and digital media work in Britain', *Geoforum* 97: 1–9. Some sections of Chapter 8 are reworked from: Warren, '#YourAverageMuslim: Ruptural geopolitics of British Muslim women's media and fashion', *Political Geography* 69: 118–27.

FOREWORD

by Elinor Chohan MBE

*Deputy Lieutenant of Greater Manchester, Trustee of the British
Muslim Heritage Centre and Founding Director of Miri Roshni*

I have been eagerly awaiting this book. From initial discussions
with author Dr Saskia Warren at various charity and arts events in
Greater Manchester during the research, I knew that it would offer
new understanding and perspectives on British Muslim women in
the cultural and creative industries through asking: what limits par-
ticipation and representation in these industries?

Dr Warren discusses how available data suggests Muslims are
less likely to apply for higher or further education in creative arts
and design, preferring more traditional vocational courses such as
medicine and law. While Muslim women are more likely to obtain
higher education degrees they are under-represented in the work-
place and Muslim females aged 18–24 years are much more likely to
be economically inactive in comparison to all females.

Equality is the common thread that runs through my work,
all of which I am truly passionate about – a trustee of the British
Muslim Heritage Centre, member of the Greater Manchester Race
Equality Panel, Deputy Lieutenant for Greater Manchester and
founding director of Miri Roshni – a charity assisting vulnerable and
destitute to achieve their full potential through education.

Of Welsh heritage, I have lived in Manchester for over thirty
years following my marriage to Mohsin whose family were economic

migrants to the UK from Pakistan arriving in the 1960s. I converted to Islam and I have been submersed in the south Asian community learning and experiencing much about the religion, culture, traditions and challenges facing this community.

In his last sermon Prophet Muhammad (peace be upon him) clarified equal rights for all. 'All mankind is from Adam and Eve, an Arab has no superiority over a non-Arab nor a non-Arab has any superiority over an Arab; also a white has no superiority over black nor a black has any superiority over white except by piety and good action.'

Every individual has the fundamental right to be treated fairly without fear of discrimination based on gender, age, race, belief, sexuality or disability. Sadly, this right is not always realised and Muslim women in particular experience much discrimination.

It is my view that this book addresses key issues in relation to equality and diversity. Why are the cultural and creative industries not deemed appropriate for many British Muslim women, and why are these sectors undervalued by the British Muslim community? In turn, how does the lack of diversity in industry effect British Muslim women in the sector? Are non-Muslim colleagues conscious of their biases and behaviour or are elitist attitudes of the dominant culture unconsciously acted out to discriminate and maintain an unequal power balance? Why is it that diversity in the cultural and creative industries fails so significantly to reflect the diversity of the population?

British Muslim women are significantly underrepresented in this sector and Dr Warren in her research explores the multifaceted reasons for why this is the case, while also addressing intra Muslim indexes of inequality and discrimination. The Social Mobility Commission was established in 2013 to set and monitor social mobility targets; sadly barriers remain and Britain's record is not measuring up especially well against other countries.

The book addresses together the lack of diversity and equality in the British cultural and creative industries and the failure of social mobility. It is a truly eye-opening account, and presents significant

research on British Muslim women in the cultural and creative industries to further evidence the harsh reality and notions we must all acknowledge in order to impact change, creating a society where every member has the same opportunity to prosper and flourish equally.

FOREWORD

by Qaisra Shahraz MBE

Novelist, Founder and Executive Director of Muslim Arts and Culture Festival, and Muslim Women's Arts Foundation

Dr Saskia Warren's fantastic book pays homage to Muslim women and their achievements. It is a breath of fresh air, celebrating and exploring the growth of Muslim women-led creative arts. Dr Warren explores how Muslim creative arts are developing in Britain, and the changing landscape of the cultural and creative industries in relation to gender, faith and ethnicity. We learn how British Muslims are widely involved in fashion, media and visual arts, and other related fields, such as Islamic hip hop, calligraphy, fictional writing, film, comedy and so on. The striking and gorgeous cover by Azraa Motala celebrates diversity, which beautifully introduces the reader to one of the key themes.

Currently, I run an award-winning, internationally successful Muslim Arts and Culture festival (Macfest) and I will be launching Muslim Women's Arts Foundation and Festival in 2022. Previously, however, my well-established writing career was the poor sister, playing second fiddle to my successful career in education. Why? The income gained from my novels and stories could not pay my bills. Sometimes, when I returned from my literary tours I would invariably be asked the same question by my father: 'What have they paid you, or you did it for free?'

Dr Warren's book is bursting with invaluable scholarly research, about Muslim women in the cultural and creative industries. I learnt a lot and found it riveting reading. The impressive thirty-five narratives of Muslim women of all ages and backgrounds provides us with a window into the world of their aspirations, insight into their personal journeys and the challenges faced both at home, within the community and in the work place. Wider social context is provided through public focus groups and workshops.

Often Muslim women are the subject of negative perceptions and stereotypes, including in the media. Dr Warren's sensitive approach in capturing the women's experiences, her in-depth knowledge about Muslim communities, Islamic values and cultural issues – for example relating to South Asian communities – are highly commendable. The book honours and celebrates not only the women's achievements but delves into, with extreme understanding and sensitivity, the hurdles the women have faced and continue to face, in both entering and progressing in the cultural and creative industries.

The author clearly highlights how societal changes and discrimination impact the women creatives at a human level. In one chapter, writing that 'Muslim women are subjected to multiple, intersecting and overlapping forms of discrimination', she shows how persistent Islamophobia and sexism in Western-liberal societies can create barriers to accessing and advancing in mainstream employment. And also how art schools have brought special challenges for Muslim women. Of the women interviewed, some experienced the feeling of being 'othered' and others found it a challenge to fit 'into a dominant white and liberal culture'.

Thus the case studies inform us that for many women it has not been an easy journey, in particular when their chosen interest or work in the arts field is either not taken seriously enough, or they are discouraged, including by their parents or family members. My personal artistic journey, which I also shared in the research project, mirrors a number of these challenges.

Long overdue, this book is of immense importance and a significant contribution, giving voice to a crucial segment of contemporary Muslim society. It leaves us with hope that social attitudes towards gender and work appear to be changing for British Muslims. And while there are concerns, there is much to celebrate.

1

INTRODUCTION

The rise of the Global Islamic Economy and Muslim women leaders in digital media and fashion has attracted recent attention. But how do these more celebratory stories align with, or interrupt, more familiar reports of Muslim women as less economically engaged, and the most likely to experience discrimination in many Western societies? Informed by over three years of fieldwork, this book offers an in-depth analysis of the everyday politics of labour and the roles of British Muslim women in the sub-sectors of fashion, media and visual arts.

British Muslim Women in the Cultural and Creative Industries sets out an innovative agenda for faith and religion in the lives of creative workers. Following the increasing visibility of digital and creative content on fashion and arts centring the voices of Muslim women, it reflects on the politics of identity and representation, and the ways in which Muslim faith and gender intersect, and are transformed by ethnicity, 'race' and racialisation, class and geography in working lives. Enriched by a historically contextualised, qualitative approach, everyday lived experiences of labour are explored through the narratives of different women. In many cases encounters with Islamophobia, sexism and racism are revealed. It further explores how faith, creativity and activism come together for Muslim women cultural producers.

I

Religion and faith have often been omitted altogether in equality and diversity work. Underscoring the point, Arts Council England commissioned a review into diversity and found that there is almost no data collected on religion and faith in culture and the arts in Britain. The importance of improved evidence and monitoring on religion extends to all areas of public life. The Higher Education Funding Council for England (HEFCE) collects compulsory data on ethnicity, gender and disability whereas religion as a category is treated as optional (House of Commons Women and Equalities Committee 2016/17: 14). A lack of available evidence can, somewhat perplexingly, be used as justification for inaction. For example, the paucity of data collected by HEFCE was given as the rationale behind why they were *not* looking at religion as a criterion for inclusion in higher education. This study on Muslim women considering the interrelations between education and employment, through creative arts and design in tertiary education and multiple sub-fields of the cultural and creative industries, makes an important inroad into addressing religion and faith in public life. In the course of the book I discuss how the historic treatment of religion and belief in law, and their continued marginalisation as priority areas in monitoring, presents concerns for equality and diversity amongst many British Muslims and for academic debate, policy and creative practice.

Original empirical research with British Muslim women provides insights into the dynamics of labour in contemporary Britain. I choose to use the term 'British Muslim' given its increased adoption. Explaining the growth in popularity, Carl Morris (2018) has suggested that British Muslim as a neologism reflects political flexibility (spanning four countries) and clearly foregrounds religion in identity formation. While not all the participants referred to themselves as 'British Muslim', as I discuss in context over the course of the book, the importance by many given to Muslim identity, and statement of being 'of Britain' means I use this term, rather than referring to Muslims in Britain, which might suggest outsiderness. I expand the notion of Muslim from a meaning that is purely faith-based to

equally include those who identify themselves as 'of Muslim heritage'.
In the study, women discuss how creative work in fashion and tex-
tiles, digital media, visual arts and museums can foster intra-Muslim
and feminine spaces of solidarity, unity and belonging. Far from a
utopian space, however, the cultural and creative industries were at
best viewed as ambivalent spaces for equality and social justice. Many
Muslim women face what has been termed a 'triple penalty' impact-
ing on their employment prospects, which was also the case in cultural
labour: being women, being minority ethnic or non-white and being
Muslim (Berthoud and Blekesaune 2007). Muslim women in this
book also discuss a politics of identity that highlights intra-Muslim
difference, revealing gendered, racialised and classed hierarchies and
prejudices that are multi-directional within working lives. There are
issues raised of oppression and Islamophobia that shape opportunities
in spaces of creative and arts education and in employment.

Over the course of the book I will focus on the narratives of
workers in three different sub-sectors of the cultural and creative
industries:

1. Digital media: I consider Muslim women in digital media con-
 tent. This includes vlogging (video blogging), digital magazines
 and digitally broadcast talk shows often produced, hosted by and
 aimed at British Muslim women.
2. Fashion: I look at the roles of women within the exponential
 growth of 'modest' fashion. This includes roles in tutoring,
 design, label-owning and tailoring. Modest fashion, put most
 simply, are styles that cover the bodily form, which in Islamic
 modest fashion often means from wrist to ankle, and head
 covering.
3. Visual art: I consider new art in the Islamic tradition that fuses
 traditional craft with modernity. I consider the roles of arts pro-
 fessionals, established and emerging artists, and the development
 of new curatorial strategies around the politics of collections,
 display and interpretation informed by post-colonial and de-
 colonial praxis.

Each of these sub-sectors does not function as a discrete entity. Many women in the study worked across multiple profiled sectors. For instance, fashion styling through social media, or with digital in the visual arts. Women often combined a number of roles beyond the cultural and creative industries, with patterns of cultural and civic work, and both waged and unwaged labour, such as volunteering. I use the term cultural and creative industries to refer to culture and the arts combined with newer economic growth areas of creative innovation. However I retain the particular term used in the different sources I draw upon when it is important for understanding meaning. In the chapters that follow I reflect on educational and career pathways in the cultural and creative industries of British Muslim women. Following Lila Abu-Lughod (2010), crucial to tracing an intimate portrait of Muslim women's labour experience in the cultural and creative industries is how Muslim womanhood is mobilised and reframed by subjects, and how it travels through various worlds, projects and mediums. Primary sources, interviews, focus groups, activity diaries, and online digital and visual analysis provide insights into how Muslim womanhood is invoked as a category, and how it is variously celebrated, contested, resisted and subverted. These narratives are explored in regard to Muslim womanhood and its changing relationship with material culture and media in the digital age. Enriched by the viewpoints of 120 cultural producers, stakeholders and members of the public, I would hope this text provides valuable insights into the changing place of religion and faith within society. It addresses minority faith experiences in the cultural and creative industries, troubling the notion of a 'new' economy, tracing longer histories of labour in the framing of questions on identity, access and inclusion.

Missing Muslim Women? The Representation of Muslim Women in Reports

Muslims in Britain have been the focus of numerous government and third sector reports. Key, if somewhat tired, lines of investigation are rates of economic participation, Islamic schools and education,

and concerns of segregration, extremism and radicalisation, with more recent importance given to the imbrications of poverty, health, housing and Islamophobia. Muslim women have been the subject of much attention due to reported underrepresentation in waged labour and economic activity. Muslim women are widely reported as considerably less likely to be in paid employment than non-Muslim women: 57 per cent of Muslim women aged twenty-five to forty-nine are in paid work compared to 80 per cent of women of that age range in total in the UK (Citizens UK 2017: 18). Often measuring lowest for participation across all social groups, there has been extensive analysis around the reasons behind this 'underperformance' with attention paid to two key milestones where economic activity has the greatest fall: marriage and motherhood (Khattab et al. 2018). It is recognised, however, that for most women of any background who have children, economic activity is disrupted before and after motherhood, and that this fails to account for voluntary work, the importance of caring duties for social reproduction and the running of the economy, and invisible labour contributions towards family-owned businesses. Of course there are also marked differences between the experiences of different Muslim women in education and work. In the economically active population aged twenty-four to twenty-five, Muslim women are the most polarised of groups in Britain, with economic activity levels ranging from 92 per cent (for single women with higher education qualifications and no dependent children), to 21 per cent (for those who are poorly educated, married, with dependent children) (Khattab et al. 2018: 1548). White Muslims, or those with lighter skin, and with high levels of qualification and fluency in English have similar employment outcomes as the national average, while black Muslims are the most likely to experience discrimination (Khattab and Modood 2015). Some have drawn from the difference in labour performance that religion and Muslim identity are therefore not key determinants of life outcome. More fine-tuned research and analysis, however, has begun to capture how Muslims have experienced prejudice and discrimination, in ways sometimes indirect or subtle, but where religion has been the focal

point. *How We Get Along*, a new report by the Woolf Institute, has found that negative attitudes to faith were stronger than for ethnicity or nationality, with especially marked intolerance and prejudice towards Muslims (Woolf Institute 2020). And while there has been a recent rise in reported cases of Islamophobia, research such as that of Najib and Hopkins (2019) strongly suggests that incidents of racism, discrimination and everyday prejudice are in fact under-reported as minority subjects come to believe 'this is just the way things are'.

Who makes up the British Muslim population? In the last national census, Pakistani Muslims comprise the largest segment of the British Muslim population at 38 per cent, followed by Bangladeshi at 15 per cent, with an increase in minority Muslim groups, such as White Ethnic, Black African, and Arab (Census 2011). The preponderance of South Asian Muslims in Britain is the result of the British Empire and its legacies. Britain's declaration of Indian independence and partition in 1947 precipitated the largest mass migration in history, displacing over 14 million Sikhs, Muslims and Hindus, and leading to the deaths of almost 1 million people. Under partition the majority of Muslims moved to the territory that became Pakistan. As a result of social and religious division under partition, Pakistani heritage is often used as a proxy for Muslim religious identity (the Census of 2011 showed 91.5 per cent of British Pakistanis are Muslim; see also Hussain 2017: 19). Equating Pakistani heritage groups with Muslim belief, or British Muslims with Pakistani heritage, has sometimes served as a pragmatic decision to paper over gaps in historic data where there is no collected specific information on religion and beliefs, or ethnic group with religion. Yet it is simply wrong-minded to homogenise Muslims in Britain. The British Muslim population is now estimated at 2.71 million and accounts for around 4.8 per cent of the general population with an increasing share of minority Muslims, who identified in the last census as black (African, Caribbean, or other), white (white British, white Irish, or other), or those who identify under the broad category of 'Arab'. Recognising the huge diversity of the British Muslim population this book includes viewpoints from majority Muslim and

minority Muslim backgrounds. Intra-Muslim difference is further reflected with stories from observant and non-observant Muslims, recent converts, those of mixed heritage, and across adult age groups (from eighteen to sixty-five years). Notwithstanding clear diversity and difference amongst British Muslims, it is evident that forms of discrimination, including Islamophobia – understood as 'anti-Muslim racism' (Elahi and Khan 2017: 7) – impact widely on working lives, together with patriarchy and sexism.

Early findings from this book have been shared in two government reports to which I was invited to contribute as an academic contributor. Both reports underline the importance of Muslim participation in Britain, and the social cost of exclusion. *The Missing Muslims – Unlocking British Muslim Potential for the Benefit of All* is a Citizens UK (2017) report that came from a commission on Islam, Participation and Public Life, chaired by Dominic Grieve QC MP. In *The Missing Muslims*, public life is understood broadly as civic life and more specifically it considers the importance of youth groups and youth schemes, and accessible cultural facilities such as libraries. However, there is not an explicit focus on arts and culture in public life. I was further an invited contributor to the All-Party Parliamentary Group (APPG) on British Muslims, *Made In Britain: Meconomics*, whose report is yet to be released, with the inquiry closing in October 2019. The dual, entwined aims of the APPG were advocacy and investigation; providing a platform to give emphasis to the long-standing contributions to enterprise and entrepreneurship of British Muslims, alongside investigating prejudice, discrimination and hatred against Muslims in the UK. One of the central planks of the report aimed to understand gender in relation to business and enterprise, and Muslim female-led businesses, with specific reference to the Muslim lifestyle market.

Attitudes of British Muslims to gender and work are reported to have changed over the last generation (Demos 2015). In the above reports, and elsewhere in scholarship, there is recognition that Muslim women are already performing important roles in British society. However, there are persistent negative representations in the media and within film and television of Muslim women as victims, subjugated,

segregated, or complicit in regimes of violence against Western-liberal values. In response, there has been a concerted effort to challenge the circulation of negative images of Muslims, such as the media training work of media company *Amaliah* to amplify the voices of Muslim women. The work of *Amaliah* has been represented in broadsheet newspapers and media companies, including the *Daily Telegraph*, *The Guardian* and *Forbes*, amongst others. Detailed scholarship on Muslim women's labour practices remains under-explored, however. This kind of work requires careful and time-consuming research. Everyday lived experiences and the nuances of the challenges faced by Muslim women from different backgrounds cannot be ascertained by the broad brushstrokes of large-scale quantitative data or surveys alone. Given the imprecision of the ethnic grouping classifications used by the census and public and private companies who perform diversity and inclusion work, the need for focused work is all the more significant.

A wide array of reports, business briefings, newspaper and magazine articles, and a smaller but growing academic literature of articles, books and chapters show Muslim women in global creative and cultural work. Yet there are very few studies that look beyond modest (or pious) fashion and its connections with digital media. Nor is there much research that complicates the binary of exclusion or success where women are judged primarily against narrow ideas of economic activity. I seek to maintain a view of the material and symbolic tensions between the hyperbole of economic success of the Islamic cultural industries and Britain's association with this growth, and the reality that Muslims in Britain and elsewhere in Europe are disproportionately impacted by poverty. Expanding the field this book considers Muslim cultural labour attending to the more-than-economic dimensions of work lives. Fashion, media and visual arts are three sub-sectors in which I investigate division of labour, status, motivations and rewards in Muslim cultural work, with reflection on indexes of difference; social, cultural and religious.

In starting to address the omissions in understanding on religion and gender in society through the sphere of material culture, I ask in this book: How is 'Muslim women' as a category mobilised by

artists and creative producers within their work and in the wider cultural and creative industries? What different roles and practices are performed by Muslim women in each of the sub-sectors of fashion, media and visual arts? What are the particular social and spatial concerns articulated around access, performance and advancement for Muslim women in each of the sub-sectors?

The empirical research underpinning this book was largely collected in one of the metropolitan areas championed briefly as the 'Northern Powerhouse' – Greater Manchester. The region includes one of the largest British Muslim population in the country, with around 60 per cent of Pakistani heritage in Greater Manchester (Elahi and Khan 2017). Historically the region was known for manufacturing during and after the industrial revolution. In particular, Manchester was famous for cotton and textiles with the city in the nineteenth-century termed 'Cottonopolis'. Industry has since moved towards a financial and service economy, with a growing reputation for the cultural and creative sectors. Nesta (2019) identified that Manchester had the largest growth outside London in 2016, with IT, software and computer services comprising the largest creative sector. The largest employment growth was identified in publishing, architecture, and film, TV, video and photography. Overall Greater Manchester was England's third largest city-region in 2014, with a growth rate from 2007 and 2014 that was the fourth highest in the country. But, as Rafferty et al. (2017) have argued, there is the need to consider inclusion alongside growth:

> Greater Manchester has not been immune to the economic restructuring that has accompanied globalisation and technological change, including increasing problems of low pay, precarious work and lack of in-work progression, and uneven geographies of growth which have left particular areas and groups of people behind – neither able to contribute fully to, nor benefit from, the growth of the economy overall.

In Greater Manchester for people of non-white minority ethnic backgrounds the employment rate was 57.2 per cent, compared with a

much higher rate of 72.9 per cent for those from white British ethnic backgrounds. Further, for those from Pakistani and Bangladeshi backgrounds the employment rate was the lowest in the UK, at 52.6 per cent and 53.2 per cent respectively (Rafferty et al. 2017: 24). The 'New Economy' in Greater Manchester has been found to deliver higher levels of lower pay than the UK average, and a 'pervasive business model of low pay, low cost value' (24). The report did not use religion as a criterion of inclusion. This work on inclusive growth, or lack thereof, provides a useful context for the present study where the majority of empirical work took place.

The nature of cultural work is not bounded by physical geography, however, and the studies of working lives in this book reflect certain flows and mobilities. Research interviews were also conducted with women living or working in Leeds-Bradford, Leicester, Luton, Birmingham and London, given that people enrolled in the research were typically on the move, primarily for reasons of training, work or marriage. As the empirics reveal, the importance of London as a 'global city' – and Britain's financial, political and arts capital – means it is often part of the life-course of artists and creatives. Or else London looms large in creative imaginaries and reflections on inequalities of opportunity. Together the effect is to reinforce the geography of 'London and the rest' (Major and Machin 2018). By aiming to focus on the creative opportunities and employment outside of London and the south-east, but finding the region remains so dominant, the book elucidates on social and spatial inequalities in the sector that are deeply geographically uneven (Nesta 2016: 16; DCMS 2016; Dorling and Hennig 2016).

Geopolitics, Culture and Muslims

This book comes at a critical moment. There is rising hate crime in the UK and elsewhere. Recorded incidents reported to Tell Mama (2018) show spikes in Islamophobia with women experiencing the highest levels of abuse and violence. Scholarly research indicates worsening race inequality in the UK (Byrne et al. 2020; Garratt et al. 2019). The resurgence in racism and its denial, and increasing wealth

inequalities, has been read as a new era of culture wars. In the UK, John McDonnell MP called out the new culture wars in relation to the Department for Education's guidance for the banning of materials in the statutory school curriculum that allegedly take an 'extreme' political stance on anti-capitalist and activist movements, such as Black Lives Matter, Socialism and Extinction Rebellion (McDonnell in Busby, September 2020). Globally, new culture wars over a struggle for dominance around differing beliefs and values are being called on multiple fronts: rich vs poor, global north vs global south, far right vs liberal left, religion vs atheism and Christianity vs Islam. Oppositional and political discourse has been fuelled further by certain digital platforms, such as Twitter and Facebook, with increased saturation of digital and personal technologies meaning information, opinions and events are shared at speed, for better or worse.

In this mass amplified context of political and social polarity there remain ongoing tensions and debates about living with difference in the UK and Europe. Some of the most fraught legal, political and media cases in recent years have centred upon political Islam, Muslim integration and citizenship in Western countries. Since the fall of Yugoslavia and the Balkan wars wider recognition has been given to the long history of Europe's Muslims. However, anti-migration political sentiment has fuelled populism reigniting the racist spatial metaphor of Muslims' as 'barbarians at the gate'. For example, the device of the 'othering' of Muslims as the antithesis of civilised Europe (Said 1978) was used in the xenophobic 'Leave' campaigns for the British referendum on the European Union. The alleged threat of Turkey joining and impacting British culture was depicted on posters with the image of a long, snaking queue of refugees from the Middle East. In a time of particular geopolitical instability, Islam is often either venerated or decried as the world's fastest growing and socially youngest religion; Islamic State, an avowedly anti-Western operation, grew on Europe's border; there is steady migration, with new arrivals, and heinous loss of life in seas and oceans for those escaping conflict zones; there are terror attacks in the West and reprisals, including in a number of European cities. These geopolitics

were brought 'home' during the fieldwork for the book when the city of Manchester became enveloped into the urban constellations of extremism and its afterlives. In May 2017 the Manchester Arena bombing, after a concert by popstar Ariana Grande, killed twenty-two children and adults. Attacks such as 'the Manchester bombing', as it has become known, have targeted arts and cultural spaces, and public spaces, including the Parisian Bataclan music venue, Charlie Hebdo satirical newspaper offices, Christmas markets, bars, restaurants and city squares. Explicitly anti-Islamic and racist political sentiment has become mainstreamed by European and US politicians and is evident in widespread discrimination across multiple areas of everyday life from education to recreation and travel: from the banning of hijabs in a primary school in London, UK, to armed police forcing the removal of a women's burkini on a beach in Nice, France. Following the backlash to 11 September 2001 in New York and 7 July 2005 in London, events such as these that have played out in global media have fuelled rather than resolved lines of conflict.

In other ways there is greater cross-fertilisation of ideas, knowledge and material culture than perhaps ever before. Amongst the most remarkable developments of the early twenty-first century is the huge growth of the global Islamic economy (sometimes referred to as the halal economy) with the Islamic Cultural Industries especially prominent internationally. The global halal food and lifestyle market was estimated to reach $3.7 trillion in market value in 2019. The recent State of the Global Islamic Economy report by Thomson Reuters found that the Muslim lifestyle sector is growing at twice the rate of the global economy and that by 2030 the Muslim middle class will triple in size to 900 million, boosting consumer demand in markets around the world (ThomasReuters 2019/20). Much discussed is the growth in religious broadcasting and the increasing role of Muslim women in digital theology; however, women in other areas of the media and digital are using online spaces to contribute to discussion about everyday lived Islam. Within Muslim lifestyle media – which has attracted especial attention in secular and mainstream spheres – there is powerful usage of digital to 'reclaim' the

narrative around Muslims and Islam from that which has been often negatively framed by largely Western controlled media channels. Some of these sites are short-lived, due to lack of funding, but as discussed later they together present a wider point on the performance of the 'good Muslim', which itself can become a stricture. Muslim lifestyle media are responsive to continued currents of Islamophobia that shine a spotlight on what it means to be a Muslim in Britain, and elsewhere (Haw et al. 1998: 345; Afshar 1994). The holding of British Muslims to tighter controls around expressions of nationality and belonging than other British people is something that I explore further, and is significant in the curtailing of creative expression. Meanwhile the interrelationship of identity and commerce is a cause for reflection, following the important work of Reina Lewis, with a growth of luxury and label-consciousness, especially for young Muslims, potentially creating a barrier for those who are less wealthy to faith and Muslim belonging.

In this book I seek to advance knowledge about the politics of Muslim identity, focusing on the multiplicities, complexities and barriers to expression, from articulations of hatred, resistance to belonging, through forms of cultural production. It is significant given the changing focus of the cultural and creative industries, one of the fastest growing sectors in the world, towards inclusion. United Nations Educational, Scientific and Cultural Organisation (UNESCO) has identified gender inequality as one of key barriers to social justice and cultural expression, with the latter now protected as a human right. But, significantly, overall growth in digital has not meant greater gender equality, since inclusion for females is falling and rates of online abuse increasing. Economic restructuring that has increased flexibility in labour has – historically and in the present day – also resulted in low wage, low security work, with ethnic penalties worsened by lack of professional networks for those who are less privileged.

More specifically, in cultural policy and the arts in Britain there has been a decades-old debate on increasing diversity and representation. However, religion and faith have been historically excluded from the debate. Gilbert et al. (2019) trace the absence of religion to

the development of post-war arts policy and governance in Britain, noting the significance of the fact that the Arts Council of Great Britain was founded in 1946. They attribute the 'lasting culture of secularism' (Gilbert et al. 2019: 27) to a cultural infrastructure of state funding that meant creativity was aligned with public funded national institutions of art and regional centres. In Britain the legacy of Enlightenment thinking and secularism – the separation of the political realm from organised religion – with strong traditions of Romanticism and Rationalism reveal a pervasive distaste or scepticism for religion (25). The sidelining of religion might be seen as resulting from a post-Enlightenment view of creativity that advances individual self-realisation over and in contrast with the apparent passive and ritualistic forms of religion. Religion has been acknowledged in the provision of inspiration for some artists, but it was not a core plank of activity or the spaces that were funded, with church or cathedral choirs and so forth seeking funding elsewhere. The lack of state funding for religious art or inspired culture has arguably meant that the arts have been given a secular framework of understanding. Religion has often been viewed as uncreative, or even anti-creative, which is evident in theoretical discussions including in the discipline of geography and other areas of social science where religion has been almost absent from extant scholarship on creativity.

Elsewhere, in a related example of creative production, Modood (2016) critiques what he views as secularism in how religion is marginalised as a protected characteristic with attention to British media broadcasting and diversity. The BBC has stated a commitment to making provision and building trust for women, ethnic groups and young people. So, Modood asks, 'Why should it not also use religious groups as a criterion of inclusivity?' Following this argument, the inclusion of religion would treat Muslims (or another religious community) as legitimate groups in their own right, instead of subsuming religion into ethno-national categories, such as Pakistani or Asian (Modood 2016: 11).

Religion and faith were in fact only recently directly protected under the law. Until 2003 it was not illegal to discriminate against

someone in the workplace because of their religion. The Race Relations Act of 1976 did not include religion although through case law it was extended to include Jews and Sikhs who were able to make a case they were ethnic groups. Another area of legal contention for British Muslims were blasphemy laws, which only covered Christianity and not other religions. Blasphemy laws were abolished in 2008 in England and Wales largely to protect freedom of speech and to quell debate about whether the laws should be opened to encompass other religions. The main pressure was applied by Muslims in the wake of Salman Rushdie's novel *The Satanic Verses* (1988). Due to a perceived disrespectful depiction of the Prophet Muhammad and the Qur'an in the book, a fatwa was issued against the life of Rushdie in 1989, forcing the novelist into hiding for almost a decade. The combination of the Race Relations Act and discourse around the blasphemy laws led to strength of belief that religion was not treated equally within the law to other aspects of identity, and that Muslims were treated differently to other religious groups in British law; a concern that was more problematic given the documented rise in Islamophobia. In 2003 the Employment Equality (Religion or Belief) Regulations 2003 brought religious discrimination under the same act as other discrimination laws, since consolidated into the Equality Act of 2010, meaning religion was included as a protected characteristic. However, exemptions made by the Act, while benefiting religious groups in areas such as non-commercial services, for example, faith schools, and employment under strict conditions, also fuel continued dispute. Exemptions of religion and belief from direct or indirect discrimination cover managing premises and services, as long as it does not impact the service provided (Equality Human Rights Commission 2016). In the context of increasing Islamophobia, the Act might be viewed as failing to offer protection from religious oppression. Modood (2016) notes how mostly Pakistani Muslims were successful in arguing for the rights and support of Muslims not only in the private but also public sphere, which presents a shift from assimilation to democratic assertiveness. Modood attributes this to a new identity politics influenced

by positive black identity. Evidence of success might be gleaned in the visibility of Muslims and religion more broadly within the public sphere resulting from the change in the 2001 census to include religion as a category (albeit an optional one) (Modood 2016). The recent changes in regulations and law described above reveal the ongoing political debates about the freedom and rights of religious individuals and groups in relation to public space and the law in a secular state.

Part of the difficulty identifying and challenging Islamophobia is that there has been no accepted definition of the term. The All-Party Parliamentary Group (APPG) on British Muslims, comprising cross-party members from the Houses of Lords and Commons, with the backing of academics across the country, agreed a definition for Islamophobia in 2018 to which I was asked to give support. Building on the United Nations definition of racism, it stated:

> Islamophobia is any distinction, exclusion, or restriction towards, or preference against, Muslims (or those perceived to be Muslims) that has the purpose or effect of nullifying or impairing the recognition, enjoyment or exercise, on an equal footing, of human rights and fundamental freedoms in the political, economic, social, cultural or any other field of public life.

The short definition (that has been much debated) is that Islamophobia is anti-Muslim racism. This definition acknowledges the role of misrecognition and discrimination or violence towards those who are not Muslim based on racial prejudices and stereotypes. Misrecognition can involve the projection of imagined characteristics onto another, which can lead to diminishment, disrespect, feelings of rejection and harm (Hopkins et al. 2017; Fraser 2000). The proposed definition acknowledges that historically there have always been broader racial and cultural assumptions about Muslims – typically homogenised as one grouping – as inferior and less civilised (Alexander 2017). It remains controversial for some exactly because in the recent history of law I have outlined there has been political organising to recognise religion as a separate category to that of race. In this study I frame

Islamophobia as a kind of violence that is interrelational and that places limits on social and spatial mobility (see also Warren 2021), acknowledging in particular its gendered dimensions.

British Muslims, Gender and Material Culture

Qualitative research can offer valuable insights into embodied labour practices and the voices of women cultural workers. Religion together with gender offers an important lens onto Islamic cultural industries and Muslim women's leadership in the wider cultural and creative industries. By attuning to religion and gender, insights are advanced that add nuance to existing frameworks for understanding the dynamics of social difference in creative labour that have focused more singularly on gender (Ekinsmyth 2011, 2014; Rantisi 2014; Reimer 2008, 2016; Hesmondhalgh and Baker 2013), class (Skeggs 2004; Bennett et al. 2009; Edensor et al. 2009), and, to a lesser extent, ethnicity and issues of 'race' (Christopherson 2008; Idriss 2016; Saha 2017a, 2017b). More sophisticated, interrelational understanding of diversity issues in commercial, religious and secular spaces offers clearer insights into the lives of female (or male) workers in the growing Islamic cultural industries and wider society. The framework around the politics of Muslim identity is indebted to the work of black legal feminist scholar Kimberlé Crenshaw. Crenshaw, in her theory of intersectionality, shows how indexes of identity act upon each other and transform each other, helping to explain how people who share some characteristics can experience discrimination and exclusion differently. Muslim politics of identity have been the subject of investigation in fashion studies, cultural studies and geography. In these disciplines there has been focus given to the embodied aesthetic labour of Muslim women service workers in fashion, and roles of designers and editors of Muslim lifestyle magazines forging new sub-cultures with the attention on mostly elite Muslim women (Tarlo and Moors 2013; Lewis 2015). Elsewhere, work on ethnicity and racialisation in online blogging cultures have revealed the racial inequalities that impact upon the earnings of content producers who are darker skinned, highlighting how race and racism stratifies

financial and in-kind rewards (Peterson 2020; Pham 2015; Sobande 2020). Being from the 'wrong' creed, non-religious, of mixed heritage, without professional connections, divorced, impacted by issues around mental health, or LGBT+ (albeit the last was intimated) were all discussed during the research as presenting specific kinds of challenges and exclusions in different spaces.

But I do not wish to suggest that the interpolation of Muslimness and Britishness is somehow new, or only a matter for contemporary society. The cultural and creative industries are often associated with 'game-changing' ideas, technologies and commerce, but in fact some sub-sectors, trade and labour routes, materials, styles and techniques reveal historic continuities. Articulations of 'othering' around fear of Muslims has extended over centuries, and yet paradoxically there has been a concurrent secular appreciation for the artistry of material culture produced by Muslim countries. The irony of the argument is made by Sophie Gilliat-Ray (2010), who uses the example of Bede (673–735) to explore material and social forms of exchange, and their social dimensions. The Christian monk, often referred to as 'the Venerable Bede', regarded Muslims as ungodly. However, on Bede's deathbed in Northumbria, valuable items were distributed from his 'treasure box' to fellow priests, which included pepper and incense. These products came from the Arab Middle East and 'must have passed through Muslim hands' (Scarfe Beckett 2004: 61) before finding their way to Bede's box. Gilliat-Ray shrewdly observes, 'So while he might have regarded the Muslims as the hateful 'other', he was appreciative of the unusual products that emanated from their world' (Gilliat-Ray 2010: 8). Various products imported from the Muslim world during the medieval period include medicinal herbs, different spices, silk and ceramics. The vignette I include above of Bede's treasure box is indicative of a long history of trade of goods and learning, including the welcoming of Muslim emissaries to England. From the geographies of empire and colonialism, there is evidence not only of British people migrating to Muslim countries, or those with large Muslim populations, but of labourers, sailors and ayahs (nannies) from those countries settling in the UK. The point

I want to make here is that there is a much longer history of social, material and intellectual exchange between the Muslim world and Britain than is typically focused on when the discussion fixates on mass migration after the Second World War and changing urban demographies thereafter.

Indeed how Britain actively encouraged Muslim migration to address labour shortages after the Second World War remains under-acknowledged. The British Foreign Office actively courted Muslims from the Arabic speaking world and elsewhere. In the early 1960s recruitment films used by the Foreign Office, available from the British Film Institute, were aimed at encouraging prospective migrant workers to come to Manchester and Cardiff (Fares 1961). Migration chains were not only about flows from particular territories and countries in former colonies, often to British cities; they had a specific, targeted Islamic religious dimension to them. Over the footage of the films, in the opening scenes there is a soundscape of muezzin chants of Allahu Akbar ('God is Great!'), specifically calling for Muslims ('Moslems'). In the opening section of the film on Manchester, it states the city is 300 km from London – situating it in relation to the imperial capital city – with 700,000 people, and one of the biggest trading centres in the world. In an act of cultural translation former Lord Mayor, Sir Richard Harper (1902–73), is introduced as 'one of the sheiks of the city' (11.02). Harper talks about how 'the link has always existed between Manchester, the Arabs and the Muslims'. In particular, the historic trade links of the wool and cotton industries; how – at the time – the port was the third largest in the country, and, in a point that chimes with the present, the diversity of Muslims in Manchester. For, as presenter Gamal Kinnay, observes 'Muslims in Manchester represent Muslims from all around the world . . . India, China, far East and near East, some have come from all around the globe, but most of the Muslims in Manchester are from Pakistan' (15.57). Gimmay interviews Muslim men from different professions to provide insights into 'the successes of brothers'. The connection between Manchester and Muslims is directly made in the film, with perceived shared linkages around trade, material culture and mas-

culinities. Kinnay closes with: 'In Manchester, that city that linked money and beauty, linked fun and work, linked reality and fantasy, I leave my Muslim brothers relaxed and content resuming their worldly work and clinging to the pillars of religion' (19.42).

Male trade and labour flows between Manchester and the Muslim world are here encouraged with specific reference made to the wool and cotton industries; what later became known as the textile and garment industries. Fashion and textiles by some measures are included in the cultural and creative industries, and are certainly part of the branding of cities from the end of the twentieth century as 'Creative Cities' (https://unesco.org.uk/creative-cities/). It is noteworthy that emphasis is placed on Manchester as a seat of learning and culture, a city that is tolerant and inclusive towards Muslims. Empire, colonisation and trade shaped lives of migrant workers and commercial goods, and other enduring resonances are evident today in undocumented labour and reported slave working conditions in the textile and garment industry in Manchester and Leicester. What is missing from much of the written history of early Muslim migrants to Britain and stories of working and labour, however, are accounts of women (for an exception see Brah 1993).

Moving Forward? On Diversity and Religion in the Cultural and Creative Industries

Lily Kong and Angeline de Dios have recently observed the point that creativity has attracted growing critique, variously conceptualised as ideological, hegemonic or as enforced creativity (Kong and de Dios 2020). The creative turn has taken a number of divergent paths that do not interact, and there have been calls to disregard it altogether. In particular creativity within policy and strategies has drawn growing concerns about the co-option of creativity by neoliberalised capital for economic ends and profiteering, and the ways this can entrench, rather than ameliorate, social inequalities. But as Kong and de Dios constructively phrase it, 'are there other geographies of creativity excluded or even silenced by the dominant "creative turn" that have yet to be acknowledged, let alone mapped?' (Kong and de

Dios 2020: 1). Religion has been overlooked in the creative turn and in research around cultural labour. As I detailed earlier, Gilbert et al. (2019) have written about the secular state-funded culture in Britain and how this has impacted upon what is considered creative and worthy of research. The fissure in academic scholarship is important for it reveals the need to address our knowledge practices, to consider alternative understandings and ways of seeing that decentre a normative secularist 'world-view'.

In research on creativity that looks at matters of equality and inclusion in labour, the 'preferred' indexes of diversity, or 'crucial axes of inequality', are class, race and gender (see Brook et al. 2020: 4, 13). Brook et al. argue diversity discourse is part of wider historical struggles over legitimacy of what counts as 'high' or 'everyday' culture. What 'counts' is also reflective of social inequalities, which for the authors are most associated with class, race and gender. When research has been undertaken beyond these indexes, it has often focused on secondary preferred characteristics of disability or LGBT+ individuals and communities (7). More research is called for beyond the 'preferred indexes' (7). While diversity discourse is not new in policy spheres, there has been renewed attention through the UK's Department for Culture, Media and Sport's first White Paper on culture for fifty years (DCMS March 2016). The DCMS called for action to diversify culture and the arts through apprenticeships and promotional pathways, suggesting issues at multiple stages of entry and advancement across working lives. However, religious faith has been neglected within debates and discourse on diversity and leadership in cultural labour. Religion and belief, although protected characteristics in Britain, are identified as particularly lacking in data from the arts and cultural sector, as research and surveys have almost uniformly chosen not to include these categories. The exception is the 'Taking Part' audience participation surveys for the DCMS, administered by Ipsos MORI and NatCen Social Research, which has collected data on aspects of leisure, cultural and sporting participation annually from 2005. But 'Taking Part' does not release or analyse findings based on religion. The annual sample data released looks at

ethnicity, illness and disability, socio-economic group, region, gender and age (Consilium and Arts Council England 2018: 62; DCMS, Taking Part 2018/19). Religion and faith are thereby eclipsed from view altogether, or the data is lacking to discuss their significance in any meaningful way. Even more striking is that no publications were found that explicitly discussed religion and faith in arts and culture.[1] Consilium, the consultancy who performed the Arts Council England review, specifically identify the need for in-depth qualitative research into religion and belief in the arts and cultural sector.

Expanding the field, the findings in this book are drawn from original empirics collected during a major research project, Arts and Humanities Research Council Leadership Fellowship, and initial University of Manchester pilot grant. Primary research comprised:

- thirty-five semi-structured interviews with Muslim women producers in media content and production, journalism, creative writing, illustration, art and fashion (forty-six conducted overall including stakeholders and internationally)
- six in-depth artist activity diaries
- eight artist resumés
- five focus groups (n=42 people)
- four workshops with young people, sixteen to eighteen years (n=40 people)
- co-curated exhibition with five artists.

Some participants appear in multiple stages. The majority of participants identified as from the South Asian diaspora, especially of Pakistani heritage, with the sample also comprising minority Muslims identifying variously as Scottish, Caribbean, Palestinian, Iranian, Egyptian, Burundian, and of mixed heritage.

Interviews were arranged using purposive and snowballing sampling of those who identified as Muslim women (with variance in levels of religious observance) and who are professionally active in the cultural and creative sectors. Activity diary-keeping involved daily entries over one month recording projects worked on, different

tasks executed, and networks of places and people engaged with. A longer entry was submitted weekly with reflections on factors that had enabled or constrained aims, and critical engagement with the terms of the project, 'diversity', 'Muslim' and 'womanhood'. Given the financial precarity of cultural production for many, especially minority ethnic actors, I prefer the term professionally active rather than economically active in order to capture the experiences of those who might not be selling, but who are instead volunteering, displaying and gifting. More accurately, the notion of the cultural ecology is fitting for understanding the various roles and priorities of the cultural producers included in the study, moving away from notions of the cultural economy. Cultural ecology decentres the idea that economic value is core to cultural production and its infrastructures, or that there is one kind of value (see Gilbert et al. 2019: 27). I wanted to help tell the stories of not only popular stars, or those who do not work, but also those in different roles in supply chains and at different stages of their life-course.

Focus groups were conducted variously, with: mixed members of the public; Muslim women only; and students enrolled on a BSc fashion course. This extensive data is supplemented by visual and textual analysis of high profile digital British Muslim lifestyle media, and ethnographic observations on site visits to studios, events, public talks and seminars of British Muslim cultural producers in the cultural and creative sectors over a three-year period. To undertake visual analysis, I performed coding and axial coding for images and moving film using a selective process to identify materials (based on every first and tenth image thereafter in each magazine or first and tenth minute checking to see there is not a cyclical pattern in the ordering of images in the source material) (Rose 2016; Krippendorff 2018). Systematic analysis included the following: the genre; topic and activity; social characteristics and manner of the presenter/s (emotional and embodied intensity such as facial expression, spoken and body language); props and settings; and the style of the segment. The co-curated exhibition that I discuss in Chapter 7 comprised five artists drawn from earlier stages of the research. The artists were selected by a mixed membership panel

of Muslims, non-Muslims, and professionals from the arts, education and academia, and were remunerated for their time and materials.

When giving talks on the study, I am asked regularly: how did you recruit participants in the research? There is a discursive sub-text on insider/outsider positionality here: that is, how did I gain access to Muslim groups to which I do not belong? This is understandable. Following the 11 September 2001 attacks, Muslim identity became highly politicised and therefore research conducted on Muslims and Islam, especially by non-Muslims, was met by greater suspicion from some Muslims (see Ryan et al. 2011). More recently, the academic Khadijah Elshayyal and artist Zarah Hussain have both reflected on their experiences of receiving suspicion and cautiousness from Muslims about engaging in research and participatory artwork, despite being Muslim themselves (Elshayyal 2018; Hussain 2015). I am a white researcher of dual British/Irish citizenship who is non-religious though open minded to religion or other ways of life and belief structures. I was raised in a household by Buddhist parents therefore I have some direct experience of how different paradigms of knowledge and belief might coexist in Western contexts, even when they do not neatly align. But although I am sympathetic to alternative and minority belief systems in the West, and I shared some interests, as well as indexes of class and gender with many of the women in the study, I am mostly an 'outsider'. It has been observed that being an outsider can be beneficial as you are not subject to the same scrutiny as someone who is co-religious (Lewis 2015). While this is true upon securing participation, my status as a white researcher, the history of British colonialism and its legacies on knowledge politics and racialised elitism in the academy might well have inhibited minorities from becoming involved in the research. Muslim women in the West have been over-represented and over-researched in ways that have not always been helpful to addressing inequalities. And, attached to these concerns, is potential research fatigue, where the same people are asked to engage in research, over and again.

So, how did I recruit women to the study? The foundations of the research started in Birmingham. I had already met Mohammad

Ali ('Aerosol Arabic'), a Muslim graffiti and calligraphy artist and various organisations and artists working with different Muslim groups, such as General Public Agency's Balsall Heath Biennale, while working as a post-doctoral research fellow at the University of Birmingham. The Arts and Humanities Research Council Connected Communities project meant moving between spheres of culture and the arts, business, local politics, and education, with many of the same faces showing up at events. Networks I formed whilst in Birmingham in the cultural and creative industries and academia introduced me to others who I should interview for the project, which gave me an 'in'. I was also undoubtedly assisted in gaining a degree of trust because my husband was engaged in charity work that promoted learning about the genocide of Bosnian Muslims in Srebrenica and ethnic cleansing in the Balkan Wars. As one participant relayed to me, they had met my husband and therefore could better trust my 'good intentions'. While we did not share a religious identity, it was inferred that we shared a political outlook and that I was empathetic.

When in Manchester, I undertook an initial pilot project where I scoped the potential for the larger project, including whether there was interest from different Muslim individuals and groups and relevant organisations in the research area. Initially recruitment was still slow, and I invested considerable time in attending Muslim lifestyle events, such as the Muslim Lifestyle Expo, festivals and events including Macfest and the Muslim in Britain awards, seminars and exhibitions in order to widen my knowledge of the growing field of Muslim British culture and to opportunistically speak with a range of artists, producers, and researchers. Participants were further enrolled through support from the British Muslim Heritage Centre, through social media, and by the aforementioned use of a snowballing technique of participants introducing me to other people. Interviews, focus groups and diary entries were conducted from April 2016 to November 2018. All names and comments have been fully anonymised, except where participants have requested identities to be revealed or where comments and creative work are already

published and attributed in the public domain. The participants are referred to by their first names, whether this is a pseudonym or their actual name, which is intended to give parity to all, irrespective of their individual profiles. In the text where participants are given a pseudonym the name appears in quotation marks, while those who wish to be identifiable appear without them. Further details of the interviews and interviewees are provided in a table in the appendix.

In the wider project I employed two research assistants from different backgrounds: one was a British Muslim woman from Pakistani heritage who grew up in north-west England and the other was a German woman (an atheist) who received a higher education in the UK and lived in north-west England. These parts of the project were primarily around knowledge exchange, with youth workshops (led by Saira Hassan), and the exhibition film, event programme and evaluation (led by Jana Wendler). They go beyond the immediate purview of the book, and I do not discuss them much, except for the exhibition *Beyond Faith* in part of Chapter 7. However the coalition of researchers from a range of backgrounds and perspectives means the research methodology takes as its impetus the recognition that racism, sexism and religious discrimination are not minority issues, nor only issues for minorities and marginalised groups.

Research is never objective, it is always messy, and (re)shapes the field we are researching. I found this when reflecting on the ways the project acted upon participants, their work and lives, but also how participants acted on the project. All these relations are situated within a wider social, economic and political context. For instance how austerity in Britain had impacted upon diversity and equality work, and encouraged a culture of entrepreneurialism. Garratt at al. (2019) discuss how austerity has impacted anti-racism and community organising as council funding is now often only available to those working on a mainstream platform of equality, diminishing race and religion as policy concerns. Organisations and activists are encouraged to act entrepreneurially and therefore to view each other as competitors instead of allies in a shared political struggle for social justice. Many of the participants in this research narrated themselves as entrepreneurs

and were entrepreneurial in creating opportunities. My research could not objectively, or in a disinterested way, trace working lives. Instead I was an active participant through the different strands of the research and outcomes in creating multiple forms of impact (I discuss this more in Chapter 7). As one participant phrased it, the diary-keeping exercise acted as 'a catalyst', after a period as a stay-at-home mother:

> Thank you diary, you've given me an opportunity to catalyse my return to design – to where my passion lies and for the first time in a long time – I'm excited about my creative prospects . . . In the near future, I'm eagerly anticipating a time when myself and [name removed] can commence work on a project I briefed him about at the start of this diary. The aim is to inspire Muslim Females to pursue their chosen career fields and to not let cultural or social pressures prevent them from doing so. Having experienced this first-hand I think there's a strong narrative that many girls/women can (hopefully) tap into.

In no ways were the wider project and my interests intended as some neoliberalised back-to-work scheme. Yet the methodology including the framing of questions around work (paid/unpaid) and the action-based research dimension could engender real-life impacts beyond the life of the project itself. For instance, the participant above was inspired to begin designing her own project for Muslim women and girls, addressing barriers to pursuing chosen careers. At the time of fieldwork there seemed to be an explosion of creative strategies and activism by Muslim women, and it seems clear that to some extent the research and practice-based project I led became enrolled as a driver for future work.

Book Structure

In the chapters that follow the viewpoints and experiences of Muslim women are central to the representation of different sub-sectors of fashion, media and art. Instead of tracing the meaning and significance of these sectors from government and business reports, or from directors of organisations and institutions, this narrative

approach looks at how Muslim women frame their own everyday labour experiences within a variety of roles.

In this introduction I have provided the context of the research, how and what was done, and why it matters. Chapter 2 gives an overview of the history of Muslims in Britain and changing demography, from former British colonies, in particular, the South Asian subcontinent to increasing complexity and a larger share of minority Muslim groups. It presents the urban geography of Muslim populations, in particular metropolitan areas with former textiles and industrial trades. I show how changing attitudes to Muslim women in paid labour in the twentieth/twenty-first century trace broader societal attitudinal shifts to women and work. Despite this, it is widely reported that Muslim women are least likely to work of any group in Britain, and especially when raising families. Across ethnic backgrounds the occupations widely narrated as the most attractive for parents, wider family and communities are discussed in particular as those sectors are identified as conventional, familiar, secure and distinguished (medicine, law, engineering, teaching). By comparison, cultural labour held an uneven reputation amongst respondents. However, there is growing interest in non-traditional pathways amongst younger generations including not going to university, studying a broader range of disciplines, and entering a wider range of fields, including the knowledge and cultural and creative industries, along with transformations in marriage practices, such as delaying marriage, or not intending to marry at all.

In Chapter 3 I consider the relationship between the British cultural and creative industries and diversity discourse. This chapter considers the vexed relationship between cultural policy and notions of diversity with consideration to new schemes such as Arts Council England Diversity Change Makers Programme and the Creative Case for Diversity (e.g. workforce, cultural offer and audience), and how specific indexes of social difference are obfuscated in these initiatives, with faith and religion missing altogether. I revisit the normative narrative of Britain as a global leader in the new creative industries under New Labour's Tony Blair from 1997. I argue how the rebranding

of Britain as 'Cool Britannia' was already retrogressive, playing on an imperialist legacy and how the symbols of creativity selected were mostly tone-deaf to a multi-cultural society. I consider the global and local 'cultural policies' that are evident from economic inclusion agendas in international organisational bodies such as UNESCO, to the use of culture and arts for social value in neighbourhood cohesion projects. Integral to the New Labour government agenda was social mobility and the arts, although inequalities in wealth actually grew at the time. And over the past 10 years – despite the increasing prominence of public debates around diversity – social mobility in the arts has fallen. The chapter reflects on critiques of diversity within policy discourse, for instance as a technology of governance that maintains the status quo, and where increasing diversity does not neatly lead to a move away from stereotypical representations of minorities. I then turn to scholarship in feminist sociology, cultural economy, political and cultural geography and cultural studies that investigates inequalities within cultural labour, and a small but growing area of work that specifically addresses Muslim politics of identity within the organisation of labour and worker's lives. I finally consider the wider implications around the pervasive slippage of usage between culture as symbolic form and culture as a way of life, and the potential need for a more plural notion of cultural policies that give recognition to a diversity of expression and beliefs.

Chapter 4 looks at Muslim women at British art schools. It opens with a discussion of the creative arts and design as the disciplines with the highest levels of white students, and how art school might be viewed as producing a world-view that is Eurocentric and Anglophone. I then contextualise the discussion of pedagogy and dominant culture, by tracing the linkages of British art school with empire and colonialism. Using the example of British-Indian art schools I argue that art school as part of its project has sought to instil Graeco-Roman aesthetic ideals and Western ways of seeing into (minority/international) students, whether in training in colonies or at home. I make the case that the training and exporting of students back to former colonies, and the Western-centric

modernist and post-modern art canon for minority 'home' students are instances of post-colonialism. I use this as a way of grounding why there might be cautiousness or hostility towards attending art school. This chapter shows the importance given to higher education in a way that is inclusive across gender. However, it shows that the subjects studied and where have now come under closer scrutiny as a result of greater anticipation that women will enter the labour market. It identifies points of discussion that shape decision-making around which course to select and which institution, and highlights the range of people involved. Experiences of attending art school are discussed and how art school functions as a dominant white space, from social culture, course expectations, and the differing creative controls to which minority students are subjected.

In Chapter 5 I trace how since the turn of the twenty-first century there has been a rapidly expanding field of Muslim lifestyle media. Especially prominent are Muslim women producing content for other Muslim women. Using case studies of Deeyah Khan's *sister-hood* magazine, Dina Torkia's videos and British Muslim TV's show *Sisters' Hour*, this chapter reveals how Muslima lifestyle media is creating new spaces of identification and belonging in Western-liberal societies. Muslim lifestyle media advocates for inclusion of Muslim women's voices in community and mainstream media in order to support broader Muslim representation and advance gender equality in the public sphere. It seeks to move beyond intra-Muslim sectarianism and fragmentation that exists in the British Muslim population but is not widely recognised by 'outsiders'. Informed by on-line analysis of social media channels, interviews, site visits, it shows expanded notions of Muslimness and womanhood in the public sphere. Muslim women in media are re-negotiating familial, community and societal norms, and making new images of Muslim women that challenge conservative and Western-liberal thinking on Islam, gender and workplace equality. However, the chapter also highlights how the ideal space of unity called forth by some of the media workers is racialised and stratified by piety. Through these optics it is subjected to different kinds of intra-Muslim and wider

public scrutiny and online harassment that can negatively impact upon motivations to remain with media work or to 'cross over' to mainstream media channels.

Modest fashion lines are now prominent in high-street chains and luxury fashion brands, in magazines and advertising campaigns. But beyond the high profile experiences of a handful of designers and models, little is known about the everyday work-life experiences of Muslim women in this growth industry. With examples from Luton, Leicester and Greater Manchester, in Chapter 6 I trace the labour experiences of women often hidden from view: small brand owners, tutors, designers and tailors. In this chapter I identify the distinctions and status hierarchies between working in textiles, 'cut and sew', and what is often termed 'proper fashion', such as buying and design work. I develop an argument on how these distinctions play into racialised and gendered ideas of ethnic/Western fashion, and manual/creative labour. Identity in fashion combined with deep geographical and educational imbalances shape social reproduction around indexes of social privilege, for example, ethnicity, 'race', religion, class. Issues of gendered inequalities are addressed in supply networks with consideration to family histories and kinship networks within transnational fashion and textiles businesses. It further highlights the moral and spiritual intentions guiding a number of those aiming to establish careers in modest fashion and textiles, such as modest clothing as necessity, sustainability and women's advancement.

I then turn in Chapter 7 to the less discussed area of the visual arts and art institutions. A number of artists are drawing upon the history of Islamic art and crafts, and challenging the notion that tradition and modernity are incompatible within contemporary lived Islam. I consider the digital Islamic art movement drawing on the work and reflections of Sara Choudhrey and Zarah Hussain. A significant feature of this work is the repetition of patterns and order, intended in their mirroring of nature to resonate with Muslim and non-Muslim audiences. There are also recurrent themes of bringing together traditional craft with new technologies guided by Islamic

interpretation of maintaining tradition and making it relevant in contemporary times. This chapter discusses the multiple barriers to success in place as a Muslim woman artist in Britain with attention to the art establishment and secular issues around the representing of religious artwork, and how status and positioning of work is impacted by ethnicity and gender. Finally it discusses the activist work taking place to address historic exclusion and silences of minority artists from major collections and exhibition spaces with consideration to post-colonialism, de-colonialism and co-production in curatorial approaches.

In the final substantive chapter I consider how Muslim women are combining creativity and activism. I first explore the experiences of prejudice, oppression and Islamophobia detailed by many women in the study with reflection on a far-right event that took place during the fieldwork, and then diary entries on everyday forms of intolerance and marginalisation within labour. I identify how living in a 'hostile era' impacts upon physical mobilities and social participation in education and employment. In the second part of the chapter I frame how cultural production is a key arena in which Muslim women are collectively coming together to challenge Islamophobia, sexism and racism. More than innovation in these sub-sectors, this work collectively represents the employment of creative methods for social activism foregrounding interrelational gendered and religious inequalities. Many of the creative actors discussed in this chapter are also active charity and women's development campaigners. I consider digital short films, a Muslim festival and creative writing group as three distinct examples of Muslim creative activism. The typologies of activism range from secular to faith-centred, highly visible to discreet acts which articulates some of the diversity of British Muslim identities and acts of citizenship in evidence today. Here a holistic approach is taken to how creativity and activism overlap in the reworking of politics of identity and belonging for Muslim women in contemporary Britain.

Note

1. Another exception is the work of researcher and artist Sara Choudhrey, who undertook a survey on British public attitudes towards Islamic art where religion was used as category as part of her doctoral research in 2018.

2

MUSLIM WOMEN IN BRITAIN: A CHANGING LANDSCAPE

Introduction

There are records of Muslims in Britain revealing a history that extends over hundreds of years. Scholarship has tended to focus on the period after the Second World War when larger numbers of Muslims settled in Britain. However, there is a much longer and important history of Muslims visiting, living and working in Britain. This social history is connected with the story of empire. The East India Company, founded in 1600, became a powerful agent of British imperialism from the early eighteenth century. Some agents from the East India Company and their families chose to return to Britain, with Indian servants and ayahs (nannies), of whom many were Muslim (Gilliat-Ray 2010). Indian sailors, or 'lascars', often press-ganged into the East India Company, jumped ship and settled in Britain, with communities in the nineteenth century forming in maritime ports, such as Cardiff, Glasgow, Liverpool, Hull and South Shields (Gilliat-Ray 2010: 41; Lawless 1997). Larger numbers settled in the capital city of London. The figures are not insignificant: 10,000–12,000 lascars were recorded in Britain at the end of the eighteenth century (Ansari 2004: 35).[1] Muslim labourers, such as Yemeni steelworkers, also came to Britain as part of the

movement of people under the British Empire at this time (Ansari 2004; Gilliat-Ray 2010; Halliday 1992a; Lawless 1997). Muslim seafarers arrived from India, Yemen, Somalia, Malaysia and Egypt. Among early Muslim settlers in Britain, who were usually male, there were marked differences of language, ethnicity and interpretation of Islam.[2]

In part the history of Muslims in Britain is stratified by class and labour. There is a rich and respectful history of trade and learning with the so-called Islamic world, including documentation of high profile and popular Muslim visitors in the eighteenth century, with evidence of wealthy elites studying at universities, working as teachers and as traders (Gilliat-Ray 2010: 32). In particular, Manchester, Birmingham and Bradford attracted Arab and Moroccan traders, with evidence of around a dozen Moroccan families and 150 Middle Eastern merchant houses in Manchester by 1830 (Halliday 1992b). These traders and their families preserved language, religious identities and cultural norms. For poorer migrants, pressure on local employment following the First World War, with a decline in the coal trade and rising unemployment for seamen, as well as soldiers returning from war, is likely to have fuelled racial tensions. Race riots between Yemeni and working-class white British are documented on the streets of Cardiff and South Shields in 1919 (Gilliat-Ray 2010: 34). During this period – between the two world wars – the geographical distribution of Muslim communities began to change with the movement of dockworkers and seafarers from ports to manufacturing cities to work in large textile mills or armament factories; the 'starting ends of migratory chains' that would attract large numbers of Muslim migrants in predominantly low wage sectors of the economy (Ansari 2004: 49; Brah 1993).

More familiar for many is the story of migration after the Second World War where migrants from former colonies settled in the UK, attracted by the availability of industrial work in a time of British labour shortages (Hussain 2017; Kalra 2000; Gilliat-Ray 2010; Ansari 2004; Dahya 1974). New arrivals mostly settled in urban industrial areas where work was concentrated. In the Greater

Manchester area this work was often found in the textiles mills, particularly in cotton and wool, although these industries were already in decline (Dale at al. 2002). Many migrants from this time came from Mirpur, a chiefly agricultural area in north Pakistan, or Attock, formerly Campbellpur, with smaller numbers from East Pakistan (now Bangladesh), in particular Sylhet (Kalra 2000; Anwar 1979; Saifullah-Khan 1976). From Mirpur, former agricultural workers in smallholdings were typically of a lower socio-economic class and educational level than migrants from urban areas or those who later arrived from East Africa. Under dictator Idi Amin's rule in Uganda conditions of forced exile in 1972 led to the expulsion of 80,000 people. Of this latter group, many were Hindus; however, some were Muslim, mostly middle-class Gujarati merchants, emigrating with whole families, rather than single men, which was most commonly the case with migrants from Pakistan.

Depending on the changing national and geopolitical context there have been different policy approaches to migration in Britain. In sharp contrast to contemporary political concerns, Linda McDowell reminds us that before 1945 the British government was worried about 'losing population; about emigration rather than immigration' (2016: 3). Between the two world wars Britons were encouraged to leave to alleviate poverty and also spread colonial power in the dominions, such as Canada, New Zealand and Australia. The British government's migration approach changed from about 1947 when the numbers arriving from the 'New Commonwealth' countries became more significant than European migrations, and the composition of the UK population shifted particularly in large cities (McDowell 2016: 4). Initially it was almost all males who migrated for work, some with jobs, and others looking for jobs on arrival. However, The British Nationality Act 1948 began the process of removing the rights of colonised subjects to UK citizenship and residence in the UK. Successive legislation was often highly racialised, impacting non-white citizens in particular (Shankley and Byrne 2020). For instance partiality, introduced by the Commonwealth Immigration Act of 1968, required those seeking citizenship to demonstrate a

parent or grandparent already possessed citizenship. It signalled a move from citizenship based on place of birth to citizenship passed on by parental lines, which favoured white Old Commonwealth migrants (Byrne 2014). Amendments to tighten immigration laws in the late 1960s and early 1970s meant that migrants brought wives and children for family reunification, or alternatively married and then brought wives to the UK (McDowell 2016; Gilliat-Ray 2010; Peach 2006). The change in structure of migration, with an increase in women and children, also led to changing housing patterns with a move away from all male dormitories to affordable houses for nuclear families, and more investment locally in communities and areas in Britain, with proportionately less money transferred abroad in remittances (McDowell 2016: 48). Of migrant women who entered the labour market, in earlier stages of post-war migration, women from India entered semi-skilled and unskilled mass production in factories. Later migrations of Pakistani women and the decline of the old manufacturing sector led from the late 1960s and early 1970s to more 'flexible specialisation' with subcontracting of certain functions and services, and an increase in low-status, part-time work and forms of 'home-working' such as piece work and sewing. As Brah (1993: 446) argues: 'The ready availability of paid work that could be carried out from home would have appeared a realistic option to Muslim women with young families to care for. Over a period of time, as homeworking became an established pattern, more and more women were likely to be drawn into it through kinship and friendship networks' (see also Mitter 1985; Anitha et al. 2012). Muslim women's engagement in the British labour market therefore needs to be understood as gendered and racialised, and in relation to the significance of region and locality.

Other than South Asian migrants, Turkish Cypriot Muslims were another group to arrive in the 1950s, and Muslim students from the West Indies, from Trinidad, Tobago and Guyana (Gilliat-Ray 2010: 46). Typically more middle class, educated and wealthier Muslim groups from a wider range of countries began settling in Britain in greater numbers in the later part of the twentieth century.

For instance, wealthier Arabs from Saudi Arabia, the Gulf states, Syria, Lebanon, Egypt, Palestine and Jordan, and skilled professionals from Iran, Afghanistan and Iraq in the 1970s and 1980s (Gilliat-Ray 2010: 50). Later migrations include asylum-seekers from Algeria, Bosnia, Somalia and Kurdistan who came to Britain in the last decades of the twentieth century.

Nagel and Staeheli (2011) discuss the relative unimportance of Muslim identities to labour migrants arriving in Britain from the Arab world, South Asia, and Turkey following the Second World War (see also Cesari 2004). This point is supported by Gilliat-Ray (2010) with the suggestion that a shared religious identity provided linkages for new social bonds, often formed around places of worship, but that new Muslim arrivals were marked by more differences than commonalities. However this altered markedly after the 1980s with much greater significance given to Muslim identities, which Nagel and Staeheli (2011) attribute to two key factors: firstly, the racialisation of Muslim minorities by dominant groups in society; and secondly to the construction and negotiation of new identity forms by Muslim minorities themselves as is explored later in the book (Nagel and Staeheli 2011: 439). For as Clare Alexander writes, there is an enduring anti-Muslim discourse that obscures racism under the guise of 'culture' and cultural difference; an othering that rehearses ideas 'of medieval cultures, barbarism and timeless antagonism to "the west"' (2017: 14). Meanwhile in the twentieth-century Islamophobic discourse is illuminated by critical scholarship on Orientalism that arose in response to colonialism, de-colonisation and post-war migration (Said 1978), where Muslims were only one target of wider societal racism. 'It is important to remember', as Alexander writes, 'that 'Muslims' in post-war Britain were configured as 'coloured', then 'black', then 'Asian', then 'Pakistani' and 'Bangladeshi' before they appeared as 'Muslims' – and while the labels may have changed, the racist content of the category largely did not' (Alexander 2017: 14; Alexander 1996).

Changes in the Muslim Population in Britain

The 2011 census showed at that time the Muslim population was 4.8 per cent of the national population, with over 50 per cent of the population of Muslims in Britain born in the UK. As Lewis and Hamid observe in relation to the changing population land-scape, 'it [is] clear no one is a Muslim-in-general but rather people belong to a diversity of ethnic communities and religious traditions' (2018: 18–19). In 2011 around 68 per cent of Muslims in Britain were from South Asian heritage (Census 2011). Pakistani Muslims comprise the largest segment of the British Muslim population at 38 per cent (around 1 million), followed by Bangladeshi at 15 per cent (400,000) and Indian at 7.5 per cent (200,000), with an increase in minority Muslim groups, such as White Ethnic and Black African. Arab was included as a category in the 2011 census for the first time, with 180,000 identifying under this category. The most recent statis-tical release showed an increase in Muslims in the UK to 3,372,966 (ONS Annual Population Survey April 2017 to March 2018). There are issues with data collected, however. Religion and faith feature as an optional question on the census (although with a robust number of returns), and concerns have been raised that in the existing census data, ethnicity group categories fail to capture the diversity of the Muslim population in Britain. In turn, issues around the accuracy and completeness of data from standard demographic surveys have reinforced gaps in the reporting of Muslims in industries across the public and private sector. A recent Runnymede Trust report, *Islamophobia* (2017), marking twenty years since the term was first coined, noted evidence of a specific 'Muslim penalty' across employ-ment, along with other areas such as health and housing. It called for improvements from public and private sector employers around the quality of data collected. Complicating the notion of the 'Muslim penalty' is that national and ethnic group categories often serve as proxies for religion. Pakistani and Bangladeshi ethnic group cat-egories, for instance, have historically been used as proxies for being Muslim. Although indicative, such designations are imprecise, in

particular masking the existence and experience of minority religious or non-faith groups. It also means that identifying discrimination as about religion rather than ethnicity or race risks reducing what is likely a complex intersection of the two, which might have been experienced by Muslims as ethnic or racialised at other points in their lives.

Available data reveal an urban geography to residential patterns of Muslims in England: 25 per cent live in Inner London, and 22 per cent in Outer London; 10 per cent live in Greater Manchester, 15 per cent in the West Midlands and 11 per cent in West Yorkshire. Overall, Pakistani and Bangladeshi groups currently account for just over half (55 per cent) of British Muslims. In Greater Manchester, where the majority of the empirical study was conducted, the largest single ethnic Muslim group is also British Pakistani, comprising approximately 60 per cent of the total Muslim population (Elahi and Khan 2017). This is followed by 15 per cent who identify as Bangladeshi. The third-largest Muslim ethnic group in the city is Indian, at 11 per cent (indicative of why Indian should not be taken as a proxy reference for Hindu), and all other Muslim ethnic categories each make up 5 per cent or less (Hussain in Runnymede Trust 2017: 20). Yet, as highlighted by the Centre on Dynamics of Ethnicity (CoDE) at the University of Manchester – in reports on Manchester City Council's census webpages – the notion of ethnicity and accuracy of census data is insufficient in building representations of migration and changing levels of demographic difference. Their point is enforced by the findings of this study where many participants reported changing perceptions of their ethnicity over time – leading to the ticking of different 'boxes' over the life-course on passport applications and census forms.

For instance when interviewed, two sisters of mixed heritage relayed to me how they were encouraged by their mother to document themselves as White European when growing up. As they matured into adolescence they felt that this silenced the importance of their Arab and Muslim identities. Another pattern was the rejection of nationhood, or 'downgrading of national identity' (Simonsen

and Koefoed 2020: 44), pointing towards more globalised or cos-
mopolitan identities. In part this can be understood through
self-awareness of familial migration histories and continued connec-
tivities with other countries and places that shaped a sense of broader
horizons, or, sometimes, outsiderness. As Werbner (2004: 896) has
written, diasporic communities are 'mobilised groups . . . cultural,
economic, political and social formations in process, responsive to
global crises and multicultural or international human rights dis-
courses . . . They encompass internal arguments of identity about
who "we" are and where we are going.' Elsewhere, Werbner (2002)
describes the political activism of Muslim women's organisations in
Britain for Muslims in Palestine, Chechnya and Kashmir. Migrants
might have multiple, overlapping affinities, memberships, even citi-
zenships, sometimes with important tensions with one another, but
which are not necessarily mutually exclusive (Nagel and Staeheli
2008; Fitzgerald 2004; Leitner and Ehrkamp 2006). Multiple iden-
tities might actively create distinct, even opposed, public spheres,
such as the Pakistani diaspora's participation as 'British South Asian'
(contributing to novels, films, music, food) and 'Islamic' in religious
discourse and debate. Or the seeming public cleavages between inte-
gration and opposition; the 'clash between Muslim Puritanism and
South Asian popular cultural "fun"', which also exposes internal dif-
ference, politics and frictions (Werbner 2004: 899).

As briefly outlined in the Introduction, the artists and cul-
tural producers in the research variously introduced themselves as:
Pakistani/British Pakistani (over half); also Indian, British, Iranian,
Eqyptian, Palestinian, East African-South Asian raised in Scotland,
Burundian, Caribbean, Sweden, Norway, Belgium, 'just mixed', 'I'm
a mongrel' . . . Or favoured more localised scales such as Mancunian,
or even 'I'm a Chorltonite'. The last reference is about belonging to
Chorlton, a 'cool', mixed ethnic and politically progressive residen-
tial area of South Manchester. What Simonsen and Koefoed (2020:
44) term a 're-scaling of identities', 'in favour of more hospitable
spaces at global, urban, local or bodily scales'. De-nationalising iden-
tity resonates with a wider point discussed throughout the book and

especially in Chapter 8, 'Creative Activism', about how citizenship is imagined and practised beyond the national by either acts of citizenship or ways of talking about citizenship that focus on the scale of the city or neighbourhood, or which are transnational, multicultural, cosmopolitan or global (Appiah 2006; Parekh 2000; Amin 2002).

Muslim Women and Work in Britain

While the number of Muslims overall with degrees and higher degrees is slightly higher than the population average (Social Mobility Commission 2017), only 40 per cent of Muslim females aged 18–24 are likely to be economically active, in comparison to 61 per cent of all females (Elahi and Khan 2017; Karlsen and Nazroo 2015). Even when controlling for qualification level and other protected characteristics, the rate of unemployment for Muslim women is significantly higher and economic activity lower, which is a situation reflected across many European countries (Khattab 2018). Where figures are analysed by ethnicity, 37 per cent of Pakistani, 37 per cent of Bangladeshi and 35 per cent of Arab women are economically active compared to 62 per cent of Indian women and 57 per cent of women nationally (Hussain 2017: 23; Khattab and Modood 2015).[3] Miaari et al. (2019) observe inadequacies with the available data as I pointed towards earlier. These points are worth rehearsing in full here:

> The literature on British Muslim women's labour market experience suffers from four lacunae: the inadequate analysis of the multi-layered facets of their identities and the disadvantages they face; the narrow range of labour market outcomes studied (primarily labour market participation and unemployment); a lack of recent studies on the integration of Muslim women, educated in the UK and with English as their first language, into the labour market; and the absence of material on several sub-groups due to the lack of data, notably Arab, Christian Indian and White-British Muslim women (Miaari et al. 2019: 19).

The available census data is now almost a decade old, with the next census data release due in Spring 2022. Also as outlined by Miaari

et al. (2019) there is a narrow range of labour included in available data that excludes the important unwaged work Muslim women in Britain might routinely perform that is crucial for the economy, such as caring duties (given high costs of childcare), working in family-owned businesses and volunteering for charities. It fails to articulate the experiences of integrated, well-educated and fluent English speakers, who have been found to have similar outcomes to the wider population. It also obfuscates the experiences of minority Muslim groups, especially those who have more recently settled in the UK. Quantitative data whilst useful for observing broader transitions cannot give insights into the lived everyday experiences of diverse Muslim women in work. Complexity, especially around politics of identity and discrimination, such as understanding intersectional facets of disadvantage, is most effectively explored through in-depth qualitative approaches.

Reports such as Demos (2015) suggest that British Muslim attitudes to gender and work have changed over the past thirty years, with younger Muslim women more likely to be employed than those aged fifty or over. Changing attitudes around Muslim women in paid labour in the twentieth and twenty-first century trace broader societal attitudinal shifts to women and work in Britain. As McDowell (2016) writes in her book on migrant women and work in the UK, over the course of the twentieth century waged work became the norm for more women of all backgrounds. A number of factors lay behind the rise of women in work including rising standards of living and appeal of new consumer goods, along with home ownership that meant a second income was increasingly seen as necessary in many households. Wider social changes were also occurring. More women went to university and on average women were having fewer children, giving more time for work which was undertaken over longer time periods across the life course. The employment gap between men and women continued to close so that by the end of the century almost as many women worked outside the home as men (just over 70 per cent of working age – 16–60 years – in 2001); however, types of employment and pay differentials persisted. For instance, cleaning

and childcare outside the home were chiefly performed by women and are typically low paid, with knowledge work such as law and higher education dominated by men. As McDowell writes: 'Cerebral functions rather than body work ... became, and has remained, a largely masculine domain, although open to middle class women with the appropriate educational backgrounds' (McDowell 2016: 6). Class-based and educational differences impact working lives with those obtaining higher levels of qualification more likely to work on a full-time basis (McDowell 2016: 13). Though overt sexist and discriminatory behaviour has lessened, it is still the case that women are excluded from most senior roles across the professions. Beyond class, and in patterns that continue today, McDowell continues, women from 'other countries, other cultures, with different voices, bodies, beliefs and habits' were seen as less suitable employees (McDowell 2016: 7). This often manifests in an intergenerational gap for migrant workers and their families, albeit one that has not closed for many young Muslims in Britain living in poverty (Runnymede Trust 2017). Counter-intuitively, pursuing higher education might be overdetermined as a pathway out of poverty due to persistent racism within the job market. For instance, Khattab (2018) argues that ethnic minorities over-invest in higher education due to the belief that higher level qualifications enable social mobility and can counterbalance ethnic penalties in the job market; this pattern is referred to as 'second generation labour market optimism' (Khattab 2018).

Therefore social attitudes towards gender and work appear to be changing for British Muslims, as they are for the wider population. For heterosexual Muslim women, marriage and the period after birth are still major milestones that mark a drop in documented economic activity levels, nevertheless. In analysis of census figures from 2001 and 2011, Hussain writes on domestic roles for Muslim women in Britain in comparison to the UK average: 'Muslim women are more likely to report looking after the family and home ... Even within the youngest cohort, Muslim females are twice as likely to remain at home to look after their families, with 10 per cent of 16–24-year-olds reporting this to be the case, compared with 5 per cent of all

females in the same age range' (Hussain in Runnymede Trust 2017: 23). In interpretation of the link between young female underemployment, the *British Muslims in Numbers* report (Muslim Council of Britain 2015) writes that family responsibilities take precedence for many following marriage. However, it later adds the important context that often there is an intention to return to work and combine work and marriage. It is further acknowledged that the barriers to employment faced by Muslim women are shared by other women in Britain, such as gender discrimination, inflexibility of work, and lack of (affordable) childcare (see also Lewis and Hamid 2018: 21).

Higher education before marriage has been shown as an important factor to whether Muslim women remain or return to employment after marriage (Miaari et al. 2019). Often there is a need for two incomes given the erosion of men's earning capacity, and higher education qualifications are regarded as supporting the negotiating position of women after marriage, along with language proficiency (Khattab et al. 2018). Qualifications can be viewed as offering protection for re-entry into the labour market later in life, too, if needed as a safety net (Dale et al. 2002: 954). But as Gilliat-Ray observes, due to the fact that the majority of Muslims in the UK are of South Asian heritage, our understanding of British Muslims and labour is skewed by the experiences of a Muslim South Asian diaspora (2010: 124). This weighting can reinforce certain stereotypes which wrongly homogenise all Muslims across cultural, geographical, educational, racialised and class backgrounds. For instance there are marked racialised distinctions found for Islamic religious identity and visibility where 'White' Muslims are the least likely to be disadvantaged in the labour market and 'Black' Muslims are the most disadvantaged of all (Miaari et al. 2019: 37).

However, motherhood is a second milestone; here available data from the Labour Force Survey (LFS 2002–13) and the UK Household Longitudinal Study (formally known as Understanding Society – US 2009) on economic activity sees a marked shift. 'Many of those women who succeed remaining in employment after marriage have higher education, but are expected to leave employment

when they become mothers, which constitutes a second important focal point at which economic activity within Muslim women in Britain falls even further' (Khattab et al. 2018: 1543). The period after children arrive disrupts paid work across all women in the UK, both for those born here and for migrants (McDowell 2016: 13; Anitha et al. 2012), although the most marked drop is documented for Muslim women. The important role of mothers in nurturing and educating children is a prominent theme of Quranic verses and in sayings attributed to the Prophet Muhammad (Gilliat-Ray 2010: 126). Motherhood as a primary role and responsibility is therefore a proactive choice for many, especially while children are young. A critical approach is needed in the analysis of data on employment and economic activity. Gilliat-Ray (2010: 126) reminds us how this data fails to capture the important roles undertaken by women, where much valued 'invisible' social reproduction work is performed by Muslim women and indeed undervalued in our societal economic frameworks (see also Women's Budget Group).

The 'new normal', as discussed by many women in the study, aims towards higher education and starting a career before marriage. In contrast, marriage and child-bearing before undertaking a degree or starting a career was viewed as a very challenging pathway. 'Wafiza' encapsulates this when discussing her struggles with getting into work after marriage and having a child, as a woman from 'Asian culture':

> My family were quite shocked as well, they always expected me to study further and go to uni and just make something of myself. Then I decided to get married because, I just thought, 'I want to get married'. Do you know what I mean? I just want[ed] to settle down and stuff . . . I think there's a quite wide space between like women, Muslim women now. Some women are like me and some, they just don't want to get married at all, they've got the secure job and everything.

'Wafiza' elsewhere is clear on the distinction between culture and faith, identifying tensions around women in paid work as cultural rather than Islamic. To underline this point about gender and work,

she draws on the figure of Khadijah, Muhammad's first wife and a respected businesswomen. In her interview above she separates out pathways for marriage and work. For the Muslim women already in secure work that she refers to marriage is less appealing. There is a suggestion that women may still feel pressure to choose, and thus a good job and financial independence could be threatened by marriage. Building upon previous work on women of South Asian origin and the relational spaces of home and workplace (Anitha et al. 2012; Bhachu 1985), employment can enable the accumulation of wages and transform marriage practices. Therefore it is possible that marriage as a route to financial security, and therefore marriage itself, is becoming less important.

Parental attitudes towards educational and career opportunities for daughters are continuing to shift with less focus on marriage for security, as I have advanced elsewhere (Warren 2018; Mohammad 2005; Lloyd Evans and Bowlby 2000; Mernissi 1987). In 2008, Ahmed and Dale argued that a change is evident across generations of Muslim women in Britain. This could be understood by a range of factors such as greater access to university, learning English as a language, younger generations spending most of their lives in the UK and therefore growing up fluent in English, and the devaluing of foreign qualifications which are rewarded less than UK accredited qualifications (Ahmed and Dale 2008). Improved access to higher education and degree level qualifications has meant improved positions in the job market can be applied for (even where discrimination is still active), and within a landscape of education and improved access, young females were maturing into women with different expectations and aspirations to their mothers (Ahmed and Dale 2008: 6). Higher education aspirations and attainment for Muslim women were shared, if not encouraged by parents, even where there was disagreement on degree choice and university (either due to prestige or location) and concern of racism (Afshar 1989; Brah and Shaw 1992; Brah 1993).

Still, this somewhat rosy picture needs to be qualified with newer research that reveals the over-representation of minority

ethnic students in lower status further education colleges and universities, and lower degree attainment even when entry grades are accounted for. Muslim students, along with minority ethnic students, have been found more likely to attend post-1992 universities (former polytechnics) and to live in the parental home during studies in higher education, with worse outcomes than their white peers (Hussain and McLoughlin 2013; see also Shiner and Modood 2002). In order to tackle inequalities in job market entry, wider guidance and knowledge of sectors were considered necessary, such as opportunities, training, support, mechanisms, rights and caring provision to improve participation. Further, Ahmed and Dale (2008; see also Modood 2006; Mitter 1985) identify that a narrow range of desirable careers, expressly medicine and law, might delimit employment opportunities, along with the need to move away from 'traditional' gendered jobs, such as working in a factory or home-working sewing garments. As I discuss further in the section that follows, it is clear currents of Islamophobia and forms of sexism and patriarchy are shaping workplace dynamics and subject experiences. Keeping view of the ways Muslim women are subjected to multiple, intersecting and overlapping forms of discrimination, this book also wants to recognise how agency is exercised in asserting work and life aims, and how women are often at the core of social and economic changes.

Suggestive from the research findings is that occupations within new creative industries, expressly social media and the modest fashion industry, and *not* attending university, might well be seen as breaking the mould. Whereas obtaining higher education and entering professions for children – daughters and sons – has been an aim for social mobility and advancement in Britain, a structural shift in the economy associated with post-Fordist and creative forms of labour might well be unsettling the investment in higher education as a means of challenging the ethnic penalty. This is not poorly informed given investment in higher education has not made a clear difference at least when viewed in terms of graduate employment and income. For instance, the Social Mobility Commission found

that British Muslim women are not achieving the 'return on education' that they anticipated (Social Mobility Commission 2017: n.p.). It is also consistent with self-directed project or portfolio working that bypasses working for companies. As 'Wafiza' phrased this, in views that might at first seem paradoxical, her father had a 'backwards mentality' of expecting her to get a degree. She describes her father's attitude to university:

> He still had that sort of mindset, that backwards mentality that, you know, 'You need to have a degree and you need to study hard otherwise you're gonna end up in a job like, in a factory or something'. You know, whatever.

For many new younger adults there is an expectation they will progress to higher education and get jobs, regardless of sex. But a new notion of 'backwards' is that there is one correct pathway to follow for a 'good' career; instead young Muslim women might not pursue higher education and might choose from a wider range of careers. For instance, by working as an entrepreneur, but outside family-owned businesses. The juncture many young people found themselves in represents a broadening out of understanding on what opportunity and status entails. British Muslims are widely involved in creative arts and other related fields, such as Islamic hip hop, calligraphy, art, fashion design, fiction writing, journalism, film, comedy, and so on, but there remains little research on this area (Gilliat-Ray 2010: 238; also see Masood 2006). Where gratitude has been expressed by younger Muslims in the past for the opportunity to explore their creative talent, this has been attributed to cultural differences in perceptions around the respectability of artistic work in comparison to established professions of law, business and medicine (al-'Alam 2003). Typically multiple actors might be involved in decision-making – parents, extended families, even community networks – often with various, and sometimes conflicting, views. Negotiations bring together multifarious roles and positions intersecting, for instance, sexes, age, education level, ethnic and cultural differences. For, as illustrator 'Mona' describes:

My dad still has this kind of thing in his head where, 'No you can only get a good job and you can only succeed in life if you go to university and get a degree'. Whereas my mum, she's born and bred here, so she was sort of like, 'D'you know what, do whatever you want to do but just make sure that you're doing it well, or you know you're giving your best effort or you're enjoying it at least'. Because she never got a chance to go to college. My granddad was quite . . . Even though he came to this country like, ages ago. But, he never sort of let her go to college or anything, and she's always been really good at art, and she loves like her creative stuff.

Muslim Women and Finding 'Good' Work in Britain

As introduced earlier there is a well-documented 'Muslim penalty' that exists across multiple sectors, including housing, education and employment. Above and beyond other explanatory factors there is something distinct in the Muslim category of identification (or misrecognition by others) that means greater inequalities are experienced. Disadvantage in the labour market was particularly harsh for Muslims out of all non-white groups (Platt 2005; Khattab 2009). Platt (2005), in her study on migration and social mobility, found religion an important factor in determining outcome of higher professional occupations (with Christians and Hindu identity increasing likelihood and Muslim and Sikh identity decreasing likelihood). Muslims are less likely than other groups to appear in the top professions in Britain (Demos 2015). Recent important studies in the UK, France and Germany have shown systemic discrimination, termed a Muslim 'penalty' (Elahi in Runnymede 2017; Bowlby and Lloyd-Evans 2009; Cheung and Heath 2007; Cheung 2014; Warren 2018, 2019; Ahmed and Dale 2008; Heath and Mustafa in Runnymede Trust 2017; Khattab and Modood 2015).[4] Extant research has typically elided Muslim identification and South Asian cultures, showing how this penalty is applied variously at shortlisting for those who have a distinctive Islamic and/or South Asian name (e.g. Mohammed/Aliyah), at interviews for those who are visibly Muslim, such as wearing the hijab, and within workplace culture

for those marginalised and refused promotion due to ethnic and religious identity (Heath and Mustafa in Runnymede Trust 2017; Khattab and Modood 2015). It was also reported that in-work cultural insensitivity, stereotyping and indirect racism were commonly experienced (Heath and Mustafa in Runnymede Trust 2017: 27; Social Mobility Commission 2017). This discrimination builds from a discourse of 'othering', meaning 'representation in terms of difference' (Al-Azmeh, 1993: 5) or a 'process . . . through which identities are set up in an unequal relationship' (Crang 1998: 61) that reinforces a hierarchy between majority and minority groups along lines of race, ethnicity, culture and religion.

Around certain industries, including some creative work, a 'chill factor' has been shown (Warren 2018). Explaining this, McCrudden et al. (2004: 390) write:

> the 'chill factor' – the various social and psychological factors that may discourage individuals from an under-represented group from applying to a firm – such as historical associations with a different group, real or expected discrimination from workmates in the opposite community, or disapproval from friends and family.

Muslims may avoid applying for or aspiring to join certain employment sectors that they feel would provide an alienating work environment or where they would expect to be 'pigeonholed' into stereotypical work. This could include sectors such as the police force, the construction industry, acting, the armed forces and the media (Heath and Mustafa 2017: 28). It is not inconsequential that two of the four examples around typecasting and stereotyping given by Heath and Mustafa are sectors of the cultural and creative industries.

Spotlighting the importance and challenges of Muslims and cultural work, in September 2017, the Muslims in Britain Research Network (MBRN) organised a conference: 'Contemporary Muslim Art, Culture and Heritage in Britain'. Lewis and Hamid (2018) consider how the MBRN conference explored the meaning of Muslim and Islamic, how Muslim arts are developing in Britain, and the response of the cultural industries. They write on the particular

challenges of labour in cultural fields: 'These questions also indicate the strains within Muslim communities around the nature of artist expression and the difficulties of gaining recognition in the mainstream arts world' (Lewis and Hamid 2018: 178). Importantly they recognise that Muslimness or Islamic principles are not always relevant to the kind of work produced. Cultural production is 'often but not always informed by their faith' (178), with a range of intended purposes from creatives expressing themselves, challenging stereotypes to raising political consciousness. There is a crucial role played by the artists and cultural producers in engaging wider groups through their work and the spaces they create. In the words of Lewis and Hamid (2018: 178–9): 'These artists and cultural producers explore difficult issues and help bridge the divides between communities. This development creates exciting opportunities but also uneasy tensions within communities as some forms of visual and performing arts are considered religiously problematic.' Of note are the second and third generation, often female, artists and activists. Lewis and Hamid's book (2018) surveys a wealth of cutting-edge work produced across multiple mediums and platforms, stretching far beyond modest fashion, which typically attracts most attention. It also considers women producers as change-makers, but leaves a critical space for further reflection on the gendered dimension of experience, along with analysis of the nature of their activism.

As I have begun to establish, there is little available research on British Muslim women working in cultural and creative occupations. However, there is much discourse relating to potential tensions with the kinds of work undertaken. For instance in tensions with modesty and shyness in showing the body, or revealing the voice on stage, film, or radio, amongst other platforms and mediums (see online *sister-hood*). There are issues with 'free mixing'. In other words, spending time with men with whom one could potentially have sexual relations. There are also potential conflicts around travel, especially longer distances without a family member, and environments associated with drinking, or other kinds of intoxicants. Historically, Milwright (2017) has written, in the Qur'an and

hadith, crafts were gendered, insofar as documents refer to guilds, to which only men could belong. Although the craft objects were revered, the people producing them were often of lower class and status in society. In fact, Milwright notes associations with poor character such as untrustworthiness due to craft makers handling physical money or belonging to a minority religion. Therefore issues of respectability around crafts, and other creative forms, were not necessarily concerns about women per se, at least not historically. In interviews in the present study, respondents often talked about a disconnect, as they saw it, between the way in which families and community groups loved beauty in Islam and the Islamic world, but did not consider the life of an artist or craftsperson to be respectable. In part this can be understood in relation to longer diasporic histories and cultural inheritances around occupational status within families, and communities. For Deeyah, magazine and film producer, these ideas around roles, and 'good' educational and 'good' occupational routes are gendered and interconnected with migrant insecurity:

> Some families are traditional, and just want to groom women to their expected roles as wives and mothers, and see other careers as a distraction from that. Some families are dealing with the experience of growing up in the diaspora, which tends to make them look for the financial security of their children as a priority. So they might be fine with a daughter studying engineering or dentistry, but if she expressed a wish to go to art college instead then they'd discourage that strongly.

Reported preferred occupations in family aspirations for daughters are medicine, pharmacy and law, which offer roles with high social capital that are relatively stable and well remunerated (Milwright 2017; see also Lewis 2015). It has been argued there are cultural attitudes to what is deemed suitable work, and acceptance that if suitable work is not available then the man (in a heterosexual partnership) will act as breadwinner (Miaari et al. 2019: 42). Graduate employment is typically concentrated within a fairly narrow range of fields. As Tariq Modood (2006: 248) highlighted, this trend has been active

elsewhere with minority ethnic groups disproportionately represented in medicine and health-related subjects, engineering, ICT, law and business, but under-represented in pure sciences and humanities. Lewis and Hamid (2018: 20) quote Atif Imtiaz (2011: 57), a Muslim commentator, who observes a preference for sciences over arts and humanities, with targeting of 'technical, scientific, medical, financial or legal professions . . . There are relatively few Muslim graduates in the humanities or social sciences . . .' He continues with a critical argument that this has led to 'our best and brightest' pursuing careers that do not foster skills, expertise and subtleties around the 'art of persuasion' (2011: 57). Although Imtiaz's insights are not underpinned by evidence from large-scale data, they could sharpen understanding for why there is a lower representation of Muslims in comparison to other faith groups amongst the professions of the civil service, journalism and solicitors (see Citizens UK 2017).

Some of the complexity around choice of subject at degree level and career is discussed in this exchange between a mother and daughter during a focus group conducted at the Muslim Heritage Centre, South Manchester:

> Daughter: I was really conflicted about what to do, and in the end I went with the Languages route. But yeah like, mum and dad didn't stop me from doing anything, but you could tell they would have been happier with Medicine
>
> Mother: Yeah, I would agree. Because I knew this would come up. So even though I am not from that generation, but still that feeling is still there, that when she said 'I want to do Languages', the first thought is 'what job are you going to get?' Especially [because] I've got a medical background . . .

It was never in doubt this young woman would attend university. Gifted and high achieving across a full range of disciplines, the focus instead was on what discipline would be best for her to pursue. The daughter discusses two choices – languages or medicine. She is clear that her parents did not intervene, introducing this as a possibility elsewhere, but that she was aware of their preference.

Both of her parents had a background in medicine, although her mother was retraining in art therapy, suggesting an interest in the relationship between arts and sciences. Despite openness to the benefits of studying arts and humanities subjects, her mother acknowledges initial concern at the choice of languages. Later in the focus group, her mother explained, 'I think it's mainly job security'. The daughter needed to undertake research to prove there were jobs in languages. An established middle-class family with several generations who were university educated, her mother introduces a generational change around attitudes to disciplines, employment and status. However, the concern articulated arises from job and financial security, rather than the nature of the work per se. It complicates the reading by Brook et al. (2020) that low and often precarious pay does not undermine the desirability of cultural work because the arts carry an alternative form of status. By taking a wider contextualised approach this extract of a mother–daughter relationship indicates how occupation status beyond matters of class might also be linked to migratory histories, and cultural, raced and religious identities.

Meanwhile, completing art school and launching her own career had implications for 'Mona', a mixed heritage Libyan and British illustrator, in terms of how she discussed a sense of purpose to her family and community. Interviewed in her third year, one week before the end of the course:

It's more about now being able to finish uni to go on in to the world but it's like everyone else knows what kind of artist they are and I have no idea, I have no clue. I have this problem with finding out who I am, it's really weird.

Later voicing a preference for the word illustrator over artist to describe her occupation, 'Mona' explains:

Mona: But I'm afraid to use that word ['artist'] because my mum would lose her mind.
Interviewer: Why?

Mona: Because it's the word 'artist'. That's really unusual. That means, totally like, no future.

Interviewer: Right. In terms of pay?

Mona: Yeah, in terms of their ideas of success, the community's idea of success. It doesn't fit in with that. So if you just call yourself an 'artist' it has the implication that you're somewhat lost.

Meanwhile for another participant in the study, 'Fatimah', who is a trained fine artist with a degree, it was clear from her in-laws that only certain occupations were deemed suitable for her once married to their son:

They were very keen for me to go back to university to do a teaching degree. [Or] I think they would have loved it if I was a doctor or a dentist, or something else. Initially they were glad that their son had married someone who was educated, but for them it meant . . . I always thought, if you wanted your daughter to stay at home and cook and clean and do all that, why did you get your son married to someone who was educated?

It has been written elsewhere that in previous generations parents might view a degree as a way to enhance the marriageability of a daughter, rather than for a career route (Brah and Shaw 1992). In the narrative above the point is not that it was expected upon marriage the daughter-in-law would give up work. Rather it was that in order to justify breaking from a normative domestic role required the right kind of occupation. Medical occupations are raised as desirable, as with the former example, and in almost all interviews and focus groups where the topic was discussed. Teaching was also seen as appropriate work (see also Brah 1993), which has been understood as gendered labour for social reproduction, particularly in Muslim faith schools for nurturing Islamic principles and Muslim community values in the next generation. As 'Fatimah' made clear, her creative work was not valued by the family, nor by her husband either, although he became more supportive after they moved into

their own place, when domestic distance was created between her marriage and her in-laws. Beyond highlighting the often various and complicated relationships involved in decision-making around education, training and career choices, this extract also suggests that not all degree qualifications hold equal status or negotiating power with family when seeking to return to work. Pursuing artistic and creative work was a harder option than more familiar pathways of teaching or medical occupations, and in turn familiarity and track record of women working in these occupations cemented their respectability, along with job security and salaried pay.

In the above discussion I have begun to build a case that the status of cultural and creative work is uneven. Contextualising the status of cultural and creative work also involves considering the wider educational and political landscape. There have been negative impacts by government policy around austerity and arts education in conjunction with economic crises since 2008. Recent studies have suggested a devaluing of non- 'academic' disciplines and extra-curricular activities for children and young people (Lewis 2015). Issues of access are entrenched given the recent introduction of the English Baccalaureate for qualifications at age sixteen, where creative arts were downgraded to non-core subjects (HEPI 2017), amidst a wider lack of state funding for arts education in music and the arts. Exclusion is likely to be only further compounded by the pandemic of 2020 in Britain leading to theatres and art institutions calling publicly for a government bailout to weather financial peril, and subsequent declaration of job losses. Given the landscape of educational de-prioritisation, poor funding, and arts unemployment in the UK, it is not surprising that as 'Asma' puts it, 'My parents believe – what is the point of arts and culture?' Interestingly, her sister is heavily involved in arts and culture in Pakistan. 'Asma' observes inter-generational difference in attitudes within her own family – despite less state support and devaluing of arts education and culture in Britain. There are also social and cultural politics in mainstream culture and the arts. Or as 'Asma' phrases it, galleries and museums in Britain have 'good intentions', 'their hearts

are in the right place, but they take a privileged position', and are 'still limited by their world-view'. British institutions dedicated to art and culture were regarded as complicit within taxonomies and knowledge practices that reinforce a 'West and the rest' world-view (Said 1978), where the approach to culture understood as a marker of distinction might serve to alienate. As 'Asma' saw it, 'Muslims link culture to identity – particularly the older generation and take a different perspective.' Although there has been a rising interest in galleries, museums and heritage centres around the display of Islamic arts and textiles, historical and contemporary, which I explore in depth in Chapter 7 (Visual Arts), there has been some ambivalence from British Muslims about the selective display of Islam (Heath 2007) and wider critique around de-colonialising museum practices.

Continuing the themes of contested perception and alienation, it is unsurprising that an Iranian artist in the research noted that in contemporary Iran the censorship of faces and bodies in art practice and gallery exhibitions has impacted heavily upon Muslims pursuing visual art, despite a Muslim history of figurative Mughal art. However, for her mother the major concern was that pursuing art did not appear a secure option for paying future bills, rather than issues of doctrine or principles. Gendered issues for women are not insignificant here, but there are challenges for all where a career entering culture and the arts is discouraged. For men, as one participant observed, pursuing art and cultural work is potentially even more of an issue, given the normative, gendered ideal of men as the primary breadwinner. In which case, 'proper professional careers' are instead encouraged by families and community networks where relevant.

Conclusion

Employment of Muslim women has attracted considerable attention as statistically their participation is lower than the UK average. However, despite various reports and studies, the roles and experiences of Muslim women in work in Britain, and elsewhere, have been understudied in qualitative research. This is a particular issue given the shortcomings of available data collected, which is

outdated, imprecise in mapping minority Muslim groups and, by extension, tends towards representing the experiences of Pakistani and Bangladeshi heritage Muslim groups. As a result the 'typical' experience of the job market might more accurately reflect cultural, geographical and socio-economic factors, rather than specifically religious or faith-orientated concerns. This is crucial because those from Pakistani and Bangladeshi backgrounds encounter some of the highest levels of deprivation in Britain (Modood 1994). Although class works in different ways depending on ethnic and migratory background, two thirds of white students' parents come from non-manual work, in comparison to only one third of Pakistani or Bangladesh students (most of whom will be Muslim) (Modood 2006: 248). Meanwhile those who have lived longest in the UK, with English as a first language, and high degree qualifications, have similar job outcomes as people who are White British. Those who are visibly Muslim, for instance who veil, or have a distinctive name, and who are also Black are the most likely to be disadvantaged in employment (Miaari et al. 2019: 37). Therefore to understand the complexity around Muslim women and labour there is the need to take into account ethnicity and racism, religion, class and migratory history, and how these are understood in people's lives.

A recent Runnymede Trust report (2017) states the need for an anti-poverty strategy. It identifies racial inequality with a Muslim penalty across key area indicators. To address this in relation to labour, it suggests employers and employment support organisations (such as job centres) should tackle certain barriers to labour market participation, which ought to be underpinned by changes to policy around racial discrimination in the job market. Runnymede identified the need for improved transparency on publication of pay gaps and protections for name-blind CVs to avoid what has been termed unconscious bias, in the sifting out at shortlisting stage of cultural difference. Other measures suggested were that long- and shortlists should reflect the local working-age population, and that progression of minorities should act as a key performance indicator for managers. The issue around implementing some of these suggestions within the

cultural and creative industries is that informal hiring processes are standard practice, given it is very closely networked for all groups, and work entry is often through familial connections for minority ethnic groups. Given that diversity and equality data collection and public sharing is not compulsory in the private sector there are also issues with reporting and completeness of available data. Cultural work raises particular challenges about access and progression that I will explore in greater depth later in this book.

In this chapter tensions are outlined between cultural and religious norms on gender and division of labour, and how this is mapped onto demarcations of the domestic and public sphere. Drawing on the seminal work of Linda McDowell and Avtah Brah, and extending analysis of gender and migration to consider faith and religion, I have argued that there are changing attitudes to Muslim women in education and work that mirror broader societal attitudinal shifts to women and work in the twentieth and twenty-first centuries. Despite this it is widely reported that Muslim women are least likely to work of any group in Britain, and especially when they are raising families. Occupations deemed most attractive by parents are discussed in relation to South Asian cultural norms in particular as sectors that are professional, conventional, familiar and secure (and typically avoid evening work), which aligns with scholarship around migration and labour markets. Paradoxically, higher education and seeking a 'good job' in a narrow range of professions for younger Muslim women might seem restrictive as a model for success. Some participants in the study questioned whether conventional jobs (teaching, medicine, law) or marriage were right for them. Instead, a broader range of disciplines and career choices were considered in thinking through what occupation could offer interest, a sense of reward and meaning.

Virdee (2006) makes the point that the kind of work people do can be structured by racism, and this often starts with education. There is ethnic clustering around certain jobs, such as driving, and certain industries, as Kalra (2000) has also explored in his work from textile mills to taxi ranks. Job opportunities are often presented

through networks, locally and multi-nationally, such as the idea of chain networks. An interesting new angle emerging from my fieldwork that I discuss in more detail later is that a structural shift in the economy towards knowledge-based work, including creative occupations, might be unsettling the overinvestment in higher education, more recently the norm, as a means of challenging the ethnic penalty. Obtaining higher education for children, including daughters, has been the aim for several generations for new arrivals concerned about social mobility, or just getting by. But an over-investment in higher education had not made a clear difference. As one participant phrased this, her father had a 'backwards mentality' of expecting her to get a degree. Whereas in previous generations there is evidence that education of girls and women might have focused less on careers than on marriage prospects, a different concern is raised here. There remained an unresolved tension for many around combining marriage and careers. Concern around entering occupations in culture and the arts is not unrelated to changing expectations around marriage, with anticipation that daughters need to have a means of financial independence, certainly for middle-class families. Analysis of statistical surveys such as census data is useful for a broader understanding of changing contours of working landscapes. But as I have begun to make a case for, there remains a need to tell the stories behind the big data of the everyday desires and challenges within how women narrate their lives and labour experiences. In the next chapter I turn to consider the governance of diversity by looking at cultural policy in Britain, past and present, and the neglected place of religion in this area.

Notes

1. The vast proportion were Indians, with small numbers of Arabs, Turkish, Somalis and Malaysians.
2. Marriage to English women from the docklands area and poorer socio-economic backgrounds is documented along with the importance of women for community-building (Gilliat-Ray 2010).
3. Following partition, the majority of Pakistan is Muslim and the majority

of India is non-Muslim, although it should be noted that India has one of the largest populations of Muslims of any country in the world.

4. Yet between 2004 and 2017, the Pakistani/Bangladeshi ethnic group had the biggest increase in the employment rate, at 11 percentage points (from 44 per cent to 55 per cent) (Department for Work and Pensions, 21 September. Available at <https://www.ethnicity-facts-figures.service .gov.uk/work-pay-and-benefits/employment/employment/latest>.

3

COOL BRITANNIA? BRITISH CULTURAL AND CREATIVE INDUSTRIES AND DIVERSITY

Introduction

The Global Islamic Economy was estimated to be $2.2 trillion in 2018 (ThomasReuters 2019/20). Driven in large part by the consumerism of young Muslims, by category the Muslim spend is detailed at: $1.17 trillion for food and beverages; followed by $283 billion for modest clothing and apparel; $220 billion for media and recreation; and $64 billion for halal cosmetics (ThomasReuters 2019/20: 4). Modest fashion purchased by Muslim women alone was estimated at $270 billion globally in 2017, with a forecast of growth to $360 billion by 2023 (ThomasReuters 2019/20: 63). The story of the Islamic cultural industries is an outlier in discourse on cultural labour for at least two reasons: the commercial and entrepreneurial aspect of much of the cultural production; and the disputed role of religion within cultural production, and more particularly, Islam in Britain and other Western countries.

The influence of the Islamic cultural industries is already visible in modest fashion on the high street, in luxury and e-commerce. Mainstream brand and retailer interest in the Islamic marketplace has grown with high-street stores such as H&M, Uniqlo, and Marks and Spencer launching modest fashion lines, rather than capsule

Ramadan collections, along with luxury brands including Dolce and Gabana, and Burberry. French fashion house Balmain was bought by Qatar's Mahoola investment fund whose portfolio also included a 25 per cent share in Italian house Valentino. Meanwhile in Istanbul the first women-only hijabi shopping centre recently opened. What is driving this development and growth? In part it has been attributed to a passion for designer labels especially in wealthy Middle Eastern Muslim majority countries. Yet the more significant driver is the young, large and fast-growing Muslim population worldwide. This is an upwards trajectory given the global Muslim population is expected to rise from 1.7 billion in 2014 to 2.2 billion by 2030 (26.4 percent), and by 2030 up to 29 per cent of the global young population (15–29 years) will be Muslim (Pew Research Forum on Religion and Public Life 2011). Islam has the youngest population of any of the world's largest religions. And, far from being peripheral in significance, Britain is regarded as one of the global leaders in halal media and fashion, ranked fifth in the world.

However, the so-called rise of the Global Islamic Economy is not uncomplicated. As ThomasReuters (2016/17) reported, there have been instances of Islamophobia, for example the hacking of modest fashion websites with anti-Islam content. Cultural producers responded to the anti-Muslim acts, through the social media channel of Instagram especially, and there appears to be no slowing of the halal industries led by 'mostly female trailblazers' (ThomasReuters 2016/17: 105). The emphasis on commerce and digital, and narrow segments of Muslim global population that are young, wealthy and cosmopolitan has brought other issues. Recently questions have been raised about the image of Islam and Muslims that is being fostered around conspicuous consumption, such as targeting of Muslim spend by luxury brands (Lewis 2015). It poses ethical concerns around the imbrications of faith with the halal and non-halal marketplace, issues of representation and misrecognition around Muslims, especially young Muslims, and perceptions of exclusivity of access for everyday lived Islam. Spending power around certain growth areas of the cultural and creative industries have variously

been perceived as a conduit, or as a barrier by critics, to an outwardly respectable Muslim life. These extant reports and studies have tended to focus on the economic growth areas of industry, rather than other dimensions of cultural value. What has not been discussed in any detail is religious faith in culture and the arts, or the place of religion in cultural policy.

In this chapter I look at religion and its neglect in relation to cultural policy in the context of a secular state-funded cultural and arts sector. I then discuss Britain's exporting of creative industries policy and its variegated mobilities in the Asia-Pacific and international organisational bodies, before exploring domestic policy shifts, including a renewed focus on diversity and inclusion. In the next section, I focus on cultural labour, introducing working conditions, tensions between diversity discourse and lack of social mobility in culture and the arts, and explore interrelational experiences of discrimination for Muslim women in cultural forms of production. In the final section I widen the discussion to think about what the 'cultural' entails in cultural policy, with reflection on recent historic debates on pan-European cultural citizenship as enabling multiple, multi-scalar identities within cultural policy frameworks. I suggest how this offers a useful way of thinking through repertoires of discourses and practices in domestic British 'cultural policies'.

On the Invisibility of Religion in Cultural Policy-making

Strikingly, Arts Council England in partnership with Consilium undertook a review of equality and diversity where they initially found no publications that specifically look at religion and faith in arts and culture. In their second review they detailed only two broadly relevant publications: a House of Commons Women and Equalities Committee (2016/17) report on Employment Opportunities for Muslims in the UK, and a Demos report of 2015 authored by Reynolds and Birdwell, titled 'Rising to the Top'. In the House of Commons report it discusses that Muslim women suffer the greatest economic exclusion in society with women the most excluded of all – 65 per cent of Muslims described as economically inactive are

women. It looks at the complex reasons for lack of breadth in degree and employment choices; however, it underscores the lack of data on Muslims (and other religious groups) and does not discuss culture and the arts or the creative industries. Meanwhile 'Rising to the Top' (Demos 2015) reiterates the point using the imprecise proxy of Pakistani and Bangladeshi, due to lack of data on religion, that Muslim students are less likely to apply for creative arts and design than law, medicine, computer science and business. Where a career 'outside the box' was considered, such as journalism, lack of access to social networks was seen as a crucial barrier to those who were less privileged. Again, the report does not specifically discuss the arts and creative occupations. Considering the paucity of research, Consilium and Arts Council England inferred that religion was treated differently to other protected characteristics: either seen as too private, or as additional data for organisations (Consilium and Arts Council England 2018: 64–5). Religion might be 'trickier to pin down' than other protected characteristics (64–5). Both the initial and follow-up report write that given the lack of evidence there is poor understanding of religion as an index of inclusion in culture and the arts. Wider research commissioned by the Equality and Human Rights Commission states that only a minority of UK-based surveys in any area have asked questions which might contribute to an understanding of religious discrimination and many fewer ask about religious discrimination directly.

The area of culture and the arts, at least that which is publicly supported, is distinctively secular in Britain. A longer lineage of creative secularity can be traced to Victorian poet and critic, Matthew Arnold, who relocated the power of religion's legitimacy to 'culture' in the crisis of belief in nineteenth-century Britain (Arnold 1911 [1869]). Arnold implied in his famous essay 'Culture and anarchy' that religion would be superseded by brilliant works of the literary imagination, and other secular kinds of texts. Secularity in arts and culture in an Arnoldian sense invests deep seriousness to culture, as the pursuit of human perfection freed from the trappings of ritual and outmoded belief (Fessenden 2011). Secularism implies

a separation between politics and religion, and operations of the church and the state. As Gilbert et al. (2019) write, the emergence of a state-sponsored arts sector after the Second World War did create a strongly secular approach to cultural policy and the arts in Britain. After the founding of the Arts Council of Great Britain in 1946 'the secularization of creativity was institutionalized in the developing relationship between the state and the arts' (Gilbert et al. 2019: 28). The geography of activities and cultural institutions gave priority to London for world-class 'national' institutions, such as the National Gallery of Art or English National Opera, with regional galleries, museums, opera companies and orchestras and art centres run typically by local councils. Gilbert et al. note this gave critics of the Arts Council lines of attack by defining the arts that are deemed important as those taking place within state-funded organisations and state-supported venues in turn rendering peripheral those practices that are commercial or amateur. Nor is it inconsequential that it created a secular infrastructure for British arts. Referring to the state founding as forging a 'habit for the arts', Gilbert et al. (2019) observe that the Anglican and Catholic churches, and indeed later other religious communities, had 'no willingness or incentive to work with the state-sponsored arts sector' (29), with leading arts produced by religious bodies finding funding support outside of the Arts Council.

The legacy of a secular cultural policy can also be discerned in academic research and action-based research. The UK Arts and Humanities Research Council, for instance, launched a Cultural Value project aimed at challenging the very value structures by which formal cultural provision is judged and evaluated. It sought to highlight the ways in which amateur arts have been neglected or even denigrated, but even within this revaluing process, as Gilbert at al. (2019: 33) argue, there is 'a clear sense of the kinds of creative practices that are being prioritised, and an ambivalent relationship with religious organisations'. For 'Our Creative Talent', a review into voluntary and amateur arts in England (DCMS 2008), interviews were conducted of a large sample size of seventy-one organisations scoping

craft, dance, literature, video, film, music, visual arts and theatre, but none included a religious organisation. This raises an important argument that despite increasing debate around post-secularism, that is the increasing visibility of religion in public space and even politics, there is still an absence of religion in academic and policy debates. Jasjit Singh, for instance, shows that the popularity of South Asian arts as a term serves to obscure the religious aspect to many of the art forms evident in the spaces in which they are shown, typically places of worship rather than conventional culture centres. In the creative turn in geography that has peaked in the last twenty years, religion and faith have been all but absent from discourse, including in relation to vernacular (or everyday) creativity (see Hawkins 2013; Edensor et al. 2009). There has been a separating out of the aesthetic and conceptual dimensions of religious creativity from creative discourse, as well as spiritual qualities. Whilst arguments that Britain is a secular country have been critiqued for their over-simplicity (Beaumont and Baker 2011; Tse 2014; Gökarıksel and Secor 2015), religion treated as separate from a mostly secular state may have obscured (public) developments in the cultural and creative industries driven by faith and religion, and what we recognise as creative.

Cultural policy is an area of public life and society that has attracted scarcely any direct attention in the debate around Muslims and equality in Britain. Domestic law around the protection of religion and belief is comparatively recent. It is based upon the Human Rights Act 1988 and the Employment Equality (Religion or Belief) Regulations 2003 introduced in Great Britain, since consolidated into the Equality Act 2010. Before 2003 religion was not generally protected by equality law, as I discussed in the introduction to this book. Religion and belief freedoms can be limited in the context of employment, education and the provision of goods and services where it is deemed necessary and proportionate for the protection and freedoms of others. These limitations have been accredited to the 'equality gap' of how Muslims are treated in Britain in key areas such as housing, work and health, given that Islamophobia is reported to be rising and remains without an officially recognised definition

by government and within policy-making. There has been Muslim political organisation around the role of religion in public life, which is evident in the case made for publicly funded mosques and Islamic state schools, and the inclusion of religion as a category of the census from 2001. It remains to be seen whether debates over representation and symbolism in the cultural sphere will result in challenges made under the Equality Act 2010 to the inclusion of religious needs and dignity around displays in public collections and monitoring over public cultural and arts funding.

Reframing 'Cool Britannia' and Geographies of Cultural and Creative Policy

Global creative industries

There is a familiar narrative on Britain as a bulwark in the globalisation of the creative industries. The 'cosmogonic myth' (Banks 2020: 709) recalls the New Labour government in 1997 changing the classification of the cultural industries to the creative industries, as one of its main new policy areas (see also O'Connor 2011). Culture and the arts were combined with growth areas of technology, gaming and design; connecting metropolitan urbanity with an emerging knowledge economy (Banks 2020). Leader of New Labour, Tony Blair, upon entering Downing Street, hosted his now notorious 'Cool Britannia' reception, a creative industries drinks party, with figures such as Noel Gallagher and Vivienne Westward collected together for a rebranding of Great Britain. It was intended to represent a high profile moment of constructing and exporting the image of Britain as cool and creative, but was arguably already a popularist, nostalgic paean to the past that was largely tone-deaf to multi-cultural Britain (Huq 2007: 144). Underscoring the point that the creativity script in policy-making is increasingly met with cynicism, O'Connor writes that 'a frisson of the new . . . now has the dead hand of marketing copy' (2020: 32). In 2014 Conservative party leader David Cameron hosted his own version of the 'Cool Britannia' reception, dubbed 'Cool Britannia II' by the media. Drinks held at the Foreign Office,

this time around, were aimed at boosting the creative industries with an even narrower representation of creatives from media figures, actors and musicians, asked to 'fly the flag'.

The history of the classification of the creative industries has been claimed as one of Britain's most successful global exports. Blair established a Creative Industries Task Force, as a core delivery area of the government's new Department of Culture, Media and Sport (DCMS).[1] The British Council in 1998 rolled out a new mapping methodology. Terry Flew (2011), Justin O'Connor (2020) and Lily Kong (2020) have written how these policy mobilities can be mapped across the Asia-Pacific, including in Singapore and Hong Kong, with a model that steered close to that of the UK, and in different ways by Taiwan, Korea and the hybrid form of 'cultural creative' in China. Intended to influence international organisations and encourage the adoption of a growth model around creative industries in developing countries, UK creative industries policy influenced the United Nations Commission on Trade, Aid and Development (UNCTAD), and UNESCO.[2] From the 2000s there has been growing global consensus amongst politicians and organisational bodies about working definitions of the creative industries and what should be included. As Flew and Cunningham (2010: 114–15) write, UNESCO (2007) compared the cultural statistics of fourteen constituencies (mostly countries, one city, the European Union) and found unanimity on the following sectors for inclusion in modelling: publishing and literature; performing arts; music; film, video and photography, broadcasting (television and radio); visual arts and crafts; advertising; design, including fashion; museums, galleries and libraries; and interactive media (web, games, mobile). As we are reminded by O'Connor, the new 'creative capitalism' ideas were also embedded within a wider geopolitics of power and trade, with concepts such as the 'creative industries', 'creative cities', 'creative clusters' and 'creative class' all identifiable to Western lifestyles – 'and the political, religious, cultural challenges that these could bring – Trojan Horse-like' (O'Connor 2020: 31).

Domestic cultural policy

Despite more convergence on a global scale, the wrapping together of culture and the arts within the creative industries has meant that culture and the arts are now typically valued against their contribution to economic growth. The classification of the creative industries and their export has narrowed discourse on other dimensions of cultural value. But the histories of culture and the arts have very different faces within UK domestic policy agendas, where diversity and inclusion are now discussed as priorities.

Historically the emergence of UK cultural policy in post-war Britain was opposed to economic activity and material production; what Bianchini termed the 'age of reconstruction' (1999: 36). Garcia (2004: 315) describes the 'neglect of economic potential' of cultural resources until the 1980s. Earlier formations of cultural policy dovetailed with state-led urban policy in the 1960s, when the first social schemes were established for economically deprived areas. Community-based action during the 1970s emphasised social empowerment of the marginalised in resistance towards government, local and central (Marinetto 2003). Particular attention was given to well-being and alternative forms of economy including through culture and the arts (Marinetto 2003). However, from the mid-1980s the emphasis on cultural policy for community building gave way to a new focus on urban economic regeneration. As Kong (2020; see also Ward 1997) writes, this involved new investment in infrastructure for cultural production, arts and event culture for attracting tourism, revival of public spaces, and a huge growth in public–private partnerships. Under Tony Blair and New Labour a paradigmatic shift was heralded in the 'new' economy, intended to drive economic growth and job creation while addressing social poverty and exclusion – often termed 'the third way'. This took an explicitly geographical orientation by evaluating the value of the arts and culture, along with sport, through positive contribution to neighbourhoods, towns and cities by regeneration (DCMS 1999). The importance of access to arts and culture was linked to place and quality of life.

Culture and creative value was always about more than boosting national profile and economic exports. The DCMS Culture White Paper (March 2016: 15) identified that the sector contributes to multiple values: intrinsic (enriching value of culture in and of itself); social (educational and well-being); and economic (contribution to growth and job creation). This spread of potential outcomes for cultural value is reflected in the dispersal of funding for culture and arts within government departments – notwithstanding commercial investment. Arts Council England, set up in 1946, is the primary funder of culture and the arts in England from DCMS and the National Lottery, with Scotland served by Creative Scotland, Wales by Arts Council of Wales and Northern Ireland by Arts Council of Northern Ireland. For local government expenditure on arts and culture, the Department for Communities and Local Government data is the most reliable at the national level, with figures reporting a reduction by almost 27 per cent in the period 2010–15 under austerity, from £89 million in 2010 to £65 million by 2015 (NLGN 2016: 12). More local council expenditure for culture and the arts is included in other areas of service delivery, such as regeneration, but also care and social policy, in children's services, public health and community development, that is not fully captured by headline data (NLGN 2016: 9).

Religion and arts, while overlooked by the DCMS or Arts Council England can be traced through the work of other government departments. For example, the Near Neighbours programme, launched under the former Department for Communities and Local Government (DCLG), which funded neighbours in communities that are religiously and ethnically diverse, where art and culture was a key strand to local projects. Near Neighbours has a Faiths Advisory Panel (comprising Jewish, Hindu, Sikh, Muslim, Buddhist and Christian members) and is now administered by the Church Urban Fund, the Church of England's social action charity. Schemes such as this, while serving an important purpose, place social concerns, such as unity, cohesion and well-being, to the forefront rather than the intrinsic value of art. In other words, balance

of emphasis was laid upon what the method of art could achieve socially, instead of originality and innovation. Despite the increasing prominence of public debates around diversity, social mobility in the arts has not improved and cultural work is largely held by white middle classes (Brook et al. 2020).

On Social Mobility and Diversity

Social mobility was a central plank of New Labour's platform. However, in the cultural and creative industries, together with education, the centrepiece of their vision, there is a wealth of data arguing that social mobility actually stalled. Middle classes dominate with 63 per cent of publishing employees having parents from higher managerial and professional occupations, the highest social-economic categories (groups 1–2, of 8) (Oakley et al. 2017). Meanwhile in film and television the proportion is 54 per cent in the highest categories, with the average in the British workforce 29 per cent from the highest groups and 35 per cent from the lowest (6–8) (Oakley et al. 2017). Women make up 52 per cent of the UK workforce, but they are a third of employees in the creative industries, are paid less, and have less seniority (Oakley et al. 2017). Ethnic minority employment in industries including film, television and music is half the national average, and represents only 3 per cent of museum, library and gallery staff (Oakley et al. 2017). As Nesta (2016) has stated, diversity in the cultural industries fails to reflect the diversity of the population in key urban areas. To contextualise this, nationwide rates of absolute mobility are largely unchanged – usually measured by comparing income of people to their parents – whereas relative mobility, where individuals climb or fall on a social hierarchy from working class to top managerial or professional jobs, has fallen.

Places where people grow up impact life chances and social progression (Major and Machin 2018, 2020). Across the 1980s in the UK 'regional context is extremely important in any understanding of the way in which individuals come to occupy specific class locations' (Major and Machin 2018: 14). However, today a

north–south divide is no longer as relevant – instead there is London and the rest (Major and Machin 2018). Studies show a clear connection between social mobility and geography. London and the south-east is 'the' regional escalator. Schools and examination results are better than the UK average across socio-economic backgrounds, and absolute mobility based on profession is much higher than elsewhere. By absolute mobility it is meant intergenerational mobility, where children are better off than their parents, although this analysis can shift depending on the measure, for example, occupation or wealth (including assets such as owning property). There are long-standing aspects of regional escalation in London that drive occupational mobility. The capital attracts inter-regional migration. The young adults that move there have higher potential for upward mobility, and there are greater rates of promotion of these young adults along with London's own young adults (Fielding 1992). Within the UK geography of labour, there are significant spatialised inequalities in the cultural and creative industries given employment is clustered in the south-east primarily and also in metropolitan city centres, with financial, along with educational and social barriers to entry (Creative Skillset Employment Census 2012; Nesta 2016).

Other important barriers identified are unpaid internships, replete in the sector but now more widely challenged, such as cost of university, rising housing costs and low levels of union representation (Brook et al. 2020). Indeed broader analysis has argued that formal education is only one dimension of what impacts intergenerational social mobility. Family and home environments foster vital 'top ups' around private tuition, books and reading, clubs and societies, debating skills, and also 'safety nets' through soft access to professional networks for children who do not perform well academically (Bukodi and Goldthorpe 2018; Holloway and Pimlott-Wilson 2014). Meanwhile privilege is not recognised evenly. Those possessing more markers of privilege are most likely to attribute success to unique talents and skills. This is shown in Create's Panic! survey (2015) into social mobility in the arts where one third of those in cultural and creative industries in London are upper middle

class (compared to a quarter elsewhere); those who earn more than £50,000 are most likely not to believe in social reproduction and instead rely on success as exemplar of meritocracy arguments (Taylor and O'Brien 2017; Brooke et al. 2018). Elsewhere I have argued that more needs to be done starting from the local level to achieve a fairer distribution of public resources around culture and the arts, and to address social difference to begin to reverse inequalities that are marked socially and spatially (Warren and Jones 2018). This would involve attending to historic racism, religious difference and class exclusion, its evolving and new forms, which impact current society and culture.

In Britain specific policy interventions around diversity include: Arts Council England's Inspire programme; providing financial assistance for diverse audiences; moving to banning unpaid internships or not advertising the opportunities within student bodies; strikes such as National Gallery for fair pay; social media campaigns, for instance #Oscars So White; institution-led programmes such as the Barbican Centre's Panic! aligning sociologists and arts workers to analyse audience data and interviews; and providing career advice, new commissions and public events (see Patel 2020). Arts Council England's Diversity Change Makers Programme (2016–18) aimed to increase diversity in senior leadership, and is discussed later in the book. Still ongoing is the Creative Case for Diversity scheme that aims to address the lack of diversity in the arts. All Arts Council England funded organisations (known as National Portfolio Organisations) need to demonstrate how they contribute towards enhancing diversity across multiple areas of delivery: their work; programming and/or collections; and audience engagement. Annual reports show there are gradual improvements around workforce diversity among NPOs. But, as Nicholas Serota, chairman of Arts Council England from 2017 acknowledges, 'aspirations are not always translating into meaningful actions or significant appointments' (Consilium and Arts Council England 2018: 2). There is a vexed relationship between cultural policy and diversity. Indeed, Karen Patel has argued, 'diversity initiatives have the potential to help

or even hinder these inequalities, paradoxically closing off entry and advancement pathways' (Patel 2020: 3 [preprint version]). Religion and faith, although protected characteristics, are usually obfuscated in diversity initiatives, meaning there is a faith-blind approach to difference and poor data or anecdotal evidence in which to frame a discussion about its importance.

Diversity in culture and the arts has been designated a priority area (DCMS 2016). But as a term 'diversity' has attracted derision for its political woolliness with 'diversity speak' now commonplace. The visibility of diversity discourse in policy making, attending to workforce, cultural offer and audience, arose from the increasing disfavour in which the notion of multiculturalism has fallen with fears of separatism and parallel lives (Cantle 2012). Diversity has replaced the term multi-culturalism as the preferred classifier, carrying a perceived alignment with neoliberal urban and economic strategies, and suggestion of togetherness – however superficial this arrangement (Schiller 2016). Diversity has been critiqued as dovetailing too neatly with neoliberalised policy agendas, such as the branding of urban villages promoting tourism and consumption e.g. 'China Town' or 'Gay Quarter'. Enrolling, together, indexes of social difference – LGBTQI+, disability, gender, ethnicity, 'race', class, age, sexuality, religion – diversity has been critically viewed as an attractive and inclusive concept that has flattened important axes of difference between distinct marginalised groups in relation to place. Too often masking the historical and political currents of a city, place or institution (Warren 2018), 'diversity speak' can neutralise particular issues and obscure exact lines of discrimination, besides any real intent towards a progressive, transformative politics.

Context is therefore crucial when thinking about why diversity matters. For instance, in the US, cultural diversity holds very specific roots and linkages with the black civil rights movement. It predominantly refers to ethnic difference and homogenising tendencies of 'national' cultures in the US, specifically black rights (see Ghilardi 2001). But when used as a proxy for racial difference, it might also be viewed as a white concept; that is diversity imagined through the

lens of institutional and epistemic whiteness (Hage 2002). White and whiteness often remains at the centre of thinking and practice and institutional structures – a status quo that appears neutral and natural – with blackness existing at the margins. Writing about how the social and spatial reproduction of ethnic and racial inequalities are institutionalised, and from the UK context, Sara Ahmed acknowledges that by 'being' the diversity person it allows others not to turn up (2012). For those minority ethnic subjects, meanwhile, it means they can become 'stuck' to a category; 'we can become constrained even by the categories we love' (Ahmed 2012: x). On black women's digital encounters Sobande et al. (2019) draw a distinction between content produced by and for other black women and its co-option by mainstream media to attract 'diverse' audiences (Sobande et al. 2019: 12). In research that chimes with the growth of Muslim women-led content (Warren 2018, 2019), Sobande et al. find black women may be drawn to online content produced by and for other black women to mitigate against the misrepresentation and exploitation of black women. Black spaces are therefore important, both symbolically and economically.

But troubling the clear delineation of white and black spaces, Frantz Fanon in his seminal *Black Skin, White Masks* (1952) examines the psychosocial dimensions of racism and self-alienation. A reflection on anti-black racism, drawing on a wide range of cinema, psychoanalysis, phenomenology, linguistics and political theory, Fanon's work explores how race forms the subjectivity of black and white people, and is integral to systems of colonial subjugation and its overcoming, as a total project. That is, how matters of race and racism permeate all areas of human life. Following Fanon, for Anamik Saha, even if greater ethnic diversity in the cultural industries were realised this would not resolve a politics of representation that reproduces negative images of minority racial and ethnic groups due to the psychosocial embedding of these tropes within the very minds and industry practices of whites and non-whites alike; those who have 'internalised the rationalising/racialising logic of capital' (2017b: 144).

Moreover this raises a critical question: does a more diverse workforce lead to more diverse representations and audiences? According to O'Brien at al. (2017), despite the pervasiveness of thinking in the cultural industries and society that greater workforce diversity is a salve to misrepresentation, in fact issues of stereotyping and oppression are deeply ingrained in racialised and classed systems of value. In other words, we need to think beyond a 'demography and representation' approach (Gray 2016). Significantly, for example, minority ethnic actors who manage to enter the cultural industries will not have the same freedom of opportunity as their white, male, middle-class counterparts (O'Brien et al. 2017: 274–5). Black actors are likely to be asked to represent black topics, whereas white actors are not constrained by identity in the breadth of subject they engage with. Saha (2017a, 2017b) frames racialisation in cultural production as the creation of epistemological effects. This limits how we come to know the world, and who is given credence for bringing into representation the world and on what basis. Nevertheless, the complicating of knowledge around diversity and creative opportunity in the cultural industries does not remove the demand of minority ethnic artists for greater representation, equality and dignity in work, as is shown in the empirics and discussion in this book.

Gendered Cultural Labour and Islamic Cultural Industries

There is now extensive research on the economic structural shift associated with post-industrialisation and how the 'new economy' is characterised by casual or zero hour contracts, with little or no security (McDowell and Christopherson 2009: 336). Lives of cultural workers epitomise twenty-first century labour conditions of greater flexibility with greater precarity (Gill and Pratt 2008). Feminist sociology and cultural economy offer a critical lens on embodied experiences of cultural workers that are shown to be differentiated in ways shaping access, opportunities and pathways within the cultural and high-tech industries (see Gill 2009, 2010; McRobbie 2002, 2009). From studies conducted in social sciences, along with large

quantitative surveys, cultural labour is often low paid, irregular, with boom-or-bust patterns of working, and given unpredictable patterns of project work, it may place higher levels of stress on social relationships, including a balanced family life (Brook et al. 2020; Reimer 2008; Rantisi 2014; Crewe 2013; Ekinsmyth 2011). In particular these studies have shown that the risks of flexible labour arrangements disproportionately impact women, who still undertake the majority of domestic labour and responsibility for childcare (something that has been further highlighted and entrenched during Covid-19 lockdowns as schools and nurseries closed) (Institute for Fiscal Studies-UCL 2020).[3] Out-of-hours networking and informal hiring practices further disadvantage primary caregivers (typically women), those from lower socio-economic backgrounds (DCMS 2016: 24; Skeggs 2004; Bennett et al. 2009; Edensor et al. 2009) and minority ethnic groups (Meghji 2017, 2019; Idriss 2016; Christopherson 2008; Brah 1993). Gender informs: positioning within social and structural organisational hierarchies; whether work is full-time or part-time; and salary levels (Leslie and Catungal 2012; Brah 1993); with distinctions of culture and class found to impact women more than men (Create 2015).

Gendered inequality in the cultural industries is further identified in a report by UNESCO. They found that in the UK, despite the fact that women are better educated, the gender pay gap in the arts appears greater than the national average with women earning less than men at comparative stages of their careers (UNESCO 2018). In fact although the number of women was much higher (a ratio of 2:1) in 2014 the average earnings of men was higher in almost every type of job, medium, geographical region and age group (Hill 2015; UNESCO 2018: 192). More specifically in the visual arts – which is a key focus of the present study – it was found in 2013 that of above 3,000 artists represented by 134 commercial galleries in London, under a third (31 per cent) were women (Sedghi 2013). In even more prominent inequity, it is striking that only seven women have won amongst visual arts most prestigious of prizes, the Turner Prize, in thirty-two years, albeit

with the positive development that five have done so over the past decade, which may point towards the gender bias closing. More broadly, of 383 European museum directors who replied to questions on diversity (only a quarter), two museums reported that their collections included over 40 per cent female artists (Jansen 2016; UNESCO 2018: 193). In July 2017, the British Broadcasting Corporation (BBC) – arguably the world's foremost public service broadcaster – revealed that only a third of the ninety-six top earners were women; there were just two women among the fourteen highest paid on-air presenters and the top seven were all men. The difference in the average earnings of men and women at the BBC was 10 per cent (though lower than the UK's 18 per cent average). In digital, often championed as a democratic space for sharing and solidarity, under-representation of women is reported in start-ups and digital boards. Digital abuse against women is also rising. Specifically Michael (2016: n.p.) reports that women are opting out of an active presence online, including social media, due to digital violence, bullying, harassment, stalking and forms of hate speech, with female artists who use the Internet for the promotion of their work particularly vulnerable to online harassment (also see Ashton and Patel 2020). In insights that are important for this book, online harassment is especially rife for women artists where their art focuses on identity or sexuality (Ashton and Patel 2020: 198; Michael 2016).

More specific studies on Muslim women and cultural labour have focused on modest fashion, news media and digital media, such as modest fashion blogging. Research on Muslim femininities has clarified the complex linkages between a gendered and racialised politics of identity and capitalist Islamic cultural industries. Or as Moallem (2005: 5) writes, the 'fabrication of a transnational Muslim femininity' that has been 'instrumental in the commodification of Muslim identity politics'. Peterson is also interested in questions of Muslim identity politics, writing on black Muslim women, and argues that racialised hierarchies impact value and earnings from so-called hijabi bloggers and their aesthetic labour. Peterson is part of a

small, emergent literature that considers a 'postfeminist sensibility' within social media spaces such as Instagram or YouTube (Peterson 2020; Warren 2018, 2019). Drawing on the work of Gill (2007), one of the core aspects of a postfeminist sensibility, after commercialism, is how the feminine body is both seen as a 'source of power and as always unruly, requiring constant monitoring, surveillance, discipline and remodelling' (Peterson 2020: 149). But, except for a very few studies, the narratives of Muslim women and critical significance of faith and religion in labour experiences has been neglected as an area of research. Evans and Bowlby (2000) researched a group of twenty-seven Pakistani Muslim women on labour experiences in Reading, exploring how paid work enmeshed with the formation of gendered, classed and racialised identities (with the largest group in teaching or voluntary work, and none in the cultural and creative sectors). In social, cultural, political and feminist geography there have been studies of veiling fashion and veiling-fashion industry. Studies have discussed the embodied differences, the multiplicities and instabilities of veiling as a signifier, revealing its possibilities for the articulation of 'new' Muslim identities, including piousness, solidarity, resistance, norms, taste and style, and beyond (Dwyer 1999; Gökarıksel and Secor 2009, 2010a, 2010b). Research has considered politics of identity, gender relations and everyday geopolitics in interviews with shop assistants and veiling-fashion industry workers that discuss how Islam and capitalist industry meet in workplace ethics and values in three veiling fashion firms in Turkey; Gökarıksel and Secor 2009, 2010). Ground-breaking research in fashion studies and cultural studies has meanwhile considered the embodied aesthetic labour of Muslim women shop assistants in fashion, and the roles of designers and editors of Muslim lifestyle magazines, helping to forge new youth sub-cultures, inter-faith dialogue and non-hijabi modest fashion (Tarlo and Moors 2013; Lewis 2013, 2015). However, more recent in-depth qualitative research into access and experiences of labour and their racialised and gendered dimensions for Muslim women are missing, together with a focus on how these are differently constituted by labour practices

in multiple sub-sectors of the 'new' cultural and creative industries in Western Europe where religious identity is becoming a master identifier.

Now there is clear empirical evidence of the growth of religion and faith in the cultural and creative industries (ThomasReuters 2016/17, 2018/19). Analysing this in relation to Muslims, Lewis and Hamid (2018) adopt a cultural studies approach, after the work of Stuart Hall, and argue for British Muslim arts and culture as sub-cultures of arts, media, music and fashion, with religious values mixed together with a British flavour. The leading roles of second and third generation women artists and activists are detailed, albeit without in-depth empirical exploration into working lives. While controversy and critical voices are recognised, so too are the breadth of identities, practices and beliefs of Muslims in Britain where there is intra-Muslim contestation around religious authenticity and orthodoxy (Lewis and Hamid 2018: 179). Lewis and Hamid compare the spread of Islam and its adaptiveness to cultural contexts to the way cultural production responds to place, through the theories of dynamic cultural hybridisation and notions of bricolage. Informed by scholars such as Richard Bulliet (1979), innovative cultural production is found to take place at the edge of Islamic civilisation. Pertinently, Lewis and Hamid (2018) argue that it is difficult to see an edge now, but that could be the Western world (180–1). The Islamic cultural industries here open an alternative way of seeing that repositions the Western-centric geography of discourse around the cultural and creative industries that I discussed earlier on. Further study can interrogate more fully the construction of supra-national identities, post-colonial dynamics of material culture, and the wider role of religion, faith, morality and ethics in the organisation of labour and workers' lives.

The European Union: Understanding Cultural Diversity with Cultural Policy

Discourse around the governance of culture and the arts illuminates the potential for multiple layers and scales of geopolitical identification and axes of belonging that is still useful in the current situation

of Britain's recent exit from the European Union. The close relationship between advocating for cultural diversity and recognising the need for rethinking citizenship beyond the boundaries of the national state is clearly articulated through global cultural production. As part of Britain's recent history, the European Union offers a vehicular notion for understanding how multiple, scalar identities are drawn – and broken apart.

Tony Bennett wrote a report on cultural diversity and cultural policy resituating citizenship within a new pan-European identity at the start of the European Union in 2001. Cultural citizenship under the Council of Europe, as it was then known, might exist together with national identity, or replace (imagined) discrete national cultures and nationalisms altogether it was thought. Embraced by the Council of Europe, in the terms of Vera Boltho, then head of the Cultural Policy and Action Department, cultural diversity was regarded as a 'new social norm', challenging ideas around homogeneity by requiring 'a rethinking of the processes, mechanisms, and relationships necessary for democratic policy development in diverse societies' (Boltho in Bennett 2001: 6). As Bennett wrote, 'National cultural policy has a new role to play in the new citizenship landscape' (Bennett 2001: 6). European values are codified in the report – of democracy and representation, and ideals of equity and fairness – in a vision for a new era of cultural participation strengthened by embracing diversity (Bennett, 2001: 11–12). Even at the turn of the twentieth century there was a shift from policies with a nationalist accent towards a more active celebration of diversity, attributed to post-colonial developments that required new approaches to explaining and marshalling discrete as well as shared space for different ethnic and cultural groups (Bennett 2001).

For Bennett (2001), responding to the pan-European cultural citizenship, by reframing culture as a right, it was necessary to consider patterns of migration post Second World War and in situ cultural difference that has not been assimilated (indeed twenty years on talk of pluralism or living together with difference is the norm). Elsewhere in the same report Lia Ghilardi (2001) makes clear that cultural planning

is not planning culture but planning urban policy in the hope of creating more tolerant (cultural) spaces. Yudhishthir Raj Isar usefully elaborates on what culture means in relation to claims to space:

> 'Culture' is now proclaimed as an inalienable 'right', conceived of as a value in itself, and justified as an inherited 'tradition'. It has entered the repertoires of discourses and strategies deployed by 'imagined communities' at different levels – from the activism of minorities, religious sodalities and local groups to the 'cultural policies' of nation-states. Perceived as threatened by a dominant source of 'civilisation', the values of different ways of life have risen to consciousness and have become the rallying cry of diverse claims to a space in the planetary culture. 'Before, culture was just lived. Now it has become a self-conscious collective project. Every struggle for life becomes the struggle of a way of life' (Sahlins 1994: 11 in Isar 2006, 373)

Isar's account is worthy of discussion and reflection because he directly addresses religion, within a broader discussion of culture not as cultural production but as a way of life. He notes that ethnicity tends to be privileged in discussion around diversity given that the term is typically applied to tensions between cultural communities and national identity. For instance, he acknowledges there are internally diverse cultural community identities, such as Basques in Spain and Sri Lankan Tamils, with similar strategies of homogenising tendencies as is evident in national cultures. Separatist groups articulate associations between territory, people and culture, but in competition with a dominant national culture. Issues of cultural diversity and rights in national cultural policy are also complicated by addressing the claims of indigenous groups and by diasporic cultures of displaced people, or mobile cultural networks. In Europe the international movement of people, especially arrivals and deaths in the Mediterranean region over the past ten years, has created tensions around human rights and cultural difference. How, then, are equality, citizens and new arrivals reconciled within particular nation states and the sphere of policy around culture and arts?

The idea of a European cultural identity founded on shared 'roots' and with diversity of cultures and unity does warrant further attention. While cultural diversity is an empirical and territorial fact elsewhere in the world, its use as a 'buzzword' is largely Western (Isar 2006). It aids the articulation of European cultural diversity as a value in itself, which reframes whether the embrace of difference is really a post-colonial reckoning, or a continuum of capitalist extraction (Isar 2006). This view also incorporates a myth of cultural homogeneity at the national level – what Isar terms a billiard ball approach. That is, clear, discrete and unchanging parameters of cultural identity. The challenge, as Isar writes, is how to respect and recognise multiple cultural identities whilst fostering a national identity with a shared sense of belonging. Dynamism of cultural production is crucial here, rather than national and cultural preservationalism, as Isar (2006: 374) explains in full:

> Enabling all the groups that henceforth constitute the national community to assume ownership of its composite cultural identity remains a major challenge for policy-makers. This is not simply a matter of combating intolerance and exclusion, but also of giving dignity, voice and recognition in the public sphere to different cultural groups while constructing – negotiating – a sense of national community. How can we forge societies that are truly pluralistic yet possess a shared sense of belonging? What can states do to help different cultural communities live together as one national community? Are current policies and practices effective in promoting attitudes and values that encourage mutual respect? How should policies and institutions evolve so as to better respond to the needs of diverse societies?

The adoption of the 2005 Convention for the Protection and Promotion of the Diversity of Cultural Expressions was an historic agreement in international cultural policy. It formally decreed that the cultural and creative industries held a dual nature that is cultural and economic. Further it agreed a set of principles for governance,

mobility of artists, sustainable development and human rights in cultural expression.

In a UNESCO (2018) Global Report 'Re-Shaping Cultural Policies', gender equality was a core issue. Principally edited by Isar, the report details: 'Diversity of cultural expressions will remain elusive if women are not able to participate in all areas of cultural life, as creators and producers and as citizens and con-sumers' (UNESCO 2018: 33). The UNESCO report details the severe under-representation of women in the workforce, especially in key creative roles and decision-making positions, and lower access to resources and pay than men. Policy actions are called for, with the integration of a gender perspective into all cultural policies and measures, and specific measures, addressing local issues. It is also documented that there is a rise in reported attacks against artists and audiences globally, mostly against musicians, and that there is growing concern around digital with surveillance and online trolling threatening artistic freedom. Digital attacks are found to most often target women and are perpetrated by those who identify as far right, religious conservatives and defenders of free speech.

More specifically in relation to Muslims and matters relating to cultural production, UNESCO (2018; 2017) report there are attacks on artists by militant non-state groups that have included extreme violence. In her 2017 report, Karima Bennoune, United Nations Special Rapporteur in the Field of Cultural Rights, stated that these abuses,

> often involve attempts at cultural engineering aimed at redesign-ing culture based on monolithic world views, focused on 'purity' and enmity toward 'the Other', policing 'honour' and 'modesty', claiming cultural and moral superiority, imposing a claimed 'true religion' or 'authentic culture' along with dress and behaviour codes often alien to the lived cultures of local populations, stifling freedom of artistic expression and curtailing scientific freedom. (Bennoune, March 2017)

Examples are given in recent years of Manchester, Paris, Istanbul and Kabul, with artists, and especially musicians and their technical staff vulnerable to attacks. Elsewhere threats such as hostile crowds and campaigning outside exhibits or performances have led to police interventions to cancel events or remove 'offensive' works from display for public safety. Or when threatened, venues and arts festivals may pre-emptively withdraw works (Whyatt in UNESCO 2018: 216). The V&A removed from its website an image of an artwork depicting the Prophet Muhammad (a poster made by an Iranian artist c. 1990) leading to debates around self-censorship and whether certain interpretations of Islam are privileged over others in the decision to remove works. Wider political issues are resonant here such as freedom of expression, questions of religious rights in secular spaces, and which ethnic or religious groups wield greater power over others, and why, in the shaping of Britain and Europe's complex cultural landscape.

Conclusion

To return to Bennett, in comments that are still prescient today, but in a very different geopolitical context: 'In most countries the artistic and cultural landscape has not evolved to reflect the realities of a changed social landscape. This rift threatens to undermine the legitimacy of cultural institutions and the public policy that supports them' (Bennett 2001: 12). For some, Britain's exit from the European Union ('Brexit') was the result of a continued belief in British exceptionalism that held up a mirror to a state of national denial about our declining international importance. Clearly there is still a need to address the history of the British Empire and its post-colonial legacy as the Windrush generation scandal, Black Lives Matter, and repatriation of museum objects stolen from former colonies underline. The declared 'War on Terror' led by the US, the UK and France has been viewed in this broader historical narrative as a culture war for a Western, liberal and secular dominant world power. Brexit and associated hostile attitudes to immigration show the need

for new engagement with thinking through the place of culture and the arts in relation to nationhood and imperialism, and as part of strategies of post and de-colonialism. Crucial here is identifying the problematic conflation of anthropological ideas of culture as a whole way of life, with the idea and realities of culture as labour and industry. The tensions of how culture is differently understood, and for whom, underscore the imperialist and Eurocentric attitude that the Global North produces culture, and the Global South has culture. For others, arguments for a progressive globalisation, freedom of movement, and cultural mixity as a positive dimension of living in contemporary Britain were simply never won (for a critical discussion of this see Rogaly 2020). Internal difference and dissonances in cultural policy and cultural value are exposed in contexts of social diversity. One majority group can benefit, whilst another minority group is weakened by cultural production:

> A cultural activity or object that is valued by one group, and whose consumption offers that group a series of positive benefits or desirable wider socio-economic impacts might at the same time also be an instrument of symbolic violence on a different group, and one of the means through which its social subjugation, public humiliation, disempowerment, marginalisation and stigmatisation take place. (Belfiore 2020: 394)

It is clear that not everyone has benefited equally from globalisation processes, and bodies, material culture and knowledge do not travel evenly or equally through space. To bring this back specifically to issues of diversity and religion, certain characteristics are well acknowledged as shaping and reshaping the power imbalances of cultural production (class, gender and race), whereas others have been hidden in plain sight. Moving ahead might involve thinking through how cultural policies from government and within organisations are not only top down in approach, and might yet need to be responsive to arguments that culture like religion is a way of life and not outside of structures of belief that do not always neatly align with a dominant secular state.

In the next chapter I turn to discussing the role of British art school as a pedagogical space and its historic connections with colonialism. It follows on from the insight of Virdee (2006) that the kind of work people do can be structured by racism, and this starts with education. I expand the framework of prejudice and oppression to include religion and identify how art school functions as a dominant white, secular and secularising space.

Notes

1. The creative industries were a central segment of the UK 'post-industrial' economy at that time accounting for around 5 per cent of the total national income and employing about 1.4 million people (Flew and Cunningham 2010: 113).
2. Through the updating of UNESCO's statistical frameworks to incorporate cultural production in the global economy.
3. The study of working across fields by IFS-UCL found that mothers in two-parent households are only doing, on average, a third of the uninterrupted paid-work hours of fathers in lockdown. To contextualise this figure, before lockdown mothers did around 60 per cent of the uninterrupted work hours of fathers (Institute for Fiscal Studies-UCL 2020).

4

MUSLIM WOMEN, EDUCATION AND ART SCHOOL

Introduction

The reputation of British art school is indelibly linked to the early 1990s rise of the Young British Artists and the 'Cool Britannia' slogan popularised by Saatchi and adopted briefly by the New Labour government. Known for provocation, hedonism and sexuality, with raucous partying and hard drinking, Tracey Emin, Damien Hirst and to a lesser extent the artistic and social behaviour of Sarah Lucas, Rachel Whiteread, Gavin Turk and the Chapman Brothers, pushed boundaries in the art scene and society writ large. Most associated with Goldsmiths arts college, the YBAs, as they were latterly termed, were trained in a narrow pool of chiefly London-based art schools including Chelsea, the Slade, the Royal College of Arts and Glasgow (While 2003; Grenfell and Hardy 2003). Already attracting attention from international art markets, the defining art exhibition *Sensation* cemented their subversive reputation. Touring to Berlin, Sydney and Tokyo, *Sensation* was cancelled in New York due to threats of financial sanctions by Rudy Giuliani, then mayor – only adding to their notoriety (Grenfell and Hardy 2003: 20). Mapping the wild success of the YBAs, Grenfell and Hardy (2003: 30) identified the close networks of institutions and stakeholders

involved. Mostly based in London, and distinguished by youthful-
ness and shared nationality, the YBAs presented as narrowly white,
with the exception of Chris Ofili and Yinka Shonibare. Following
on from the racial and aesthetic politics of the BLK Art Group, a
collective of young black artists formed in Wolverhampton, and
British counterpoint to the wider Black Power Movement, the dom-
inant 'white space' of the YBAs movement attracted derision (http://
www.blkartgroup.info/index.html). Writing in *Third Text*, Kobena
Mercer (1999) is scathing of an attitude and symbolic language that
communicated a 'don't care localism' playing on outmoded stereo-
types of Britishness and a 'withdrawing and retreating from differ-
ence into an identity politics of its own' (Mercer 1990: 55). For
Mercer, the YBAs were less characterised by innovation and edgi-
ness, and more by retrogressiveness, at least politically, representing
'come back to what you know' (55).

In this chapter I outline a history of the British art school and
its links to colonialism in order to contextualise discourse and debate
around a politics of difference for Muslim women art students and
emerging artists. I discuss a Western-centric modernist art framing
and art canon that creates a hierarchy of aesthetics and taste; one that
is encoded racially and separates out religion from the secular world.
The story of the success of the YBAs is a case in point: a contempo-
rary British art movement that is embedded within art school-forged
institutional and stakeholder networks; and a group that is almost all
white. It is not insignificant that the group were centred in Britain's
imperial capital of London, still one of the foremost art capitals in
the world. I trace the implications of hierarchies and inequalities
within a closely socially and geographically networked art world, and
the experiences of Muslim woman artists, the spaces they negotiate
and create. How does religion coexist with secularity? How does
(Islamic) religion intersect with much more widely discussed pro-
tected characteristics of gender and class? And how does the evangeli-
cal secularism of the notion of the arts as 'good' work travel across
social difference? Networking as a way of organising forms of labour
might well be endemic to the arts but it creates exclusions. I ask, in

what ways are the social and cultural dynamics of art school and its spaces negotiated by those for whom religious faith is a master narrative in the politics of identity?

British Art School and Social Difference

According to the Higher Education Statistics Agency (HESA), creative arts and design reports the highest proportion of white students of any discipline area (82 per cent 2018/19; with only 2 per cent identifying as Asian) (https://www.hesa.ac.uk/news/16-01-2020/sb255-higher-education-student-statistics/subjects). This whiteness underscores the central point in this chapter that the social and cultural politics of difference within the world of the art school has been neglected. How the institution, pedagogy and culture of art school intermesh with the everyday lived experience and ambitions of minority ethnic students in British art schools merits further attention. In particular, how ethnicity and race come together with gender and the underplayed role of faith and religion in these students' experiences, which provides vital context for understanding the boundaries, limitations and fissures of visual arts education.

Art school is most closely associated with fine art, but encompasses many disciplines: painting, sculpture, fine art photography, film and video or combined arts and performance, and, in some schools, fashion, design and architecture. Academic and industry-led studies have given emphasis to the importance of art school for launching British talent,[1] the financial riskiness of pursuing the creative arts, and touched upon class privilege and whiteness in the art world. These studies have tended to focus on professional outcomes of graduates or the life histories of already established artists and movements (often applied anachronistically, like the YBAs). Knifton and Lloyd (2017) have written on both the authorised and counter-hegemonic discourses of art school and its history in Britain, describing how, 'Across its institutional history, the art school has always been a site where identity and creativity are fought over and defined' (Knifton and Lloyd 2017: 9). To provide a brief history, art school reflected British imperialism in trade and design from the mid-

eighteenth century. A publicly funded enterprise in Britain from the early Victorian period, art school sought to cultivate new forms of education and production during industrialisation (Quinn 2015). Philosophically underpinned by the writings of George Berkeley[2] and Jeremy Bentham, art school was positioned as a public utility for moral and ethical refinement through teaching taste, aesthetics and industriousness (Knifton and Lloyd 2017; Julius et al. 2020). Many art schools were established during the nineteenth century to create a workforce that was skilled for industry (Banks and Oakley 2016). In the twentieth century art school became more counter-cultural and experimental. Influenced by the Bauhaus art school (1919–33), most closely associated with the short-lived school site in Dessau, Germany, and the far reaching avant-garde's approach to cross-disciplinary art pedagogy and practice of the early 1960s, art school from the 1970s became a site of feminist struggle over patriarchal structures. Geographies of art school were important then, as they are today. For example, the BLK Art Group formed outside London, in the de-industrialising urban landscape of the Midlands with artists attending Wolverhampton and Nottingham Trent Polytechnic such as Donald Rodney, Keith Piper, Eddie Chambers, Marlene Smith and Claudette Johnson (http://www.blkartgroup.info/index.html). Focusing on classed hierarchies, Stallabrass (2001) claimed the rein-vention of contemporary art during the 1990s as non-elitist for a new era of artists and the opening up of a wider public audience. The discourse on art school has centred either on art practice and aesthetics within the market and commercialism, or, alternatively, the importance of political context and politics of identity.

Pedagogy and practice are often not carefully delineated by bounded disciplines in art school, a legacy of the Bauhaus move-ment. Despite this seeming creative freedom, there is now a strong focus given to professional development. A move towards art col-leges joining with universities had the dual impact of more carefully regulated curricula and increased focus on internships, placements and training arts workers for 'good' employability outcomes (Banks and Oakley 2016: 50). In the context of a move from polytechnics

to post-1992 universities and the impact of market competition in the academy, destinations of graduates are important for league table performance and attracting future students. Knifton and Lloyd further note, 'twin processes of globalisation and commercialisation of the art world have had noticeable effects on the art school over the last few decades' (2017: 9). Contextualised by the late 1990s shift towards creative industries discourse, scholarship argues for a growth in what are often termed neoliberal practices in art schools, encouraging entrepreneurial, market-orientated approaches from students around their creative interests (Taylor and Luckman 2020; Flew 2019). Flew (2019) describes this as a shift of emphasis from artistic concerns towards commercial and applied forms of creativity; or from the internal to external.

Cultural work is now typically organised through networks, rather than firms, with launching and sustaining careers often reliant on networking. Art networks of contacts built around social capital might involve the exchanging of tacit knowledge, emotional support, idea and skills, finance and patronage (Coles and MacNeill 2017; McRobbie 2002). For instance the YBAs circulated around Goldsmiths, the White Cube Gallery, the Institute of Contemporary Arts (ICA), Saatchi, and Michael Craig-Martin, Iwona Blazwick, Jay Jopling (Grenfell and Hardy 2003: 30). Integrating these networks within the art school through tutor-artists is one way to embed networks, which can be viewed as disrupting the linearity and boundedness of art school, followed by comparatively isolated studio working (Knifton and Lloyd 2017). But it also raises the issue of reproducing rather than changing the visual arts scene (Umphress et al. 2007; Wreyford 2015). Or exacerbating inequality and lack of diversity through the hiring of similar people – known as homophily. There is an identified tension between policy makers attempting to open up cultural sectors to a wider range of cultural producers to allow for more talent, while producers might favour trust as a barometer for collaboration on projects that feel risky or experimental (Oakley 2006). Where 'notions of "the market" and of "risk" and "trust" together come to constitute a situation that reproduces the status

quo', accentuated by a longer culture of informal hiring and net-working for gaining work (see also Wreyford 2015 and Conor et al. 2015).

So what are the rates of art school graduates entering and sustaining occupation within the cultural and creative industries? The 'Creative Graduates, Creative Futures' study in the UK (Ball et al. 2010) involved 3,500 art, media, crafts and design graduates up to eight years after course completion from twenty-six UK HE institutions. This study (Ball et al. 2010) followed the seminal Destinations and Reflections study (Harvey and Blackwell 1999) and also found precarious employment among the graduates surveyed, especially in the first year after graduation, with high levels of self-employment (45 per cent of the participants surveyed) and portfolio working (48 per cent had more than one job). While students were more attuned to the possibility of the arts as a career given the growth of the art market, and professionalised in this sense (Oakley et al. 2008), the chances of financial success remain slim as an artist, which was recognised. Of course this varies considerably depending on specialism and country. Architecture, digital and design (in US and Australia) is comparatively better paid and more likely to be full-time (Bridgstock and Cunningham 2016). Craftmakers in the UK rarely make enough to live on from their creative work alone (Luckman and Andrew 2018; Patel 2020), meanwhile challenging the popular mythology that blogging and vlogging are easily convertible into a social media career, those who professionalise their activities often invest considerable money and time (Ashton and Patel 2018). Significantly, supporting the notion of cultural ecology as more accurate than cultural economy for encompassing the more-than-economic within cultural working, in a study by Bridgstock et al. (2015), arts graduates maintain high ratings on subjectively defined measures of career success that reinforce suggestions of creative work as 'good work' (Banks and Hesmondhalgh 2009). An ambitious Nesta project by Oakley et al. (2008) found that among fine art graduates since the 1950s from University of the Arts in London, most want to continue working in the arts, and further

that most are successful in this aim (80 per cent in the creative and cultural industries or teaching), with increasing numbers working in the cultural industries when broken down over each decade of graduation.

Atypically white cohorts of students and graduates in creative arts and design embark on cultural occupations that can be highly precarious and very low paid. Yet cultural occupations apparently have a 'particular sort of social status' and are 'highly desirable', which Brook et al. (2020: 17) attribute to the very fact they are marked out as middle class and therefore 'good jobs' (17). Their research highlights gendered exclusion from top creative jobs for women with 'relentless hostility' to women with caring responsibilities (23). There is a distinctive shared solidarity and politics found by Brook et al. (2020) amongst cultural workers around values and social attitudes: 'This new faction is liberal, open, and tolerant' (17). As I have introduced in Chapters 2 and 3, contested values and interpretations circulate around cultural forms, such as art and literature, evident across different Muslim communities. Figurative art is a case in point. But concerns around the veneration of images are not particular to Islam. Historic divisions and tensions around scriptural doctrine and the idolatry of images or 'icons' are common across the Abrahamic faiths, including in the iconoclasm (literally 'image breaking') of Byzantine Judeo-Christianity in the eighth and ninth centuries (see Milwright 2017; Lewis and Hamid 2018). It reminds us that the status of cultural occupations as 'good' is thus contingent upon: time and region; religion, culture, class and wealth; style and form; and whether work is displayed in a religious or secular space.

Yet beyond class and gender there is a lack of in-depth critical and empirical understanding about how geometries of social difference impact the lived experience of attending and graduating from art school, particularly concerning ethnicity, racialisation and religion. Indeed, questions around a fuller politics of social difference and identity in British art school are pertinent given heightened awareness of the role arts and educational institutions perform in reproducing inequalities in and through the attribution of status and

how this is spatialised (core or peripheral) in the Western-centric contemporary art world. As Divya Tolia-Kelly and Rosanna Raymond rightly identify, 'the curriculum, the university, the museum' produce 'an institutionalised set of imperial and colonial values and thought', or 'world-view' (2020: 7). Part of this world-view, as Tariq Jazeel (2013) reminds us, is the legacy of Enlightenment thinking that separates out religion from secularity; a sacred–secular binary that can be destabilised when confronted with a modernist aesthetics that might not be wholly religious but nor is it decidedly secular (for instance Jazeel considers Tropical Modernism). Recognising the British art school as atypically white and productive of a world-view can attune us towards the possible existence of different structures of knowledge and ways of apprehending our aesthetic world. In the section that follows I will briefly discuss how a politics of knowledge and aesthetics becomes more attuned by focusing on the imperialism of British art school as an active agent in the world.

British Art School and Colonialism

British art school is enmeshed with empire and colonialism. It is in this historical light that contemporary experiences of minority ethnic students can be more fully contextualised. The relationship of art school to colonialism raises two particular issues that I want to discuss here: first, in Britain, the continued teaching of an art historical canon shaped in Western spaces of education and display (by academics, curators, critics) that positioned Western art practices as enlightened and supremely skilful in relation to primitive and nativist work from the Middle East, Africa and elsewhere; and second, historic training and exporting of British teachers to cities in the former colonies for the transmission of European ideals on form and beauty, and extraction of material goods. For instance, sending teachers to leading cities of government and commerce in India to set up art schools for the training and transmission of 'good' taste by European classical standards, and the extraction and decimation of traditional Indian craft. As a connected point on the dynamics of post-colonialism and material culture, artists and cultural producers

from former colonies also travelled to the UK and attended British art school before returning to their country of origin.

First I turn towards how Western art is universalised as the global standard for art. Or, as Partha Mitter (2008: 531) writes, 'a universalist canon within an epistemological framework that goes back to the enlightenment' (see also Mufti 2016). Embedded within this logic are 'ways of seeing' (Berger 1972) that have 'faith in the universal' of modernist art and aesthetics and that exclude art associated with the periphery (Mitter 2008). Where examples of diaspora or Asian or African artists are included, Mitter argues, they do not significantly enlarge the canon. Instead, non-Western artists might only feature due to their compatibility with and thus reinforcement of the discourse and practice of Western modernism (Mitter 2008: 531). Meanwhile Mercer (2005) argues for the art-historical amnesia prevailing in black British art where discourse on ethnicity and politics of identity have meant a forgetting of the art object. Aligning with Mercer, artist and professor Sonia Boyce launched the *Black Artists and Modernism* project to address the under-recognised and contested work by British black artists produced within the context of modernism (http://www.blackartistsmodernism.co.uk). A useful critical analysis of the canon and its authority is offered by feminist art historian Griselda Pollock. The art canon can be considered a secular version of religious doctrine that establishes and confirms artists and works as central for the pursuit of knowledge and understanding. That is, the canon signifies:

> What academic institutions establish as the best, the most representative, and the most significant texts – or objects – in literature, art history or music. Repositories of transhistorical aesthetic value, the canons of various cultural practices establish what is unquestionably great, as well as what must be studied as a model by those aspiring to the practice (Pollock 1999: 3).

As Dominick LaCapra comments, the canon (somewhat contradictorily) reaffirms a 'displaced religious sense of the sacred text as a beacon of common culture for an educated elite' (see Mathur 2005:

706). Crucial to the distinction of the canon are the professionally esteemed individuals who impart gravitas. While there circulate multiple, sometimes overlapping canons, the Western canon, self-scribed as the foremost, has been maintained by artists, writers and the academy. Most pointedly we might think of critic, writer and professor Harold Bloom's *The Western Canon* for literature (1994). Of central importance, as Pollock notes, is that artists themselves legitimate and enable predecessors. And over time women and non-European artists have been left out. Through a continual incremental process the canon becomes familiar, produced and reproduced by institutions such as museums, publishing houses and educational sites, where it, 'gets put on the curriculum as the standard and necessary topics for study at all levels in the educating – acculturating, assimilating – process' (Pollock 1999: 4).

Fredric Jameson's widely influential essay 'Modernism and Imperialism', initially circulated in pamphlet form, introduces the spatiality of global imperialism into his discussion of literary history and argues for imperialism as constitutive of modernist aesthetics in the West. Taking a Marxist approach to imperialism as the coordination of political interests with economic interests, Jameson is further influenced by the ideas of Walter Rodney that capitalism leads to the 'development of underdevelopment', where 'imperialism systematically cripples the growth of colonies and its dependent areas' (1988: 47). Comparatively Stuart Hall's legacy from cultural studies includes one of the most enduring critiques of the Enlightenment mythic ideal of dispassionate universal knowledge and centring of Western art and 'western-oriented or Eurocentric grand-narratives' (Hall 1999: 7). As Dipesh Chakrabarty has argued, it is the tendency to conceive of Europe as the primary habitus of the modern which relegates non-Western history to a mere episode in Europe's history, and explains the development of non-western culture as an incomplete historical transition to the modern (2000; also see Mathur 2005). But, significantly, as Saloni Mathur reminds us, Chakrabarty's argument calls not for less of a focus on Europe but more – not a decentring of Europe, but rather a re-positioning of

its knowledge practices, and a closer look at its interpenetration into all aspects of life in the non-European world (Mathur 2005: 707).

A closer attention to European imperialism and its shaping of former colonies and the wider world can be told through a brief history of the British-Indian Art School. In 1851 the East India Company's contributions to the Great Exhibition of the Works of Industry of All Nations displayed Indian Craft (textiles, inlaid metals and arms), receiving critical and public attention. Indian craft works were purchased for the education of British students in design, which did show appreciation for the skill and artistry; however, the stronger impetus was the imperial improvement of Indians through European ideals of form and beauty. In London a school was established for the education of new colonial art teachers, with the purpose of 'the supplying of Art teachers to all places that seek to establish art schools' (South Kensington Museum 1864: 16; Tarapor 1980: 59). In colonial India, Sir Charles Trevelyan proposed that a network of British-run schools be established in 1853 for training Indian craftsmen and promoting their economically threatened industries (Tarapor 1980: 60).[3] The public funding of British-Indian art schools was thereby framed as a way of protecting the declining tradition of Indian arts and crafts. However, the overall intent was aesthetic and cultural imperialism. For as Trevelyan is documented as stating, it was

> to advocate the launching of a program that would 'set the natives on a process of European improvement' in such a way that 'the national activity [would be] fully and harmlessly employed in acquiring and diffusing European knowledge and naturalising European constitution'. (Trevelyan, quoted in Tarapor 1980: 60)

Multiple government sponsored art schools were established in major Indian cities: Madras, Calcutta, Bombay and Lahore. These cities were primarily seats of government and European commerce rather than centres of Indian art and industry; their avowed aim was to 'improve the taste of the native public as regards beauty of form' (Government of India, Home Office 1898: 62, reproduced in Tarapor 1980: 60):

> The Indian art student was considered to be terribly handicapped as compared to his more fortunate brother in Europe [who is] accustomed, through his toy books, to pictorial art from infancy . . . The Indian child . . . as his perceptive faculties are developed, may see a number of mythological pictures of the usual terribly grotesque kind . . . When he commences his art studies, therefore, he has, in an artistic sense to be taught to see. (Government of India, Home Office 1898: 88, reproduced in Tarapor 1980: 61)

Significantly, the notion of 'being taught to see' recalls the observation of Berger (2008) that learning to view artworks is a training in 'ways of seeing' that couples discipline with a Eurocentric lens. As suggested in the extract above, the Indian artist was also always configured as a male, and the vision that was cultivated was a male gaze. Antique casts, watercolour sketches and drawing copies, Gothic mouldings and Greek statuary were imported from South Kensington, the oldest art school in Britain, now known as the Royal College of Art, to form the basis of the Indian art students' training, along with drawing-masters to teach them 'many things not found in their own art . . . [and] at least to show how to draw from nature correctly and artistically' (Temple 1882: 279). The Bombay School by 1896 could boast that its resources represented 'the best collection of casts of Greek and Graeco-Roman sculpture that exists on this side of Suez, and [that] no student [could] go in and out of the place without seeing them' (Bombay Gazette 1896, reproduced in Tarapor 1860: 62). Starting from a position of paternalism the British-Indian art school project can be properly regarded as a strategic outpost for furthering cultural dominance. Artistic and philosophical ideas were inculcated through the institutional framing, collections, pedagogies and practices of the schools. It institutionalised an aesthetic reorientation of Indian student subjects and attempted their assimilation into Graeco-Roman and European ideals.

India's pre-industrial culture was threatened but not yet destroyed by European commercialism and colonialism, following the imperialist modern schema laid out by Jameson. However,

there were vehement critics at the time. As William Morris lectured, before the Birmingham Society of Arts in 1879, the finest craft-work of the country 'is fast disappearing before the advances of Western conquest and commerce – fast and everyday faster. While we are met here in Birmingham to further the spread of education in art, Englishmen in India are, in their short-sightedness, actively destroy-ing the very sources of that education' (Morris in Tarapor 1980: 5). In recognition of different global aesthetic fields and practices that we might associate more progressively with post-colonial and post-modernist approaches, Birdwood observed 'it is not for Europeans to establish schools of art in a country, the productions of whose remote districts are a school of art in themselves, far more capable of teaching than of being taught' (Birdwood 1878: 103; Tarapor 1980: 37). Politics of knowledge production in art school and the art market is undergirded by these accounts where the aesthetic styles and skills of students in the former colony were actively assimilated into a European vision of a Universalist standard of form and beauty. Lines of critical thinking are thereby opened through the exemplar of the Indian-British art school around pedagogy – the philosophical approach that informs who teaches, what they teach and how. This was connected to the capitalist underpinnings of a market-orientated and extractive ideology of European imperialism that shaped early cultural industries and their transnational relations.

Geographical and aesthetic linkages between British art school and former colonies were maintained in the transnational training of arts professionals. The opening of art schools in India was part of a wider investment in art schools including in Britain. Before the Great Exhibition of 1851 there were around twenty schools of design arranged under the Head School at Somerset House. But art schools in Britain over this period grew exponentially, so that by 1884 their number had multiplied nearly tenfold, to around 200 different schools that were publicly owned (Knifton and Lloyd 2017: 3). Similar practices were established in other creative fields, such as the Architectural Association's Department of Tropical Study in London in the 1940s, which attracted international students, with

important graduates of modernist architecture including Ram Karmi (Israel), Muzharul Islam (Bangladesh) and Valentine Gunasekara (Sri Lanka) (AA Archives 2016). As Jazeel (2013) observes the training of artists and architects from the former colonies in Britain, and exporting back, was another kind of post-colonialism. Of course central to this transnational passage were distinctions of class. For with Sri Lankan modernist architects such as Minnette de Silva and Geoffrey Bawa: 'It was, after all, colonialism's class structure that had enabled their own passages to the UK as well as their professional training and exposure to the international style' (Jazeel 2013: 106). The spatial metaphor of the passage opens alternate positions from which to look upon material culture and the aesthetic world. Developing his concept of sacred modernity, Jazeel locates de Silva and Bawa's architecture in an aesthetic realm of Sri Lankan modernism, combining colonial and distinctive Sri Lankan styles, which resisted post-Enlightenment binary thinking of structures of religion and secularism. For, thinking of modernism's others, in the words of Jazeel,

> in southern Sri Lanka a Buddhist aesthetics and philosophy also textualize society in ways that do not announce themselves formally as religion, but rather remain present within an aesthetic realm that cannot be pinned down by the normativity of a sacred/ secular binary. (Jazeel 2013: 106)

After all religion itself as a category was a construct of comparative religion and Western rational empirical approaches to fieldwork where people outside of Europe and the US were categorised and compared against Christianity (see King 2013). The example of Buddhism is helpful as a way of clarifying Eurocentric structures of thinking and their delimitations. Buddhism was organised into a world religion and compared according to metrics of (dis) similarity against the standard of Christianity. But, as Jazeel writes, the dominant Sinhala-Buddhist symbolism in landscapes such as Yala National Park, cannot be framed absolutely in a sacred–secular binary as religious or worldly. Instead, after Raymond Williams,

the aesthetic realm can be understood as an ethnic and nationally informed structure of feeling that dominates over nature (see Jazeel 2013: 112). Ethnicity and belief systems here intersect in the production of symbolism and how they are then viewed.

The colonial history of British-Indian art school and praxis around modernist aesthetics are embedded within what can be understood as a 'worlding' of Western art practices and institutional structures and pedagogies. Jane M. Jacobs (1996: 15), in her important post-colonial text *Edge of Empire*, writes: 'How can the spatial discipline of geography move from its historical positioning of colonial complicity towards productively postcolonial spatial narratives?' Rather than an original and borrowed Western modernism exported elsewhere, attention should be directed to Western processes that centre western knowledge, thereby highlighting core-periphery geographies. Jacobs links a more nuanced appreciation for the dynamics between core-periphery geographies to urban futures, but the spatial approach may usefully spotlight art, and creative futures. 'Worlding is a practice of centering, of generating and harnessing global regimes of value' (Jacobs 1996: 15). Worlding might thus be an intervention, a series of overlapping circulations, such as cities, and, also, regimes of 'subject-making'. Ananya Roy is also interested in '[a] genre of postcolonial analytics that critically deconstructs the "worlding" of knowledge' (2011: 308). The post-colonial is not presented as a 'condition' but 'as a critical, deconstructive methodology' to 'enable new lines of urban research and theory' (2011: 308). Debates on the relationship between the core-periphery in art are current in contemporary praxis of post-colonial and de-colonial strategies in art school and museums as I explore further in Chapter 7 (Visual Arts). Mathur, whose expertise is Indian avant-garde movement's resistance to European modernism, critically asks: 'How, for example, should we acknowledge the dominance of western museums, while also subverting – or at least not reproducing – their history of universalizing and totalizing claims?' (2005: 701).

To return to contemporary art, the growth of the art market combined with globalisation paradoxically led to a new vision of

British nationalism for the YBAs. It was given rise to by the superiority and confidence that is indivisible from a history of empire. Mercer's viewpoint on the YBAs' 'pathetic neo-nationalism' was that it was a means to attract attention from the international art scene and market that involved an arrogant 'standing apart and turning inward to promote its own cultural identity' (1999: 55). Coming back to what you know left African and Asian artists highly visible yet muted, highlighting what Mercer refers to as an 'unspoken policy of integrated casting' of black artists (1999: 55). By integrated casting, the process of supporting only one or two minority artists is presented – as artists in this study reinforced about the art scene today – which in turn maintains majority white as the norm. Within this vein diversity has become part of the establishment, in echoes of Sara Ahmed's writing on diversity in institutional life (Ahmed 2012). Minority artists may exceptionally be included and yet – marked out by their alterity – they remain on the periphery. On what he terms 'first world countries', Jameson writes on voices of the internal 'other'; for instance, black women's literature, 'which must be registered as a problem by the imperial or metropolitan other' (1988: 49).

It is towards the contested voices, practices and delineations within modernism that Boyce seeks to return and enlarge in her art and archival project around black British artists. Perhaps more acutely British Muslim women artists are figured as the internal 'other' for their place in modernism, postmodernism and the art canon. As outlined in this book's introduction, perceived tensions around Muslim identity and the contemporary art scene can intersect and act together to multiply exclude in difference from the status quo that is gendered, racialised and religiously obscure. Mufti illustrates the alienation process of colonialisation on creativity using the example of Orhan Pamuk's Nobel Prize-winning speech where he recalls a childhood exposed to his father's library of mostly European and Republican Turkish books: 'a record of the disorientations of a Muslim society undergoing state-enforced Europeanization, suddenly cut off from the entire literary heritage produced until just a few decades earlier in a version of the same

language but in another script' (Mufti 2016: 11; Pamuk 2007). It is of course relevant here to consider whether minority artists in Britain and other Western countries are marked out as different in a way that negates potential for success. Or what kind of social and cultural politics contextualises and texturises the conditions by which minority artists might achieve markers of success, and at what personal stake? It is to the vital narratives of Muslim women who attend art school that I now turn.

British Art School and Muslim Women

As I outlined earlier in Chapter 2 of this book the stories of women migrants in labour have historically been overshadowed by a focus on the male as the primary economic subject. Gendered disparity in the representation and division of cultural and arts practices can be multiply located – from all-male guilds, a male-dominated canon, to the idea of male creative genius. Gender and class are widely recognised and researched in relation to art graduates and artistic labour. Even where a fuller range of protected characteristics are acknowledged, on disadvantage and exclusion the preferred 'others' that complicate gender and divisions of class are ethnicity and disability (see Conor et al. 2015; Brook et al. 2020). In the sections that follow in this chapter, I attend to the silencing of religion and faith difference in a secular, humanist art school tradition. Moreover, it seeks to write in the experiences of Muslim women artists who have been positioned as Western modernism's 'ultimate other': female, religious, and (in many cases) with non-Western heritage.

The following section analyses how studying and practising the arts is narrated in the lives of artists and by their family and friendship networks. It does this by reflecting on multiple points in educational, training and professional trajectories. Familial pride and aspiration are clearly present for academic achievements for all children (no matter sex and gender). However, what subjects are studied and where has now come under closer scrutiny, as a result of greater anticipation that women will enter the labour market. In this chapter I discuss the critical factors that shape decision-making

on educational and career pathways. In particular it draws attention to the wide range of actors involved, and patterns around key areas of tension and negotiation, such as location of institution, issues of travel and mobility, and concerns around visual form.

Choosing to study at art school

The accounts of the artists that follow are mostly of artists from Pakistani heritage. The majority of the wider sample in the study identify as being of Pakistani heritage, and this was most weighted in the visual arts. However, it is necessary to note that this is not reflective of a hierarchy of status for Muslim artists in the art world (where the Middle Eastern market is predominant), nor it is likely to represent the breakdown by ethnicity of Muslims in different sub-sectors of the arts and cultural industries, although only data on ethnicity rather than religion exists. The artists in the study discussed their degree choice in relation to parents, diasporic communities and friendship groups. 'Mona', from a mixed Libyan and British background, noted:

> My mum said that's the only thing that I rebelled against . . . The norm you know, 'go to uni, be this kind of person' and I was just like no . . . My dad was [like] 'I knew it all along'. Dads are always like that, but . . . 'Oh, I knew all along, you wouldn't go for that' [the normal subject choice].

'Mona' did not conceive of art as a viable occupation. Pursuing art in higher education was similarly linked to rebellion and rebelliousness by many women in the study. Instead 'Mona' had planned to take 'a normal job':

> I think first of all I didn't even think about going in to a career of creativity, it didn't even make sense to me. I was like 'no, of course not'. Dreamland. No way. I draw on the side and I have a normal job of a day . . . That's how it was throughout all of high school, I was like 'of course, that would be ridiculous to be an artist. What?!'

'Mona' was encouraged to pursue a cultural occupation by her social sphere; a group of 'cool kids' from different Muslim backgrounds. One friend was an illustrator, another friend studied art history at degree level. 'So I had friends around me . . . I just kind of followed them.' They supported 'Mona' into advanced level qualifications in art followed by a degree in graphic design that she had not considered a realistic option.

The case of 'Mona' gives an insight into how the status of creative and artistic labour is uneven, and contingent upon identity and distinction according to educational, cultural and economic background. These interwoven sets of social dynamics that impact upon educational choices and employment decisions are described by 'Fatimah', an art school graduate now in her forties. In the extract below she reflects on a meeting with another woman from a Pakistani and Muslim background at a wedding:

> She was showing me photos of how creative her daughter was – this was a Muslim Pakistani lady – of her cakes and her drawing and her artwork. And she was saying to me, my daughter really wanted to go to art college, but we told her that we don't think you should be going to art college, it's not a proper career, it's not really right for you, you know, you need to do something more academic. So she went to university to do something science based. Because art isn't really 'a proper career', and I just thought, they're from my generation and their attitudes – I thought people's attitudes had changed, but they haven't really. And I didn't say anything to her about what I'd done or about what I did, because I just really couldn't be bothered. I just thought, if I start I'll just have a real go at her! You know. And I just looked at her daughter and thought, she's so talented and she's so creative, and I have met other Muslim Asian women who are really creative but whose parents have forced them to do something – or they felt that they ought to do something – that's more academic.

Values are shaped by class status and growing up within a diaspora that privileges occupations which reflect more conventional forms of

academic distinction. The encounter at the wedding narrated above introduces science subjects as more appropriate for a 'proper career'. Careers in medicine and engineering have been esteemed over generations – albeit historically for men. Across the research the high status and preference given to a narrow set of professional fields by parents and grandparents was repeatedly raised. Reasons given were the clear merit in these occupations, denoting, as they do, high achievement in learning and qualifications, contribution towards society, availability of work opportunities and good remuneration, besides clarity of occupational pathways within the sectors. Wider social mobility concerns underpin these insights, where the work-based horizons of young people are often closely aligned with the careers of family, or other community networks, though this was not necessarily about gendered issues of control and constraint by an extended family or diasporic community.

Negating a simplistic reading of gendered roles, in the extract below another artist describes how obtaining a degree was important in the eyes of her father for all four of his daughters. She describes how the father wanted a higher education for his daughters, to advance upon what would commonly be available in Pakistan. Her father gives emphasis to how important it is that education and independence should be Islamically informed:

> It was about having a degree, yeah, he wanted us all to be educated and I think that was because coming from Pakistan and being here as someone who doesn't have any of the things that people already situated here have what he wanted that for his daughters . . . I think there was another aspect of us being able to stand on our own two feet and me and my sisters are really happy with how our parents brought us up because they have always given us the opportunities to do things independently but kind of rooted within important principles.

All four daughters in the family were expected to get a degree without interference from wider family or other ties: 'And because we didn't have any brothers he wasn't comparing us to anyone. And

because we don't actually have family, we don't have many relatives in this country, we didn't have any issues of having to please people.'

Supporting the point further that growing up in the diaspora meant greater independence in decision-making (Werbner 2002) were the views of 'Saila', a textile designer and painter. Also Pakistani, her family made friends with other middle-class Pakistani doctors when they moved to the UK to live in Liverpool, then to Manchester:

> As a Muslim British Pakistani person growing up I didn't have any extended family here, everyone lived in Pakistan. So it was literally just me, Mum, Dad and siblings. And so you kind of look for family elsewhere. Through work my parents came across other British Pakistani doctors especially, and you kind of have more common ground, and you speak the same language, and so when you come together we made up a family network of primarily British Pakistani doctors.

Instead 'Saila' describes how her family became her parents' friends and their families. This was not free of academic and career pressure with the network distinguished by class, education and profession. The close community of Pakistani families with whom 'Saila' socialised would compare their children's activities and levels of achievement. In this instance belonging to a diaspora, language, education and profession are the discussed markers of community formation, with religion left mostly implicit. Influenced by her academic family and their social networks, 'Saila' opted for a BSc course in textile design and business management, within the School of Materials, situating a 'soft' choice of textiles within the 'hard' sciences, making it appear more rigorous: 'I had that slight thing in my head that I wanted to do something that was a little bit more academic . . . I went for Manchester because it was the one that was a BSc.' Patterns of pursuing higher education and the lengths to which many students now go to secure professional well-paid employment are evident with students selecting the most prestigious universities (Reay et al. 2005), work-relevant extra-curricular activities (Brown et al.

2004), postgraduate qualifications (Brooks and Everett 2009), and studying abroad in Anglophone countries such as Australia, the UK and US (Brooks and Waters 2011). To justify her choice in a creative field, 'Saila' felt the need 'to prove myself, and to excel', graduating with first-class honours.

Deciding to pursue training in cultural and creative fields involved a meticulous process for each of the women. It included negotiations with parents, grandparents, place-based judgements, and even speaking with God for guidance ('Salat al-Istikharah'). The outcome of these negotiations was enabling for the women (evidently given their occupation in the cultural and creative sectors). It was noted, however, that while parents were supportive, many of the women's friends did not share the same experience with less allowance for choice over degree subject and intended occupation. Though for some, such as 'Mona' who I introduced earlier, friends who were interested in art offered a bridge into the art world. The interests of friends expanded the horizons for 'Mona', creating a Muslim female support network around creativity. Elsewhere, however, friendship networks were described as constraining choices, if art was outside the realm of 'normal'. This was especially pertinent when there were contrasting ideas on the purpose of pursuing higher education or career. Art could be viewed as offering non-financial rewards that enhance occupational satisfaction and provide a sense of purpose (Ball et al. 2010; Oakley et al. 2008). But, as 'Nadia' noted, her peers did not understand why postgraduate study was worthwhile unless you would earn more money. She described pushing back against this narrow valuation of the qualification where 'the terms are superficial'. Some of the insights from the interviews above are not limited to Muslim groups or any ethnic minority group in particular. Yet together they highlight how the reputation and status of art school and cultural occupations were not viewed as highly desirable for many of their families. Family pressures and social expectations did not usually conceive of art school as near a horizon of possibility.

Studying at art school

The question for most respondents on deciding to apply for art school was which one? Points of consideration and parental-child negotiation hinged around location, travel and safety. Or to put it another way, discussion often raised concerns around mobilities – spatial and social. Where opportunities were more localised, this typically held parental preference in the narratives. The clearest example is 'Aamira' who was permitted to attend fashion school at BA degree level because it was at the same further education college she had studied A-levels and in the same town as her family home. However, for 'Zaya', who had previously studied a BA in fine art at UCLan, Chelsea College of Arts was the sole master's degree course for which she was accepted. She did have family in London making the move more straightforward. Studying in London suited her for professional reasons as well, 'I thought there would be a lot more kind of options for me if I came down south.'

Concerns of safety and risk-taking that placed pressure points around travel and mobility were further explained elsewhere. In the case of 'Fatimah', who positions herself as East African Asian, she describes parents who were 'a little bit more liberal because they had lived in that diverse, that society, with different cultures' of Kenya and Uganda before moving to Scotland. But she reflected, 'It was still very difficult, being at university, especially being at art college I think, that was quite tough, especially as a Muslim and somebody from my culture.' Adversity between her religion and culture was most felt around course field trips. 'That was quite a fight to try and go on trips. There was a trip to Paris that I really wanted to go to, and then eventually I did do.' She experienced the sensation of feeling 'I'm free! It's freedom for a week! And I can go out and do things.' This contrasted with her experience of living at home during the rest of her studies at art school with parents saying, 'No, you can't do this, no you can't do that.' Social practices that were not permitted were drinking or having a boyfriend. The experiences she did have – though satisfying at the time – led to later reflections that her faith

was not as strong then, and sometimes 'Islamically' her actions were not correct. As 'Fatimah' elaborated:

> There's certain things I did at art college which weren't right, Islamically weren't right, like life drawing for example. You know, drawing nude men, that wasn't right really. But at that time, it was like, 'well I'm doing it, I'm at art college, fine'. Whereas in hindsight now, I shouldn't really have done that. And drawing nude women as well I suppose. So if my daughter did go to art college, I would tell her it's not really right for you to do that. And I know it might be hypocritical of me to say that, because I've done it, but I suppose you'd have to, like I said, you have to tell them what's right and wrong, and at the end of the day it's their decision, that's their choice.

Here 'Fatimah' discusses the representation of the human figure in Islam. Widely regarded as non-permissible, the representation of the human or animal form is viewed in tension with teachings of the hadith that only God should create the animate form. It is significant to note, however, that the wider history of the Islamic world and art can be viewed as more plural with many examples of human and animal forms represented from miniature paintings, to murals, to sculpture, to ceramics and painting, both historically and in the present. The development and range of Islamic art is explored in the new Islamic gallery of the British Museum, London, or the Department of Islamic Art at the Metropolitan Art Gallery, New York, and their linked webpages. However, the power and belief attached to this understanding, regarded by many Muslims as a basic tenet of 'correct' behaviour, means associations of art school with life drawing and figurative approaches are often presented as antithetical to Muslim beliefs. A recent graduate, 'Zaya', explained the concerns held by her Muslim peers of a classical fine art training based on drawing the human figure:

> There was the thing about drawing nudes, you know, Islamically we should not be drawing, like the nude figure and things. I

remember on my Instagram, I'd get messages from people who were thinking about studying fine art and then they'd be like 'but don't we have to, like, do life drawing', and [I'd respond] like, er, I'm sure if you said that you didn't want to do it, for whatever personal reason that was, you'd be fine. But I think that's another kind of thing that people would assume that we have to do.

'Zaya' describes how she acts as a translator for other Muslims who were interested in art school but concerned it was not compatible with their religious beliefs. Acting as an ambivalent cultural broker through social media, 'Zaya' shows how traditional practices such as life drawing are part of the standard European curriculum but how there is space for students to draw attention to their difference and expect alternative provision. It underlines core and peripheral practices, and the way religion and faith is framed as a personal choice, which can be viewed as marginalising its importance for equality. At the same time, 'Zaya' promotes understanding that art school can work as a more flexible pedagogical space and enable difference, here in relation to religious views and dignity in education, than is presumed by her Muslim peers.

Navigating social norms and networking were other key issues raised by participants. Along with mixed classrooms, the event culture of art school – art and fashion shows – might involve 'free mixing' with men and exposure to drinking cultures and drunkenness. 'Zaya' describes how she 'had never been to the pub before that year' but now 'literally every week the school would be going to the pub'. She recounts how she was encouraged to attend by a teacher in order to meet and welcome a new artist in residence. Her language reveals her hesitation around being associated with, and part of, a pub environment, but feeling a social and professional weight of expectation: 'One time I did go, my tutor actually asked me along, and said 'just come'. Then I did go, but I didn't stay for long . . . A new kind of artist in residence had come from another country, so we were just kind of trying to welcome her as well, so [in that case] I'll come, and I'll speak with her.'

Due to the combination of a tutor suggesting she attend and the rationale as work-related, 'Zaya' could justify to herself mixing around alcohol on this occasion.

Discomfort from compromising on religious beliefs to 'fit in' was expressed elsewhere. 'Nadia' reflected on the need for setting personal boundaries:

> So for example, one of the things I don't like is being around alcohol so I don't go to pubs and I don't go somewhere if I know it's going to be something oriented around drinks. And I can't stand the smell of alcohol. I've had like issues where people become very tipsy around me and I don't like engaging with that kind of environment at all so I've just set those boundaries for myself, like those kind of things that I don't cross over, and I don't compromise on my principles in order to achieve something.

This is a negotiation – or set of tactics – around dominant culture in art school and the wider art world that the subject highlights, here informal networking over drinks, and chooses to reject. Even if it means losing a creative opportunity, moral principles guide her actions. Each specific encounter involves establishing boundaries and trusting the other person to act respectfully, as 'Nadia' explains:

> So what I do and I don't deny my rules, so if someone invites me, I say, 'I don't go to the pub', and I've never had any issue with anyone. I don't shake hands with males, either, and you can imagine I meet a lot of people. I've been in this situation loads of times, hundreds of times, like someone will put their hand forward and I won't shake it. I'll say, 'oh don't worry about that, I don't shake hands'. So there will be that moment, is this going to be awkward?

Dealing with difference in everyday encounters within art circles contains a sense of personal risk for the artists where reactions are unpredictable and hostile potentially. But choices could be limited to get on. As 'Nadia' observes, 'I stand out much more openly, [being] what might be perceived as a practising Muslim, you know.

Things like networking in art, you have to, there's no way you can cut yourself off and still expect to be actively working within the arts.' Therefore she finds ways to operate in environments that she would not otherwise choose to engage in. Stallabrass (2001) describes the close networks of the YBAs exhibiting together, attending the same group of institutions and socialising together, and being represented by the same galleries. As While (2003: 257) comments, 'These social connections seem not only to have provided valuable support to artists, but also appear to have provided the flexibility to unite disparate artists under a common banner.' An experience of outsiderness not only negates the same opportunities for success, it also cements distance around the social and well-being. A white lens operates within mainstream visual arts networks and art spaces (Meghji 2019) that plays on a cultivated sense of Britishness where there are 'viable expressions of exportable British culture' (While 2003: 259).

Spatial examples were given of marginalisation, too, such as within art school buildings. For instance, a prayer room was provided at Camberwell, and yet this was not a 'comfortable' space to use. 'Nadia' reflects that this is likely because she was the only obviously Muslim student in the college, and thus a prayer room was not prioritised:

> I think I was the only person wearing a hijab in the college that I could see. I was the only person who was making use of what was supposed to be a prayer room but it was actually just a really small disused broom cupboard. I think there were a couple of employees that might have been using it but they definitely hadn't invested in this space, it was not great.

The relationship between spatial marginalisation and minority status, and its subversion, was grappled with elsewhere. Azraa decided for her final show that she would hang a large banner of a self-portrait she had painted on the front of Chelsea College of Arts (Figure 4.1). This seemed to generate some push-back and debate from other students, which she heard about:

Figure 4.1 Azraa Motala's self-portrait on banner, Chelsea College of Arts, MA Final Art Degree Show, 2018

> Yeah, I heard that one of the students in my class said, 'Why do you need to be so big?', and she was just complaining about that. Then one of the other students said, 'er, well, she's kind of been under-represented and marginalised for a long time, she needs to be able to kind of put that there and say "look, here I am."'

In relaying this Azraa identifies the politics of representation taking place at Chelsea College of Arts in decisions over where students are shown, and the space they are given. It precipitates debate around the broader significance of the Finals show through raising the question of what action the art college can take to address historical exclusion in the art canon. A sense of white fragility is also revealed by the student who complained. DiAngelo (2011: 54) describes white fragility as a 'state in which even a minimum amount of racial stress becomes intolerable, triggering a range of defensive moves', including argumentation and silence. The account

of the student suggests white fragility in their pushing back against positive action to address inequalities, which is indicative of how struggles and tensions are ongoing around diversity and equality of opportunity.

To return to the earlier discussion of Indian-British art schools, there is always an exchange of people, ideas and cultural goods between Britain and former colonies. However, it is not a level playing field. The transnational mobility of artists and culture reveals continuity in some ways, as with the earlier examples of Sri Lankan born architects Bawa and de Silva studying at London's Architectural Association, but with a new conceptual and political context that turns a lens on the legacy of empire, and continued racialised hierarchies and religious marginalisation. Religious faith for the artists might inform their artistic work and aesthetic, but also infuses many areas of educational life, from social events, to networking, to teaching pedagogy. The symbolic disruption of the self-portrait oil painting of a young hijabi woman painted and hung on the front of Chelsea College of Arts is suggestive of a wider political agency around the augmentation of public space, civic buildings and educational establishments. It shows the place of religious identity within British culture, where Muslim youth sub-culture is emblazoned across an illustrious art institution founded in late imperial Victorian Britain, serving to unsettle the historic marginalisation of Muslim cultures as inferior, and subvert the Western male artistic gaze of the Muslim woman as odalisque. The intervention serves to challenge institutional whiteness at a material and symbolic level. I explore this further in Chapter 7.

Attending art school, and indeed any tertiary level course, is often a time of exploration and self-questioning. Artists describe how this 'rite of passage' is intensified as a minority and in specific ways as Muslim. 'Nadia' describes feeling frustrated by the pressure of defining her artistic identity, before graduating aged twenty-two:

> Instead of finding answers to all of the questions that I had I was just finding more questions and it was kind of frustrating and I

was at this point where I was only just understanding what even
artistic practice means and understanding your own personal con-
text and the context of the wider world and your place within that
so I was almost like a baby within the whole kind of art field . . .
there's a whole world to it, a whole scene in itself.

The artist describes outsiderness to the art field that became
clear at art school. More than this, she describes how art school
is a 'whole world' for which she was unprepared. She spent the
degree trying to understand her own place within the art school
and art world. Art school is often described in terms of journey-
ing and transformation of self. For those in this study, Muslim
women artists, attending art school brought special challenges. The
almost clichéd journey of self-discovery in relation to the socio-
cultural structures of art school and its pedagogies are often politi-
cal for minority artists. For 'Nadia' it ignited a deeper, intimate
geopolitical and post-colonial wakening. As 'Nadia' phrases it,
'Understanding . . . the context of the wider world and your place
within that.' Here the destablising effect of entering art school is
articulated through an education that reveals, often for the first
time, how personal experiences of outsiderness and exclusion are
embedded within British Empire and its afterlives. Encountering
daily experiences of feeling and being Othered are part of the lived
realities of many in post-colonial Britain. She observes the gap of
social and cultural capital she brought to art school in relation to
many of her peers that left her feeling ill-prepared. And yet, it is
a whole world from a Euro-American perspective, or 'one-world
thinking' (Mufti 2016), through which a minority artist is de-
centred. 'Mona' succinctly described this experience as 'an identity
crisis'.

Unlike many other courses, art school graduates are often under
pressure to start launching an independent career upon graduation.
It means identifying their 'USP' (unique selling point), in entrepre-
neurial language, or understanding their practice in relationship to
the art canon and market. Muslim artists in the study recounted

tutors pushing them to 'find themselves' and be 'authentic'. In the legacy of colonialism art school characterises the predicament of minority artists dealing with issues of representation and capitalism. Where the origins of modernity and culture of capitalist society of the contemporary art world takes place, in the words of Mufti (2016, 12): 'within a history of worldwide imperial violence; the persistence into our times, albeit in altered forms, of the racial and cultural antagonisms of the colonial world; and the ongoing struggle over the right and the ability to define the contours of human experience'. British art school raises questions of whether artists were typecast due to minority ethnic and religious identities, or whether their white peers were also expected to engage with issues of self-identity in the same way (see also Jiwa 2010). Or as Anamik Saha terms it, were they subjected to greater forms of creative control? Paradoxically, the Muslim women were often asked to 'fit in' to a dominant white and liberal culture, and drinking scene, as suggested by the interviews above.

'Mona' captures best the vulnerability of a young adult student asked to expose more of herself when there is a wider geopolitical context of national and international hostility towards Muslims and Islam. 'Mona' in her activity diary entries feels her way when explaining how at art school she feels different to her peers as the only hijabi, and wants to 'hide', which then impacts issues of representation in her artwork. She writes: '[I] feel as though there is not much of a similarity between me and my other peers. When it comes to drawing on paper and the illustration side of myself I can hide a little better.' Her tutor explains 'Mona' needs to put her identity more into her art work to enhance 'authenticity'. 'But I feel as though me using my actual identity may have a negative effect' ('Mona'). Given the context of the erasure of contemporary Islamic art as a genre and the wider hostility towards Muslims in society and discourse around a Muslim equality gap it is unsurprising that as a young artist 'Mona' feels exposed and therefore conflicted about revealing her religion and difference in her work. Especially when 'Mona' identifies inconsistencies in the tutors' approaches to inclusion: 'Not

only that but other aspects of illustration include things that I can't be included in. During [visual artist residency] all the students were invited to go to the pub and talk in more detail about his illustration style. Which is something that as a Muslim I can't be involved in.' 'Mona' describes processes by which tutors attempt to make her work recognisable within the structures of art school, but where tensions emerge around the intimate geopolitics of representing the symbols of Muslim identity and faith in a dominant culture that is uneven in attitudes towards difference.

Those interviewed largely discussed art school as an enriching and generative experience, whilst also being disorientating and alienating. As 'Nadia' describes, undertaking PhD research was an exciting period of time as she fostered a sense of being part of an 'Islamic arts network' emphasising feelings of connectivity across the small, yet influential group of contemporary artists to emerge in the UK, such as Zarah Hussain, as I discuss further in the next chapter. Meanwhile another student, 'Aamira', discusses the sheer weight of networking and alumni experiences facilitated by her art college and constant exposure to new things that she valued. Finally, whilst cognisant of historical and contemporary forms of marginalisation, often acting spatially in the lived everyday, some of the artists did express that strength was obtained through solidarity within minority networks. Azraa describes solidarity between non-white students who were awarded John Hoyland scholarships at Chelsea College of Arts for their MAs: 'It's fun because there were three of us, and we were all scholarship students, and all of ethnic minorities, and we kind of tended to have time to talk about our work and that's when – that's where the best ideas kind of came and, you know, those were the best conversations I had to be fair.' Jackson (1989) has written how sub-cultures have often emerged through their very marginality from mainstream culture. While this does not in any way negate the seriousness of the challenges faced, and it is possible that these were downplayed given my own positionality as a white researcher, there is the more hopeful suggestion that minority and political social networks and scholarships can create enabling

systems of support for emergent artists from different backgrounds in majority white spaces.

Conclusion

By taking in-depth qualitative interviews in this chapter I have foregrounded the world-view of Muslim women around key stakeholders, institutions and life events that shape their educational and early working lives as art students and emerging artists. In two commissioned reports for Arts Council England on equality and diversity it was found there was a paucity of research discussing religion and belief in relation to the workforce, with none specifically focusing on arts and cultural sector (Consilium and Arts Council England 2014, 2018). In the lived stories given in this chapter the relevance of religious identity and structures of feeling are presented around the infrastructures of art school, which are understood relationally with other markers of social and geographical difference. For those Muslim woman artists in the study there are key pressure points where a balance of opportunity and dignity at work become difficult to hold together; around dominant social cultures and especially drinking cultures, studying figurative art and life drawing classes, and to some extent prayer and dress, although through the accounts there does appear to be social progress in the latter two areas.

The chapter presents a Pakistani heritage majority in the sample of artists that is suggestive of greater complexity around discourse of the Muslim community and Muslim world than is implied by the art market where the Middle Eastern art market and 'Arab' artists predominate. A number of the issues raised resonate with studies of minority ethnic or black artists. However, there are specific religious issues raised as I detailed above. Artists in the study raise concerns around parental attitudes to certain social activities, to field trips, and living away from home for study or work. In their discussions the artists contrast the 'culture' of the art school with the 'culture' of their families and communities, making clear where they might overlap with, but are distinct from, religious belief. Pursuing higher education for middle class and upwardly mobile families for their

children is presented as desirable irrespective of sex and gender. More striking is the emergent finding that greater gender equality around pursuing higher education and a career with less focus on marriage for security has sharpened parental focus on the nature of the work. Departing from Brook et al. (2020), who give emphasis to a majority white workforce in cultural occupations, forging a career as an artist for the women in this study is often not considered 'good' work. That is until external markers of success are demonstrable, such as prizes. Within the world of art school, artists are encouraged to fit into the wider culture, such as attending boozy art openings and hosting visiting artists at pubs, which for the women in the study is discussed as a dominant, white culture. It is also reflective of the pragmatic legal designation of religion as protected but private (see Introduction and Chapter 2); meaning that how religion meets with public space and the learning environment of art school presents an ongoing negotiation between students, tutors and peers where the institution should make 'reasonable adjustments'. The young artists in these contexts hold less power and discuss the frictions as a personal challenge rather than matter of religious rights. The social and infrastructural qualities of experience – material buildings, event culture, pedagogy and informal networking culture – often acted together in ways that were marginalising. This is overlaid upon a history of colonialism at art school and canon that centres Western art and enlightenment values, separating out humanist knowledge and secularism from religion and the afterlife. Artists did not always explicitly discuss the politics of art school; however, when invited to reflect upon their experiences they share common views on cultural marginalisation and attitudes about being positioned on the aesthetic periphery, along with pressure to perform identity work in their creative work. Thereby they experience artistic pressures around matters of representation provocatively characterised by Ralph and Gibson (2021) as 'Too Muslim or not Muslim enough?' Instead of innovating around a tradition of British modernism or otherwise, tutors encouraged 'authentic' work on identity and heritage. This risks returning to a kind of neo-nativism that presents to the students

they are not considered wholly British, which was variously difficult, unsettling and destabilising.

Notes

1. For instance, David Bowie, Pete Townsend, Brian Eno, Vivienne Westwood, John Galliano.
2. Berkeley's approach has been understood by Quinn as theological utilitarianism that equated public happiness with a divine order; meanwhile Bentham takes a classical, secular utilitarian approach.
3. Cheap Anglicised imitations were placed on the market.

5

MUSLIM LIFESTYLE MEDIA

Introduction

Since the turn of the twenty-first century Muslim lifestyle media has expanded rapidly. Within the sub-genre especially prominent are Muslim women producing content for other Muslim women. Muslim women bloggers – so-called 'hijabi bloggers' – attract large global followings. For instance, Huda Kattan, an American born to Iraqi parents, now based in Dubai, has 45.5 million Instagram followers @HudaBeauty, which *Vogue* Arabia contextualises as 'nearly 15 times the population of Dubai' (https://en.vogue.me/culture /huda-kattan-10-facts-about-her/). The Islamic marketplace reveals geographical diversity with hubs of activity based in countries such as Indonesia, Quwait, the United Arab Emirates, the US, Canada, Australia, The Netherlands and the UK. Working from these countries and others, Muslim women bloggers are optimising their reach by communicating across multiple media platforms, such as YouTube, Twitter, Facebook and Instagram.

Muslim lifestyle media creates digital spaces of exchange and is associated with consumer capitalism. As I discuss in this chapter there are also less explored dimensions around access to informal education that can transcend local or national contexts. Often a

stated intention of Muslim lifestyle media is strengthening supranational identification with what is sometimes termed the global Muslima, or Muslim female community. Online minority spaces for identification and belonging are found to be especially attractive in hostile local environments where subjects might experience multiple forms of social and economic exclusion in the lived everyday (see Warren 2018, 2019). The Islamic marketplace, modest fashion and hijabi blogging have received academic attention in relation to identity formation and belonging, but there are very few qualitative studies into the everyday performance of media work. The critical roles of Muslim women in performing media and digital labour has not been widely explored, nor has the strategic work of mobilising representations of Muslim women that are positive and inclusive of intra-Muslim difference (for an exception see Lewis 2015). The lack of attention to Muslim women's labour power is perhaps surprising given the growth in popular and scholarly interest in issues of gender, Islam and sectarianism, access to education and labour and its gendered, racialised and faith dimensions, the role of digital media in social organising, and the continued rise of the Islamic cultural industries. Original empirical insights in this chapter explore the lived experiences of female producers within the burgeoning arena of Muslim lifestyle media and its imbrications with 'mainstream' media.

Islamic cultural industries, and wider non-halal cultural industries, impact upon the representation of Muslim femininities and norms about Muslim women's identities, lifestyles, and place in the world. Ideals of Muslim womanhood are produced and circulated that draw together Islamic teaching and practices with contested new (and old) notions of piety, modesty, beauty, lifestyle, motherhood, professionalism and citizenship (Gökariksel and Secor 2010a, 2010b). In making visible the roles of Muslim women as producers within influential streams of lifestyle content a challenge is offered to the reification of binary stereotypes that position men as breadwinners and women as consumers. This activism aligns with feminist theory that seeks to disrupt binary thinking around gender and

space. Publicly circulated images and narratives created by Muslim women combine notions of Islamic piety and femininity – ways of being a Muslim woman – while also reshaping them in relation to socio-spatial conditions, and cultural norms (Gökariksel and Secor 2010; see also Lewis 2010). There are also inequalities and unevenness in the projection of the 'ideal' Muslim woman, with real issues of racism and other forms of prejudice. Multiple overlapping scales of identification and belonging – from local communities to the international sisterhood – can allow for Muslim practices and affiliations that are heterogeneous, but do not offer a salve for intra-Muslim conflict or anti-Muslim racism.

The Growth of Muslim Lifestyle Media

Muslim media channels have long offered an alternative to mainstream outlets produced in the vision of a public sphere that is white, male and secular. In the UK, established Muslim media includes *The Muslim News*, *Q-News* (now defunct), *Crescent International*, Forum Against Islamophobia and Racism (FAIR); Radio Ummah and Radio Ramadan (Rigoni 2006: 265). Channels such as these provide a platform that challenges Islamophobia in mainstream press, opens lines of discussion around imperialism, international affairs and human rights, and seeks to forge a space of identification and belonging for Muslims. Husband (1998) writes the overt Muslim identification of these publications was a transition from initial community media that tended towards distinct diaspora foci and concerns, such as the Pakistani community in Bradford. This media was the domain of men, with male editors, journalists and an anticipated male readership (Husband 1998; Ahmed 2019). *Jang*, which is still in circulation, has a head office in Karachi, Pakistan, with multi-located regional offices including in London, is written in Urdu and English, and serves a Pakistani diaspora. Thus the recent proliferation of media content produced by Muslim women marks a new wave of women who are seeking alternatives to traditional Muslim and Western-liberal media dominated by male voices.

Reina Lewis argues that a new genre of English-language Muslim women's lifestyle magazines emerged in the UK (*emel* and *Sisters*), the US and Canada (*Azizah* and *Muslim Girl*), and Kuwait (*Alef*) (2010: 8) in the beginning of the twenty-first century. This media was distinct from previous community media due to the prominence of fashion within the genre (Lewis 2010: 8). Published in hard copy, these magazines were an important precursor for the Muslim lifestyle digital media that followed. The magazines were the product of negotiations around internal community debates with external mainstream fashion and digital industries. Aimed at new Muslim audiences and a niche readership in search of identification and affirmation, Muslim lifestyle magazines were designed in relation to established, mainstream titles (Lewis 2010: 59). It was magazines such as *emel* and *Sisters* in the UK that opened contemporary debates around the representation of the human body, female modesty and the contested combination of Islamic piety and fashion. Moreover, these magazines set the precedent of building a readership mostly identifiable by faith and gender, with other markers of social distinction – nationality, class, ethnicity and so forth – absorbed into the primary identification of 'Muslim women'.

As one of the journalists who worked at *emel* observed it was 'so much more' ('Tiymah') than a modest fashion magazine. The magazine broke new ground by representing Muslim lifestyle in ways that did not prescribe a particular approach or denomination and yet it was religiously grounded. Its aim was to present a 'positive and confident message about Muslims in the UK, and beyond', with an 'ethical outlook' ('about'; *emel* website). In print from 2003 to 2013, *emel*'s scope widened to cinema, visual arts, food and restaurants, interior design, gardening, health and education, and politics. In its approach, therefore, *emel* attempted to expand a Muslim marketplace and reflect wider mainstream magazine culture. One of *emel*'s watershed moments was a cover star image of Baroness Sayeeda Warsi without head covering, with further images of her inside, showing the full figure of a powerful female politician ('The colourful Conservative', issue 79, April 2011). The linked article refers to

Warsi, of Pakistani heritage from Dewsbury, West Yorkshire, establishing herself as 'a prominent and independent-minded person who at times speaks for women, Asians, Brits and Muslims alike' (https://www.emel.com/article?id=99&a_id=2332&c=32). This articulates the ways *emel* sought to address multiple constituencies at once. The feature generated much debate and some negative responses in relation to the images, as characterised by the interviewee 'Tiymah' as 'How dare you?' The editor (and co-founder of *emel* with her husband, Mahmud al-Rashid), Sarah Joseph, and the original team of the magazine are networked figures with credibility meaning they were well placed to push boundaries within Muslim communities. Whilst not seeking to be overtly political, the roots of the magazine were distinctly geopolitical and intercultural. The magazine, founded after the 11 September 2001 attacks, can be viewed as a response to rising tensions, which earned Joseph an OBE for inter-faith dialogue. As a woman-led and written publication it paved the way for the rise in social media and Muslim lifestyle magazines that followed.

In the UK, Muslim lifestyle media launched more recently includes: the digital magazine and platform *sister-hood*, British Muslim TV's *Sisters' Hour*, Islam Channel's *Women's AM*, Dina Torkia's YouTube channel and Instagram (806 subscribers and 1.3 million followers respectively), and *Amaliah*. Muslim lifestyle media is closely associated with modest fashion – clothes that provide bodily and hair coverage – that is now prominent in fashion magazines, high-street retailers and designer collections. Beyond fashion and beauty, Muslim women in lifestyle media are discussing with their audiences political topics, especially those with a gendered dimension, such as honour killing, female genital mutilation, and also the politics of Muslim identity and activism in Western-liberal states. *Amaliah* for instance states its aim as 'dedicated to amplifying the voices of Muslim women.' An educated and upwardly mobile demographic are leading this new digital media, including social media platforms of vlogging, blogging and micro-blogging. Unsurprisingly the value to be extracted from 'hijabi bloggers' has not been missed by mainstream media outlets. For instance, Torkia [pen name, 'Torkio'],

a mixed white and Egyptian blogger, was invited as the magazine cover star for *Blogosphere* where the roles of Muslim women in social media was heralded as re-shaping media industries, in a special issue with 'a political edge' (*Blogosphere*, February 2017). Departing from the male-led 'Muslim chic' that appeared after the release of Spike Lee's film *Malcolm X* (1992) and peaked around 2003–4 (Inge 2016: 71), it is clear from the sheer presence and volume of subscribers that young Muslim women are the current bellwethers of the 'new Muslim cool'.

Digital Media, Identity and Inclusion

For young people especially, social media and digital is important as a medium with near market saturation. Beyond more superficial engagements, the medium facilitates geopolitical networking across national states and territories which can expand democratic opportunities to engage in global social movements (Gerbaudo 2012; McCaughey and Ayers 2003) and political participation in resisting authoritarian governments (Tufekci 2017; Newsom and Lengel 2012). Religion and the media are increasingly evolving dialectically (Herbert and Gillespie 2011; Hoover and Lundby 1997), with opportunities for collective identity building created through new channels where identities are shaped, communicated and contested (Gerbaudo and Treré 2015). This involves more actors who are from outside of institutions in religious and spiritual discussion, addressing different constituencies, and it allows for the emergence of creative modes of protest and resistance (Baer 2016; Gillespie 1995).

However, the digital public sphere recreates inequalities, even as it offers new spaces for organisation. Gillespie (1995) has shown that the digital world does not function as an ideal public sphere; it reflects male domination of the traditional public sphere with women more likely to report the experience of abuse and to avoid posting comments as a result (see also Hargittai and Walejko 2008). Recently, the inventor of the World Wide Web, Sir Tim Berners-Lee, made headlines globally when in an open letter he criticised

how thirty-one years later the Internet was failing women and girls due to online harassment, sexual abuse and non-consensual sharing of intimate images. This followed a study by Berners-Lee non-profit Web Foundation and the World Association of Girl Guides and Girl Scouts that 52 per cent of young women had experienced online abuse. In 2019 Berners-Lee launched the Contract for the Web, a global action plan to tackle misogyny online (https://webfoundation .org/2019/03/web-birthday-30/).

Digital transformation can offer technological advancement, although not necessarily for reasons of social progression. It is significant that digital media has been a medium to amplify as well as offering a challenge to religious clerical authority, and enrolled to spread traditional teachings and factional agendas by different schools of Islamic thinking ('madhhab') (Inge 2016). Still the online opportunities for Muslim women to participate in discourse on everyday faith and religious identity in the public sphere are not insignificant (Lewis 2015: 244; Nouraie-Simone 2014). The medium has helped facilitate Islamic feminism movements with women engaging in discussion and (re-)interpretation of women's rights in the Qur'an. More broadly it has enabled more women to build the power to influence other Muslims on everyday lived Islam, reflecting on faith, gender and living a 'good' life.

More specifically, Muslim lifestyle media and social media channels purport to create spaces of solidarity and belonging for Muslim women living in the West. Such channels seek to combine Muslimness, womanhood and Western lifestyles and values. This aligns notions of what it means to negotiate homogenising representations of the 'ideal' Muslim woman with the contemporary attitude of mainstream bloggers celebrating individual choice and forms of self-expression that are embedded within cultures of consumption – orientations that are post-feminist rather than anti-capitalist (Duffy 2016, McRobbie 2004). The paradoxical performance of authenticity has been highlighted elsewhere (Ashton and Patel 2018). Vloggers carefully select and edit content with an audience in mind to foster relatability, intimacy, and ultimately support (Ashton and Patel

2018); their authenticity is thereby staged. Yet studies on women's entrepreneurialism in digital media industries have shown persistent gender inequalities, and how the valorisation of authenticity is not equally rewarded across social difference, for example, black, LGBT+, plus-size (Duffy and Hund 2015; Sobande 2020).

While opportunities are provided for women in particular around flexible working, home-working, and fostering on-line support networks afforded by digital cultural production, bloggers are often comparatively poorly rewarded for labour that mostly benefits large multi-national companies. Typically part of the business model for bloggers and vloggers is receiving free products, payment for promotions of brands, and showing adverts on videos (Brydges and Sjöholm 2019), with minority ethnic producers often paid less than their white counterparts (Pham 2015; Peterson 2020). Beyond prompting critical reflection on asymmetrical material rewards, Muslim women bloggers as a sample group surface other intentions and work-life experiences that bring into sharper view previously overlooked aspects of the creative industries. Content for social development is produced by Muslim women in articulations of intra-Muslim education and communitarianism. These are part of changing Muslim identities in a digital age, and a devotional commitment to Muslim syncretism, even as multiple intersectional aspects of discrimination are encountered.

The Media and 'The Muslim Woman'

For many young Muslims geopolitical events and reprisals have served as 'curiosity triggers' to pursue greater knowledge of Islam (Inge 2016: 74) in order to make sense of a Muslim identity used as a primary identifier – an identity that frames the others (Ansari 2002). A spiritual turn towards the global ummah took place in the early 2000s amongst young Muslims and new converts amidst a crisis of recognition that has been particularly evident in secular countries in Europe and North America (Lewis 2015). At the same time the new 'Muslim power' has been articulated in the rise in scope and visibility of fashion, media and social activism (Warren 2018, 2019). Creative

labour and forms of production have sought to offer positive, affirm-ing images of Muslims living in the West, 'who [are] cosmopolitan in their outlook and creatively engaged in public life' (Tarlo 2010: 197). However, complicating ideals on digital inclusivity, research on black digital transatlantic dialogue and digital blackness reveals inter-cultural black digital discourse between black spectators and markets, and US hegemony, especially 'global powers' of the UK and US. Bringing nuance to critical discussions on black spaces, Sobande et al. (2019) write on black women's digital encounters, identifying the tensions between countercultural and commercial online experiences. They find black women may be drawn to online content produced by and for other black women to mitigate against the misrepresentation of black women and display cynicism towards its co-option by mainstream media to attract 'diverse' audiences (Sobande et al. 2019: 12). Studies on racial capitalism have gained new attention and grown in size, with two key lines of argument around the extraction of surplus value from black bodies and the reinforcement of social hierarchies (Gray 2016; Saha 2017a, 2017b; Saha and van Lente 2019). In relation to media, anti-racism and diversity discourse, Saha and van Lente (2019) argue for the need for spaces for minority writers to flourish. Positioned differently, but also as a sub-culture, Muslim youth identity has multi-scalar imagi-naries, with localised and international axes of belonging and socio-political commitment. The spiritual and activist turn in Muslim lifestyle media reveals political awareness on how the body of the Muslim woman is often used as a symbolic battleground for com-peting geopolitical forces, and instead seeks to articulate meaningful everyday Muslim identities in the contemporary world.

Falah and Nagel (2005) argue the term 'Muslim women' has increasingly been adopted, especially by younger generations, in an act of supra-national identification with the Muslima – Muslim women community – that crosses race, ethnicity, sects and class (see also Dwyer and Shah 2009). This is a gendering of the phenomenon of 'master signifiers' of Islam and Muslimness, e.g. being Muslim, that Ansari (2002) refers to in relation to those who are younger and

second or third generation in particular. Yet it is significant, too, that the 'Muslim women' nomenclature can delimit differentiation, and serve to essentialise individuals to their gender and religion, along with eliding important distinctions that complicate lives (Kandiyoti 1996). As I have explored in Chapters 1 and 2, in Britain even early Muslim settlers were arguably more dissimilar than aligned, speaking different languages, from different countries and with differing Muslim sectarian beliefs and practices (see Gilliat-Ray 2010). Prioritising religious faith as a master identifier came later from the 1980s and has in part been understood as a response to the Muslim equality gap. The political and social mobilisation of the category of 'Muslim women' can be seen as reflective of a wider prioritisation of religion in the construction of personal identity by ethnic minorities, understood as a response to unfair treatment, stigmatisation, and higher levels of social and economic exclusion, most acutely experienced by Muslims (McGhee 2008; Khattab 2009). Notably it marks out a distinctive, preponderantly female space. Karlsen and Nazroo (2015), in an important recent study into UK-based ethnic minority groups and identification, found Muslim women to be the least likely to feel a sense of belonging, which has been intensified by scrutiny in public debate and also in academic research (also see Hopkins and Gale 2009; Dwyer and Shah 2009).

A number of Muslim women working in digital media content are engaging in critical discourse on politics of identity and belonging. I argue that digital content produced of vlogs, blogs and microblogging on Twitter and Instagram act as forms of everyday activism in the circulation of images of Muslim women that explode the 'homogenous and homogenizing production of the Muslim woman' (see Moallem 2005: xx). The identification of Muslim women, as miriam cooke (sic) observes, has forged a 'political consciousness . . . affirm[ing] the inextricable bond between gender and religion that enables a negotiation of the outsider/insider boundary' (cooke 2007: 141). Crucial to the ongoing negotiation of boundaries is the recognition of 'gulfs of difference' whilst feeling incorporated within 'a global community' – the ummah (cooke 2007: 141; see

also Lewis 2010). In attempting to recognise and strengthen the Muslima community in and through creative labour, media workers are maintaining the production of images that represent the range and multiplicity of Muslim women identities and experience, whilst offering a counterpoint to what Inge (2016: 70) terms, 'white British culture and "Middle England"'.

There is renewed attention to the conditions of cultural production for sharpening understanding of inequality and the often negative representation of minorities. Studies have considered the complexities of a gendered and racialised politics of identity, with intra-Muslim diversity, and how these hierarchies are constituted within cultural labour and cultural and creative industries (Tarlo and Moors 2013; Lewis 2015; Gökariksel and McLarney 2010; Gökariksel and Secor 2009; Moallem 2005). There are contradictions and tensions between recognition that the feminine body is seen as a source of power and the commercial disciplining of the body, which has been viewed as a conundrum of post-feminist sensibility. Peterson (2020), through the example of Leah Vernon, a self-identified fat, black Muslim woman, shows the subversion of an industry norm around minority ethnic influencers that perpetuates racial injustices and neoliberal structures that can lead to the individualising of risk and responsibility. Vernon inserts her unruly body into social media influencer space. As Peterson argues, this works to symbolically dismantle the ideals of pious Muslim femininity while she also asserts her rights as an economic subject, highlighting the impact of precarity on her mental health and campaigning for racial and economic justice. These insights are relevant to Torkio in the negotiation of a 'performance of authenticity' where glossy, desirable style icons curate their content to 'carefully insert some messy "getting real" posts' while still appealing to image conscious consumer-followers (Peterson 2020: 1195; Duffy and Hund 2019).

Close readings such as Peterson's provide important ways of framing the breadth of producers working in the cultural and creative industries and their intersectional lines of activism beyond faith and religion. Elsewhere studies might have privileged a broad ethno-national

category, such as 'South Asian', largely because this is the language of councils, funders and diversity surveys, but where religion might also be relevant (Saha 2017a; Malik and Dudrah 2020). Empirical research into the active role of beliefs and religion in concert with other identity markers is needed to avoid adopting a singular and secular understanding of experiences of employment in the cultural and creative industries and elsewhere. For instance employment issues around access and progression, knowledge creation and societal impact. What is at stake here is more than a miscalculation of the dynamics of labour market exclusion, including the reality of Islamophobia (or other religious discrimination) within workplaces and society. It includes holistic matters of social justice and equality. Diverse epistemologies need grasping towards in matters of religious belief and spiritualism in the significant dynamics of the material/immaterial, and religious or spiritual intentions that influence labour practices.

Certainly, the growth of religion within geopolitics and social identity formation requires consideration of religion in understanding the dynamics of power relations and social inequalities (Dwyer 2016). Lily Kong (2001: 212; see also Tse 2014) has argued on the limitations of geography to engage with religion as a category, '[while] race, class and gender are invariably invoked and studied as ways by which societies are fractured, religion is forgotten or conflated with race'. The conflation of religion with race is significant in understanding social discrimination as emphasised in the definition given to Islamophobia of anti-Muslim racism (Runnymede Trust 2017). Highlighting the blurring of 'race' with religion in everyday life, example is given of the stereotypical depiction of a South Asian brown-skinned male by the media to represent Muslims (Runnymede Trust 2017). Given the vast difference within the global Muslim following, the ummah, one body or look cannot represent the whole. To address this bias, activism in creative labour can operate as a tactical strategy for diversifying representation, visibility and promotion (Banks 2010). Saha (2019, 2017a, 2017b) argues that to address inequality in the representation of minorities we need to move beyond simplistic assumptions that diversifying the cultural

workforce will automatically lead to more diverse representations of minorities. Although Muslim and gendered activism through plural media channels has directly sought to challenge delimiting norms and for promotion on personal and collective levels, with the potential to reach mass audiences.

Muslima media platforms as part of the digital world are reshaping public narratives of Muslim women living in the West. In the rest of this chapter I reflect on how a sample of creative producers and activists who self-brand themselves and their work under 'Muslim women' are negotiating the interplay of gender and religious faith within digital media, and mobilising in the process new axes of identity and belonging. In investigating experiences of creative labour with particular attention to social inequalities and variables of gender and religion this chapter develops from discourse on intersectionality to understand how axes of difference are simultaneously implicated in how people experience socio-spatial inclusion and exclusion (Crenshaw 1991; Essers and Benschop 2009). It departs from intersectional debates that focus solely on forms of oppression, however, by considering the significant ways in which 'Muslim woman' as a category is being mobilised as a term of solidarity and distinction. Or an act of resisting multiple forms of social and economic exclusion, even when the representation remains mostly symbolic.

Educating about Intra-Muslim Diversity

Muslim-centred media in the West offers media space for identification and affirmation involving shows where Muslim women in a diversity of roles, practices and beliefs are represented. A key example is British Muslim TV's *Sisters' Hour*. Presented as a 'Muslim lifestyle show', *Sisters' Hour* is hosted by Nadia, a Palestinian British Muslim, born in Kuwait, who moved to Grimsby in 1990 as a four-year-old, and Sakinah, a Caribbean British Muslim, raised in Brixton's Wahabi community by parents who had converted when they arrived in the UK. Nadia and Sakinah observe their backgrounds as Muslim women 'could not be more different'. They identify as Muslim to situate themselves within the ummah, and dislike 'labels'

placed on strands of Islam that divide its following. Yet, it is added that they would now be identified with Sunni and Sufism respectively (although Sufism is 'not really recognised' by some Muslims, Sakinah notes, pointing towards the edges of intra-Muslim tolerance). In her free time Sakinah is a musician who performs in a well-known acoustic duo, *Pearls of Islam*, which fuses Caribbean blues and reggae and Guyanese soca with Arabic Qasida poetry. The show *Sisters' Hour* – a name play on mainstream BBC Radio 4's *Woman's Hour* – is described as: 'A lifestyle magazine. You dip in and out. One minute we'll be talking about FGM and the other minute we'll be talking about organic farming or the most recent singer that has come out in the Nasheed [Islamic song] scene.'

Nadia observes: 'It's a platform to show the diversity, to show the awesomeness, to show the variety, just to show the beauty of women, Muslim women.' Visible difference with points of unity for presenters and guests is a hallmark of the show where skin colour and choice of clothing reveal 'the visual policy foregrounding diversity [that] testifies to the supra-ethnic appeal' (Lewis 2010: 81). In representing difference and diversity positively, the show seeks to mobilise an educational experience for the presenters and audience members alike: 'All of us are very, very different. That is what is beautiful about Women's Hour [Sic]. We all come from different paths and we all come from different journeys. We all represent a different path of society.' The presenters, and not the (male) producers, have control over the programme content and speakers. An informal and entertaining format is engaged that normalises and expands representations of Muslim women beyond stereotyping of passive victims, or violent misguided political agents (Falah 2005), and shows the compatibility of Islamic lifestyle with street credibility (Inge 2016). Hence, seemingly ordinary subject matter, ('[an audience member] said it is really airy fairy'), can be viewed as digital activism that acts to recontour public discourse around the representation of Muslim femininities.

Sisters' Hour offers an alternative to Western media accessible through private subscription. It carves a space within the pre-

dominantly male-led Muslim TV and within white male and secular digital space for discussing and sharing everyday lived experiences of Muslim women. This is needed as, 'people group Muslims all as one . . . that's what the media do all the time. They don't realize how diverse we are as a community' (Nadia). As Falah (2005: 317) writes, '[Western media] 'frame geopolitical realities in particular ways and guide readers to think about "the other" in a binary and narrow way'. The show functions as an educational space that seeks to broaden narratives and understanding of intra-Muslim diversity across ethnicity and race, denomination and British regionalism to strengthen bonding within and across the Muslima. This intent to forge a more inclusive Muslima media space is also activated in the spiritual journey of the presenters working on the show. Nadia describes how:

> It was only when I came here to do this job, I realized that, gosh, there are so many ways to practice your religion [Islam], and so many more beautiful ways, and I hadn't known about it before . . . Meeting people like Sakinah helped me . . . You are then welcomed into a different world, and see lots of different things.

The presenters give a sincere articulation of flourishing as Muslim subjects through their work; however, strictures to how Muslim femininities are presented on the show were raised elsewhere. In a different interview with a guest presenter on the show ('Mia') it was raised that the male producers enforced how sleeve and trouser hem-lengths must cover wrists and ankles, and that the hairline was fully covered. It was suggested that the producers sought to avoid complaints from an inferred conservative attitude towards bodily dress and Muslim style by segments of their audience.

Expanding upon the role of digital media to open 'a different world' of Muslim practices and to promote Muslim diversity, Deeyah Khan advances that Muslima identity is about more than matters of faith, religion and piety. Now living and working in the UK, Deeyah is a Norwegian-born Peabody Award-winning film-maker and producer. She is founder of Füüse, an independent film,

live arts and digital production company that also produces *sister-hood*. A digital magazine, *sister-hood*, amongst other things, showcases the talent of women of Muslim heritage in poetry, art, rapping and digital cultural production. Discussing why the platform was established, Deeyah says:

> *Sister-hood* has always been necessary. It was founded out of my own experiences of a community that tried to censor my own creativity. I recognised that there were many women like myself whose creativity was being held back – by their families, by their communities, by their own expectations and a lack of positive role models and opportunities . . .

The category of 'Muslim women' is deliberately re-phrased by Deeyah to 'women of Muslim heritage'. Such a re-articulation, she explains, serves to foreground gender and gives emphasis to heritage and culture:

> I wanted to break down the categorisation of women of Muslim heritage being based in faith. To me, it's a very unfortunate effect of political Islam that the public understanding of women of Muslim backgrounds is all about their faith and levels of religiosity, when for many of us, it's just a part of our identity, not the totality of it. So I sought to build a platform that would demonstrate that diversity: which would include women who had left Islam, and women who were still believers on the same level as each other. I felt that, just as men were dictating the conversation about what it means to be a Muslim, so were the devout: and that this was not a fair representation of our community.

The formats of *Sisters' Hour* and *sister-hood* reveal a mediascape that is not simply a Muslim public sphere made distinctive from a Westernised public sphere (Lewis 2015), but an attempt to unify disparate Muslima habitus through a new modern Muslima media space. In the instance of *Sisters' Hour* this promotes a strengthened ummah. As Nadia says (August 2016): 'we do have a Muslim community but within that everyone is off in their own little circles'.

She adds that Sakinah receives most of the public criticism pointing towards how black and minority denomination Muslims can struggle for acceptance amongst majority Muslims even within dedicated 'safe' spaces such as *Sisters' Hour*. Meanwhile *sister-hood* is alternatively orientated towards a tolerant and expansive Muslim identification that de-centres discourses of piety.

Drivers for each platform can be seen to arise from the so-called crisis of recognition post-11 September 2001 to understand the place of Islam and Muslims in a non-Islamic state and the wider world. The supra-national identification with the Muslima that crosses race, ethnicity, sects and class turns towards Muslim solidarity in a context of widespread Islamophobia in Western societies (Falah and Nagel 2005; Dwyer and Shah 2009). Both represent and mobilise platforms that combine a renewed confidence of belonging to a global Muslim community with understanding the breadth and richness of being Muslim within a Western-liberal state to create a strengthened sense of place in the West. In the section above I have introduced the educational intent behind how Muslim women as a category is mobilised in two contrasting digital media platforms to foster an expanded Muslima platform of affiliation and belonging. In the empirical sections that follow insights are given into the various personal and spiritual challenges of performing this contentious identity work in digital and media for those Muslim women in the study.

'Being in the Media is Difficult': Negotiating Muslim Femininities

Radical Islam, media and political currents of 'Islamic terrorism' along with situated practices amongst diasporic communities forge powerful, often limited representations of Muslim womanhood. Persistent Islamophobia and sexism in Western-liberal societies can create barriers to accessing and advancing in mainstream employment. The so-called 'chill effect' has meant that certain minorities avoid seeking employment in some industries or concentrate on a limited pool of professions already known for inclusion. These insights were expressed at the Muslim Lifestyle Expo 2017, in

Trafford, Greater Manchester. A seminar was held titled 'Sisters are doing it for themselves', featuring a number of high profile panellists. Roohi Hasan is a multiple award-winning senior producer for ITV News who has received the Excellence in Media Award from *The Muslim News* and previously won their Asian Women of Achievement Award. At the Muslim Lifestyle Expo 2017, Roohi describes how she experienced over fifty rejections from media until she was finally taken on. She paused before adding,

> One of the no's that came in was the community, my parents' [Pakistani Muslim] community, who tapped me on the shoulder when I was a kid and said don't [join the media], don't let your kids join the media, it's the work of Shere Khan, it's evil. Luckily my parents ignored that and I was able to join the media.

Explaining these points of view, Hasan notes that the media has been widely seen as discriminating against Muslims. For as Elahi and Khan write (2017: 6), 'stories about British Muslims are still likely to cast them as exotic or aberrant, when not directly associating them with terrorism'. Therefore by working for the media she has been seen by some as 'selling out'. But only by entering the media can the kinds of injustices experienced by Muslim people and others whom are marginalised, misrepresented and maligned be countered:

> What's interesting is that I became a journalist because I wanted to shine the spotlight on injustices in the world and be able to tell these stories. My mum became a doctor because she wanted to be able to help people. But my mum never gets asked every day how many Muslims she helps. And yet I get asked every day. This year, so many times, people from my community and my own generation have thought it was quite okay to call me a sell-out for working in the media.

Hasan suggests an experience of insularity where she felt pressure to work in a narrow set of fields (as I explored in Chapter 2), and describes the tainted reputation of the media. Hasan's parents helped her push back against conservatism from the South Asian Muslim

community on the one hand, while dealing with Islamophobia from the media establishment on the other. But, as she notes, these persistent attitudes reinforce barriers to widening participation in a broader range of sectors: 'We shouldn't have to go to work to go and do things for our community . . . I would ask the parents here to allow your kids to dream big and allow your kids to explore outside of the boxed careers, and don't worry about the path not trodden.'

One of the panellists, a 2017 winner of a mainstream and prime-time TV reality show, Saliha, reflected on her position as a role model for other Muslim women due to her success:

> It's always been difficult for me to accept that people are seeing me as an inspiration. [But] people have come up to me and said that, and it's really deeply flattering. I think it's a huge responsibility as well because being in the public eye and with people looking at your actions and assessing them you come under more scrutiny than you ever have done before so I view it as a challenge and a responsibility . . .

Saliha highlights the added scrutiny she experiences through her profile and visibility in the mainstream and digital media with judgement around her actions due to her Muslim identity. In order to cope with the attention, Saliha emphasises the support network of family, friends and husband who encouraged her career, and the 'great sense of pride it gives them'. Instead of her domestic and public roles operating in separate spheres, she notes this familial support and shared sense of achievement is what 'keeps her going'. Diverting attention from her own ability and ambition, Saliha further highlights the role of the supra-human in the success she has achieved: 'It paid off so I was very lucky, and then I think the other aspect is just thanking God that you got the opportunity . . . the destiny that's been set out for you, I think it does play a huge part . . . There is something greater in all of this rather than just me trying very hard and it being about me.' Faith is presented as fundamental to her career purpose. Instead of an individualist notion of success, then, professional success is framed as shared and sacred.

For Deeyah – initially working in Norway, before moving to the UK – the positioning of her primarily as a 'Muslim woman' by others was disorientating, given their assumptions of piety:

> Making your way into the film and media is no easy task. The industry is predominantly run by older, middle class, white men, and their understandings of how the world is, tend to predominate. So this is how women like me often get cast into visions of the world which are far from our own experiences.

Deeyah explicates the lack of support in attempted to enter an industry such as the film industry known for multiple barriers to entry. She needed to negotiate the ossification and othering as a Muslim, pious and minority ethnic woman in a mostly white, secular and masculine field of the cultural and creative industries; a process of re-signification which was especially difficult given her own estrangement from religious faith.

For those for whom being Muslim and women was aligned with religious piety, challenges were experienced in balancing the demands of their professional and spiritual lives. In fact, as Sakinah articulated, there might even be a conflict between being a 'good' Muslim woman and 'good' TV presenter:

> As a Muslim being in the media is difficult because there are certain aspects that contradict what a Muslim should be. You are putting your ego on stage, on TV, on a platform, you are putting your ego out there for people to come up to you and say this is amazing.

The ego-centrism of broadcasting and its associated demands to build an audience is here seen as misaligned with notions of Muslim femininities that emphasise the need for modesty. As Saliha observed, aesthetic forms of creative labour place the symbolic and corporeal space of the Muslim female body under heightened degrees of scrutiny.

Meanwhile another presenter, a convert from mixed heritage white British and Jamaican background, reflected on the gendered

dimension of working in a male-led industry. 'Mia' describes the issue of not having a guardian when travelling for work, but in secular terms of support rather than as a moral imperative:

> Although, I wouldn't say it's ideal for the timid types nor those who believe their partner should be their defender at all times. In a predominately male industry, you must learn quickly how to fight your own battles. I'm still mastering the art of shutting my director down politely but firmly but I'm okay being comfortable, being uncomfortable because that's what my twenties are about.

'Mia' talks in this interview extract about challenges of international travel that were expected within her presenting gigs, such as shooting abroad accompanied by a male boss who made her feel uncomfortable. Noticeably she seeks to normalise these structures of feeling as age-related and a personal matter of growth and personality. Yet 'Mia' recognises the gendered hierarchy within the media and particular problems Muslim women might encounter in negotiating this dynamic. On the attention she attracted filming in Jamaica as a mixed heritage Jamaican Muslim woman, 'Mia' states the 'intersectionality is very strange'. In this extract, although there is reference to matters of belief about guardianship, the primary axes of identification and exclusion within the hierarchy of the industry are age and sex. Elsewhere the potential for discrimination around social characteristics is opened up as 'Mia' talks about the difficult art of agreeing a freelance pay rate whilst starting out in the industry:

> Striking a balance between keeping the client happy and putting a figure to your working effort is no easy task – charge too much and you may lose the client – on the other hand, charge too little and you're working for pennies.

Observations about ethics and media practices were further offered in relation to unscrupulous accounting. In the visit to Jamaica the presenter was concerned that there was a lack of respect towards participants in the film. For instance there was no food budget or

money to support the participants in the event being filmed, despite the film focusing on poverty. Yet the crew were staying in a five-star, all-inclusive hotel. 'Mia' felt understandably uncomfortable with the inequities and ethics of the situation.

Elsewhere the informal educational role of vloggers as Muslim influencers was raised by the case of Dina Torkia. The UK's most high profile Muslim blogger, Dina's early visibly Muslim, pro-hijab actions in media and fashion can be seen as encouraging Islamic norms and behaviours in ways that are relevant for contemporary young Muslims in Western-liberal contexts. For instance Dina regularly uploads videos where she responds to questions submitted by her viewers who are in the majority Muslim women. Characteristic of her responses is an accessible, humorous approach to her everyday experiences of negotiating expectations of Muslim womanhood by religious, social and commercial forces. This is perfectly captured in Dina's response to the audience question, 'Why do you wear the hijab?':

> I don't like wearing it, it is a pain in the arse . . . The only reason I wear it [is] I know it is what God wants . . . If God was not in the picture this would be off my head . . . But I've never even had a cheeky day out (without it) . . . My sister and I have been consistent with keeping it on. I've managed it as I've been keeping it interesting through interest in fashion, style, creativity. But [consistency] is key.

Veiling as a practice has been viewed as essential to the cultivation of piety (Mahmood 2006; Gökariksel and Secor 2009) or a multi-faceted gendered performance that signals social distinctions such as class, age, ethnicity and race, and urbanity, or an ambiguous signifier that cannot be placed (Tarlo 2010; Lewis 2015; Gökariksel and Secor 2009, 2012; Dwyer 1999). Departing from a perspective that Islamic virtues and fashion are in tension, Dina artfully reworks their relationship. Instead she points towards how creativity through styling has meant any physical discomfort of hijab-wearing is bearable over a lifetime (and career) in public.

Controversially for some, at a later stage in the course of my research, Dina decided to remove her headscarf for much of her online content. The removal of her headscarf after creating a brand for herself around modest fashion resulted in a backlash, some of which she captured and exposed in another online video. Dina reads out comments posted by members of her viewing public which include how she should die, and that her family should die too. Hijabi fashion and Muslim lifestyle media is positioned as enabling for a faithful and cutting-edge existence for young, cosmopolitan Muslimas. But if the Muslim icons that lead social media change their minds or practices, projections placed onto them as Muslim role models can be intense. As 'Clementine', another respondent, noted, '[Muslim bloggers] are put on a pedestal but can fall from grace quickly . . . They never put themselves out there as the biggest role model, a great example, but they're suddenly held to that standard.'

The need for aligning the performance of creative labour with the public maintenance of modesty was enforced elsewhere in the study with reference to audience feedback. Nadia notes on dealing with comments:

> They're mainly good, and positive. I'd say 95 per cent positive, and encouraging, with 'we love this, and can we have more of this, please?' But we have had a few . . . In particular critical comments orientated around modesty, with the view 'these ladies aren't dressed appropriately'. You'll always get that, and whatever, that is what they feel.

Nadia highlights that audience engagement is typically supportive. She then distances herself from the negative comments made on her appearance by employing space for interpretational difference on modest dressing between Muslim women. Writing on Turkish and Moroccan Muslim women entrepreneurs, Essers and Benschop (2009: 413) have observed a similar strategy where boundaries are created within Islam by individualising the relation between God and believers; this in turn enables the acquisition of more space for women's autonomy. This is especially pertinent in Muslim lifestyle media

that seeks to create supra-national unity across distinctions of piety, denomination, class, race and ethnicity. Privileging Muslimness and womanhood, and practising tolerance towards other markers of diversity and difference, is positioned as offering a platform to serve a strengthened sisterhood and ummah. The motivations articulated variously reveal crucial faith-orientated, educational and communitarian aims that complicate a simplistic coupling of creative labour with post-Enlightenment individualism and secularism in the West. The simultaneity of being othered and speaking on behalf of the other means subjects experience the regulation of the female body in the space of new media even as they attempt to explode stereotypes attributed to Muslim women: 'You *will* receive death threats' (Nadia 2016, *my emphasis*). Or, in comments that are particularly insightful for those Muslim women engaged in mobilising new images of Muslim women, Baer (2016: 19) observes: 'With the rise of digital media, the body has taken on further significance as a site of both self-representation and surveillance, not least with regard to gender identities and gender norms.'

Discussion: On Inclusion and Expansion in Media Spaces

> This is a message to Muslim girls. We are very, very judgmental of each other, and we can't grow the ummah like that. We're not going to grow if we continue to be the way we are. We will continue on BMTV (British Muslim TV), it will be the only platform. We won't get into mainstream if we continue to be petty with each other, which is what happens. (Nadia, Presenter, British Palestinian)

> Mainstream is not for me . . . But I want to encourage Muslim women to go into mainstream. Because who talks for us? It's the media and it is men. That's something about Muslim women, they go to Muslim men, and the men talk for them. (Sakinah, Presenter, British Caribbean)

Muslim lifestyle media advocates for inclusion of Muslim women's voices in community and mainstream media in order to support

broader Muslim representation and advance gender equality in the public sphere. It seeks to move beyond intra-Muslim sectarianism and fragmentation that Lewis and Hamid (2018) remind us exists in the British Muslim population but that is not widely recognised by 'outsiders'. A more expansive, inclusive and unified media space is needed in order to move public discourse forward from political Islam, sectarian divides, terrorism, surveillance, migration and segregation to give emphasis to everyday Muslim lives in the West. By advancing the voices of women, space is given to those marginalised by patriarchal structures and religious and racialised prejudice in Western-liberal societies. New insight is given into the challenges experienced by minorities in labour markets, which can serve to exclude and undermine a sense of place and belonging.

Insightfully, the narrative on encouraging other Muslim women to enter a digital public sphere regarded as masculinist and potentially suspicious is legitimated by claims to helping others by growing the ummah (Essers and Benschop 2009). The need to perform caring duties and responsibilities disproportionately expected of women has been well documented in feminist geography (Ekinsmyth 2011, 2014; Leslie and Catungul 2012). Rethinking and expanding this work in relation to Muslim identity and faith, the continued intra-Muslim pettiness outlined above by Nadia is likely to be counterproductive for da'wa – propagation or outreach intended to show the attractiveness of Islam for Muslims and non-Muslims. Da'wa was also directly referred to by 'Mia', the presenter who travelled to Jamaica:

> Being a Muslim woman in Jamaica, seems to peak interest from both genders. You are asked questions pre-loaded with misconceptions which presents opportunities of da'wa and at the same time told that you're very strange for being Muslim and Jamaican!

She talks about her double exclusion as a minority – being Muslim and black Jamaican – as a positive opportunity for education on the breadth of Islam.

In order to achieve this intended spiritual and collective growth, Muslim lifestyle media and those women who act as figureheads can

be seen to offer an accessible medium that presents positively everyday Muslimness, as Nadia says:

> It would be lovely to have more Muslim women that don't always talk about Islam. We can talk about our love for Yorkshire Tea or visiting stately homes [that's me]. It's not just that we talk about Islam and defending ourselves. We are normal, everybody is normal and wants to get on with their lives.

Muslima platforms speak from a position of embeddedness in local social and cultural contexts while seeking to strengthen supra-national affiliation with a global sisterhood. For instance, in referencing Britain's favourite drink (tea) whilst at the same time attempting to enrol more Muslim women in digital and media work, platforms such as *Sisters' Hour* aim to foster what Emma Tarlo (2010: 197) describes as: '[a] positive public image which [is] explicitly Islamic without being threatening, traditional or foreign'. In the extract Nadia embraces English heritage in the forms of stately homes and everyday norms around consumption demonstrating the potential for identity as a bricolage that combines different elements. Most significantly she underlines the point that Muslim identity is more than matters of piety, and that she is normal and belongs in society.

The presenters' comments give further emphasis to the social motivation of addressing systemic patriarchalism. Gender norms are open to transformation in digital media and social media as near saturation of the youth market has meant participation in debates has become more accessible, and the range of platforms has enabled visual content that can represent, re-represent and disrupt traditional binary notions of male/female roles, qualities and lifestyles. The body as a contested site is not left behind in a feminist utopia in digital space for Muslima media platforms typically involve self-branding and commodification of the body along with profiteering from gendered consumption (see also Baer 2016; Brydges and Sjöholm 2019; Gökariksel and McLarney 2010). Yet social media and digital platforms orientated towards commercial economies are creating oppor-

tunities for re-signifying and expanding representations of Muslim women in the West. This motivation unites Muslim women producers across the research. Film producer Deeyah makes the point:

> This platform is needed in several ways: first, without women in Muslim communities feeling able to speak up, we will be stuck with the same male-dominated institutions that have served us so badly in the past, and that continue to dominate the conversations about what it is to be a Muslim in the world today. There's a need to encourage women to speak out, to provide them spaces to find their voices.

Here the articulation of challenging patriarchalism is not a case of Western feminists igniting resistance for oppressed Muslim women. Or – in a reformulation of Gayatri Spivak's well-known phrase – white women saving brown women from brown men (Tuhiwai-Smith 2012 [1999]; Spivak 1985). Legacies of colonialism and cultural imperialism reside in what cooke (sic) terms the 'rescue paradigm' of Western (white) feminism mobilised around the liberation of Muslim women's bodies and the politics of veiling, amongst other concerns (2002: 485; Ahmed 1992). This interventionalist politics continues to encourage resistance towards a feminist movement seen to privilege white, middle-class and secular interests.

Curating Muslim women's histories, Islamic teachings and readings, sister-hood functions to explode narrow, reductivist presentations of Muslim women by documenting important women leaders over space and time. Taj ul-Alam (1612–75), Leyla Alasgar qizi Mammadbeyova (1909–89), Shirin Neshat (1957–), Sharmeen Obaid-Chinoy (1978–) and Haifaa al-Mansour (1974–) are all featured, amongst many others. By offering an alternative feminist teleology that de-centres the Western tradition, *sister-hood* magazine offers a way forward. It highlights the contributions of Muslim women throughout centuries and across the world to demonstrate the rich traditions of Islamic feminism and Muslim women's rights. In echoes of Abu-Lughod (2002), Deeyah (2016) observes, 'it is a mistake to try to capture feminism for the West or to silence

non-Western feminist histories, legacies and futures'. While distinct in tone examples of Muslim lifestyle media such as those discussed reveal a commitment to harnessing greater power over aspects of gendered and faith identification, while fostering new spaces of minority belonging in Western-liberal societies through social media and digital technologies. 'Tiymah', a journalist and academic, suggested a distinction between the space of the media becoming more diverse (share), and growing diversity in media space (volume). As 'Tiymah' explained, 'the space the media occupies has expanded hugely' with new platforms that can be utilised to publish content, referencing Instagram, Twitter and YouTube. But she clarified, 'I don't think people are *actually* becoming one with this.' The creation of an alternative canon of woman leaders for Muslims and non-Muslims that writes in the history of Muslim women might then remain siloed as a counter-cultural exercise, or anti-canon, in the vast content comprising contemporary social media and culture.

Conclusion

Rather than a marginal concern, Muslim lifestyle media and its workers offers crucial insights into a fast-evolving cultural, economic and technological world that pushes forward knowledge of the increased visibility and augmentation of religion, faith and faith identity in public life. Original empirical insights into the rise of this sub-sector are presented that reveal the intentions, and often difficult lived realities, of Muslim women working in digital media and the public sphere. It thereby provokes a fuller contemplation of the scope of socio-spatial inclusion/exclusion in labour by pursuing and advancing how faith and religious identity interplay with gender in the shaping of societal norms and modalities of outsiderness.

Reina Lewis foresaw the new wave of Muslims who would enter emergent forms of media and foster new sub-cultures and styles: 'If market conditions allow, the ongoing development and diversification of Muslim style media and the advent of a new generation of style mediators look likely to provide a forum for the creation, expression and contestation of Muslim identities' (Lewis 2010:

88). But moving beyond matters of style, this chapter has sought to emphasise how issues of Muslim identity politics are interconnected with larger personal and communitarian concerns that distinguish these forms of labour. Accordingly, discussion is opened on how the category 'Muslim woman' is mobilised and then reworked within the spaces of media to challenge stereotypes and highlight multiple, intersectional aspects of exclusion. In tracing the intentions guiding cultural producers in the study aims are uncovered that are variously educational and devotional: encouraging intra-Muslima bonding across race, ethnicity, creed, piety and nationhood; challenging patriarchy and imperialism in its multiple forms; and spreading knowledge of non-white feminist movements across the Muslim and non-Muslim world. These narratives and platforms provide empirical weight to voices that argue against the incompatibility of Islam with women's advancement, or that Muslim women are subjugated under patriarchal social orders. Instead it reveals agencies through the utility of digital technologies in the West that are enabling the formulation and expression of new contemporary Muslim women's identities.

By addressing labour with geographies of religion and gender, knowledge of emergent spaces of belonging and devotion is advanced that serves to interrogate inequalities and power relations in labour markets and sub-sectors that have traditionally been inscribed as male, white and secular spaces. In future research and policy directions, a geographical imagination is useful to bring spatial knowledge to advance understanding on the intersections of religious faith, gender and issues of 'race' and racism within cultural production and high-tech labour markets. In-depth and embedded research is needed to address a paucity of knowledge around the positioning, marginalising and resistance of producers as religious and ethnic minorities, or woman creatives, placement of work in non-mainstream or anti-capitalist spaces. Ossification can occur as a 'Muslim woman' in a Western-liberal state that can limit choices and crossing-over into mainstream markets, or controlling the content of material when working outside of minority channels. Addressing these issues

involves further consideration towards how subjects negotiate fields of creative labour, and, in turn, how these fields might transform in relation to incorporating the voices, actions and belief systems of new subjecthood in the digital age.

6

MODEST FASHION AND TEXTILES

Introduction

M odest fashion lines are prominent in high-street chains and luxury fashion brands, in magazines and advertising campaigns. A conflation considered strange, if not incompatible, when first launched, modest fashion is now entering the mainstream. Ethnic and Asian fashion styles that were popular in the 1990s can be seen as important precursors for the later visibility and mainstream retailing of modest fashion. For instance the short-lived trend of wearing saris over jeans, bindis, and henna, which also brought some critical debate around issues of ethics, transnationalism and aesthetics in sartorial choice, as a precursor to the cultural appropriation discourse more prevalent today. Usually attributed to fashion designed for minority faith groups from the Abrahamic faiths – Islam, Christianity and Judaism – modest fashion at its simplest is stylish design that provides bodily cover. Academic studies and the fashion industry have focused on Muslim modest fashion, and to a much lesser extent Hasidic Jewish and Mormon forms of style, with some discussion of non-religious markets (Lewis and Moors 2013; Lewis 2015; Tarlo 2010). The wider marketability of longer garment lengths and more relaxed tailoring is now evident in fashion from

high street to luxury, with crossover mainstream appeal. Starting as a niche segment of the global fashion market thirty years ago, modest fashion has grown exponentially with key high-street stores such as H&M, Zara, Nike, Marks and Spencer and Uniqlo launching their own modest fashion lines. The first hijabi model on a British *Vogue* front cover, Halima Aden, along with luxury brands such as Dolce and Gabana, Versace, Chanel and Balenciaga releasing abayas (long robes) and headscarves, meanwhile show expansion at the higher end of the market. Given the visibility of Islamic modest fashion it is unsurprisingly reported as the fastest growing sector of fashion (ThomasReuters 2018/19, 2019/20). Industry buzz around the sub-sector has made headlines across the global fashion world and media, such as the reporting by Al Jazeera, the Islamic Fashion and Design Council and *Vice* that by 2023 Islamic fashion will reach $361 billion turnover.[1]

Muslim spending power has been courted in the global fashion industry, through style and marketing, but also the seasonal targeting of religious holidays. In 2012, Shelina Janmohamed of Ogilvy Noor, part of consultancy firm Ogilvy and Mather, asked businesses looking to expand their consumer base: 'Have you thought about going halal?' (*The Financial Times*, 5 January 2012).[2] Ramadan advertising campaigns led by DKNY, Tommy Hilfiger and Net-a-porter, and Ramadan capsule wardrobes launched by high-street retailers and luxury brands have targeted Islamic religious communities. In fact the 'Ramadan economy'– the Islamic period of fasting, the Eid-al-Fitr celebrations and gift-giving that follow – is identified and targeted by high-street retailers and brands in what is now the third biggest season for UK businesses after Christmas and Easter (Ogilvy Noor 2018). Religion is not 'a latecomer' to marketing, however, with campaigns for normative Christian consumer culture in the West (Lewis 2015: 288). Extending and augmenting the reach of a brand to new religious groups might be viewed as 'future-proofing'. Islam is the youngest of the world's major religions (seventh century) and the future growth of the Islamic cultural economy, including modest fashion, is predicted around the consumption of a rising

number of young Muslims across the world. Departing from the anti-capitalist position that characterises early Islamic revivalism, for many young Muslims connecting with contemporary Islam is less formally organised in hierarchical structures and more socially led through informal forms of consumption, and Muslim lifestyle choices (Lewis 2015: 289; see Chapters 5 and 8). Terming the new generation of Muslim fashionistas 'Muslim Futurists', consultancy firms such as Ogilvy Noor can be seen as attempting to subvert the old debates around Islam's compatibility with modernism and contemporary lifestyles. Or, in their words, 'people who choose to live a life they feel is both faithful and modern, and believe that both of these aspects are their right'.[3]

But these kinds of industry reports act to flatten the so-called Islamic world and the diversity of Muslim life. Modest fashion reveals nuanced localism, varying in style across the global fashion world. Varying ideals and forms of modest fashion in the Muslim world are reflective of cultural, ethnic and religious differences over time, and changing cultural and political economies of fashion. This has presented questions on how and why modest fashion is categorised. As Annelies Moors (2013) writes, the *Modest Clothing Directory*, started in 1998 in the US, is segmented into multiple categories of location, religion and style. Begum et al. (2018: 25) observe that marketing activity has tended to focus on wealthy consumers in Gulf states, and then the growing middle classes in the Philippines and Indonesia; however, there is Muslim 'spending power' in South Asia and elsewhere, beyond the 'Muslim world'. Vital more-than-economic dimensions of modest fashion are often lost in the dominant narrative of business marketing and growth. Originally rooted in the alignment of self-presentation with religious doctrine and its interpretation, modest fashion practices bridge the sacred and everyday. In 2013, Linda Woodhead wrote that it was ground-breaking to think of religion and fashion together (Woodhead in Lewis 2013: xvii). Religion was transforming in relation to society, she reflected, just as fashion has grown to include new items for religious consumers (Woodhead in Lewis 2013). The extent to which Islamic

principles shape commercial Islamic modest fashion has been ques-
tioned (Lewis 2015), but in a dynamic and fast-changing sector from
micro-businesses to large multi-nationals, it warrants further explo-
ration. Modest clothing has been meticulously studied in writing
on veiling practices in the geohumanities and religious studies that
conceptually explore everyday 'lived' religion and material religion
(see Dwyer 1999; McGuire 2008; Lewis 2015; Secor 2002; Tarlo
2010). Feminist and cultural approaches to veiling predominate, in
which complexity is discussed around issues of performance, identity
and morality in the representation of veiling practices and symbolic
meaning-making by consumers, media and wider society. Less atten-
tion has been paid to modest fashion production, except for the
insightful work on 'Islamic-ness' in veiling-fashion industry firms
in Turkey (Gökarıksel and Secor 2009, 2010b). More research is
warranted on the role of religion within fashion industry, especially
the experiences of fashion labour by different Muslim women in
dominant secular society, and relational geographies of heritage and
ethics within a globalised fashion industry.

Muslim bloggers or hijabi bloggers have attracted popular and
academic attention, alongside a handful of prominent designers
and models. Leading hijabi designers have become established in
North America, Europe and Asia, in Muslim majority and secular
states. To spotlight only three: Hana Tajima, a British-born British-
Japanese Muslim designer who has partnered with Uniqlo for five
seasons, recently launching S/S 2020[4]; Ibtihaj Muhammad, who
won a medal for the US in fencing at the 2015 Summer Olympics
whilst wearing a hijab, is also a fashion designer with her own
clothing range, Louella; and Dian Pelangi, an Indonesian blog-
ger and designer with 5 million followers on Instagram who held
a designer-in-residence place at the London College of Fashion in
2015. Broadening horizons of knowledge beyond the old fashion
capitals of the West, these examples reveal flows between places, in
education, training, taste and lifestyle. But beyond the high profile
experiences of a few, very visible industry 'insiders' little is known
about the everyday gendered, racialised and religious dimensions of

working in this growth industry. Beneath a thin veneer of glamour and financial opportunity that is attracting young women to the fashion industry, often through social media platforms, this chapter reveals how the realities of the industry are often very different.

In an influential piece titled 'Bridging the gap', in 1997 Angela McRobbie wrote about the need for learning and debate across fashion production and consumption: (1) to acknowledge poverty and hardship, especially of textile and garment workers, many of whom are women and minority ethnic; and (2) to nuance understanding of the enduring appeal of fashion consumption, for consumers from all backgrounds. As McRobbie (1997) writes, fashion is a feminist issue because many of its workers are women, self-employed, work from home and are typically poorly paid. A recent report by the Migration Advisory Committee underlines that this is still true today: those in supply and production – weavers, knitters, tailors and dressmakers, textiles, garments – earn 'considerably below' the median across all UK occupations (2020: 537). Over half of these occupations are more reliant on non-UK labour than the average across all other UK occupations (Migration Advisory Committee 2020: 537). Meanwhile political complacency can occur in certain higher status quarters of fashion, exacerbated by division of labour that means many (white, middle-class) graduates in fashion design might never visit a factory during their degrees, or have fitted a zip onto a garment (McRobbie 1997). McRobbie discusses how 'class, ethnicity and gender have to be continually re-interrogated for their meaning and they also have to be "thought together"' (McRobbie 1997: 81). While McRobbie is correct in identifying multiple, intersecting issues around access and disadvantage, in this chapter I want to highlight religion and faith as mostly overlooked; a blind spot that is especially clear in modest fashion. Focusing on Muslim labour and fashion, this chapter identifies barriers to entry and progression in the fashion industry, and how these are spatialised by geographical imbalances around educational and employment opportunities. Interrelational differences of gender, ethnicity, class and religion shape choices around, and distinctions and status hierarchies between, educational institutions (whether to

apply to 'community college', known as further education colleges, or higher education universities), ethnic-Western fashion and manual-creative labour. Distinctions and status hierarchies persist between textiles and cutting, and buying and design work, or 'proper fashion'.

In this chapter I give empirical insights into perspectives of recent graduates from a leading fashion design course. Then using three central stories, from women variously based in Luton, Leicester and Manchester, an argument is drawn on how identity in fashion combined with deep spatial imbalances shape social reproduction around indexes of social privilege. Opportunities in fashion are largely clustered in London, along with the most prestigious fashion courses. Although London is a hugely diverse city, there are barriers to moving to the capital given high cost of living and fashion has a culture of unpaid or poorly paid entry level jobs. Intersectional issues of gender and ethnicity are addressed in supply networks with consideration to family histories and kinship networks within multi-national fashion and textiles businesses. Despite challenges of earning a living in fashion, the chapter closes by turning towards the moral and spiritual intentions guiding a number of those aiming to establish careers in modest fashion and textiles, such as modest clothing as a human right, educating about Islam (da'wa), sustainability and women's advancement.

Geographies of Fashion: Imperialism, Difference and Exclusion

Geographies of fashion are significant in the uneven spread of British industry with a vast concentration of business in London, a global fashion capital. Manufacture of apparel is mostly concentrated in London and the East Midlands, with shrinking hubs in Greater Manchester, Yorkshire and Scotland (Froud et al. 2018: 1656). Beyond London there is little in the way of luxury industry, with exceptions of Mulberry and John Smedley, and instead textiles, design and manufacture for high-street retailers and e-commerce predominates with the growth of fast fashion (British Fashion Council 2015). There has also been a small but expanding market for 'Made in Britain' heritage and luxury mostly for Asian and Middle Eastern

markets (Froud et al. 2018), and attempts to promote onshore British manufacturing with international buyers and designers.[5] As a fashion world city, London might be seen as an imperial city in terms of hierarchies, economic power, geopolitical positioning and anxieties of status in comparison to other 'old' fashion world cities, such as Paris and New York (Gilbert and Casadei 2020). But thinking about the broader geographies of fashion uncovers '[a] heightened awareness of issues such as fashion sustainability, fair trade, and the working and living conditions of garment workers' (Gilbert and Casadei 2020: 399). After all, 'beyond flows of goods . . . [there are] different kinds of people, including designers, entrepreneurs, in addition to skilled and exploited migrant labour' (Gilbert and Casadei 2020: 399).

In Greater Manchester and Leeds-Bradford the historical geographies of the fashion industry are tied to migration from Pakistan, in particular with (mostly) men finding labour in textile mills. Transnational and multi-national mobilities continue today in networks of exchange in the textile and garment industry. Tracing continued relationships between the former colonies of the Indian subcontinent and post-colonial Britain highlights how established global centres of the fashion world are sustained in part by smaller, often less visible world regions and cities ('second-tier' or 'not-so-global' fashion cities (see Rantisi 2011; Larner et al. 2007) and free-trade zones of Sri Lanka and Bangladesh). Since the 2000s global free-trade zones across South Asia linked to outsourcing of orders by manufacturers in the West in garment manufacturing has led to intra-regional competition (Begum et al. 2018: 12). Such work asks us to think about distinctive forms of fashion formation that are possible in different places, but also trains attention to their special economic, cultural, social and religious contexts. Informed by Ian Cook's 'follow-the-thing' approach to demystifying commodity chains (Cook 2004), Gilbert and Casadei (2020) move beyond the global fashion city to what is happening in smaller fashion cities and regions, 'from a contained space of creativity and distinctive consumption cultures into a point in a journey from raw materials

to consumer' (Gilbert and Casadei 2020: 400). Uncovering the complexity of fashion supply chains and ethical trade-offs made by producers and consumers, Crewe (2017) and Ibert et al. (2019) employ the notion of disassociation; a process by which geographical, cognitive and emotional distance is created around responsibility and accountability for human and environmental impacts of consumption. In relation to dis/association, it is pertinent to consider the geographies of fashion in relation to what is visible in fronts of cities (runways, shops, fashion weeks, fashion marketing) and made less visible in the back of cities (warehouses, supply). This approach reminds us that while poor working conditions and hardship exist 'out there' in often convoluted, globalised supply chains, they are also operational 'at home'. Britain's textile and garment industry has a high number of vacancies with many jobs undertaken by those in the EU (23 per cent) and outside of the EEA (21 per cent) (Migration Advisory Committee 2020: 549), with 'price-sensitive' elements of UK apparel made through practices of informal subcontracting and low wages (Froud et al. 2018: 1644; Hammer et al. 2015).

Outside of London, the highly dynamic growth of e-commerce has been significant for the British fashion industry. Catering to the Instagram generation, e-commerce giants such as Boohoo.com, who own PrettyLittleThings and NastyGal, with their head office on Dale Street, Manchester, are creating designs based on celebrity culture allowing customers to purchase looks influenced by their favourite celebrities for very low prices and often next day delivery. The popularity of e-commerce and fast fashion has aided a return to onshore manufacturing calculated to serve very tight turnarounds in the supply chain from design to production to wear. But 'Made in Britain' does not mean made more ethically. There is a shocking amount of waste with a reported 3000 new items added each week to Boohoo.com, and unsold items typically burnt or ending up in landfill. Cost prices are given to suppliers by retailers where the re-shoring of production back to the UK has led to a resurgent manufacturing in the UK, though it is a fragile economy with narrow margins when dresses might retail for as little as £5–10. Boohoo.com have

factories in Manchester, Leicester and London. E-commerce brand Missguided also has factories operational in Manchester, along with Leicester and London. In contrast with normative ideas of large-scale factory operation, the present day system has been described as a 'bizarre microeconomy' (Homeworkers Worldwide Association 2019: 3) with larger factories undercut by smaller factories. In fact the average UK garment factory employs fewer than ten people with smaller orders given on a 'test and repeat' basis (Froud et al. 2018: 1644, 1658). Competitive bidding processes between suppliers are reported to be encouraged by 'predatory retailers' (Froud et al. 2018: 1644, 1658), with the cheapest offer winning the contract, even where there are red flags about payment of workers. The 'dark side' of the return to onshore production in Britain has been documented for a number of years including the breaking of employment law and concerns about health and safety (Hammer at al. 2015; Froud et al. 2018). Less discussed until recently are the reported exploitation and slave labour of undocumented textile and garment workers in factories based in Leicester and Manchester. Fresh pressure was placed on the UK government to intervene when Boohoo.com's Leicester factory was associated with the local lock-down of Leicester due to outbreaks of Covid-19, where factory workers continued production even at the height of pandemic in order to meet their orders.

A focus group held with white graduating students on the BSc Fashion Management course at the University of Manchester underscored how attitudes towards 'suitable' fashion work are racialised and classed. The idea of staying in the city of Manchester after graduation was dismissed. Jobs available in textiles and manufacturing were not viewed as desirable, nor were the e-commerce brands based in Manchester seen as a 'good fit'. London was the destination of choice. The image of 'proper' fashion as a white and exclusive space was introduced. As one 'Phoebe' said:

> It's blonde white girls that seem to go into it. I don't know, that's just how I've always seen it. Pretty girls and, you know, English background . . . I think people are scared off by what's portrayed

in movies and stuff as well, and it being kind of cut-throat . . . This sounds awful but because I am English and white, I don't feel too restricted.

Another, 'Bella', noted how she finally got a break in industry by securing an unpaid placement at Marks and Spencer, which then led to other work. But, as 'Bella' confessed, it was her mother who got her the role. Her mother cold-called the British high-street brand, which has a large fashion department, and talked her daughter into a position. She acknowledges confidence given by white privilege and by class, when entering a career in British fashion: 'Not everybody's going to have a white, British, middle class mother who speaks well.' On the geographical inequality in fashion work, 'Bella' further explains that applying for buying or design jobs in London should be straightforward for herself and 'Phoebe':

> I think location is a really big issue, and we also both happen to be from London, or like surrounding, so I can easily live at home. But I do actually know a girl who got offered a job at Arcadia, but she's from up North and their entry-level pay was too low for her to be able to cover rent in London, she didn't have anyone she could stay with and living costs, and she just had to tell them 'I can't be paid that', like 'I can't live off that pay', so she couldn't take that job. So I do think the fact that [I'm] from London is good.

'Phoebe' and 'Bella' further discussed how they were unrestricted as they could take jobs 'even the unpaid ones' as they were 'supported' therefore fashion entry level jobs that were poorly paid or unpaid would be possible. Asked to consider if there were barriers to other people from minority backgrounds in fashion they reflected on the importance of 'identifying with the brand' ('Phoebe') and, if you don't, 'well, it's less likely they'll want you because you need to fit in with the company culture' ('Bella'). Brand image and company culture are here equated so that the ideal worker does not have alternative tastes, cultures or beliefs. Intolerance towards difference is articulated as neutral, or self-evident, for brand coherence and

strength. Returning to the notion of, 'front of city' and 'back of city' is relevant. As for the graduating students' views on a Muslim woman: if they were 'sitting and sewing or drawing' it might be fine, but in the buying areas there 'might be cultural barriers': 'Yeah, you'd have to have people that were okay with going against what they actually believe in, and that might be an issue for maybe Muslims, I don't know' ('Phoebe'). The examples given where Muslim beliefs and fashion might clash were on shorter lengths of hems and sleeves, and 'slogans', which referenced the popularity in high-street and luxury brands for irreverent punchy statements that often include swear words.

'Inside' mainstream fashion was viewed as an exclusionary, white, and ever so slightly dull space. 'Saila', another graduate of the BSc in Fashion Management from a Muslim, Pakistani heritage background, best characterises this in her example of interviewing at Laura Ashley. 'Saila' describes:

> feeling very, very out of place, because every person I saw was Caucasian with blonde hair and blue eyes wearing floral tops and jeans, and the only person of ethnic origin was one lady in HR. And I thought, I can't work here.

'Saila's' sense of outsiderness was shaped by a company aesthetic that meshed quintessential English country style with an almost uniformly white workforce, apart from support staff. After experiencing all of her degree classmates finding work before her, except for the one other minority ethnic person on the course, 'Saila' decided to adapt her identity and appearance to fit in:

> I mean, I got to the point where I thought, maybe I should dye my hair or change my appearance, just to look a little bit more like I fit into the criteria of what people want when they want a young female textiles designer.

In the end 'Saila' changed her name on her CV – and it seemed to work; she found a good job. Later, upon discussing her experience of entering textile design with new colleagues in a research diary entry,

'Saila' notes feeling taken aback that everyone had secured internships and work soon after university. 'In contrast I had struggled to even get interviews. In made me wonder whether it was because of who I was, my race, my name?'

But unfortunately a sense of outsiderness linked to ethnicity and racialisation persisted once 'Saila' entered a textile design company in Dalston, North London. She was the only non-white person, although the company did employ a range of international designers who presented as white. Amongst a number of observations of racialisation and racism, 'Saila' described an overt example where her managers actively encouraged the designers to treat their Indian suppliers differently in order to communicate a clear hierarchy. They were encouraged to keep the suppliers 'in their place':

> I am finding that some of the other designers are very condescending when talking regards the embroiderers in India. My manager mentioned that we must email in a harsh tone with them to show who is in charge. This made me feel very uncomfortable as I see their [the suppliers] email correspondence as professional, and feel this comment has come from bias against the factory workers because they're in India.

Post-colonial superiority is strongly suggested in these extracts. Racist hierarchies and attitudes towards treating different workers with different levels of respect are shared that would shape everyday communication across the textile supply chain between India and Britain. As 'Saila' describes, the encouraged subjugation of the factory workers in India by the buyer in London is steeped in imperialism and also reveals varying levels of status in division of labour along the supply chain from suppliers to designers. For 'Saila', whose work is inspired by the culture and colour palette she associates with the Indian subcontinent, and her memories of visiting grandparents there, the attitudes are deeply unsettling and troubling. Moreover, the boundaries of racism are not spatially distanced but also permeate the studio space in other ways, with 'Saila' perceiving more criticism of her designs despite comparable sales to her colleagues.

Stories from Modest Fashion and Textile Workers

In the empirical sections that follow I now turn to trace the stories of three Muslim women who work in fashion and textiles outside of London. Their different roles and positionalities show distinctions between design work and sewing; hierarchies that place Western fashion as superior to 'ethnic' fashion, and the impacts of ethnicity, race and racialisation, gender and motherhood on their opportunities around advancing education and employment opportunities. The fashion industry has long used intensive female labour in unregulated sweatshops and home-working, with Asian and Greek-Cypriot migrant communities identified in the subcontracting of flexible and non-unionised labour (Mitter 1985). I show how the racialisation and the marginalisation of ethnic fashion begins early in the shaping of what kind of institution and qualification is sought, which has continued ramifications later in distinction and status within the competitive fashion industry. I argue that moving away from 'front of city' to 'back of city' perspectives further complicates the overly celebratory economic narrative of modest fashion as a booming industry. It shows exploitation, hardship, and vulnerability in fashion supply chains that are 'Made in Britain'.

Aamira, fashion tutor and designer, Luton

Aamira experienced feeling out of place when studying for a fashion degree at her local further education college. It was a significant transition, socially and educationally. For the first time she felt different to the other students:

> I went to a school which was predominantly full of South Asian Muslims, so when I went to a college it was no Asians and all white and black students . . . I was the only Asian girl, and I was the only Asian girl with a head scarf, and I think I was the only Muslim as well in that class. For three months I think I hated it.

Aamira was asked lots of questions about her life – did she go clubbing? Did she have a boyfriend? – leading to self-questioning:

For the first month or so I was really uncomfortable because I was not used to that kind of questioning, I didn't know how to answer them because I've never had to answer these questions . . . All of a sudden it started feeling like, 'Oh my God. Do I belong to a really bad sort of world?'

Instead of following a clear pathway, Aamira's education and early working life in fashion was incrementally established with negotiation between her and her father. Each opportunity presented by the college course involved asking her father's permission. Aamira relayed this process as a sign of respect. The purpose of each trip needed to have a tight rationale for the completion of her assignments: 'if they were [a] useful trip I went, or if they weren't so useful I didn't'. Aamira describes how for her father a series of stages were required to feel 'comfortable'. This was supported by her decision to remain at a nearby further education college to undertake a BA Fashion degree. While she had wanted to apply 'to London' – wrapping up fashion, education and the capital city together – she noted that the college teaching and facilities at the further education college were 'very good' so she was content to stay locally. Over time trust was established, through a track record of hard-work and success. Personal commitment with markers of achievement, such as prizes, developed her father's confidence in the next stage of career development.

A major event in her education was an overseas field trip. Aamira recalls a dialogue with her father on the subject of attending a college overseas trip to Première Vision Paris, a huge global marketplace in north Paris where six major industries meet twice annually, including yarns, fabrics, leather, designs, accessories and manufacturing. Première Vision Paris is where designers, from high street to luxury, will attend to buy fabrics and trimmings, and learn about colour ranges for the future season. A process of building trust and negotiating over time with her father culminated in the request:

Now as part of my 3rd Year I had to go to Paris. Every time I would think, 'Okay, I've come to this hurdle', and it's got hard, 'How do I go about this one?' So I sat him down, I said to him, 'I

need to go.' I think what I love about my dad is he would never say no, he would always find an alternative solution. He [said], 'That's fine. Can mum go with you?' I was, 'I can't see why not.' 'Take mum then.' End of . . . So that's one thing I like about him . . . He wouldn't say, 'You can't do this', it was just, like, can we try Option B, and that he would make it possible for me.

As I have explored elsewhere the narrative departs from a rigid notion of patriarchalism in relation to pursuing education and work for young Muslim women in Britain (Warren 2019). Aamira explains, 'He wouldn't say, "You can't do this."' Undertaking the same opportunities as her classmates, mostly white British and non-religious, could not be taken for granted with Aamira thinking carefully about 'pitching' the request: 'How do I go about this one?' But there are accommodations by both parties, and a supportive institutional context (see Brah 1993). For Aamira her initial tutor at college accompanied her and her mother on the field trip to Paris not disclosing a recent breast cancer diagnosis: 'she should have not flown, but I think she knew how much the trip meant to me'. Transitions towards increasing diversity involve multiple stakeholders, connecting the intimate family context and the institutional, in alternative ways-of-doing. Or 'option B', as Aamira terms it.

A steer placed on staying local meant seeking less prestigious alternatives in forging a career pathway in the sub-sector. Already she had outlined that after her initial tutor was on sickness leave, she was replaced temporarily with a tutor from Central Saint Martins. For Aamira this was a 'turning point', where:

> What I'd been taught up until that point it was great, it was really practical skills, but this is where I realised what fashion was. This is someone that [had] come from [Central] Saint Martins, he used to turn his nose up at Luton. He just got there and it was, like, 'What are you girls doing? This is not fashion.' We were [like], 'What do you mean?' and he sat us down. What he taught us in 3 months changed my view and everything completely to what I've been doing for the 4½ years.

After finishing her degree in fashion in Luton, the next step was to find work at a designer or tailor, with the most respected opportunities identified in London. Aamira already felt networked with the London fashion industry through a previous tutor who had worked at the London College of Fashion, and friends who had made the move south. However, Aamira's father had reservations about her moving alone:

> I was coming to the end of the BA. My friend was working at Saville Row [and] said to me, 'Right, do you know what? I can put in a good word for you.' So I had that conversation with my dad and he was, 'Look, up until this point I haven't said anything, but I don't know how I would feel you coming to London to work.' And I had this conversation [with him], 'What is it that you're scared about?' He goes, 'I just don't know, I just don't feel . . .' I said, 'Do you think it's because I'll be working around men; is that something that would bother you?' He's, like, 'It's not that,' he goes, 'I just don't know, I don't feel like I would be . . . I just . . .' He goes, 'Why don't you give it some time and look for something locally?' I knew that was not going to happen, there was nothing local out there.

Aamira recounted making light of her father's concerns, remarking that he was more likely to attract male attention in the fashion industry than her – using a stereotype of fashion and gay culture. Despite her ability to joke with her father it did not change the situation. Aamira 'out of respect' for her father's concerns with free mixing and living away from home decided to stay in Luton. Staying local meant Aamira would remain in the family home until she married. Aamira did not feel ready to launch her own label which was the suggestion of her father, and therefore in discussion with him decided to pursue teaching. Instead of entering fashion at this point, she became an ESOL/TEFL teacher, completing her CELTA qualification, and then started tutoring in BTEC Level 3 fashion at a further education college. In this instance, while it meant not 'climbing the ladder', restrictions on geographical mobility led to the exploration

of alternative pathways that enabled 'getting by' then 'getting on' (Reynolds 2013; see also Holland 2007).

Aamira embarked on a portfolio career juggling multiple strands of design, teaching, event organising and dressmaking in Luton, the city she grew up in. She describes the college she had studied at and now taught at as 'on the outskirts' of Luton, and how 'fashion were not courses [sic] that people from our ethnicity pick'. Asked to explain, Aamira says that 'you'd get [South Asian] girls pattern cutting', but not studying 'proper fashion'. She describes how the first eight students 'wore veils, they were strict Muslim women', explaining they were mostly Pakistani with one Arab. However, the desire to learn came from the students she observed, recounting a telephone conversation:

> I can remember speaking to her on the phone and she was, like, 'Is this a proper fashion course?' and I was, 'It's a proper fashion course.' And she goes, 'No, the reason why I'm asking, I have been to the centre before.' Because it was an outreach centre where I was working. 'I have been to the centre before; I did a summer course and it was ethnic cutting and I didn't want to learn that, I wanted to learn fashion.' I go, 'No, no, no, I can assure you the course that I'm running it's going to be *proper* fashion.' [Aamira gives emphasis]

This extract again re-enforces the hierarchical distinction made between ethnic pattern cutting/sewing and design. The former shows practical, manual skills, whereas the latter is used to give emphasis to creativity. It is used as a marker of distinction. Adding weight to this point, to show the seriousness of the course as fashion – rather than textiles – Aamira guided students to make Western clothes they would not wear themselves in order to demonstrate they can. Embedded in this logic is a status hierarchy between design and textiles courses. Also it suggests how ethnic identity and textiles are recognisably linked to South Asian heritage and migratory routes, and indeed cheap, unregulated feminised labour, particularly for those from working-class ethnic minority backgrounds (Mitter 1985), and

therefore marginalised in style and marketplace in comparison to the 'Western' fashion world. Aamira encouraged her own students to show their breadth of skill across styles in order to gain visibility and recognition by an imaginary white employer and client base:

> I said, 'I don't want somebody to look at your work and think, "Oh, that's from an ethnic designer" . . .' Not because there's anything wrong with that, but I just felt like I want people to know that if these guys wanted they can go mainstream, it's got nothing to do with ethnicity.

Concerns around social difference and education are raised by the status of further education, in relation to higher education (although Aamira's did offer degree programmes). Typically underfunded in Britain, further education colleges serve mostly vocational courses and minority ethnic students are over-represented in number. Aamira attempted to provide opportunities for her students to boost their visibility:

> [B]ut then I wanted to do a really big end of year show, like what I had for my BA basically and call fashion scouts, that was the whole idea. When I went to the college I was working for at that time, they were [like], 'We haven't got any money, we haven't got the budget', typical of FE colleges.

Instead of funding the fashion show, what later became Luton Fashion Week, through the conventional channel of the college, Aamira and her students raised money in the local South Asian community. She describes entrepreneurialism in generating money for the fashion show, which also highlights the extant networks Aamira and her students were able to mobilise:

> [I said] 'what we'll do is we'll raise money and we'll get more of the local businesses and we'll do a show' . . . So it was just me and a few of the students going round to all the local community begging for sponsorship and I think our biggest sponsorship at that point was £50.

Aamira used fashion as a means of reaching out to other South Asian Muslim women and helping them to gain skills, confidence and visibility in Luton. It is not insignificant that she pulled the women on stage after the fashion show, into the limelight in front of family, friends and press. But it also points towards the way that fashion itself might not be deemed very suitable or attractive to South Asian and Muslim students, at least conventionally. As Aamira points towards, there was a gap of understanding about fashion designing as a career for her. Relatives were instead familiar with gendered and lower status work of sewing and tailoring:

> Initially I think my relatives didn't understand what I was doing. My mum right before I decided to do my online [business], she was a bit, 'So you've been doing fashion for 5 years. When are you going to make something for yourself?' She didn't understand that I was doing designing and not pattern cutting; it's really hilarious. My dad's, like, 'She's a designer, not a tailor.'

For Aamira the imbrication of fashion and religion were apparent on her pilgrimage to Mecca where next to the religious site [the kaaba in the Grand Mosque] was a large shopping mall. Commercial material culture and spiritualism are viewed as entirely consistent in her perspective on contemporary Islam. Since the interview Aamira has launched her own bridal label, a fusion of Western and Asian styles, and 'was in talks' with John Lewis. The language used by Aamira on achieving her ambitions is of crossing over and scaling up: 'I want to be at that place where I can see my brand going mainstream. That's where I want to be.'

Wafiza, fashion label owner and designer, Leicester

Gendered struggles around independence were reported by a number of participants. One of the starkest examples was the story of 'Wafiza', the daughter of a textiles factory worker, from Greater Manchester now living in Leicester. Her father had worked in the textile and garment industry for twenty years. At one point he had owned his own factory but it had closed due to financial difficulties.

She weighed up that, on the one hand, she felt she had benefit-
ted from drawing on her father's networks and experience, but,
on the other hand, she struggled to gain autonomy over her busi-
ness. Insights are given here into the dynamics of inter-generational
family and community networks working in fashion and textiles
and gendered difference:

> My dad's helped me a lot with my business and everything, but
> I've had to leave everything to him, sort of on the project side, and
> it's been quite difficult because I haven't had a chance to speak to
> these people [suppliers] myself, because my dad sort of feels like,
> 'No, it's fine, she doesn't need to speak to them, I'll sort it out
> myself,' because they'll look at me and they'll just be like, 'Oh,
> you know'— just sort of disregard you if that makes sense?

Although she does not have a close relationship with her father, he is
heavily involved in business decisions including picking her suppli-
ers and setting up meetings. 'Wafiza' draws a portrait of the textiles
and garment industry in Leicester as male dominated and culturally
networked. On setting up her own business, she reflects on a series
of difficulties: 'I don't know what to call them, a lot of um, mishaps?
A lot of people undermining me . . . the textile industry is weird.
It's predominantly male-dominated, if that makes sense?' Asked to
explain more she describes in detail the messy social process of work-
ing in a local supply chain for her small label:

> I went with my dad to the cutter, the person who cuts fabric and
> everything. And we went there twice to explain which fabric goes
> with which design, and everything, and you know he was like,
> 'Yeah, yeah that's absolutely fine', I wrote it down for him, I
> showed him, I did everything I possibly could, and still he cut the
> wrong fabric with the wrong design. So that's one of the major
> things that happened that really screwed everything up. So that's
> a perfect example. And then he had the nerve to just, say to me,
> 'Oh, d'you know what, that roll didn't fit on my cutting table, so
> I just decided to cut this fabric instead' and I thought, how dare

you, you know, without my permission, just cut a fabric, just because it didn't fit, that's ridiculous, you know what I mean? I didn't give you permission to do that, what makes you think you can just go and do that, that's not what you're getting paid for. But um, my partner was like, 'Oh no you shouldn't have paid him' and everything, but, it's like, they just kept hassling my dad so my dad just paid him basically. So I couldn't do anything. It's not like it was a legally binding contract, and I can't just pull out contracts for everyone because he's sort of – I don't think he speaks much English and he just, um, he was like fresh off the boat if that sounds a bit too rude.

'Wafiza' reflects on a series of professional and social problems where a fabric cutter introduced by her father cuts a different piece of fabric without her permission, and then demands payment, which her father chooses to settle. 'Wafiza' suggests there are cultural links between her father and the cutter. In the full interview she discusses South Asian culture, and then she describes the cutter as hassling her father and as a recent arrival ('fresh off the boat'). Multiple indexes of discrimination come into view in the recounted story. For example, the distinction made by her on new migrants and established citizens from shared ancestral lands. But from her vantage point the lines of discrimination are distinctly gendered, with age also significant to understanding the dynamics:

Because you're a woman, and I'm young, and they just don't think that much of you, and it's quite horrible, because you feel like, well hang on a minute, it's my business, I'm the important one, why can't you speak to me about it? But that's why there's ended up being a lot of things going wrong, to be honest.

Left with a poor set of options, and a lot of unused material, 'Wafiza' decided to 'make it work'. But,

because of that particular fabric, the way that it's been cut, the size turned out too small. So it's like a whole domino effect of like just problems. And because of the sizing, I'm now going to have

to re-label everything, and it's like, it's costing more time and money, just 'cause of one person.

For 'Wafiza' it serves as a drain on resources – in terms of time, money and mental health. Unfairly, the series of mistakes by the two older men are then taken as proof of her inability to run a business. Broadening out her discussion to a wider series of encounters, 'Wafiza' found that the male suppliers she worked with failed to treat her equally: 'In my own experiences as a Fashion and Textiles Business owner, I have found that some men will mock you, and dishonour you in front of colleagues and partners.' Due to these experiences of feeling undermined on multiple interactions, and a lowering of self-confidence, 'Wafiza' asked her father or husband to accompany her on business meetings. For instance she expands on her husband's ability with 'the business side', involving finding stockists and sales given 'he has the gift of the gab'. Elsewhere in a diary entry she writes: 'He will be helping me sell as that's his forte and I know he can get results for me.' Whereas, she reflects self-critically, 'I am not good at marketing – that is one of my weaknesses.' She also demurs, 'I really don't think I'm cut out for the fashion industry.'

Insightfully, 'Wafiza' connects her self-doubt with structural issues that shape gendered roles in the textile industry and underline her reliance on males. This was a source of deep frustration:

> I find myself asking why I should need to take a male with me to discuss a business proposition. Am I not capable of it? This raises many questions as to why we as women are not allowed the privilege of talking for ourselves and of being taken seriously. This social stigma around women being homemakers and nothing else is still around. Women, particularly in the South Asian community are looked down on and it's even worse when you are made to feel like you are not good enough to do anything else but be a housewife.

Here she describes the process by which she loses confidence to represent herself, and in a vicious circle comes to rely on male patriarchal

systems to run her business. Running her own modest fashion textile design business, she had not personally experienced Islamophobia – instead gender and culture are deemed more significant:

> But, yeah, I have had a lot of people being sort of patronising, and sort of, well I mean I get it nearly every day when I'm speaking to suppliers and things, they just sort of think, 'Well you're a woman, you're not gonna understand.'

'Wafiza' associates patriarchialism with the South Asian diaspora, surfacing critical questions on whether the inequality she experienced is a result of Islam or cultural norms justified according to interpretations of Islam (see Alexander and Welzel 2011; Hopkins 2009a, 2009b). In her opinion 'the South Asian culture is shit':

> Yeah, and it's all just to do with culture but people get it really mixed up, like, they think that it's religion, [and] it just develops more hate toward religion, but, the religion is so unbelievably accepting of all these things. It's unbelievable.

In diary entries 'Wafiza' gives further insights into the precarity of launching a new business in the busy modest fashion marketplace. For instance she discusses receiving a message on Instagram from a male who appears to be a model asking for her to send free items to him to pose in. These practices of influencing are common marketing tools in the fashion world, and she considers his 60K following adequate enough to take the proposition seriously. But it also shows the ways that social media has left fragile start-ups with new challenges of assessing international scamming, or 'freebies' for exposure, and the blurred terrain in these informal marketing arrangements. Meanwhile high profile stores such as a menswear store in Notting Hill charge to sell new designers as part of their ranges and take a cut of any profits, and the costs of insurance and domains also act as barriers to those without financial backing. 'Wafiza' raises 'getting sucked deeper and deeper into a hole that I can't get out of financially'. She extends the loan payments for a loan taken out for her fledgling business although it means adding on further

interest. She then describes feeling undervalued as clients drain her time while underpaying her: 'Today was typical as in me spending a lot of unnecessary time on clients [fashion] design work who are paying next to nothing for my efforts. I'm sick and tired of explaining myself.'

Despite the challenges she experiences at work, 'Wafiza' is clear on her right to work and to get equal respect. Her right to work is justified according to positive role models within the Qur'an, in this instance Lady Khadijah. In echoes of Islamic feminism, 'Wafiza' talks about Khadija, the wife of Muhammad, a successful businessleader: 'Do people forget how the Prophet Muhammad (salallahu alaihi wa sallam) treated the women in his family? Have we forgotten that his wife Lady Khadijah (radi allahu anha) was one of the most successful business women of her time?' 'Wafiza' challenges gendered norms that naturalise feminine domesticity as Islamic showing how social, economic and religious identities are entirely compatible for her, and other Muslim women. Knowledge of her religious faith is used to challenge patriarchal cultures and expand options in the workplace, and in her domestic life. 'Wafiza', who had left university, married and entered motherhood in her early twenties, enrolled in a new university course, contributed writing for Muslima lifestyle media, and had recently taken the decision to separate from her partner. Strength accrued through knowledge of Islam and feminist Islamic interpretations provide 'Wafiza' with conviction in her right to work. This is supportive of the findings of Khattab et al. (2018) that debunk notions that Islamic religiosity might act as a further barrier to work for Muslim women, instead showing how self-education and knowledge of the religious scripture can mean subjects are more confident in advocating for their rights, including the right to work.

Clementine, designer and tailor, Greater Manchester

The final example is 'Clementine', a young black Muslim woman born in Burundi and raised in Belgium before settling in Manchester. She is the mother to a toddler. Clementine describes her work as 'self-employed seamstress, fashion designer, tailor. And I do volun-

teering on the side.' Like Aamira, 'Clementine' makes the point that there is a geography to fashion in Britain that privileges London. She reflects on this hierarchy in fashion schools and employment prospects, in particular with established brands:

> Thinking of fashion for instance . . . you feel like you either have to be a graduate from Central Saint Martins or London College of Fashion to actually have a chance to get any job, a respectable job in fashion or with a big brand name. Otherwise . . . I did a Foundation Degree which was at the Manchester College, but my degree was given by Salford Uni. So standing next to someone who graduated at London College of Fashion, you just feel a bit inferior.

'Clementine' regards two London-based institutions as feeder schools for respectable jobs in the fashion world. By comparison, her qualifications at a further education college followed by a previous polytechnic means she feels disadvantaged as a candidate in the job market. She points towards the different status of textiles and sewing and a fashion design or buying course. This point is made by contrasting working for a luxury brand or in design with the usefulness of learning new practical, manual skills:

> It was a Foundation Degree. I looked at the prospectus and I thought, 'I kind of like this because it's not about going to work for Gucci or anything like that, it's about getting the technical skills.' I considered London and stuff but that was more about design and not really getting the technical skills down, so I thought if I was going for the route of having my own business I need all the technical skills . . . So I thought, 'I want to just learn everything from the ground up and learn all the different bits.' I looked at the modules, I was like 'oh, I like this, there's sustainable fashion in there, there's this and that, I like it'. So I went for that.

'Clementine' describes the different kinds of roles in fashion where technical skills have a lower cachet and status. However, in her decision-making process technical skills are most important to

running her own business as a tailor. Also important to her decision-making on the course was proximity and sustainability. It needed to be convenient and to satisfy her values. But despite her considered selection of the course and clear enthusiasm she was not offered a place for the progression onto the full degree following interview. 'Clementine' describes the discrimination she experienced due to her pregnancy at the time: 'I was really hyped about talking about my work and telling [the interviewer] about my inspiration behind it and telling her about my passion with sustainable fashion and all the things I want to change in fashion, but the focus was on "you're pregnant and you're not going to be able to commit to this", basically.'

The tutors appeared to have a 'type' of student in mind for their course. 'Clementine', a pregnant Muslim black woman, felt that she did not 'fit': '[They] just want the best sketchers and the best 100 per cent ten-hours, twelve-hour work people and that's it.' Her pregnancy meant that the college did not think she would be able to dedicate enough time to a course where they wanted students to be willing to work up to 70 hours per week. Pregnancy is a protected characteristic therefore the comments of the tutor representing the college constitutes direct discrimination. Course requirements were thought by 'Clementine' to orientate towards single people with no other commitments; the 'ideal' candidate. Beyond excluding those with caring commitments, 'Clementine' reflected on how representing as a black Muslim led to judgements about her work:

I don't want to use the whole 'black Muslim' as a limitation, but I think it's there anyway. Like I've seen that with just the campus interview, like it was perception, that you don't get the full chance, that they don't really look at you like, 'she could do that, that, that, that'. Because automatically you assume like, that somehow how I dress and how I look, that that's what I'm going to do. 'She's just going to things for an African aesthetic' or 'she's going to do things for Islamic modest aesthetic, and it's not going to be as broad, she's not going to be as open minded and do like lingerie and stuff'. But that's not necessarily the case,

you know. It's just the perception thing where people just look at me like 'oh, it's just another kaftan designer, for heaven's sake'. Which is another reason why I kind of want to do the entrepreneurial route, which I know I'll face challenges and difficulties anyway, regardless, but at least I'm fighting for my own things, trying to get a seat at the table, like 'let me in, let me in' sort of thing.

As she was a minority ethnic applicant, the tutors on the course anticipated an identity-based approach to the clothing she would make as an African or Muslim. She notes that that is 'not necessarily the case'. She aligns herself with a friend on her course, also from a minority ethnic background:

> Modest fashion, which is not what they're after. I did feel like that. And there was another girl on my course, 'Shahina', she's Asian as well and she was really . . . her vision wasn't really appreciated or taken in. She was into textiles and prints and colours and stuff like that, and that was like 'nah, that's not really what we do around here' . . . She's into fusion as well. She's from a South Indian background and she likes just like mixing cultural and Western culture, mixing those stuff together, like a sari fabric on a hoodie type thing. She's into that type of thing, which I think is an amazing vision, something new, something fresh. But they weren't into it, they just wanted someone who can design for Max Mara, Gucci.

In this extract of the interview 'Clementine' discusses the dismissal of a style of clothing – textiles, prints and colours. She highlights the significance to the fashion work that the person is from a South Asian background and they like fusion, juxtaposing material and style in a sari fabric used for a 'hoody', or hooded jumper. Her friend therefore makes fusion clothing meaning she is bringing together South Asian and Western cultural influences. But this departs from the design of clothing encouraged by the tutors of luxury tailored Western or brands associated with revealing looks. In this interview 'Clementine', with perspicacity identifies the racialised aesthetic

judgements that shape the hierarchies of fashion college. Importantly, she doesn't want her creative capacity to be pigeon-holed according to her identity – minority ethno-religious black – with awareness this might be viewed as niche or peripheral to mainstream. But she also seeks tutors that demonstrate awareness and respect towards various and different global fashion styles, skills and cultural influences. The designer reveals sensitivity to implicit bias and racism in the disparagement towards minority ethnic clothing, styles and tastes, and how this is overlaid upon the geographical status of the institution, 'Basically go to that community college for that.'

For Clementine the experience fuelled a sense of her own need to prove herself, rather than pure anger at a sense of injustice. Asked about experiences of discrimination in the rejection, she reflected:

> It's . . . with being black, I've always had this thing where I've got to work harder anyway than any other person. I just felt there's this thing where you've got to work twice as hard to get the same place where someone else would work half as hard. So when that got thrown at me, I thought 'that's just another thing, like the whole being black thing'. I've just got to work three times as hard being a mother.

For her own label 'Clementine' says she would like to dress anyone. However, her more specific ambition is to provide accessible, affordable modest wear for a full breadth of women:

> I want to be able to provide opportunities for younger girls to feel like they can dress modestly but still [be] stylish and good and feel good about themselves. I think it's important to provide an affordable, good-quality, modest line for all generations and all different types of modesty . . . I want to give variation.

'Clementine' uses the example of her mother from Burundi to demonstrate the range of different styles across the huge breadth of Muslim nations, cultures, ages and sub-groups. What is deemed stylish and Islamically appropriate and affordable for some, will not appeal to other Muslim demographics.

On a smaller scale, working at home in Oldham, Greater Manchester, 'Clementine' considers the social benefits of fashion work. She reflects on clothes as a human right and crucial for survival. This contrasts notably with more normative, market-driven narratives of the lucrative expanding Muslim marketplace: 'Food, clothes, shelter, those are things that people always need. I was like, "yeah I could do that". And then yeah, I thought "fashion, I'm going to get into it".' 'Clementine' talks about fashion as making a difference to people's lives who are most in need. Her language on clothing is more in line with charity and development than the buzz and allure of fast fashion. Moving away from individualism and concern for personal ambition, she reframes her vocation as responsive towards global community objectives. The stated aims are social: to give something back to the community, or for wider education purposes. Elsewhere Muslim women in fashion and textiles also discussed social value, such as by teaching knitting as a way of stress relieving and addressing depression, as well as learning new skills and developing the self through clothes making and crafts. Increased interest in social value and sustainability dovetails with a wider move from fashion students and fashion pressure groups around rethinking the current fashion system.

British Modest Fashion: Spatial Inequalities, Racism and Social Reproduction

The three narratives above represent very different cases, with distinct challenges and experiences, and yet taken together it is striking that they consider entrepreneurialism as a way of maintaining some control, despite everyday struggle and low pay within the sub-sector. Introducing women entrepreneurs in the cultural and creative industries, Naudin and Patel (2019) offer the following definition of cultural entrepreneurialism as 'individuals who are self-employed, freelancers and owners of micro-enterprises or who have a portfolio career and work within the so-called creative industries' (Naudin and Patel 2019: 2). Paradoxically, it is notable that the decision to start a micro-business was ultimately made for Aamira and 'Wafiza'

by their father or husband. In a sector where there are multiple ways in which Aamira, 'Wafiza' and 'Clementine', and others in the wider study, are discriminated, marginalised and excluded from mainstream work, they have struggled with finding opportunities, which is exacerbated by limited options to travel or move away for work. Deviating from reports of a booming modest fashion industry, each of the women's fashion micro-businesses is financially precarious. Accordingly, Aamira took on paid teaching work to create an income and support her fashion design, 'Wafiza's' modest fashion label was failing as a business, and 'Clementine's' ambition for her own modest fashion line was paused while she worked flexibly as a seamstress or tailor around childcare. In the words of Ashton and Aquista (2020), in a market characterised by freelance and portfolio working, 'aspiring creatives are encouraged to make a job rather than apply for one' (Ashton and Aquista 2020: 31). But, more critically still, we might understand this approach to work as 'forced entrepreneurialism' (Oakley 2014), and homeworking in the fashion industry as exploding 'the myth of the desirability of working from home' (Mitter 1985: 37), where modest fashion is far from a utopia of equality and human rights.

In a four-year study of dressmakers in Australia, Luckman (2018) critiques the idea that all cultural workers absorb the neoliberal ideal of growing a multi-million pound creative business. Instead contextualising the cultural and creative industries, where funding has been withdrawn and tertiary training around entrepreneurial skills education only serves the illusion of fairness and equality of access, Luckman advances the critical knowing of micro-business creative owners, many of whom are women, who seek out enterprise as 'the least worst option' (Luckman 2018: 315). While many of the women in the study are contemporary makers who reflect a 'do-it-yourself', or self-starter spirit, it is the case that a 'Trump-esque' hyper-masculine driver of risk-taking is not reflective of their lived realities of insecurity and precarity. Rather the women reveal complexity around combining cultural work and business approaches, for example through tactics of using a disembodied brand name (to

avoid exploitation of self), resisting growth, or focusing on quality and artistry (rather than quantity) of goods as an environmental response to the climate crisis (Luckman 2018: 317). Luckman's study resonates in multiple ways with the often ambivalent accounts of the women I detail above who struggle to earn a living from textile and garment work. Elsewhere Luckman acknowledges that parents, usually women, seek home-based self-employment as an imperfect solution to family-unfriendly workplaces and unaffordable childcare (Luckman 2018: 320). Yet Luckman's research and extant literature around 'mumpreneurs' – those who combine micro-business and feminine identities of motherhood – typically focus on middle class and mostly white cultural workers.

A micro-business that could be run alongside primary care-giving for young children was a practical solution for juggling motherhood and employment for two of the participants, 'Wafiza' and 'Clementine'. It might offer a means of earning a living when international qualifications are not recognised or UK-awarded quali-fications, such as those taken at further education colleges, are under-valued, where there are issues of access and advancement around indexes of social difference, and where there is undocumented labour or pay below the minimum wage (see Mitter 1985). But there are further endemic racialised hierarchies in the treatment of mainstream fashion brands as higher status than ethnic fashion, as the narra-tives of the women identify both in education and the workplace. Modest fashion appears exoticised, as a timely and lucrative trend, with success closely aligned with designs in mainstream high-street and luxury brands, and their potential for capitalist growth. In the case of 'Wafiza', there was no safety net and she ran up debts trying to maintain her start-up modest fashion business, leaving her feeling depressed. Meanwhile for 'Clementine', direct discrimination when pregnant impacted her educational progression, and left a lasting impression that paid employment in a fashion company was beyond her reach, as a black Muslim woman. The examples I provide above point to the ways in which historic supply chains in textiles are still active in relations of exchange for workforce, materials, production

and aesthetics, but also in post-colonial attitudes that distinguish between division of labour in core creative jobs and peripheral manual labour. These attitudes are spatialised in fashion, not only with regards to the West and 'the rest' (Said 1978), which has been somewhat disrupted by the growth in emerging economies, fashion cities and fashion weeks, including from the Global South, but by internal bordering where minority ethnic and religious fashion workers are made to feel they do not 'fit' the mainstream and where labour is often hidden from view. While some of the participants in the study had longer transnational family histories in textiles and garments, it was important for many to distinguish between sewing and cutting, whether at home or in factory work, and 'proper' fashion design work. In the case of 'proper' fashion, such as being a female boss of a fashion business, status was inferred through education level, creative enterprise and leadership that showed gendered intergenerational mobility according to these metrics, even when participants remained financially dependent.

Naudin (2018) has argued that place is important as a means of situating cultural entrepreneurialism. Place can constrain but it can also provide confidence. For Aamira, upwardly mobile, of Pakistani heritage and Muslim, her home town of Luton offered a secure and supportive place in which to get by and get on. Reynolds (2013) has argued, in relation to black youths in predominantly black neighbourhoods, that the positive dimensions of identification and belonging for well-being and confidence are often under-played in understanding why people remain in the same areas. Moreover whilst some 'get stuck' in cycles of poverty, others use available educational and community resources and networks to 'get by' and then 'get on', which can lead to social and geographical mobility over the life course (Reynolds 2013; see also Holland 2007). While launching a fashion label directly after graduating is typically a career venture for mid or late career, there is an appeal that it enables a designer to work from home and sounds impressive. Running a business, even when it is financially unsuccessful, can be about 'face-saving', as Luckman (2018) has identified, which this chapter suggests can

be understood at the scale of family and even of community importance. It also avoids exposure to discrimination and exclusion at short-listing and interview stage described by 'Clementine', which is widely practiced as unearthed by Runnymede Trust and discussed in Chapter 2. The desire to maintain family – and especially daughters – within a close geographical range can be seen negatively as patriarchalism (Mernissi 1987; Mohammad 2005). This does need to be understood, however, within a broader context of social exclusion and discrimination for minorities, in particular Islamophobia and racism for Muslims in Britain (Razack 2008). Supporting the launch of a fashion label from home might in this vein be seen as 'protecting' a Muslim woman from potential discrimination in the mainstream labour market. In black areas, cultural producers might access a greater concentration of religious and ethnic commercial spaces that provide minority ethnic and religious resources and support structures. Therefore place can multiply act to enable and protect, and can take on different aspects across career stages that shape pathways to progression. An unintended outcome is this might serve to reinforce social reproduction and a geographical glass ceiling, where well-paid and higher status fashion employment is still clustered in the 'old', expensive, imperial fashion capital of London and dominated by white, affluent, middle classes.

Conclusion

This chapter discusses the worklife experiences of different Muslim women within modest fashion and textiles, which complicates the narrative of women's empowerment and high financial rewards. It instead points towards the complexity of social, political and ethical positions of modest fashion producers as they negotiate multiple, often conflicting pressures. On the one hand, high profile women's leadership in fashion design and digital influencing through vlogging, Instagram and modelling is widely seen by supporters as evidence of gendered strength and beauty within the Muslim world. Sometimes referred to as post-feminist and certainly capitalist and materialistic, the feminine body is fashioned as a fleshy, living and

individualised cultural product through which to sell positive images back to consumers and earn money. Politically the very presence and active participation in the public sphere of Muslim fashionistas, especially when discussing the public life of Islamic faith through everyday pious fashion choices – what counts as modest and whether that matters – makes inroads towards addressing gendered inequalities in who has a right to speak and to control the female body. Muslim women's entrepreneurialism and business savvy is viewed as a success story in that it offers an alternative to the regular reports and statistics of Muslim women as the most excluded from paid labour in Britain, and elsewhere in Europe. However, while some might financially thrive, there are more critical studies of how diversity sells in the marketplace, where minority digital influencers earn less than their white counterparts (Pham 2015), and migrants are paid below average salaries, or even below the minimum wage in factories (Migrant Commission 2020; Froud et al. 2018).

While overlapping fashion and digital spaces have offered Muslim women's solidarity, especially bonds that transcend national contexts (Warren 2018, 2019), it is widely recognised that within modest fashion there are racialised distinctions in hierarchies and status where light skin is typically viewed as more desirable and therefore more valuable, as I explored in the previous chapter. Fashion designer and textile insights from the study further indicate hierarchies between mainstream and ethnic fashion that is imbibed by some of the producers who aim for mainstream recognition and success. This matters because it is overlaid upon long-standing distinctions between the status of educational institution and type of fashion occupation, with those from minority, non-white backgrounds less likely to progress into well-paid, secure employment due to perceived brand 'fit'. Moreover the commercialisation of Islam has recently received some criticism. As Begum et al. (2018) remind us there is now a perceived risk of material barriers to practicing Islamic faith due to the proliferation of images of luxury brands and consumption culture aimed mostly at young Muslims. In this chapter I have outlined how some of the women working in modest

fashion have experienced patriarchialism, racism and direct discrimination due to pregnancy and motherhood, from Muslims and from other religious and non-religious people.

Building out of a discussion of whether modest fashion is a temporary or enduring segment of apparel, the prominence and spread of modest fashion for secular and Islamic brands raises issues around ethics and social justice. There are often dismissed ethical and moral dimensions guiding entry into fashion garment and textiles labour. In particular the cases I have discussed consider a mix of Islamic and secular principles around women's education, women's economic independence, da'wa (educating about Islam), and human dignity. Each of these undergird why subjects chose to attempt a career in modest fashion and textiles. Running counter to the flashier practices identified at the outset of this chapter there is also a growth of concern for a greener and more environmentally sustainable set of Islamic lifestyle practices for young Muslims, although this was only raised by a small number of participants. Increased awareness in some quarters of more sustainable materials and production processes are connected to the ethics of supply chains with consideration given to environmental and human costs, for instance, the Rana Plaza Factory collapse in April 2013 that killed 1,138 people. Although participant identities were often multiply located, for example with dual national status, it does not mean that workers' rights, pain and suffering in global fashion production were major themes arising in the interviews and focus groups. In the narratives there was not a strong labour identification and association with former colonies where there was identified shared heritage, such as in free trade zones in South Asia. Instead the creative and inspirational benefits of transnational identities and belonging were discussed, or longer histories of gendered struggle around economic independence. Concerns raised typically focused on everyday personal and immediate familial struggles in fashion and textiles at home in Britain.

I argue in this chapter that labour conditions are gendered and racialised within the broad arena of the growing modest fashion world, and embedded within longer historical international trade

practices between the Indian subcontinent and Britain, as they exist in varying post-colonial relations and configurations elsewhere. There are unresolved tensions between the ethical and political positions of actors within the fashion world, even as they might seek to address specific issues, such as greater gender equality in British textiles or visibility of Muslim women in fashion. This ambivalence around modest fashion can be observed across the fashion value chain, from production to consumption. No one is a pure, untainted subject or a paragon of virtue, even when we consider the role of faith and religion within fashion production and modest fashion. It is evident in the capabilities for discrimination and prejudice that can, and do, flow multiple ways, as we saw with 'Wafiza's' view on recent arrivals. Far from anti-capitalist, the women in the study viewed business entrepreneurialism as a means of furthering women's development and strengthening solidarity between Muslim women. For an everyday consumer of modest fashion on British high streets, Muslim women's advancement read through the reshaping and widening of accessible clothing choices was progression enough: 'Modest fashion has supported hijabi bloggers. I don't really care or think it is important. It is just more money for them [bloggers] though it still makes my life easier' ('Asma', November 2017).

Notes

1. Al Jazeera is a Qatari state-owned broadcaster based in Doha, Qatar, owned by the Al Jazeera Media Network. See <https://www.ifd council.org/why-muslim-fashion-is-taking-over-the-luxury-world/> (last accessed 1 December 2021); Vice 2019; <https://www.vice.com/en_asia /article/evyejj/why-muslim-fashion-is-taking-over-the-luxury-world> (last accessed 1 December 2021).
2. See <https://www.ft.com/content/55ff3a61-5ded-3ae5-9946-9541258 04e62> (last accessed 30 June 2020) and <https://www.ft.com/content /55ff3a61-5ded-3ae5-9946-954125804e62> (last accessed 1 December 2021).
3. Available at <https://ogilvy.co.uk/news/wake-power-female-muslim-con sumers>.
4. Hana Tajima launched her collaboration with Uniqlo on 3 July 2015 in

Malaysia, Indonesia, Thailand and Singapore. It was released in USA on 26 February 2016.

5. Available at <https://makeitbritish.co.uk/kate-hills/> (last accessed 1 December 2021).

7

VISUAL ARTS AND THE ART WORLD

Introduction

There is a prominent phrase in the hadith used by the Prophet Muhammad صلى الله عليه وسلم which is oft quoted in relation to the arts: 'Allah is Beautiful and He likes beauty' (Mukhtasar Sahih Muslim 2000, vol. 1: 65). Religious faith coexists with secularity in the lifeworld of Muslim artists, art-making and the contemporary art world. However, there are historic and contested issues of categorisation around what has commonly been termed Islamic art, and the continued politics of representation that shapes distinctions made between Islamic religious art and 'international' contemporary art. Informed by the voices of Muslim women artists, this chapter seeks to trouble these distinctions. I explore how the marginalisation of religion within art discourse has led to a narrowing of notions of modernity, unchecked barriers to the art establishment, and perpetuated a nativist notion of 'authenticity' for minority artists and their artwork. I discuss the breadth of how notions of Muslimness and Islamic principles in art travel to and are circulated in different art spaces and contexts, and the continued politics of knowledge production around how artists and artworks are represented within the Western art world.

A defining feature of Islamic art, as it is commonly termed, is the repetition of patterns and order. In mirroring nature, patterns such as calligraphy, geometry and arabesque (or stylised floral patterns) are intended to follow universal mathematical principles, and to resonate aesthetically with Muslim, other religious or non-religious people alike. Most associated with compass or straight edge work in two- or three-dimensional form, Islamic art is traditionally decorative or functional. In the history of Western art, craft practices have often been viewed pejoratively for their perceived associations with repetition rather than originality, domestic labour and household objects. In the Qur'an and hadith there is no direct reference to 'art'; no word in Arabic or Persian exists for art in the Western sense. Outside of value distinctions made between design and art, most discussed in contemporary discourse, and arguably misunderstood, are tensions in the treatment of form and makers within the Qur'an and hadith. In the Qur'an there is no direct condemnation of image-making (of animals or human form). However, there are negative references to image-making as sinful documented in the hadith. These references are made to representations of animate life in paintings, sculpture and textiles (hangings and cushions). Painters and sculptors are presented in a negative light in examples where the maker is seen to position himself in competition with the supreme creator, Allah (Milwright 2017: 178; Grabar 1987; Hawting 1999). Painters and sculptors are referred to by the masculine pronoun, and imagined as the male subject. We can presume from documents, therefore, that the principal artists and housepainters were men; however, there is reference to women's creativity in a manual of hisbah that condemns tattooing. In the hadith, instead of animate figurative art, it is suggested to makers – of paintings, drawings, textile and other craft – to instead focus on plants, trees and other inanimate subjects (see hadith by Muhammad al-Bukhari (d. 870). Creative expression is thereby directed towards nature and universal patterns.

In recent years prestigious prizes by leading galleries and funders, and collections by Saatchi Art and other commercial art collections,

have re-opened critical discussion on the place of Islamic art within contemporary art and the cultural and creative industries more broadly.[1] By way of an example, since 2009 the Jameel Prize has been awarded in conjunction with the V&A for contemporary art and design inspired by the Islamic tradition[2] and digital Islamic arts received recognition in the Lumen Prize 2017, an international prize that celebrates art with technology. Meanwhile in Iran in 2016 an exhibition of Arab modern art from the Barjeel collection opened at the Tehran Museum of Contemporary Art with considerable international attention; but it avoided discussing religion altogether. The term 'Islamic art' remains controversial. Definitions of Islamic art typically use parameters of work from particular regions and territories, or time periods. Otherwise definitions are centred on religious Islamic identity – of the artist, the patron or cultural community – where the work was produced. Therefore museums, commercial galleries, private collectors and experts have tended to variously define Islamic art according to: (1) the Islamic world (or lands); (2) works produced between 650 and 1250, the height of the Islamic Empire; (3) works produced in the Ottoman, Safavid or Mughal Empires. Classifications typically centre on traditional skills and forms, and are historically demarcated by the fall of the Ottoman Empire and founding of the Republic of Turkey in 1923. Islamic arts are argued by some as now obsolete in a traditional sense, and situated instead in relation to regional or cultural classifications rather than the Islamic faith (Issa 1997; Shabout 2016). For Muslim artists today, however, the argument for a demise of Islamic visual art might amount to a disavowal of their place in the story of contemporary art history and art canon, as we see later.

Framing a contemporary Islamic art scene is even more contentious. Yet art from Arab and Iranian artists, or art from the Muslim world, as it is differently framed, has become an important, if not one of the liveliest streams within the contemporary art scene over the last twenty years, with a growth of the art market and spaces in Middle Eastern countries. In fine art, quite distinct from discourse and debate in media, since 11 September 2001 religion has arguably

been subsumed or obfuscated by the master signifier of region or ethnicity (Jiwa 2010). International exhibitions have mostly privileged a Middle Eastern locality and ethnic heritage of the artists over Islam and Muslim identity in the categorisation of the shows, if not the marketing visuals (*Word into Art: Artists of the Modern Middle East*, British Museum, 2006; *Unveiled: New Art from the Middle-East*, Saatchi Gallery, 2009; *Light from the Middle East: New Photography*, V&A, 2013). Exceptions to this are the Los Angeles County Museum of Art's *Islamic Art Now: Contemporary Art of the Middle East*, 2015–16 – although still emphasising Iran and the Arab world – and The Whitworth's *Beyond Faith: Muslim Women Artists Today*, 2019–20. The emergence of artists in Britain, such as Sara Choudhrey and Zarah Hussain, has brought together traditional elements with contemporary mediums, expressly digital, departing from purely decorative or functional applications, and foregrounded the significance of Muslim faith and spiritualism in their work. Despite mainstream success, artists might be dissuaded by influential figures in the art world from identifying as Islamic artists. As one artist posed critically: 'I am inspired by Islam and I am inspired by the culture as well as the religion, so how is that not what I am? And if I'm okay with saying that then how is that a problem?'

In this chapter I will reflect on the work of these contemporary visual artists in relation to discourse on social difference and the art world, and especially the roles and practice of Muslim women within visual arts and British arts institutions. In the case of Sara through the prism of digital Islamic art I consider the hybridity of technology with geometric forms and the combining of innovation with tradition for a new religiously informed contemporary art. I develop this discussion in the case of Zarah, with reflection on pathways into the visual arts as a minority artist practising openly as a Muslim who is inspired by Islamic traditions in visual form. I consider how selected examples of Sara and Zarah's art are underpinned by faith and how the artists negotiate their own Muslim faithfulness in working conditions that are sometimes conflicting. The contemporary art world is still largely imagined as Western,

predominantly male, white and secular. Said (1985: 42) observes: 'the essence of Orientalism is the ineradicable distinction between Western superiority and Oriental inferiority'. Hall established that Western cultural identity, including ideas of ethnicity and race, were defined through a hierarchical, imperialist yet dynamic relationship with notions of the non-Western ('Asia', 'Africa', 'Middle East'). Rather than fixed and static, cultural identity (and culture) is 'always a production, which is never complete, always in process, and always constituted within, not outside, of representation' (Hall 1990: 222). In addressing the special contribution made by Sara and Zarah, and opening up the discussion through reference to a selection of emerging artists, this chapter considers the challenges of gaining visibility and recognition within 'mainstream' and commercial art spaces as a minority Muslim woman living in the West. It re-considers the roles of Muslim women in British galleries and museums, at a time of critical reflexivity around post-colonial and de-colonialising strategies in collections and knowledge production in material culture.

Digital Islamic Art

Sara Choudhrey

Sara is a London-based artist-researcher, currently associate lecturer at University of Kent, where she completed her PhD in digital arts in 2018. Sara has presented her research and exhibited art across the UK, with a number of large-scale commissions funded by Arts Council England. Recent exhibitions include *A Place in Pattern* at the William Morris Society, London (2021), *Digital Light: Code Makers at Bletchley Park* (2020), *Here and Beyond*, a solo exhibition at the Kensington Town Hall, London (2019), and *Manifesting the Unseen*, a group residency at Guest Projects, London (2018). Sara's work was also exhibited in *The Botanical Legacy – Travellers in Ottoman Lands* at the Royal Botanic Garden in Edinburgh, and the Islamic Arts Festival at the Sharjah Art Museum, United Arab Emirates.

Sara's creative and academic work shows how form in the Islamic tradition ought to be viewed as fine art. In the piece *Digital B-order*

(2016), Sara plays with the institutional framing devices of Western art and the art gallery and museum. Audience activated, *Digital B-order* is formed of a dark grey Perspex® that is semi-transparent and an internal wooden frame with LEDs inserted, overlaid with laser-cut Perspex panels in a floral, curved motif of Iranian style. Highlighting the artistry of arabesque in the margins of the Qur'an, Sara places proximity sensors to illuminate the frame itself – rather than the canvas – seeking to open a dialogue between traditional Islamic art and the international art scene (Figure 7.1). For as Sara suggests, 'The work speaks of hybridity but also of globalisation, and allows for the decorative ornamentation to draw connections between East and West, alluding to the long history of material interactions that continue today.'

Digital B-order tracks back and forth between tradition and the contemporary, east and west, revealing interconnectedness and exchange, but also enduring hierarchies and difference. It points towards the partiality of the history of modernism, which, as artist, curator and academic Araeen (2000) reminds us, has been written for and about mostly white artists from Europe and North America. Even the term 'Islamic art' is complicated in its etymology as a modern Western notion that arose from the nineteenth century when archaeologists, academics and designers introduced studies of the regions now termed the Middle East into their research (Choudhrey 2018; McDonald-Toone 2019). The interest in forms of Islamic culture coincided with an increase in travel to the area, evident in representations of Middle Eastern sites within paintings and print (McDonald-Toone 2019: 45). For instance, in Owen Jones's *A Grammar of Ornament* (1856), with chapters titled 'Arabian'; 'Assyrian and Persia'; 'Turkish'; 'Moresque from the Alhambra'; or in Jules Bourgoin's *Les Éléments de l'Art Arabe Trait des Entrelacs* (1879) comprising 200 designs of geometrical patterns, including twenty-eight from traditional sites – doors, windows, pavements, ceilings – in Damascus and Cairo (McDonald-Toone 2019: 46). To further explain, Jones was one of the foremost designers and tastemakers in Victorian Britain, acting

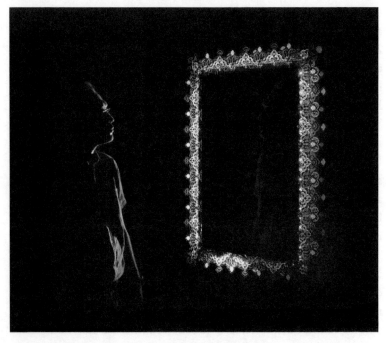

Figure 7.1 Sara Choudhrey, *Digital B-order*, 2016

as superintendent of works for the 1851 Great Exhibition. The folio explored patterns and motifs from nineteen cultural design periods and the natural world. In the second example, Bourgoin was a trained architect and skilled draughtsman from France who documented Arabic design, particularly in Cairo, a city in which he lived for several years. Cognisant of this history, *Digital B-order* powerfully shows how visual form can open other ways of seeing that bring into relief alternative structures of knowledge and belief systems about the world. Giving emphasis to the point that the cultural is political (Hall 1997: Jackson 1989), *Digital B-order* also represents the marginalisation of religion and art practice by artists from Britain's former colonies or the diaspora in the Western art canon by spatially representing the relationship between the core and periphery. With insight, the work spotlights calligraphy in the Qur'an as art, which meets a definition of religious art given that

the scripture represents religious icons and is the most traditionally revered of craft practices according to the holy text. *Digital B-order* is a carefully layered work that expands the boundaries of what we categorise as contemporary art practice, encompassing religion and digital technologies.

Informed by post-colonial strategies and women's activism, *Digital B-order* contributes towards addressing the underrepresentation of Muslim artists from the UK and the Muslim diaspora in exhibitions on Islamic art that have often focused on the Middle East and Middle Eastern imaginaries (Choudhrey 2018: 13). The term 'Middle Eastern', widely adopted within the region and outside, can be traced to externally imposed nineteenth century colonial cartography (McDonald-Toone 2019). The interest in Middle Eastern art, with residencies typically given to Arab, Saudi and Iranian artists, is indivisible from the art market. Middle Eastern art has boosted local and international art markets. In fact, there has been a growth of Middle Eastern art in the art market in the wake of the 11 September 2001 attacks. In visual arts the aesthetic geopolitical response to Islamic terrorism has taken an area-based approach. Sensationalism of the Middle-Eastern 'other' has been put on display for a largely Western audience. For instance the poster for Saatchi's exhibition *Unveiled: New Art from the Middle East* (2009) featured a veiled woman, with media propagating an orientalist fantasy meets neo-liberal feminism: 'The veil is lifted on hidden talent' (Cumming 2009). Meanwhile intra-Muslim diversity and difference within the art world is often buried in art discourse and arts programming.

Digital Islamic art is a new school of practice that explicitly places tradition and religion into the contemporary art world. Pushing forward the definition of Islamic art, Sara uses new techniques and technologies. She hand-draws a shape, which is then digitalised to create a vector file that can be used on different materials such as laser-cutting, laser-engraving, water-jet cutting, animating and projecting. Hand-made elements might then be involved again at the end of the process, such as by painting rosettes. The significance

of floral patterning using the mathematical principles of geometry entails 'a universal language' given its presence in the natural world (Dabbour 2012). There is a religious significance to geometric form where the continuity in pattern can be held as analogous for the infinite nature of God and His eternal presence (Sutton 2007). Otherwise termed geometrical sacred art, the form can be seen as sacred in relation to attributing it to Divine or sacred creation (Nasr 1987), but also by demonstrating a religious harmony in the natural world and cosmos (Critchlow 1999; Dabbour 2012). The form might therefore be viewed as representing God without engaging in forbidden figurative image-making. As Sara writes, 'Geometric patterns particularly allow for this representation of the concept of infinity without making any visual indication of Divine appearance' (Choudhrey 2018: 35). Combining traditional and digital elements in matters of form aligns principles of art with science and mathematics, modernity and Islam.

When classifying her art, Sara carefully weighs up the inscription of her work as religious. Revealing doctoral training in art history, she assesses how 'explored through the historical context, Islamic art is not necessarily a religious art, as it does not directly represent the religion through iconic forms' with the exception of calligraphy for Quranic scripture (Choudhrey 2018: 40). Instead a distinction is made between religious art and art 'informed by religious principles' (Choudhrey 2018: 40). Sara makes this point acknowledging her Muslim background, but also gives emphasis to the equal significance of her own educational and skills background – her pathway into art from information technology, rather than art school. The avoidance of drawing figurative forms is partially secular – it is practical and contextual around her training: 'As a teen I felt my skills didn't lie in portraiture, for example. Later it became a conscious decision, a form of adherence to a religious principle.' Though Sara describes a process of becoming more religious across her life course that gave new significance to more practical choices such as selecting form and medium:

As an artist you're making a choice about what your work is and you know, it's like saying do I want to do nude painting? No I don't. Okay, that's more religiously-oriented, I wouldn't do that, but at a very young age I decided I'm more into patterns than I am into drawing people and animals . . . I would describe myself as a practising Muslim . . . engaging in learning about the religion and implementing that in my day-to-day life.

Sara describes an active process of learning and practice where internal spiritual developments are embodied and inform her everyday and professional actions. Significantly, she seeks to nuance and resist closure around the motivations behind her work and how it is categorised in the art world. Her artwork is consistent with her faithfulness and piety, though not constrained by them: 'my everyday life is driven by a purpose, endeavouring to be a good Muslim . . . [But] it doesn't mean my work can or should only be appreciated in that kind of context.' Sara can be seen to situate her digital work within Western contemporary art *and* Islamic art, building a case for how contemporary art can include religion, without the need for siloing her work as religious art, Islamic art or by faith and Muslimness. Explaining this, her art does not overtly depict a religious icon or religious subject, and instead is produced in dialogue with a changing global Islamic culture and cohort of artists engaging in computer programming with traditional Islamic forms who are not necessarily Muslim, or even religious (for instance the hybrid art of British-born artist of Jordanian heritage, Sama Mara). In fact an intention is to open up aesthetic understanding around universal forms that connect all humans, or as Sara terms it, through her art, 'to instigate contemplation of interactivity between persons in the wider global community'.

The creative process can become a spiritual experience. Sara reflects, '[I] find the process of creating complex patterns challenging, meditative and rewarding' (Choudhrey 2018: 117). The creative repetition of working with patterns itself becomes part of the rituals of a practice of faith. There are many references within the

Qur'an conveying that beauty can be manifest in varying material and non-material forms. Examples include descriptions of beautiful carpets, the gardens of paradise, beauty in the appearance of people, the beauty of the natural world and what it brings forth in growth and expansion (such as vegetation and natural stones), and also the beauty of good character (Gonzalez 2016; Choudhrey 2018: 28). Beauty as written about in the Qur'an is therefore multiply located: in form in nature and cultural production, as something to be sensed, acquired and embodied, whether interpreted with a rational or philosophical approach (Bolkhari 2017). Enrolling together these references to beauty with further guidance on how Muslims should perfect their actions, suggests a more holistic approach towards creativity, one that might align with forms of worship. Beauty might therefore be understood as a way of becoming: 'In other words, a Muslim's actions should be conducted to the best of their ability with the intention to make their work of the highest standard. Therefore, with an appreciation for beauty and workmanship, any pursuit is justified to be fulfilled as artistically beautiful as possible' (Choudhrey 2018: 29). The role of faith in the making process is thus significant here, and yet the vision is inclusive.

Geometric art is seen as a 'kind of bridge' that connects the faithless with the faithful, and 'arts' and 'science' minds. Replacing the geographical metaphors of east and west, which have often been bound up with essentialising and stereotyping of identities around places, 'the bridge' as a metaphor instead valorises all kinds of difference, along with situating knowledge as inclusive (Schmidt di Friedberg and Johnston 2019). The metaphor of the bridge, which appears elsewhere in interviews, conceptually lends itself to a broad range of critical, intersectional and internationalist geographies (Schmidt di Friedberg and Johnston 2019). Viewing geometry as a bridge, Sara sees how geometry relates to mathematics and science, 'so someone who has no knowledge of religion, [who] might come from a different religion even can find a connection to that'. As a result, the work might speak to the viewer on a subconscious level.

Or as Sara observes, the patterns and shapes are 'something they already know, a memory or a familiarity'. It therefore opens the potential for a post-secular geography of contemplation, between believers and non-believers:

> You've got geometry in kind of a Euclidian form, it's pre-Islamic, it's outside of religion but if you are religious you'll connect it to things like divine creation anyway so for me that means that a lot more people can engage with the topic and with the work itself.

The interactive element to the work is present in earlier work, such as with *Reflect* (2010), exhibited at the Watermans Gallery, London (Figure 7.2). A sculptural work, *Reflect* comprises a geometric pattern digitalised, then applied to aluminium where a real-time digitally manipulated camera feed projected audience motion creating a dynamic flux alike an underwater rippling effect. 'By openly exhibiting as an artist inspired by Islamic art and alluding to more than what meets the eye I was inviting the viewer to delve more deeply, to reflect, as the name suggested, upon their surroundings and question things

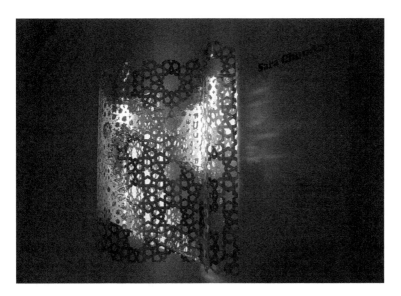

Figure 7.2 Sara Choudhrey, *Reflect*, 2010

beyond the surface to understand cause and effect, leaving any deeper interpretations open to the user.' Audience reception of the work might ignite a quasi-religious and unifying experience through the reflexive and elemental dimensions of the piece (see Choudhrey 2016).

A politics of knowledge production is foregrounded in the making, documentation and representation of Islamic art and its development. Pursuing a doctorate at the University of Kent offered an opportunity to present a new strand of Islamic art – digital Islamic art. The process of documentation is a kind of political act by writing Islamic art into the context of the British contemporary art scene. As Sara notes,

> the Islamic arts network or community within the UK, they'd been very active for a few years at least at that point so I was like, 'well the people are there and they're talking about it, they're making the work, so why isn't anyone documenting it?' It was a bit ridiculous.

Until that point the work was represented in Asian networks only and there was a lacuna in the art world 'justifying it and saying it exists'. Gaining recognition by curators, critics and academics, who together comprise the art world establishment, was important because: 'If it is not documented, it doesn't exist.' Giving emphasis to the challenges of writing Islamic art back into contemporary art, Sara writes on attending exhibitions and observing animations, murals and installations that were based upon visual and stylistic elements of Islamic art, 'but this work was not always labelled or described as such' (Choudhrey 2018: 12). She also discusses the difficulty in tracing the lineage of artists working in this tradition due to fissures in the documentation (Choudhrey 2018: 12). As Araeen (2000: 5) writes on modernism's 'others', 'The main issue was not just the artists' exclusion from the art scene, but the ignorance and suppression of the whole history of their contribution to mainstream developments.' Informed variously by the theorisation of Said, Bhabha and Hall, Araeen argues the very concept of modernism in art, underpinned by language and history, can be viewed as representative of dominant

structures of Western art institutions and their enduring power. It is a hierarchy that enacts racial and religious exclusions which minority artists can find themselves reproducing when attempting to erase social difference in the positioning of their work. Therefore even working within the knowledge and delimitations of a Western art history that positions Islamic artwork as peripheral in significance, the act of naming digital Islamic art and recording it becomes a form of cultural activism to place the work into art discourse. Or, as Sara observes, 'it was more important for me to do that groundwork, to do the documentation'. Doctoral research offered access to resources and a pathway to gaining legitimation, where other opportunities such as co-curating presented ways of fostering networks and gaining visibility in the art world.

Zarah Hussain

Zarah Hussain is the most prominent artist in the digital Islamic art 'network' called forth by Sara. Zarah fuses spiritualism and digital using hand-drawn Islamic geometry with digital software to create animations made with code. Her cross-media work also encompasses apps, paintings and sculptures. Winner of the Lumen Prize 2017 in the People's Choice category, *Numina*, a large (5 m × 5 m) work in the foyer of the Barbican, received the most votes out of any winner in its four-year history. Zarah has held solo shows, a key marker of artistic success, at Birmingham Art Gallery and Cartwright Hall. In 2020 a new print collaboration was announced between the V&A and Zarah in the commercial production of limited edition prints ('Spring'). She holds an MA from the Visual Islamic and Traditional Art programme at the Prince's School for Traditional Arts in London. Zarah is represented by Hopstreet Gallery, Brussels.

Zarah's work seeks to reflect the 'order and harmony of the world around us'. She discusses how geometric shapes appear in nature – such as the hexagon in Graphene or rhomboid shape in diamonds – and as forms that on a primordial level we connect with as humans. As she reflects, architecture from Europe to India – ancient Greek architecture, Taj Mahal or Alhambra – shows awareness of

the mathematical principles in design, but 'no culture or religion has a monopoly on that [geometric patterns and ordering]'. For Zarah there is a spiritualism in these shapes that show mathematics in nature, universal ideas and concepts. However, she observes,

> Inspiration is not exclusive ... I practise but my work is not restricted to people of faith, they might have no faith. There are patterns in everything and people relate to that. Human beings are meaning making machines, we order things.

Zarah gives emphasis not to God or otherworldliness, but interconnectedness. She has a traditional training in Islamic art combined with knowledge of digital and software.

In *Magic Carpet I* and *Magic Carpet II* (Figure 7.3) designs were projected onto the façade of the William Morris Gallery in Walthamstow as part of the Walthamstow Garden Party 2014 and 2015, which coincided with the end of Ramadan and celebrations of Eid-al-Fitr. Zarah notes this opened an aesthetic dialogue between the design principles of Morris and her own art, and symbolically

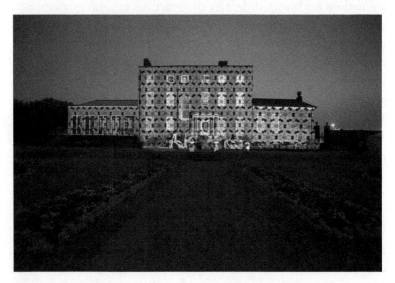

Figure 7.3 Zarah Hussain, *Magic Carpet II*, 2015, William Morris Gallery, Walthamstow Garden Party, London

overlaid Islamic design on an eighteenth-century Georgian mansion built in the 1740s, set in Lloyds Park in north-west London. In other creative work, she has sought public engagement, for example in *Southend Colour* (2015), shown at the Village Green festival and outside Focal Point Art Gallery, Southend, UK (Figure 7.4). As part of the commission by the Essex Cultural Diversity Project, Zarah held a series of workshops at a local mosque and Southend libraries to explore colour and pattern with residents of Southend. The digital Islamic artwork *Southend Colour* is programmed to dynamically respond to audience participation by changing colour according to data submitted by personal technologies on migration, identity and demographic change. This resulted in a visual documentation of community sentiment and augments the known space, projecting Islamic pattern onto walls of local buildings and contemporary art gallery. In a piece about the making of *Southend Colour*, Zarah speaks about the process of building trust with the Muslim communities in Southend, where she was viewed as an outsider and with suspicion despite her own Muslim identity.[3] Zarah highlights the complexity of insider/outsider relationships in participatory research and practice. After

Figure 7.4 Zarah Hussain, *Southend Colour*, 2015

several months, through speaking with the local imam and women volunteers, and delivering art workshops (attended by 200 children) she enrolled a wider Muslim community in the participatory digital artwork. Significantly, Zarah gives emphasis to gendered dimensions of developing trust and understanding with women volunteers pivotal for brokering relationships with wider Muslim communities during the art commission process.

Zarah grew up in the north-west of England, and studied English literature and history at Manchester University (graduating in 2001) before working as a journalist at the BBC on current affairs, religion and ethics, and then pursuing art training. In narrating her experience of art, Zarah reveals the importance of geography for addressing inequalities of access and hierarchies around style. As a child, Zarah experienced racism that fuelled a need to discover her heritage and drew inspiration:

> You're learning Shakespeare and you're doing maths, and everything feels like, what is me? Where am I, where am I from? I think that's where the instinct for Islamic art came from. I read. I read a lot . . . And I'm sorry, but . . . You can stick your civilisation and you can stick your British political history . . . I'm reading about the golden age of Islam. I was reading about al-Ghazali. Hang on, we invented numbers! We invented algebra, we did this, we did that, you know? There was a little bit of sort of well if you hate me, I'll hate you back.

Her pursuit of learning and practice around Islamic art is understood by Zarah as a reaction against a hostile racist England in the 1970s:

> I think that's where an interest in Islam, an interest in my own culture, an interest in poetry, interest in literature, an interest in art . . . There was a kind of element of you know what, your culture sucks . . . I became a bit of a rebel.

She emphasises her 'very, very good' art teacher who introduced her to Islamic visual culture through a book on Moroccan design, and the studios at her school which were 'like a sanctuary'. Later, when

working for the BBC, she was asked to research Islamic art for their webpages and discovered the Prince's School. When interviewed by *Studio International*, the interviewer says the Prince's School in London was 'not too far away'. Zarah corrects her, smiling: 'For me it was, it was the other side of the world.' Here Zarah gives emphasis to the relational experience of distance and mobility. Geographical barriers of pursuing art training is overlaid with material barriers, as she observes, 'Without financial backing it would have been very difficult to up sticks and move to London.' Zarah was awarded a full scholarship. The discipline of the Prince's School – '10 am till 5 pm, everyday, at your desk working' – was a new experience, or 'massive shock'. Zarah describes the experience as a 'process of unlearning' during the course where she was taught to paint. Highlighting the precarity of graduation and living as an artist, Zarah graduated in 2004 but then went back to television to work freelance as 'as you know being an artist and making a living from being an artist is quite difficult'. In television as a freelancer, 'You can have three months on and off. So you can work it round your practice.'

Even with an established art profile, navigating the contemporary art scene is highly competitive. Zarah says, 'you've still got to go out there, you've still got to pitch'. A 'hit rate' of a successful artist could be 20–30 per cent. However, specific challenges are experienced for those who are not privileged. As Zarah explains, 'the art world is a difficult place, you probably know, and it's a place that is elite, deliberately. And at a commercial level, it's for people who can afford to buy art work.' Zarah highlights the art world does not operate in order to serve inclusion. Her professional insight of the art world recalls the work of sociologist Pierre Bourdieu (1984 [1979]), who argued that markers of distinction, cultural, social and economic, are often transferable and socially reproduced, which maintains elitism. Foregrounding race and racialisation, these ideas are supported by the arguments of Araeen (2000) that the exclusion of black artists and suppression of black history is embedded in the 'very ideology of art institutions' and the 'failure of the west to come to terms with its colonial past' (see also Brook et al. 2020;

Mould 2018). Significantly this is a matter of history, but it is also entwined with capitalism and commercialism. As Zarah describes it, for those who do not 'fit', there are multiple intersectional axes of exclusion:

> I think it's difficult for people of colour, I think it's difficult for women probably compared [to] for men, and I think it's difficult for working class people. It is an elite world and some of it is about who your contacts are, who your connections are, who you know, it's very opaque.

Speaking on the power of networks, Zarah's *Numina* (2016–17) (Figure 7.5) and the *Magic Carpet I* (2014) projection were initiated by informal coffees and meetings with friends, who then introduced her work to other contacts in the art world. *Numina* showed at the Barbican art and learning centre in London. Describing how the project came to fruition, Zarah had met a friend for coffee in a park where projection mapping was discussed, and then a year later someone from the Barbican contacted her to say they had spoken with

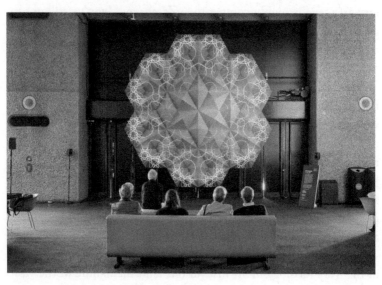

Figure 7.5 Zarah Hussain, *Numina*, 2016–17

the same friend, and 'knew you are interested in this, why don't you come in and have a chat?' As Zarah narrated, 'Once I understood what it was and how you could do it, I had the idea for *Numina*.' This recounted social episode is a clear example of how art networks can facilitate opportunities to develop new skills and to show work. But even with good connections built over years as a practising artist, Zarah describes a tension with increased visibility and opportunities as a Muslim artist who is overt about working in Islamic art. Zarah shares mixed feelings as a Muslim woman placing work into a highly visible space such as the Barbican foyer, and situating her practice within the Islamic tradition:

> My worry sometimes is, I'm a Muslim, I'm a Muslim woman and there is so much negativity in the press and the world about what is going on. I'm doing something from the Islamic tradition, and I'm not hiding that, I'm saying this is what this is. I didn't get one negative or horrible email. And I was expecting that there may be. So that was refreshing, I realised people were much more tolerant, and open to ideas and new experiences than you might think.

The Art Establishment and Institutional Structures

The examples above introduce some of the complexity of gaining visibility in space as a British Muslim woman with regards to the art establishment and representing artwork as part of an Islamic tradition. Together they raise the Western canon and Eurocentric ideas of international contemporary art, contestation around the definition and scope of Islamic art, obfuscation of religion in dominant secular contemporary art, racism and other forms of bigotry and exclusion, as well as regional geographical inequality and uneven opportunities to traverse and occupy space. Primarily Sarah and Zara remark on intersectional issues of Muslim faith and ethnicity. Interviews with other figures in the art world also drew out nuances around these issues. In this section I will turn to the perspective of a prominent arts professional to sharpen understanding of how the art establishment and institutional structures function in the UK.

A leading arts worker discussed the challenges of minority identity within the art world. The professional ('Sabina') was part of Arts Council England's Change-Makers programme[4] in which black, minority ethnic or disabled arts workers were invited into institutions as part of a training programme to develop new senior leaders and to advise on implementation of diversity policies and practices. It aimed to create sector, organisational and individual change. 'Sabina' discussed the interconnectedness of racial identity and funding regimes in spatial language, questioning whether her work as a change-maker addressing inequality and discrimination can 'sit in an institutional context' or 'needs to be on the periphery'. Explaining this, 'Sabina' noted that if a person is not a direct employee of an institution there is greater freedom to critique how it operates and reproduces inequities. A pertinent issue with how diversity is treated by institutions is that it is often seen through the eyes of a white (male-led) institution. In these cases, the funding available is typically reliant on an artist whose work explores issues of diversity and is tied to events programming – bringing in different audiences and demonstrating institutional reach and impact – which 'can be constraining for the artist being culturally placed, or straight-jacked, in this racial framework'. Diversity work can produce race, rather than referring to an objective fact that can be measured, for it acts as 'a technology of power/knowledge, a means of managing the very difference it expresses' (Gray 2016: 242; see also Saha 2017a on British Asian theatre). Although as Saha acknowledges while racial hierarchies are ultimately kept intact by diversity policies, including arts funding for cultural diversity, racialised minorities 'who were once demanding to be heard, are now being heard' (Saha 2017a: 315).

However, special issues arise when a minority artist does not desire to be viewed through a 'racial framework' – 'if they choose not to and it's the only route and access into the arts of course it's problematic' ('Sabina'). Raising similar concerns, but writing on young, male, Arab-Australian artists in Australia, Idriss (2016: 407; see also Werbner 1997) observes that they are typically offered marginal

spaces in which to express themselves and expected to act as cultural brokers for 'their supposedly neatly bounded communities in the name of social inclusion'. 'Sabina' continues that 'processes of racialisation and multiculturalist discourses produce specific vocational identities, namely that of the ethnic minority, community artist who uses their creative forms of expression to redress social inequalities'. By comparison someone who is white and male is not constrained in that way by racially defined funding criteria that require artistic output to reflect personal identity markers. Nor is there the same expectation that artwork will perform a social function to engage new, ethnically diverse audiences into peripheral or mainstream art spaces.

For those who choose to publicly identify as a minority artist, in terms of faith, ethnicity, or otherwise, by the time they are mid-career other issues come to the fore around status as a result of the politics of identity. Mid-career artists can remain unsure if they are selected for shows or gallery representation because of the fit of their identity, rather than the perceived quality of their artwork. A structural issue around readdressing racial inequity can lead to overlapping professional and personal issues where excellence is brought into question and confidence is undermined. 'They will invariably question "am I in this show because of, you know ... Does it tick a box, you know?" Of course they'll question that. And would their white counterparts have the same issue?' As 'Sabina' explains: 'And that's again to do with the structural issues that we have around race and privilege and entitlement.' Of course all artists deal with challenges around platform and profile. Race, however, is 'profoundly complicated'. Dedicated art spaces and funding routes can reproduce marginalisation through alterity to the mainstream. Yet importantly they provide a foothold that gives some visibility and support. As this arts worker reveals, the benefits of this can change over the life course.

Race, racialisation and religious difference are only part of the equation for understanding the complexity of discrimination. In order to understand how exclusion operates it is necessary to discuss

racialisation and religion with gender. For Sara and Zarah the primary identity markers narrated as artists were around Islam and Muslim faith. However, for 'Sabina' issues of gender and patriarchialism are the larger issue in museums and all institutions, and also in the South Asian communities that she is familiar with. As she has observed, men will always find a space to move around in and get by, but movement tends to be restricted for Muslim women both in communities and outside of them. This refers to patriarchialism in dominant white and secular society, and also that which is experienced in social networks rooted in family or friendships. 'Sabina' elaborates:

> It's usually, the voice of the other is generally marginalised, but you know it's either a Muslim male that speaks on behalf of all Muslims, and the complexity of that patriarchy is generally overlooked . . . A male experience, a Muslim male experience, might be very different and will be very different to a female Muslim experience . . . the idea of agency as well, and the practice of power is even more complicated because it's in those other structures that exist which exclude and discriminate . . . So in the context of what I'm talking about, which is a patriarchy, it's possible to be discriminated on the basis of race and religion and gender, but women are somewhere at the bottom of that strata . . . As a woman I think it's hugely important, and also for people I have interacted with because their voice is usually hidden or marginalised. It doesn't even have a platform because it sometimes is channelled through the male voice. And I'm very much aware of that.

When discussing South Asian communities, the interviewee is talking about Pakistani or Bengali groups in particular. She acknowledges that the marginalisation of women is related to class and socio-economic background. Those from conservative and traditional families can experience 'trouble at home' if they do choose to practise as an artist. In Sabina's experience working with artists she acknowledges the 'huge amounts of bravery and courage'

and 'real innovation and pioneering' of 'having to negotiate those spaces' of the home and public space. She continues that the 'decision to do that is really difficult and it can put you in a position of danger'. The danger identified is resultant from an issue of shame for some South Asian Muslim women because of perceptions of a lack of modesty when their voice is heard or a photograph taken. This gendered experience of shame and shaming can make decisions such as whether to cover with a veil or not when stepping into a public space highly pressurised. Another respondent, an artist, spoke on the specific challenge presented by being a Muslim woman entering dominant secular public spaces. She highlighted the slippage between religious and racist bigotry directed most at hijabi women:

> Women are more vulnerable, women are more visible, women are easier to attack. You know, you'd think twice about going up to a 6 foot 3 inch bloke, and yelling 'Paki' at him, you wouldn't. But, to a woman, you're visible in a headscarf, it's easier, and I understand that fear and I understand not wanting to be at the centre of that.

For those artists who had negotiated internal and external spaces, and experienced gendered tensions in personal and private lives around the pursuit of their art, 'Sabina' remarked:

> I have huge respect for some artists that I've worked with who have actually, you know, broken new ground and they've against all odds managed to forge a career in the arts because of all those other things that they've had to deal with.

Prejudice by curators at national galleries and museums was raised elsewhere in interviews, for instance, expressed by minority curators who were openly critical about artists choosing to wear the veil. Such derogatory comments included that the veil was backward or prehistoric, and in fundamental tension with contemporary practices. Reflecting on such an encounter, where traditional Islamic rituals and practices are attacked as irreconcil-

able with modernity, one of the artists responds: 'just because they are historically governed or are rooted in history does that makes them illegitimate? No, religion isn't constrained to a particular time period or a particular place.'

Politics of Representation and Visibility

The burden of representation weighed on many artists profiled in the study. A number reflected on how increased visibility would lead to challenges around the perception and representation of all Muslims. Again the issue of representation arises from the othering of Muslims in the West that by turns marginalises and homogenises a hugely diverse people, culturally, linguistically and spiritually. Elsewhere complex ordering processes of artists has been researched in the decision about what identity markers to use, when and where due to the hyper-politicising of the identity marker of 'Muslim women' and its fetishism (Behiery 2015; Jiwa 2010; Ralph and Gibson 2021). Returning to the view of 'Sabina', introduced earlier, recognition is given to how the media and catastrophic ('terrorist') events have been a 'springboard for defining a whole raft of 1.5 billion people globally'. Post 11 September 2001 the ways in which a small minority of people describing themselves as Muslim and allegedly acting in the name of Islam has disproportionately influenced how Muslims imagined as 'one community' are represented in the public sphere, especially in their profiling in mainstream media. For any minority subject: 'when you're the only person in that space it's even more difficult because then you have that burden of representation' ('Sabina'). This issue of representation was discussed by several people. For instance artist, Azraa, observes:

> We're all perceived as kind of a homogeneous group, when you all have individual identities, individual strands of identities, you all kind of originate from different parts of the world, definitely. So this [self-portrait] is just a glimpse into who I am as a person.

Azraa talks about a self-portrait painted during her time at art school, Chelsea College of Arts, which is a large oil painting representing herself, a young Muslim woman, in everyday wear, sitting on a throne (see book cover image). In the painting she wears a black abaya, gold hoops, adidas tracksuit bottoms, and colourful trainers. Exploring questions of youthful self-identity and Muslim representation guided her at this early juncture of her career, because:

> I think, especially in our kind of political and economic climate, it's very important, especially with [the] Brexit thing right now to be able to represent, to self-represent, in a society where bodies of South Asian and Muslim women are just pawns in political discourse. You know, just to be able to say like this is who I am, and you don't get to kind of paint me with your brush.

The artist refers to the geopolitical significance and symbolism of the Muslim woman in British and wider Euro-American political discourse around migration and the integration of social difference. Here Azraa partly alludes to female agency over self-representation, which is significant in art history given the preponderance of male artists and female subjects. To paint herself with her own brush offers a rebuttal to the masculine gaze of the painter (if not to the viewer) and to the orientalising way that Muslim women as subjects have typically been represented in Western art (Said 1978), such as the reclining figure of the odalisque. As Azraa notes, the pose in the throne is most closely associated with monarchs, especially with kings. At the graduation show, the culmination of the art degree, her work was hung on the front of the art school, an opportunity she sought. The prominence of display of Azraa's painting received mixed responses from her peers: for some it appeared she had been privileged due to her minority background; yet for others it was fair given the historic marginalisation and silencing of minority artists and Muslim women (see discussion in Chapter 3). Such debate on diversity and equality places the careers of minority artists such as Azraa under the lens more than that of her peers. Diversity discourse might then be experienced as an additional pressure. Azraa

becomes attuned to unsubstantiated critiques that inclusion goals are overriding standards on rigour and excellence. Azraa battles with these ideas:

> I shouldn't just be approached because I'm an Asian, Muslim and brown, kind of thing. You know, like – and [that I am] a female . . . I should be approached just on the merit of my work and how it can fit into the criteria, not just cause I tick these boxes.

For another artist, 'Saila', slowness of securing graduate work – something she could only attribute to discrimination given an exceptional track record, including prizes – pushed her towards seeking opportunities beyond 'mainstream' pathways. 'Saila' featured her paintings in Muslim digital publications, put on a solo exhibition, *Unglish*, and took part in a large group show of South Asian Artists in London (*The Beauty of Being British Asian*, Trueman Brewery, Shoreditch). For her 'the struggling made [me] try different things . . . to really force my name out there'. 'Saila' used her multiple, overlapping identities as a minority artist in Britain to position her work within both Muslim and South Asian spaces. In trying 'different things', the artist explores her cultural, religious and classed identity within the Pakistani British diaspora, such as paintings depicting consumption culture on the Curry Mile in Manchester and her father sailing a boat in the Lake District. By the time she gained employment as a textile designer she had invested time and developed an emerging profile within fine art leading to exhibitions that attracted media attention.

The case of 'Saila' indicates that a balancing act is required to maintain creativity, whilst avoiding the exploitation of Muslimness, or being othered, in order to forge a career in the arts. For 'Saila', a mixed media artist who worked across painting and textiles, this involved pushing back on 'assumptions' she did 'a certain kind of art that [is] associated with Islam, like geometric art'. For her the choice of medium, in this instance painting, was a means of resisting typecasting. Supporting 'Saila's' viewpoint on the need for non-white artists to operate without tighter creative control than that experienced

by white artists, other artists explained how tutors encouraged more 'authenticity' in their degree work. By 'authenticity' tutors suggested that the artists 'put more of themselves into their work'; a neologism for identity work. Authenticity to culture and religion requested by a preponderantly white, middle-class art world risks becoming another way in which minority artists are essentialised and ultimately pigeon-holed. Reworking ethnicity and identity markers is possible, however.

Dwyer and Crang (2002: 427) explore how ethnicity is constructed, considering the making and representation of ethnicity within society and markets. They complicate the relationship between commodification and ethnicised subjects, by arguing that artists themselves are not simply exploited by these processes but are often knowing actors. That is, 'how commodification is not something done to pre-existing ethnicities and ethnic subjects, but is rather a process through which ethnicities are reproduced and in which ethnicized subjects actively engage with broader discourses and institutions' (Dwyer and Crang 2002: 427). In fact commodity culture might be viewed as a lively and heterodox set of fields in which to prise open understanding about ethnic distinctions and unsettle purist and essentialising ideas of authenticity. Dwyer and Crang (2002: 427) discuss this in relation to fashion, with implications for other creative sub-sectors and ethnic imaginaries:

> Commodity culture does not inevitably result in the production of superficial, thin and bland ethnic differentiations. Nor does it inevitably involve the appropriation of ethnic forms constructed as 'authentic' through being located as exterior to the operations of commodity culture. Rather, as in the case discussed here, commodity culture can mobilize varied ways of thinking about cultural difference – varied 'multicultural imaginaries'. Indeed, it is a field within which creative work can be done on fashioning those imaginaries of cultural difference and ethnicity.

But Saha argues in response for a more structuralist understanding of racialised hierarchies within processes of cultural production that limit choices around creative expression in capitalist society. Minority cultural producers often become complicit within their own narrow representation due to market pressures (Saha 2012, 2017b). Dwyer and Crang downplay 'the entrenched forms of racism in modern capitalist societies (and therefore the cultural and creative industries) that bear upon the everyday lives of blacks and Asians' (Saha 2012: 436). Saha notes that despite their best political and ethical efforts, black people and Asians can experience racism that is not only about barriers to entry and glass ceilings, but those which are 'rationalized, standardized and commercially driven' in contemporary cultural production (Saha 2012: 436). Minority artists working commercially are vulnerable to complex hegemonies and the enduring strength of imperial discourse that order artistic hierarchies (see Said 1978). While it is right to give emphasis to individual agencies, the structural forces of white-dominated cultural industries can steer minority artists down narrow stereotyped routes of 'Asianness', and the 'racialised pathologies that such signification holds' (Saha 2012: 437). This was most clearly shown by one artist who talked about the kind of work she ended up making in her final year degree show in the 1980s. With humoured self-awareness, she describes fitting into clichéd symbolic tropes of an 'authentic' South Asian textile artist: 'I think I based it on Lahore and just all the ethnic stuff really, it was very ethnic-y, all my final stuff. So there was lots of printed materials and I printed lots of floaty scarves, hand-painted.'

A conflict of identity can be experienced in relation to negotiating a sense of place and Muslim woman subjecthood in a white dominated and secular art world that marginalises and excludes religion. Sara, who I introduced at the start, suggests the authentic Muslim artist should be able to claim a lineage in Islamic art without negative implications for their career:

At the same time I find it's really kind of difficult because if an artist doesn't mind that, if they say I am whatever then that isn't

necessarily an issue, like myself, if I call myself an Islamic artist, then someone else will be like 'well, why are you pigeonholing yourself?'

Sara articulates the strange dislocation of a minority artist in a commercial art world whereby who someone is, and how they identify publicly can shape opportunities and success. Identity work is simultaneously private, intimate and fits within institutional systems of ordering that positions subjects and their work as mainstream or marginal, as part of the artistic canon or outside of it (see Idriss 2016; see Araeen 2000). Araeen makes the argument that non-white artists will typically become successful by 'showing their identity cards' (2000: 16), and yet Idriss (2016), who researches on Arab Muslim artists, shows this self-essentialisation can relegate work to community arts, which is often marginalised and given less status and where the stories of the artist are more important than the quality of the work. Authenticity around a politics of identity might be mobilised as a currency and yet it might also curtail status in the most elite of circles and spaces.

It is relevant here to observe that there is greater complexity in the history of representation in the Islamic world than is often assumed. 'Nazneen', an Iranian artist and art historian, emphasised this point. She highlighted the history of Persian miniature painting that depicts figures including Muhammad himself. In the art of the Umayyad (661–750) and early Abbasid periods (749–c. 900) there is an active patronage of representational art (Milwright 2017). As Islam spread from the seventh century outwards from the Arabian peninsula the figurative artistic tradition in newly conquered areas such as the Indian subcontinent influenced the style and development of Islamic art. In ornamentation from the Mughal Empire (1526–1761) figural representations are common outside of religious art and architecture, and in secular spheres such as palaces and households.[5] There are also active ways that artists negotiate religious censorship. For instance, in contemporary murals in Iran where the subject is religious therefore the formal depiction of the

figure is permitted. For 'Nazneen', who paints in an abstract figurative style, a sense of personal integrity was recognising the validity of her choices as a person of Muslim and Zoroastrian heritage, who was not religious, and for whom the study of history of art reveals variance, nuance, and unevenness around the treatment of visual form.

Action-based Approaches in Museums and Galleries

Over the past ten years there has been a wave of attention and initiatives around diversity work in British museums, galleries and learning spaces. While there is little evidence of changing demographics within the cultural workforce, particularly at management level, there is heightened visibility of access and equality initiatives. More than changing audience profiles, diversity work requires restructuring the workforce, platforming or exhibiting or showcasing different arts, writing about and reviewing different arts. In order to respond to increasing urban diversity and to remain relevant it has been clearly communicated that institutions need to perform better across all stages. Arts Council England for the first time has emphasised the importance of diversity, with Sir Peter Bazalgette the very first chair to prioritise diversifying audiences, artwork and workforces (Faruqi 2017). As detailed earlier in this chapter, one of the ways in which Arts Council England sought to effect change was through the Change Makers Programme, to develop new senior leaders from diverse backgrounds and to seek advice on diversity policies and practices. The stated aims are a move to diversify programming and representation in the senior workforce; and also to build audiences – with recognition that there is a need to be responsive towards social pluralism and to change working practices.

On the need to move towards a post-colonial museum studies that repositions its knowledge practices, Mathur (2005: 706) writes:

> This raises important questions for the critical study of the museum or for critical curatorial work, because the knowledge paradigms of the museum are a classic product of European

modernity, and would appear to demand the repositioning that Chakrabarty suggests. How, for example, should we acknowledge the dominance of western museums, while also subverting – or at least not reproducing – their history of universalizing and totalizing claims? What kinds of critical practices will this require? What kinds of exhibitions should we be seeking? In short, what kinds of narratives should we imagine and tell?

Museum studies, if conceived in this way, would have a broad interdisciplinary relevance in the humanities and social sciences, but it would not lose sight of the museum itself as a complex social and political institution (Mathur 2005: 706). A new era of museum practice does appears to be underway. The new paradigm breaks with old (universalist) didactic pedagogical practice steeped in paternalistic principles on enlightenment values and education of the masses, towards a subject-centred methodology that approaches institutional knowledge production critically. Anti-racism, post-colonialism, de-colonialism, anti-capitalist and feminist theory are informing curatorial approaches and decision-making on issues of display, interpretation and collections.

In human geography recent attention to social and engaged pluralism in work on migration and difference in cultural and social geography and strands of economic geography are indicative of a critical approach that is sceptical of singular narratives of cultural forms and the world. In attempting to open up ways of seeing, pluralism shares a political orientation with calls to de-colonialise museums and knowledge production. Museums and art galleries have curated collections in ways that have privileged Western art within the history of art by centring certain artistic objects as the most important and valuable. Much has been written on how museum taxonomies are rooted in a colonial era racism that orders, ranks and displays other cultures and people for the viewing pleasure of mostly white and middle-class audiences. In calls to de-colonialise museums and collections artists, academics and activists have asked for museum workers to engage with different voices, different interpretations and

different objects or performances in their spaces (see Tolia-Kelly and Raymond 2020; Meghji 2017, 2019). Or, as has been happening since the 1990s, albeit in a piecemeal fashion, have argued for the restitution of works to the places of the world from which they were first removed, often without the consent of those to whom the work originally belonged. Object restitution and repatriation since the 2018 Sarr–Savoy report in France, which advised the large-scale return of African objects, has meant that museums, galleries and heritage sites are entering into a geopolitics of cultural diplomacy. In order to show this new action-based set of approaches to curating collections, I will now turn towards two examples, including one for which I acted as co-curator.

Practice around post- and de-colonial approaches to museum and gallery practices has largely centred on matters of collections and their interpretation. Recently Birmingham Museum and Art Gallery attracted widespread attention in the museum sector, featuring in MuseumNext, a conference of museum professionals from around the world, and garnered media coverage on their exhibition display *The Past is Now*. Museum workers collaborated with six local non-white cultural activists framed as co-curators who were asked to reinterpret the objects in the museum to critically engage with the storytelling of the British Empire and the city of Birmingham's role within it. The six co-curators were: Shaheen Kasmani, Sara Myers, Aliyah Hasinah, Mariam Khan, Sumaya Kassim and Abeera Kamran. In her presentation of the experience Shaheen describes how diversity has failed. Many museums and galleries have not had a successful diversity drive. As she argues, de-coloniality is not another word for diversity, it is an upfront challenge to white supremacy by decentring a Eurocentric view and valuing the narrative that has been othered. Referencing the work of Fanon and Said, Shaheen here dismantles systems of thought, epistemologies, methodologies, philosophies, faith and the straight white man. Shaheen critiques the hierarchies in museums as entrenched, observing the small budget given to payment of the co-curators which led to feelings of exploitation, the ways critical interpretations were rewritten,

and the impermanence of the show, 'a temporary ethnic exhibition to tick a box', with the re-interpretation failing to filter out to a reworking of the wider practices at the museum. In a wider political context, Shaheen views colonial structures and micro-aggressions that enabled the Windrush scandal and Grenfell Tower disaster. Therefore, whilst the process of reinterpretation was radical for the museum, 'we just thought we were telling the truth'. *The Past is Now* was an important, if controversial, moment in the history of curating for Birmingham Art Gallery, receiving negative press from *The Times* newspaper and some trenchant critiques from the guest co-curators. It highlights the challenges of adequately addressing historic inequity of representation through one project, and points towards the need for structural change in how art galleries, museums and collections engage with the multiple legacies of colonialism.

In recent years there has also been considerable energy around de-colonial, anti-racist and feminist approaches to exhibition-making and curatorial practice in the city of Manchester. This has drawn some historical rootedness through the centenary anniversary of suffrage for middle-class women (working class suffrage followed) and critical reflection on the British Empire and legacy of colonialism arising from the seventieth anniversary of the partition of India. For instance, the New North and South was a series of collaborations and exhibitions with partner organisations from the UK, India and Sri Lanka (Warren 2020). The New North and South partnerships launched:

- the Waqar Khan exhibition at Manchester Art Gallery, a young contemporary artist from outside of the normal art school route
- the display of Urdu and Farsi scripture in the windows of Manchester Art Gallery, Manchester Museum, and The Whitworth, the three leading museum and art institutions, to welcome in South Asian communities
- the new South Asian Galleries in Manchester Museum working with the British Museum.

A clear signal of the intention behind this series of ideas and interventions are that a stated aim of the Manchester galleries is to 'use art for social change' under Alistair Hudson and Esme Ward, and to de-colonialise their spaces and collections including through the repatriation of stolen sacred ceremonial works.

This provides some useful context for the second example I will discuss here. *Beyond Faith: Muslim Women Artists Today* was a major exhibition that was intended as the culmination of the same research project that gave rise to this book. *Beyond Faith* was an exhibition for which I was lead researcher and co-curator. Broadly the co-curated exhibition sought to investigate the renegotiation of Muslim women's identities and spaces of belonging in contemporary Britain. It aimed to bring together different voices and contemporary practices of Muslim women artists working in Britain to: (1) nuance and challenge narrow representations of religious conservatism, victimhood and subjugation often perpetuated by the media and Western-secular policy and reports; (2) pluralise voices of Muslim women in public space, and provide a new platform for their work; (3) show creative ways in which many Muslim women are negotiating their own image, representation and positionality in cultural forms and industry; (4) show and fund contemporary art practice by Muslim women artists; (5) provide some opportunities, and points of shared identification and belonging for minority ethnic and under-represented groups in art galleries.

Beyond Faith opened between June 2019 until February 2020. The exhibition featured the work of five different, contemporary Muslim women artists in conversation with pieces drawn from the historic collection: Robina Akhter Ullah, Shabana Baig, Fatimah Fagihassan, Aida Foroutan and Usarae Gul. Co-curated with the artists, Uthra Rajgopal, assistant curator, Andrew Vaughan, learning manager, Jana Wendler, research assistant, and myself, the exhibition comprised a large gallery space in which each artist had their own section, with shared cases that displayed smaller items, and free-standing objects. Robina showed printed geometric textile work using Pakistani and English textile techniques. Shabana's work

was mixed media with original line drawing, painting and textiles with repetition of symbols of prayer and everyday life ('posh tea'). Fatimah, a recent graduate in illustration, showed her wallpaper design and a mosaic of wood and canvas with mixed tiles. Aida's work was selected from a series of twenty-eight oil on canvas paintings called *Women's Life*. Finally, for her exhibit Usarae selected acrylic on canvas paintings of the cultural landscapes of Manchester, such as restaurants on the Curry Mile. The exhibition also extended into the main exhibition space with pieces from the artists shown in dialogue with *Four Corners of One Cloth: Textiles from the Islamic World*. Filmmaker Ricardo Vilela created an exhibition film featuring interviews, performances and processes of making with each of the artists that was on display in the large gallery space. The filmmaker worked together with the artists in order to represent their voices and art in appropriate and sensitive ways, whether using visual images of the individual dancing, or using subtitles where the artist did not want their voice, face or body on display. *Beyond Faith* therefore created a conversation with researchers, arts professionals, and audiences about representation and social difference in visual art.

Resisting closure around Muslim women's identities in Britain and form in contemporary art practice were important aspects of the exhibition and event programme. Intra-Muslim diversity and placing work by explicitly Muslim (of Muslim faith, culture or heritage) artists into dialogue with modern and post-modern art sought to push back on typecasting of artists of Muslim faith, which Araeen (2000) discusses in relation to Arab artists. Like other artists working outside the West, Arab artists are often asked to represent their cultural heritage within their artwork, their nationality or their political environment (Araeen 2000). In short, exhibitions often ask for a display of culture as seen through the eyes of the West, either through 'singular narratives' of war and trauma, or by excluding Arab artists from the canon of art history. Attempting to open dialogue around narratives of Muslimness, *Beyond Faith* coalesced around multiple themes of identity, culture, otherness and belonging. These themes were co-produced through analysis

of earlier stages of the research (by interviews, focus groups and artist diaries) and workshops with the artists. For some of the artists certain themes resonated more than others, and were questioned at different points in the exhibition's production. The exhibition sought to provide a platform for a select group of women based on some shared characteristics, whilst not reducing, assimilating or speaking on behalf of them. On curating difficult knowledge, Irit Rogoff (2007: n/p) presciently writes of the need for openness in acknowledging limitations and the potential for failure, 'A pedagogy at peace with its partiality, a pedagogy not preoccupied with succeeding but with trying'.

Beyond Faith aimed to give space to building new interpretative bridges. The artists developed new constellations of interpretation around selected artworks from The Whitworth art collection. The range of audiences to *Beyond Faith* was indicated by feedback visitor sheets and cards, and included white, middle class audiences and newer, Muslim and minority ethnic audiences. Deliberately cutting across curatorial and educational functions of the contemporary gallery, the co-curatorial team included those associated with access and inclusion (education and learning), and distinction and excellence (curatorial). It therefore sought to offer a way of navigating new ground with awareness of how ethnic minority artists are often asked to work as cultural brokers and community bridges (see Idriss 2016), rather than as important international artists where work is judged on criterion of originality and skill. *Beyond Faith* used common aspects of peripheral identity markers in the art world – Muslim identity, and gender – to begin to readdress social inequalities and to spotlight the contributions of Muslim women artists. It thereby offered an action-based approach to attempt to transform the findings in the wider research project into a structural intervention in the contemporary art world. I include it as a leading example of praxis that sought to sharpen knowledge of the tensions and contested narratives around matters of identity and artistic distinction, addressing the role of religion, ethnicity and gender in the exclusionary and hierarchical nature of visual arts and the art world.

Conclusion

> People [are] not wanting to call themselves Islamic artists because
> there's a fear that they might be marginalised or they wouldn't be
> given the same opportunities or the work wouldn't be exhibited. I
> understand that. ('Farzana', Visual Artist, British Pakistani)

In this chapter I opened with a discussion of 'digital Islamic arts',
a hybrid term combining digital art and Islamic art, and the work of
prominent artists Sara Choudhrey and Zarah Hussain before reflect-
ing upon the narratives of a wider pool of arts professionals and
emerging artists in relation to institution structures and framing, and
the politics of representation and visibility. I moved on to discuss
action-based approaches to expanding the representation of Muslim
artists and contemporary Islamic art in Britain and beyond in lead-
ing gallery and museum spaces.

As the quotation above suggests, there are tensions between
religious expression and secularity in visual arts and the art world.
Reported advice given by leading professionals in the art world
not to position oneself as an Islamic artist raises pertinent ques-
tions. Beyond reinforcing prejudice, Islamic religious faith is typi-
cally eclipsed from the story of modernist and post-modern art.
Distancing Muslim faith and Islam from the narrative of artistic
production can thus serve as a strategic act, albeit for individual
artists this can be an act of self-erasure. In the art world, a review of
collections and exhibitions suggest preferred master identifiers, of
ethnicity and region, such as 'Middle Eastern' or 'Arab'. It appears
ethnicity and area-based approaches are more palatable to the art
market than religious systems of belief and creativity inspired by
a higher purpose. Post-enlightenment humanist values and scepti-
cism are apparent indicating pervasive issues around the acceptance
of modernism's 'others'. Knowledge of the art world truly attuned
to social pluralism – that the world includes different ontologies,
epistemologies and methodologies – would include the role of
religion and faith in contemporary art. The examples I explore are

Muslim women artists and contemporary forms of Islamic inspired practice. However, there are resonances around gendered and religious exclusion from the art canon, and their intersections, that can be brought to light elsewhere. In relation to abstract art, for instance, the Swedish painter Hilma af Klint, a member of the Theosophical Society, was erased from the story of modernism. Pertinently, Klint's erasure has been attributed to three things (Jeffries 2020): her spiritual beliefs; her lack of art networks; and her gender.

More than an issue of denying minority subjecthood, then, the rewriting of a persona to allow entry into mainstream art leaves discriminatory attitudes around religious artists unchecked. The discrimination is spatialised through perceptions of what 'fits'; making a perceived 'misfit' of material culture crucial for framing relational understanding of equality and social justice. Cultural spaces are often discussed as classed spaces, but they are also racialised. As Wallace observes cultural spaces are most visited by middle classes and 'middle class identity is often synonymous with whiteness' – in turn leading to black people of any class to 'passing' or 'code-switching' (Wallace 2017: 916; see also Meghji 2017, 2019). Beyond the 'preferred' indexes of class and gender in research on social inequality and exclusion, then, this chapter is attuned towards addressing other gaps in what is deemed important to research. In focusing on Islamic religious faith and inequities in narratives of cultural labour for the first time in the context of museums, galleries and visual arts, this chapter uncovers how certain key aspects of identity and history are obscured from view and therefore from mainstream critical discourse. Such documentary work undertaken by artists and curators including Sara Choudhrey is therefore crucial to readdress the marginality of art from the Islamic tradition within the story of Western modernity. Post-colonial strategies around rewriting art history and the landscape of contemporary art can help reframe a tradition of Islamic visual culture. An issue of form is raised where traditional craft is regarded as an outlier to the innovations of modernity and post-modernity. Combining traditional craft and technology in new Islamic art, such as digital Islamic art, offers a way of respectfully and

playfully remaking symbolic forms that offer new narratives about the place of Islam in contemporary culture.

The chapter further raises issues of identity and self-identity, and how this is interconnected to positioning artists within the art world and funding regimes. There are persistent concerns around marginalisation and under-representation of minority artists, especially women, within patriarchal structures at home and in art institutions. A Eurocentric view of the art world and growth of local art markets in oil rich nation states have acted together to place limitations on the breadth of contemporary art practice on show from those of Muslim faith or heritage. Dedicated art spaces and funding routes can reproduce marginalisation through reinforcing parallel spheres and enforcing alterity to the visual arts mainstream (such as leading museums, galleries, buyers, critics and fairs). Yet they can provide a foothold on 'the ladder' and enable visibility and support at the start of an artistic career. Nevertheless, there are many artists who are alert to limitations placed on creative artistic production. Why should only minority artists perform identity-work, as a 'South Asian' artist, 'Islamic' artist or otherwise? Identity-work that stereotypes minority artists and limits the scope of their creative oeuvre raises the spectre of multiple forms of artistic and aesthetic regimes of prejudice. Conversely, a light is shone on the seeming neutrality of white privilege where artists are not expected to work 'authentically', or require cultural diversity funding that can plague confidence across stages of the artistic life course, asking themselves: 'was I selected because I am a minority? Rather than because of quality?'

Notes

1. There is also the Muslim Museum (an online museum that lists British Muslim artists), set up by Mobeen Butt, which explores the relationship of Britain and Islam, and the history of Muslims in Britain.
2. The Jameel Prize is open to artists and designers from any ethnic, religious or cultural background.
3. Available at <https://essexcdp.com/commission/zara-hussain/> (last accessed 1 December 2021).

4. Available at <https://www.artscouncil.org.uk/funding/change-makers> (last accessed 2 December 2021).
5. For example, see <https://www.metmuseum.org/toah/hd/figs/hd_figs .htm> (last accessed 4 December 2001).

8

CREATIVE ACTIVISM:
TACKLING ISLAMOPHOBIA,
RACISM AND SEXISM

Introduction

Over the course of this book I have explored the roles of Muslim women in creative fields and how issues of identity are shaping working lives. In this chapter I give more space to the discussion of discrimination, oppression and hatred experienced by many of the women I researched with. Social identities are multifaceted therefore reported lines of discrimination were multiple and complex. Although matters of identity are interrelational, for some these sorts of marginalising experiences were mostly relating to gender, for others issues of ethnicity, race and culture were prime, whereas elsewhere discrimination was viewed as clearly a matter of prejudice against Islam and as Islamophobia. In relation to discussions around negotiating multiple indexes of prejudice and othering, Muslim identity was located variously at: multiple scales (the city, national, transnational, diasporic or in terms of the global 'ummah'); in relation to denomination (for instance Sunni, Sunni-Salafi, Shia, Sufi); or cultural and heritage area (with broad references to South Asian, Arab, British and so forth). I begin by outlining some of the women's reflections on negotiating working lives punctuated by a far-right Islamophobic event. I then discuss everyday encounters

with intolerance and othering. In the following sections I move on to discuss digital films, a Muslim festival and writing group to reflect upon the various and multiple ways that the women in the study responded to hate with their own kinds of creative activism.

Mountz and Hyndman (2006) write how intimate forms of discrimination and racism are tied to global networks of exchange. The global geopolitical events of the rise of political Islam, terrorist attacks and Western imperialism in foreign and home policy, fuelled Islamophobia in Britain, with hijabi women most targeted (Alexander 2017; Najib and Hopkins 2019). In tandem, patriarchal attitudes and behaviours, including restricting women's mobilities, are afforded greater legitimacy through Islamophobia – anti-Muslim racism – where there are rational concerns about hostility and violence in public spaces (Alexander 2017; Najib and Hopkins 2019). Understanding the spatialising logic of Islamophobia in relationship to women's labour transitions might usefully be advanced through feminist thinking. External threats can encourage working from home. Relevant for understanding the cultural labour performed by Muslim women that I have discussed in this book, new aspects of labour might involve: work extension and intensification; anti-essentialist (not singular locations of work); anti-normative (for example, beyond singular performances of work); and beyond waged labour or organised production (Richardson 2018: 2). Unsettling traditional binary gendered notions of the home as feminine space and public space as masculine, Muslim women's activism places women's issues into the public sphere, and highlights how the lives of minority religious women and their families in Britain matter.

More than creative innovators in sub-sectors of the cultural and creative industries, many of the actors profiled in the research are active charity and women's development campaigners. Arts and culture can offer a vehicle for social change and a space for hope (Malik et al. 2020). I use creative activism to refer to activities that seek to use visual art, fashion, writing or other cultural forms to advance understanding and knowledge of difference and discrimination with address to a wider public. The intrinsic spiritual and embodied

dimension of making art offers a motivating impulse for some. I consider how contemporary formations of Muslim identity have in different ways intermeshed with creative expression. Religious identity expands a normative conceptual and organisational framing for arts and culture, which Gilbert et al. (2019) persuasively argue is strongly secular in approach within Britain. By revisiting and revisioning the landscape of arts and culture, overlapping geographies of the sacred-secular are brought into perspective. This serves to broaden knowledge around the contribution of minority religious actors who have been under-recognised in secular state and industry policy reports, and where religion is not featured as a criterion of inclusion in work around issues of access, despite being a protected characteristic. Attending to the imbrications of civic and cultural interests therefore offers a re-framing of cultural ecologies that have been recently sidelined by a narrow championing of economic growth narratives.

What I want to establish here is the intersecting nature of charitable work and creative labour in what I term Muslim creative activism. Porosity between the civic and cultural sectors, evident in actors moving between them, might suggest their compatibility for advancing a political vision or ethical outlook. There are cases where an established arts career leads into active political campaigning, underscored by the prominence of the individual. It is pertinent to consider the visibility of activism that is Muslim-centric, about inter-faith relations, or women's equality. In part this active synthesis between the civic and cultural also raises the question of whether charity and activism might be utilised as a gateway into creative labour. For example, through the building of social networks, community spaces, audience followings, status, or provision of a regular salary. As I have explored earlier in the book, in Chapter 3 and elsewhere, livelihoods built around minority ethnic identity can foster opportunity, or a route in when there are a limited set of choices, but it can also shape boundaries for creativity and success. When contouring what Muslim creative activism entails, therefore, it is necessary to take pause to consider more holistically a politics of identity within cultural labour, and how gendered, ethnic

and religious difference are acting together in spaces of cultural production.

Through creative activism, Muslim women are calling into space the ideal of unity, while disrupting and interrogating Muslim womanhood as a singular concept, and mobilising alternative spaces of social formation. Creativity thereby offers a dually constructive and destructive potentiality. Feminist geopolitical approaches and Ahmed's social theory of discomfort feminism are helpful in understanding these series of dynamics because of their resistance towards closure and recognition of multiplicity and difference. Tensions arising between personal and collective agencies (family, community) have typically been the source of exploration in studies tracing market choices and exclusion. Important stories of transnational cultural production and the emergence, and continual remaking, of diasporic migrant identity have long been discussed, where recognition is given to how form and identity travel together (Blunt 2007; Dwyer and Crang 2002; Crang et al. 2003; Dwyer and Jackson 2003). Cultural goods and cultural work, including the performance, making, sharing, selling and consumption of music, dance, food, novels, poetry and fashion, are central in the building and rebuilding of diasporic identity over time and in relation to place, as Werbner (1990, 2004) has shown in relation to Manchester's Pakistani communities. However, as I have explored throughout this book, there are evident structural ways in which inequality, poverty and exclusion are reproduced within the labour market and wider society. I suggest that adopting a multi-scalar, relational and structural approach that critically looks at how institutionalised and societal norms come together with subjective agencies through a series of cases can better inform the nuanced complexity of minority labour experiences in contemporary Britain. The concept of agency has been critiqued as romanticised and while I do not seek to overemphasise agentic power over structural inequalities – for this might serve to minimalise oppression and exclusion – it is pertinent that the women profiled in this chapter are organising through performance and material culture as a way of creating more hopeful spaces.

Muslim Activism in Britain

It is useful to begin by noting that the term 'British Muslim' has itself gained ground as a form of activism. Contextualising its growth in popularity in the realm of political action, Carl Morris explains: 'there are multiple ways through which the term "British Muslim" is mobilised as an active concept and site of solidarity' (Morris 2018: 418). In the wake of the outcry surrounding Salman Rushdie's *Satanic Verses* (1988), a post-modern novel inspired in part by the life of the Prophet Muhammad, new expressions of unity were articulated and performed across the very different and disparate Muslim population in Britain. Although of course there was also dissent and criticism towards the issuing of a fatwa on the life of the author according to charges of Quranic blasphemy. The nomenclature of British Muslim thus speaks of Muslim identification and belonging to Britain, but it should not be viewed as a neutral construct. For British Muslim, 'actively yokes together a form of civic nationalism with religious identity' (Morris 2018: 416). It arose in a specific political juncture, as Morris explains, that requires further carefully contextualised reading given its very flexibility – spanning four countries and range of attitudes towards the coexistence of Islam and Muslim ways of life in a secular state. It is this very political flexibility, whilst clearly foregrounding religion, that has led to the increased adoption of the term. As Morris details: 'It is a creative syncretism and synthesis that can range across the merging of British political ideologies with faith-based activism, to the meshing of pedagogical and intellectual heritage, to the expansion of an Islamically-informed civil society, or the development of Muslim cultural and media resources in the public sphere' (Morris 2018: 420).

Taking a broader historical approach, Elshayyal (2018) provides an examination of the origins and movement of Muslim identity politics in Britain over the past fifty years. She finds that Muslims have been politically organising qua Muslims (rather than ethnic-national groupings) since the 1960s, with this gathering pace from the 1990s. While the forms of Muslim activism are as diverse as

they are pioneering, the main points of action revolved around issues of education and its provision, before moving into concerns with identity and legislative lobbying, after what came to be known as 'the Rushdie affair'. Key moments include the founding of the Federation of Student Islamic Societies (FOSIS) in 1963, the Muslim Educational Trust (1966) and the Union of Muslim Organisations (1970), to the reformist groups of the 1980s, such as the influential Young Muslims UK (YMUK), through to the rise of Salafi-oriented networks in the 1990s. Elshayyal highlights that emergent features included the influence of wider transnational Muslim political networks, as well as the role played by these early groups in developing different forms of Muslim leadership and organisation. From the 1990s the 'formalisation' of Muslim identity politics can be observed in the establishment of the Muslim Council of Britain in 1997, following national attention on Rushdie's *Satanic Verses* and public debates around freedom of speech, blasphemy and religious discrimination. Core to the lines of debate drawn by Elshayyal are the arguments of the 'Equality Gap' that derive from the work of Modood to examine the specific discrimination that Muslims face as an ethno-religious group. It is worth briefly rehearsing these legal and religious arguments.

As I have discussed earlier in this book, while the Race Relations Act 1976 made a significant difference to many lives, it did not explicitly include faith and religion. Instead religion was subsumed within ethnic and racial categories. Case law applied to the Race Relations Act led to an unevenness under the Act that meant Jews and Sikhs were protected, as they were regarded as ethnic groups, but not those from other religions, including Muslims and Hindus. Given the rise after 11 September 2001 in Islamophobia and recorded hate crime against Muslims the lack of legal protection for Muslims by the Act gave weight to attitudes of British Muslims they were unfairly treated by British law. Elshayyal thus argues that while the Race Relations Act 1976 was an important step forward for equality in the country, it gave no clear space for religion. Her book traces the political dynamics that led to the demands for a more unified

representation of Muslims in Britain. British Muslim activism in this reading is thus interconnected with a continued fallout around the Race Relations Act 1976 in the perceived marginalisation and lack of protections for religion. With the establishing of the Equality Act 2010 religion and belief were included. However, there is a degree of tension, or British pragmatism according to Modood (2016), within British law that positions religious faith outside the public sphere, thereby allowing for different systems of belief as long as they do not contravene the law of the land.

In recent history British workplaces and holidays have organised around Christian and Christian secular norms, such as Christmas and Easter, with a standard working week protecting the most important Christian day of prayer, Sunday. Workplaces under the Equality Act 2010 are expected to make reasonable adjustments for religion and belief, such as: prayer facilities; the right to wear clothing that respects religious beliefs, even when there is a uniform; respect towards religious holidays through annual leave or unpaid leave; respect towards food requirements and not imposing cultural norms, like the drinking of alcohol. Freedom of speech is protected but not if it impinges on the rights of others, such as the distribution of hate leaflets in the workplace. But for those working in the cultural and creative industries, many of the jobs are self-employed, rather than organised through companies, therefore the regulation of equality and diversity legislation is significantly weaker.

Muslim Creative Activism: New Directions from Women and Young People

There is a growing literature on Muslim activism, across formal and informal forms of political organisation, although the gendered dimension remains largely overlooked. An exception is the formative work of Werbner (2002), who describes the political activism of Muslim women's organisations in Britain for Muslims in Palestine, Chechnya and Kashmir. Werbner focuses on the Pakistani diaspora in Manchester, the roles of women locally, and in wider geographies of international charity against violence towards women.

Crucial to her ethnography on diaspora is the 'compelling sense of moral co-responsibility and embodied performance' across national boundaries (Werbner 2002: 12). Werbner further articulates the formation of diaspora through aesthetics; such as how novels, poems and films foster identity and exchange. In ethnographic observations, women engage in active 'displays' of heritage through material culture and performance by exchanging gifts, dance and singing, and also fundraising and lobbying. Yet in the fieldwork observations mostly undertaken in the 1970s and 1980s women remain peripheral figures in male-dominated social events. Werbner also describes hostility towards women-led charitable organisation where there are gendered inequities in community judgement. Most pertinent for the present study, Werbner shows how aesthetics and politics are two important conduits for strengthening local and supra-national ties. A stronger moral engagement with the global Muslim community is observed, alongside an increased engagement with British political institutions leading to stronger articulations of membership within British society. More recently the point of Muslim-led activism leading to multiple, stronger allegiances is underpinned by the research by Morris (2018) that I referred to earlier on the growth of usage in the term 'British Muslim'. Accounts like Werbner's stress not simply the coexistence of 'homeland' and host society affinities but reveal the interactive, multi-layered and overlapping nature of these affinities. Migrant groups, according to this perspective, belong to multiple communities, have multiple political objectives, and in some cases have multiple citizenships. While there can be important tensions between different memberships, they should not be seen necessarily as mutually exclusive (Fitzgerald 2004; Leitner and Ehrkamp 2006; Nagel and Staeheli 2008). After all, as Modood (2016) argues, British Muslims' assertiveness around their rights and activism is informed by Western ideas of equality – that is, an acceptance and pride in the public sphere. Modood's point is clear on rights to education, for instance, effective campaigns for publicly funded Islamic schools.[1] Relatedly, Werbner and others have argued that the private and public spheres are no longer distinct, which is evident in

Muslim women's activism where women's issues, supposedly those of private and domestic space, are brought into public view to ensure equal rights. Elshayyal (2018) describes the turning away from mainstream British politics by many young Muslims. But this pattern might differ depending on the nation state. In mainstream Scottish politics, where there is ongoing struggle around Scottish independence from Britain, Finlay and Hopkins (2019: 15) have observed the 'active confidence in many of the young women, with a number of participants engaging in politics and civic life through a variety of participations', where subjects resist the gendered difference and insecurity that is spatialised in the public sphere. Instead, by taking on visible political roles, young women, 'mobilise counter exercises of power that aim to resist and undermine the dominant forms of discrimination' (Finlay and Hopkins 2019: 15). In short, young Muslim women are making themselves seen and heard in political life, through both formal and informal political paths, which is informed by their historic treatment by the state.

Elsewhere studies on Muslim political engagement and citizenship have de-centred the relevance of nation and nationality, attending instead to practices in the neighbourhood (Dunn 2003) or supra-national, global or cosmopolitan identifiers (Warren 2018; see also Simonsen and Koefoed 2020). Re-scaling of identity is particularly striking as a theme in studies with younger Muslims. Mustafa (2016: 466) captures this eloquently: 'Active citizenship, as the lifeblood of democracy, is expectantly performed through political and civic activism where young Muslims are seeking to reframe citizenship in post-national and universal terms, project community or humanity rather than nationality as the significant frame of reference.' Departing from more recent narratives of consumption and materialism in the lives of Muslim youth, Musafa argues that: 'Participants embrace civic duty and public spiritedness for a radically different set of reasons and priorities guided by faith and universal humanitarian values rather than neoliberal market-oriented economic concerns' (Musafa 2016: 466). But, as Nagel and Staeheli (2011) remind us, activism by Muslims is not necessarily faith-led.

Muslims express and enact various religious and secular identities in their activism, wanting to be 'active citizens'; however, this does not equate to unified ideas on the role of religion in public life in the UK and US (Nagel and Staeheli 2011: 438). Returning to my earlier point about multiple identities, and shifting master identifiers, for some Muslim identity ought to be a private matter, and public political selves might be organised instead around, for instance, Arab identities or women's rights.

Especially insightful here is Harris and Roose's study (2014) for identifying the shifting landscape of civic engagement particularly amongst young people. They argue for a reconceptualisation and reframing of citizenship when understanding contemporary practices of Muslim youth from immigrant backgrounds. Harris and Roose propose that an Australian government focus on Muslim youth and a lack of mainstream community activity and formal citizenship practices does not account conceptually for a broader set of civic practices engaged by those from immigrant backgrounds who have shifted towards 'do-it-yourself' citizenship. The main focus of civic socialisation for young people now is in the leisure and consumption domains, Vinken reminds us (2005: 150), including media and Internet use, cultural activities, and shared consumer interests, fashions and musical tastes. Direction in how to live well can be provided by faith, as amongst a social, political and economic landscape of risk and uncertainty, and DIY culture, 'Islam can provide a welcome foundation for guidance' (Vinken 2005: 150). Self-fashioned renewal and revivalism in personal piety is thus pursued (Vinken 2005: 807). In other words, the shift towards DIY as a technique of becoming a civic actor plays out in the domain of religion for many young Muslims, who connect elements of Islam with good citizenship. Harris and Roose (2013) show how social practices, civic-ness and Muslim youthfulness come together in migrant lives. Research should include a regard for the ways that pietisation interlinks with the emergence of post-traditional lifestyles (see Turner 2008: 20), as well as an understanding of 'Muslim cultural capital' (Jakubowicz et al. 2012: 56; Bourdieu 1979). Or, in the words of Harris and

Roose (2013: 810), 'resources inflected by an interaction of tradition and modernity, that can facilitate young Muslims' participation'. Significantly the study points towards the relevance of cultural production and consumption for understanding the contours of Muslim activism, and its changing landscape. Political orientations and gestures are often transitory, with ephemeral links, such as one-off donations, volunteering or blogs, rather than in formal memberships that are easily traceable. In this regard Muslim youth activism reflects wider currents of political transition in how youth engage with politics, in a move towards more informal practices.

Directly addressing British Muslims and art and culture, Lewis and Hamid (2018) highlight how creative forms are not uncontroversial, however. They acknowledge intra-Muslim difference and divides around issues of creative expression, and Muslim/non-Muslim barriers: 'These questions also indicate the strains within Muslim communities around the nature of artist expression and the difficulties of gaining recognition in the mainstream arts world.' They also recognise how cultural production is 'often but not always informed by their faith' (178), detailing a range of purposes from creatives expressing themselves, challenging stereotypes, to raising political consciousness. In the rich empirical examples drawn by Lewis and Hamid there is suggested an intended overlap between creative expression and activism. But more than issues of situating minority artists as community brokers, and the associated negative impacts this can have on artistic status in the wider art world, they describe the special concerns that are particular to Muslim sectarian difference and Islamic interpretation. In their words: 'These artists and cultural producers explore difficult issues and help bridge the divides between communities. This development creates exciting opportunities but also uneasy tensions within communities as some forms of visual and performing arts are considered religiously problematic' (Lewis and Hamid 2018: 178–9). Alongside religious doctrinal concerns with certain art forms, from some quarters, other kinds of challenges are laid bare. The relevance of Islamophobia in the cultural and creative industries is raised. But they leave room for further analysis of

different kinds of gendered actions and what the significance of the gendered dimension of this creativity means.

Daniel DeHanas asks an overarching civic question of the youth he researches: 'what kinds of citizen are they becoming'? Writing on post-migration religion in London, DeHanas explores how faith-orientated cultural production can multiply imply self-realisation and change, and can arguably act as a form of pillared activism for young Muslims (2016).[2] By pillared activism, DeHanas refers to actions for social change built on the rituals of Islamic practice. Mostly centred on the Five Pillars of Islam, actions might relate to shahada (confession of faith), salah (prayer), sawm (fasting during Ramadan), zakat (alms giving), and hajj (pilgrimage to Mecca). DeHanas notes the ritual practice of the pillars, with practice every day, such as prayer and confession, or each year, for fasting and alms-giving. Therefore the pillared activism is underpinned by 'the consistency of regular communal practice' (DeHanas 2016: 179). He outlines two mechanisms of pillared activism: (1) solidarity through ritual; and (2) social change through ritual. For instance repeated rituals create stronger kinship ties and bonds; meanwhile certain rituals, such as zakat are themselves vehicles of social change. Charity given through zakat might contribute to social change because they finance an Islamic system of redistributive justice (DeHanas 2016: 181). As part of his ethnographic fieldwork of Bangladeshi youth, DeHanas attends a Ramadan 2009 event in East London where he observes the coming together of these mechanisms where men invoke zakat and kinship to get donations. Islamic ritual practice here merged together with political practice (DeHanas 2016: 182). Explaining how Pillared activism works in the context of the Big Iftar event for Ramadan, DeHanas says '[It] is effective because it harnesses the pre-existing architecture of Islamic rituals for new and creative ethical ends' (2016: 186). He also describes the mingling of politicians, celebrities and musical performances that created an event culture: Baroness Pola Uddin, reality television star Syed Ahmed and white English Muslim Naseeha singing nasheed songs mixed with R&B. In the latter case,

Naseeha performed 'Allah, Help us Change', an example of 'person based spiritual change', as DeHanas defines it, with comparisons to revival activism (2016: 177). Culture and performance, such as comedy and music, is part of the landscape of communal activism. It is framed as a channel for a different, higher spiritual purpose. In the context of my research it is revealing that the community leadership discussed is mostly male, despite the examples of high profile women performers or women political figures who can draw a crowd.

We can understand there is a significant gendered dimension to the channels by which individuals contribute to discussion of religious faith and everyday life in the public sphere. This broadening of ways to reach and build a listening public has been especially popular with young Muslim women. International studies have attended to the Egyptian mosque movement (Mahmood 2001, 2006) and Pakistani women's religious militarisation as more radical forms of women's piety and organisation (Zeb Babar 2017). In this work the Western-liberal political ideals of equality and freedom are highlighted as inadequate to understanding the motivations of women involved, which are examples nonetheless of female agency. For some it is impossible to conceive that a woman could choose to actively advance a religious political movement that curbs and curtails their rights, even for the pursuit of a purer life and promise of an afterlife. In a different direction, and with focus on contemporary consumption cultures, the imbrications of digital, religious faith and creativity have been written about in relation to so-called Mipsters, the M-generation and New Muslim Cool (Lewis and Hamid 2018; Warren 2018; Warren 2019). I have discussed this in greater detail elsewhere in the book. This work underscores the potential extractive quality of commodification around a Muslim identity by industry consultants, marketing and creative design teams, but also the creative agencies employed by Muslim women and young people to monetise their 'unique selling point' in a way that aligns with, or steals back from, the commercial zeitgeist. There are important inequities of experience between different Muslim women; black Muslim

women have been marginalised by the dominant representation and discourse centred on British Asian Muslims, for instance. Writing on online Muslim women's activism spaces, Newsom and Lengel (2012: 32) question

> whether these spaces can in fact provide voice to marginalized persons, or if they are re-creating digital, gender, and political divides. We suggest they are simultaneously empowering and restrained by hegemony, that they provide an impetus if not the means for altering hegemony.

In the transformation of local knowledge into global knowledge, Newsom and Lengal argue that gendered messages are constructed, essentialised and reconstructed by Western corporate media. Perhaps as a counter-politics, quieter forms of creative activism are evident, too, along with social dynamics that extend beyond the young and fashionable in their more-than-economic aims.

I will now turn to some empirical examples of the hatred and prejudice encountered by participants in the study. The participants were asked to complete a working activity diary of their cultural production for one month. Unexpectedly during this time, a far-right hate event was organised called 'Punish a Muslim Day' (3 April 2017). As the entries reveal, it was notably received by most participants as yet another example of tension and oppression in a hostile era that impacts the lived everyday. I will then discuss the empirical findings from the wider study that identify forms of intolerance and othering, before moving onto case studies of what I term Muslim creative activism.

Dealing with Hatred

'Punish a Muslim Day'

Across the research fieldwork participants reflected on their experiences of living with difference. At points, however, these experiences were spiked by overt hatred espoused towards them, either encountered directly or indirectly. Especially pertinent were the troubles

mapped in activity diary entries where participants were asked to write about their daily work experiences: What they did, where, and with whom? What aided any achievement? What acted as a barrier, including any instances of sexism, racism and Islamophobia? The emphasis on enabling and disabling factors was intended to avoid inscribing a deficit model into the narrative of working lives of British Muslim women. In other words, by avoiding building an expectation that gender, faith and ethnicity work together in ways that engender negative consequences. Considering the growth of the Islamic cultural economy and visibility of Muslim women there is a further need to deepen understanding of work lives. Diary-keeping provided a space for reflection and recording of any issues encountered. During the month in which these entries were written, conceptualised as a snapshot into working lives rather than a representative overview, the far right in Britain called for a 'Punish a Muslim Day'. A White Supremacist, now jailed, sent a series of threatening letters encouraging violence against Muslims with a scorecard detailing points 'awarded' for acts such as pulling off a headscarf or bombing a mosque. The perpetrator sent it to various parties including four Muslim MPs, and the House of Commons, which sparked nationwide attention.

All of the participants who recorded and shared a diary in the research discussed their feelings and movements on 'Punish a Muslim Day'. Words used to describe responses to the day included fear, apprehension and hostility. Plans were typically postponed or cancelled altogether. They were written about in a fatigued way as yet another setback. One participant already had difficulty putting in protected time for her work outside of childcare and domestic duties, so this space might simply be lost. 'Sadia' describes taking a commission with a short deadline and how 'being a mum makes things unpredictable'. In order to do the work she needed a collective effort with her husband helping to look after her son and younger brother while she undertook the photography for the design project. Her professionalism in the ability to meet a project deadline was now compromised:

Over the long weekend I had planned to visit the various locations my client [name removed] had asked me to illustrate on the map of Manchester – in order to photograph them; however there have been various warnings issued on social media by both my Muslim and Non-Muslim friends that have deterred me from heading out today . . . I am now consequently dealing with a slower progression rate.

Pointing out the horrible prominence of 'Punish a Muslim Day' the participant received communication from Muslims and non-Muslims circulating on social media. 'Sadia' reflects that she was more vulnerable as, 'being a hijabi Muslim can unfortunately make you an easy to spot target'. The combination of April Fool's Day and 'Punish a Muslim Day' 'made me wary of spending too much time in the city centre'. Her visibility as a Muslim is then linked to career outcomes. 'Sometimes being a hijabi Muslim in this hostile era makes the road to success difficult to reach. I had to postpone my plans for the time being – just to stay on the safe side.' Although the 'scary date in the calendar' ('Sadia') marks a peak in anxiety, there is a longer timescale in which the women are fearful for their safety, meaning activity is not only disrupted for that day. The lived situation is described as that of a 'hostile era', an all-embracing and unpredictable time-space distinguished by violent potential. As a result 'the road to success is difficult to achieve' where immobilities caused by fear and anxiety enhance the risk of exclusion. Islamophobia here acts as a kind of violence that places limits on social and physical mobility.

'Sadia's' reflections recall the insights of Noble and Poynting (2010) on Australia and the Cronulla Riots; the racial vilification of the Muslim 'other' and majority white spatial regulation. For, as they write, conceptualising the pedagogical relationships between space, racism and mobility: 'movement is experienced differentially, and the pleasures and powers it confers are not distributed evenly but linked to relations of inequality and practices of social exclusion' (Noble and Poynting 2010: 490). Routine marginalisation allowed

for by global vilification creates contexts of everyday incivility that are demeaning and insulting for migrants trying to make their way through public space. Noble and Poynting discuss this in relation to the exclusion of Arab men from beach life by white vigilantism, but the spatialisation of forms of racism and spatial regulation by majority white actors of cultural difference is shared in the instance of 'Punish a Muslim Day' where Muslims in Britain are encouraged to feel a sense of not belonging where they are (Noble and Poynting 2010: 496). Tragically, the theory of the racialised pedagogy of space is a process of learning to feel less like citizens (Noble and Poynting 2010: 500, 502):

> Effective citizenship requires access to and comfort in a multitude of spaces. The consequences of racist vilification are that certain groups lose the ability to act and learn in and through social spaces, they lose the opportunities to develop skills of wayfinding within and across spaces, retarding the capacities to negotiate within and across spaces, diminishing the opportunities to invest in local and national spaces. Their resources and opportunities for place-making in public space shrink along with their mobility.

Whilst overt links to social mobility are not outlined above, there are clear insights around the curtailment of mobility and horizons. Elsewhere similar stories were shared: cancelled trips to the library, to college and to work. Particularly moving was the entry of one participant about her university coursework:

> Honestly I'm too scared to even leave the house as it is apparently being reported in Sky News that letters have been posted to houses in the Midlands [on] 'Punish a Muslim Day' . . . I was meant to go to Stockport Library to research further into dreams but for now it's postponed.

Postponement of her final year design assignment due to Islamophobia suggests how violence and fear impact the ability to get on, and to thrive. Poignantly her assignment was on the topic of 'dreams'. On constrained mobilities, she downplays the significance, noting it is,

'Pretty irritating as time is of the essence lately for my project.' For another Muslim woman in the study it felt safest to return to her parent's house to spend the day amongst loved ones:

> The atmosphere on the day felt strange and unknown – I had strategically planned to spend the day at my mum's so as to avoid any sort of altercation. Whoever created this campaign succeeded in spreading and instilling fear; it's the first time something like this has circulated so close to home and being a hijabi Muslim can unfortunately make you an easy to spot target.

The gendered dimensions of the day were reflected on by 'Nina':

> I live very close to one of the busiest roads in Leicester, and today on the 3 April, I can only see a few men walking the streets, purely because some idiots decided to name this 'Punish A Muslim Day' and have managed to scare everyone into staying at home.

In this extract the participant shows how 'Punish a Muslim Day' disproportionately impacts upon the presence of Muslim women on the streets. It serves to compound other reported issues around travelling alone that are culturally inflected with patterns in some South Asian communities but also in this account from a mixed heritage white British and Pakistani participant. Barriers to mobility, such as attending school, college and university trips, are often justi-fied according to Islam and grounded theologies of violence against Muslim women, for instance limiting mobilities because communi-ties are 'under siege' (Razack 2008). These same rationales are then internalised and articulated, including by some women in the study explaining why they chose to stay at home. For example, one diary entry by 'Mona' read: 'Generally in Islam it is advised that you shouldn't be travelling long journeys by yourself, especially if you are female in this modern day as the violence towards Muslim females is becoming much more of a common offence.'

In lieu of adequate protection and reassurance by the state, the subjects in the study take their own precautions to 'stay safe'. As 'Sadia' noted, 'I feel as though there were a fair few warnings from

fellow Muslims and non-Muslim friends checking in to make sure I "stayed safe" but no such statement was issued from the authorities around the time.' But for another participant, 'Wafiza', staying at home would only reinforce a culture of fear, anxiety and exclusion:

> I'm just not having it, after being told by my mum to stay in and only go out if I have to, I ignored what she said and went about my normal day-to-day business. It's pathetic to feed into their tactics if you ask me. Why should we stop our lives to entertain a few racist idiots?

In the diary entries participants were relieved (as was I) that they did not encounter any attacks that day and nor did anyone close to them. There were no major incidents recorded nationally. Unanticipated aspects of social organisation emerged in response, especially around activism. For as 'Saila' reflected:

> The flip-side of situations such as this is that they bring out the best in people who are willing to make a change. Social media was flooded with a counter response to this campaign – 'Love a Muslim Day' – I found this gesture to be truly inspiring and touching.

The positive 'Love a Muslim Day' can be seen as 'a worthy gesture' (Aziz 2018), but is arguably reactionary and also hinges around an identity marker of Muslimness that still serves to 'other'. Yet the caring sentiment is well received by this participant at least, and shows an example of counter-cultural activism. We might also view quieter instances of agency through participation in the research study, such as the writing of each diary entry that gives space to telling stories of discrimination, as a form of everyday activism.

Everyday intolerance and othering

In everyday registers of intolerance, Muslim identity was questioned by majority groups in unwanted ways. Typically comments, jokes and observations by colleagues did not directly contravene the right to practice religious identity in the workplace; however, they did

variously harass and demean respondents based on their expression of Muslim identity and Islamic faith. 'Wafiza', designer and business owner, describes working with men who did not respect her Islamic faith, describing the experience as 'scary at some points'. She differentiates between physical and mental abuse, explaining 'not that they ever approached me physically, but, just mentally, it was disturbing'. After the Manchester Arena bombing another participant experienced being asked by a co-worker to explain why her religion permitted terrorist acts. But while there were direct cases of prejudice and intolerance, for some it was the seemingly innocuous remarks that served to undermine, which I would like to discuss more here. 'I've heard sometimes [from white males], "Oh you'd look really pretty without a hijab" ('Mia'). The backhanded compliment dismisses her as a faithful Muslim subject and presumes she courts (white) male desire. Another participant working in media recounted her boss at work commenting pejoratively on her abaya (a long, loose robe): 'Oh, it looks like my dressing gown!' ('Sultana'). Airing of unconscious biases (or perhaps conscious biases) about Muslims that suggested subordination were also shared, for instance: 'Oh my maid is a Muslim . . . They (colleagues) don't know how offensive that is!' ('Nazneen'). A number of women in the study had migrated countries during their life courses, with some moving several times. Experiences of racism and Islamophobia travelled with them. For instance, originally from Iran, 'Nazneen', introduced above, compared her experience living and working in Britain and Sweden:

> I had a degree, my first degree was in Industrial Design so when I got to Sweden they said, 'oh can women do engineering stuff, can they go into factories then [in Iran]?' . . . And then I was working in a museum and my boss asked me 'did you come on a plane to Sweden?' And no [I said], I came on a camel [she laughs ruefully].

'Nazneen' discusses the ways in which she was asked direct, invasive questions as though she were an object of study with undertones of moral judgements by those in the host nation, that recalls Said's (1978) 'Orientalism'.

So they constantly ask you questions which make you feel utterly uncomfortable and if it's something very personal to me they make it like the whole nation, [like] you're representing the whole country. Can they [Iranians], can they keep fish at home? Or cats? You know, it's patronising.

'Nazneen's' recounting of colleagues' questions on 'being Iranian' suggest an exoticising and othering of thinking, values and beliefs (Said 1978; Werbner 1990). Although she had not experienced the same in Britain it conjured disquiet in her mind that made her constantly question: 'What do they imagine? You know it's [a] kind of racism, hidden racism. It makes you paranoid, is that what everyone else is thinking?'

Supposed silliness or joking left many in the study feeling uncomfortable. It rendered the line between playfulness and racism blurred, which served to unsettle the ground for subjects to stand up for themselves. For example, this came to the fore for several participants in the politics of naming where dominant cultural norms were imposed. Here colleagues might 'joke' or even directly ask if a participant can be called something 'easier to pronounce' for a white British workforce. However, only rarely in their written accounts did participants directly challenge their colleagues on this. It was only in interviews and diary entries that they observed white privilege and cultural domineering at play in the secure confidence demonstrated to ask to rename someone with a Western Anglophone name. Unsurprisingly, given the right to dignity in the workplace that protects equality and diversity, the women included found it offensive to be asked. This speaks to the reflection highlighted above by 'Nazneen' of the gap between the public and private selves, and the difference between what someone says and thinks. But on occasion a racist ordering of what fits and how people can be treated differently rose to the surface and was clearly embedded within institutional working practices.

As mentioned in Chapter 6 on fashion, 'Saila' experienced first-hand structural racism that was actively encouraged by the director

of her London-based textile company to keep Indian factory workers in the supply chain in their place. For 'Saila' this attitude by the boss unleashed a wider culture of disrespect in the design studio. Now she was 'finding that some of the other designers are very condescending when talking [about] the embroiderers in India'. She describes herself as standing out from the other designers: 'I am a little bit older, the only ethnically diverse person and the only Muslim.' Elsewhere she recalls colleagues putting her on the spot about her faith, 'jokily' asking her to have a drink on a night out and then following up a couple of weeks later by asking why she does not drink alcohol. Feelings of being out of place were entrenched when her younger colleagues compared notes on work experience and 'Saila' realised that, despite an excellent academic record and award successes, she was the only one after university who 'struggled to even get interviews'. 'It made me wonder whether it was because of who I was, my race, my name?' This experience of difference, although understood as racism and exclusion, was nevertheless emotionally felt as a personal issue: 'I felt alienated and ashamed.' Economic exclusion at the start of 'Saila's' career reinforced a sense of difference from her colleagues that continued when work was gained, individualising and isolating even when the unfair situation was recognised as structural.

Racism and prejudice were downplayed in other accounts. In daily entries that discussed barriers to achieving work aims, there were entries about negative experiences of being in public space, such as the reporting of direct racism. For instance, in one example, 'Wafiza' starts with the positives of the day and minimises the importance of the comments. She treats the racism as indiscriminate, everyday abuse, and not really about her, writing:

> Although I did encounter some racist comments (if that's what you call it) from a random woman in the city centre. The time was approximately just after 3 pm and this particular woman was part of a group of drunkards hanging around Barclays bank, and were shouting abuse to every coloured person that walked past

and I think I just happened to be one of those people. Some of
the comments were, 'you bloody Pakis taking our jobs', 'you don't
belong here, go back home', etc. and I decided to just walk past
without turning back.

It is significant here that the participant described herself as mixed
white British and Indian heritage, not Pakistani. The horrible abuse
received, then, was a comment on her as brown or a non-white
person, and therefore not 'belonging' to Britain. It points towards
the way that Muslimness and racism are enmeshed in Islamophobia
(Elahi and Khan 2017). The casualness of the comment 'etc.' mean-
while points towards a wider culture of under-playing racism and
Islamophobia, which is especially relevant given the implied address
to a white and non-Muslim reader (that is the researcher who com-
missioned the diary, although it is also true of the majority of aca-
demics). In this case, she reflected that it was not typical for her to
experience racism or Islamophobia but still records a couple of inci-
dents of it: 'It didn't scare me or affect me in any way, but I sort of
just felt disheartened at how the minority sees Asian/Muslim people.
I mean some people don't even know the difference!'

During the wider research project a series of focus groups were
held in order to provide control groups into how mixed Muslim,
multi-faith and non-faith, ethnic, and gender groups responded to
questions around issues of diversity in the work force, and percep-
tions of Muslim women in cultural and creative industries. In this
work two focus groups were held at the Central Library in Oldham,
Greater Manchester. The majority of respondents were respectful
and listened to one another, and carefully considered how diversity
and equality figured in different workplaces. For the most part, with
some notable exceptions, the participants had not really considered
work in the cultural and creative industries, felt their schools had
done nothing to introduce them to the possibilities of this kind of
work, and more broadly that there were limited opportunities in
the immediate Oldham and Rochdale areas, with a need to travel
for access to a broader range of different employment sectors. It

was viewed that digital in other ways was compressing time-space, however, with reflection on online training courses breaking down the need to travel to certain places. The move towards digital learning and working was seen as a positive, democratising shift by several of those present. Sophisticated discussion took place in one of the focus groups on the distinction between culture and religion with acknowledgement that there are differing approaches to gendered distinctions in acceptable behaviours. For others there was a strong belief on the impossibility of separating out religion from culture – subscribing to the view that religion is the product of culture.

Yet there were a number of comments that were more confronting. One white, middle aged man, who was quick to anger, set out his vision that hijabs ought to be taken off in public space, and that a white majority find it very offensive for women to cover. He also commented on the fall of attendance in churches and the 'building and building of mosques', describing how 'it is a circus in Oldham'. Less dehumanising and divisive, but also with singular ideas of Muslim women as oppressed, were two other white male friends in their twenties who said they had seen that Muslim women often had to walk behind men, and can't mix or enter workplaces. There was apparent misrecognition of Muslims and Asians, with the BBC presenter Anita Rana, a Hindu, referred to as a Muslim. She was framed as an example to 'other Muslims'. As discussed in the book's introduction, misrecognition – through the wrongful projection of characteristics – can lead to diminishment, disrespect, feelings of rejection and harm (Hopkins et al. 2017; Fraser 2000). It evoked the problematic notion about an 'acceptable' face of Asians in media and in TV, which was evidently not that of hijabi Muslims. In this often uncomfortable focus group, one of the participants was a black Muslim woman who wore a headscarf and worked in textiles. In a follow-up interview I conducted with her a fortnight after the event, she commented on how she thought the focus group was well chaired as everyone was given a chance to speak. She upheld the idea of freedom of speech, even when the comments about Muslims were misguided, and, in my view, demeaning. As the chair and lead

researcher it was a relief to hear that in her view the right balance was struck, but it still raised pertinent questions about the tensions, conflict and discomfort that can arise from giving space to the views of others with whom we do not agree.

In the paragraphs above I have discussed the ways in which participants have experienced sexism, racism and Islamophobia in their everyday working lives and which I observed first-hand within the research setting of the project itself. In some cases this has spiked around particular events such as 'Punish a Muslim Day', whereas more typically participants experienced a lower level but pervasive sense of marked difference and otherness due to their identities as Muslim or ethnic minorities. I then discussed two focus groups of mixed members of the public where the majority were tolerant and respectful, but where there were instances of racism, Islamophobia and misrecognition. In the next section I will move on to discuss particular case studies where subjects have combined creative work with activism.

Muslim Creative Activism

Digital short films: #YourAverageMuslim

Online fashion and media work are a hyper-visible aspect of a Taylorist shift towards flexibility and home-working. Mobile work-ing has been acknowledged as enabling Muslim women balanc-ing paid and unpaid labour, and child care (Tarlo 2010; see also Ekinsmyth 2011). The combined impacts of the gender gap, struc-tural racism and Islamophobia act together to create barriers for mainstream employment, access and advancement. Home-working for women enabled by increased levels of digital saturation might foster a more fulfilling and inclusive experience, but can also result in exploitation, isolation and higher levels of online abuse (Richardson 2018). They can thus be seen as ambivalent spaces of intimacy and violence (Richardson 2018). The Internet has removed gatekeepers at entry level, though democratising and heterotypic effects have also opened channels of critique and abuse (see Crewe 2017). Given that

all the participants in this study are highly active on social media – often on multiple channels – the daily grind of encountering prejudice and abuse becomes a routine aspect of everyday working lives. In some cases the women incorporated responding to critics and audiences into talks, blogs, vlogs and Twitter feeds as a means of 'talking back' (see Dikeç 2005; Rancière 2007; Warrren 2019).

In the UK, at the forefront of modest fashion, media and social activism is Dina Torkia, who I introduced in Chapter 5. Over time and with more exposure, Dina's work has become more overtly politicised, tackling critically the representation of Muslim women in British media and society. In one short video – where Dina is preparing a meal – she shows and talks about how the family home is messy and unclean, and how audiences at home will judge her for this: 'People will say on blogs "why is she moaning about a dirty house – why doesn't this bitch just clean it? Women should keep the home clean." Well this one doesn't!' In this film short, and others similar in tone, she acts to forcefully disrupt the image of a 'good' Muslim woman. A lens is opened onto the home as unruly, non-conformist, even a site of disappointment. Dina reflexively points towards the ways social media reconstitutes her body as a discursive object. Audience commentary is then mobilised as her image and text is circulated. Whilst trending on social media raises her profile, and ultimately brand, the wider public reach also creates spikes in sexist and Islamophobic vitriol. She relays that non-Muslim users term her a 'rag head' and terrorist due to wearing the hijab, and she also admits being 'pissed off' with Muslim men 'and their obsession with the way women dress'. Nevertheless, she seeks to challenge ideals of Muslim womanhood: 'I like to break stereotypes.' Dina says this whilst wagging her head and smiling; her husband, Sid, is standing in the background, laughing.

Despite breaking stereotypes, the focus on the politics of identity – or 'Muslimwoman' as a primary identity (cooke 2007) – can entrench ossification. I would argue that this tension is at play even where interventions are pitched as progressive – including the *Beyond Faith* exhibition I co-curated and discussed in the previous

chapter. These tensions form the point of departure for a series of commissioned shorts, #YourAverageMuslim. The stated intention of the shorts is to tackle notions of what kinds of work and interests are 'normal' for Muslim women as defined by white, secular mainstream media, and patriarchalism. Frustration at mainstream media approaches to representing her success 'as a Muslim woman' served as a catalyst; as Dina says:

> For how many years are we going to be 'breaking the stereotype'? It kind of takes away from what they are actually doing, their actual skills. These girls that we're following are just living their lives, they are not doing what they are doing to break the bloody stereotype.

Filmed with two white male film-makers and Muslim women leaders, the social interactions displayed are crucial to the narrative. At once Dina shows the audience members at home she can mix with non-related men professionally, whilst educating the white, male filmmakers about Muslim femininities: 'see you are learning so much, right now'. Echoes of feminist visual and film theory can be observed where the subject seeks to unsettle the male gaze and subvert notions of gender (Mulvey 1989). But departing from a white, feminist canon, Dina uses her multiple platforms and audience to challenge stereotypes and multiple axes of discrimination and exclusion that impact the everyday lives of Muslim women across the Muslim and non-Muslim world. It is here significant this social activism uses personal, mobile technologies that are widely accessible: 'Please watch it, share it, and use the hashtag 'your average Muslim'. Tell your story. Last night we were trending on Twitter. Peace.' In other examples we might think of the spoken word poet and blogger Suhaiymah Manzoor-Khan AKA 'The Brown Hijabi' and her TED talk entitled 'I'm bored of taking about Muslim women' where the viewer is called out for objectifying, essentialising and ultimately delimiting her creativity.

It is noteworthy that home and family life are mobilised symbolically and materially within Dina's videos and more widely in

Muslima lifestyle media which serves to naturalise the multiple, overlapping roles of mother, wife and businesswoman. Feminist Islamic interpretations of the Qur'an that give emphasis to the historic active roles of women in business and public life are also common. The empirical findings recall the work of Ahmed who critiques 'the figure of "the happy housewife," black critiques of the myth of "the happy slave," and queer critiques of the sentimentalisation of heterosexuality as "domestic bliss"' (Ahmed 2010, 2). The home and marriage are deconstructed as spaces of happiness, but so too is the utopian world of work. Digital films and Muslim lifestyle channels arguably mobilise alternative spaces of social formation. At the same time in these pieces there is a palpable tension.

Engaged in a politics of representation, the creativity here is orientated towards alternative world-building, and augmenting realities of gendered exclusion through enhancing visibility in the public sphere. Paradoxically, Muslim lifestyle producers are constructing distinctive, successful careers (or USPs) around a shared politics of identity. Most recent work reveals ambivalence and discomfort towards engaging with mainstream representations of Muslimness and womanhood, attributed to historical and contemporary struggles around symbolic appropriation. While engaged in the production of culture that deals with politics of identity, resistance is offered towards becoming an object, or being objectified as 'the muslimwoman', for the consumption of other non-Muslims. When considering #YourAverageMuslim in tandem with her appearance in *Vogue* magazine in the issue, 'The New Suffragettes', the work of Dina can be seen as fraught with tensions and contradiction around becoming an acceptable face of diversity in an otherwise dominant ordering of white space.

Muslim cultural festival: Macfest

In Chapter 5 I discussed how media work is perceived as holding especial risk and responsibility. Media as an occupation was seen as holding communitarian potential given the social impact it might have on how Muslims are represented and viewed in society, and

the real impact this can have on everyday life. These sentiments were echoed by many participants. For example, in this case study, Qaisra resolves how to align the politics of identity as a 'Muslim woman' in her professional and civic roles. She is an acclaimed published author who is perhaps best known in Pakistan, the country of her family heritage. More recently, Qaisra had become a leader in the charity sector, flying the flag for inter-faith relations. Her next contribution was the founding of Macfest, the first Muslim Arts and Culture Festival in Manchester (the British Library and P21 gallery held a smaller MFest on 27–9 April 2018). In the extended extract below Qaisra discusses the relationship between her creative and activist roles:

> A lot of the work I'm doing is related to community activism and promotion of peace. Especially since 9/11 it has been forced on me. I have been building cultural bridges through my work in schools as an author. I can use that platform to talk about and explore a range of issues, including explaining the difference between arranged marriage and forced marriage, and the veil. This is where I focus on my Muslim identity. In schools teachers and students view me primarily as a writer. I deliberately focus on my Muslim identity as an author and how the two are linked. I explain to them that I love my faith and I am not a terrorist. Why am I doing this? Because I want them to connect with me, as a Muslim person. I use my literature as a form of advocacy. I shouldn't have to. But [with] the current situation, the world politics have forced me to position myself as a role model, a social connector, a bridge builder. Above all, I have always challenged their views of Muslim women.

Qaisra speaks about herself as a politically and religiously moderate and successful British Muslim. As detailed in the guide for the inaugural Macfest in her biographical statement, Qaisra is listed in the Muslim Power 100 and recognised as 'The Most Influential woman in Manchester'. At the time of the interviews the current geopolitical climate was tense in the wake of the Manchester Arena bombings and Islamic State; this is the world politics Qaisra refers

to as 'forced' upon her. In response she uses her identity as a British Muslim woman strategically to emphasise goodness and normalcy as 'a role model, a connector, a bridge builder'. As she explains later, talking about interconnectedness, 'I am a British Muslim woman of Pakistani origin. I lay the emphasis on all three. All three identities are of equal importance.' But discussing her audiences she recognises they might identify with one aspect of her instead of the whole. Instead of framing identity as composite, Qaisra discusses how audiences might segment her and 'relate to me as a British and Manchester woman' but 'not relate to me as a Muslim woman.' Feeling responsibility for challenging negative stereotypes of all Muslims or Muslim women could prove frustrating:

> Due to Islamophobia and xenophobia I do feel I have been channelled into becoming a Muslim voice. Not necessarily in my literary work, my stories, but on social media, through my public speaking, and inter-faith and community events I organise, and so forth. Again, my aim is to promote the positives about being a Muslim. I'm so fed up of having to constantly defend Islam and Muslims. At times I resent this role. Why should I have to [do this]? I am spending so much time and energy on all this . . . For example, I want to get on with writing my book. But instead, here I am on media, having to talk, and talk, in particular defending Muslim women and Islam.

The geopolitics of Muslim identity means that high profile Muslim women are asked to speak on behalf of other Muslim women. There is ambivalence within her speech about 'becoming a Muslim voice.' Qaisra's advocacy results in deficits of time that impacts upon her productivity as a writer. Although her writing focuses mostly on exploring Muslim women's subjectivity, the repetitive need 'to talk, and talk' over time, to 'position identity in the positive' (Lewis 2015: 71) and counteract negative stereotypes is challenging. It is a role only required of someone whose sense of place and belonging is under question. Still Qaisra clearly articulated a sense of purpose, agency and autonomy in her advocacy, mingled with excitement

in its scope and potential: 'Now I am actively celebrating being a Muslim. It is for this reason I have set up Macfest [Muslim Arts and Culture Festival] in order celebrate Muslim heritage and diversity . . . I am using my Muslim identity deliberately.'

During the time of the interview the initial ideas for Macfest were percolating for Qaisra. It involved exploring and establishing a Muslim arts and culture world festival – with the thinking following an iftar meal during Ramadan that took place after the London and Manchester attacks. The Muslim festival was conceived as a major project spanning Art and Literature, and different Muslim communities in Greater Manchester, including Somali, Turkish, Bosnian, Bengali and Pakistani groups. Macfest was launched, and the inaugural event took place 17–25 November 2018 at the British Muslim Heritage Centre, with outreach events in various cultural and educational locations across Manchester including schools, universities and galleries. The events included calligraphy classes, an exhibition, film, book talks, panels and discussions, dance and singing, amongst other activities. Gender was notably a key theme, for instance in the session, 'Muslim women speak out: Challenges and Celebrations'. Macfest offers a prime example of a city festival initiative that brings together creativity and activism, minority and mainstream voices in response to geopolitical events. But the festival gains strength through local networks and energy from hopefulness:

I end up presenting the picture of a proud Muslim who has been given a public platform due to my writing life. I actively use that platform including when talking to German students and teachers. Therefore, I have become a sort of a figurehead, it is a role that has been forced on me . . . I am living a normal life. I am an ordinary Muslim. I am not extreme or rigid in my outlook when it comes to my faith. After 9/11 I was quiet for three years, and then I thought I don't need to be quiet. I was encouraged to use my literary platform. First it was building cultural bridges through literature, then inter-faith work has brought me into the fold, and then becoming vocal on the behalf of Muslim women.

In this explanation, behind her multiple roles, Qaisra describes how her own writing came first as a novelist, followed by success – especially in her parent's homeland of Pakistan – which then gave her a stronger sense of duty as a figurehead for moderate and progressive Muslim culture in Britain. She distinguishes her novels from her charity work, however, seeing the platform of recognition given by the former as fostering her image as a 'proud Muslim'. Qaisra's fictional writing has strengthened European connections, with her work taught in German schools, and her inter-faith charity work has placed her within a progressive liberal public sphere. Her civic and creative work is intended to support gendered equality (with female-led novels) and a dominant strand in the Muslim festival Macfest is the contribution of Muslim women to cultural production in the Islamic world. Thereby the interfaith and festival world organised by Qaisra, together with her creative writing, are not formal political activity, nor can it be understood as pillared activism. Instead the civic and cultural work serves an imaginative, humanising role: encouraging crossing boundaries of social difference, walking in another's shoes, giving time to another perspective, promoting empathy, learning and appreciation, and exploring Muslim women's subjectivity and consciousness. It is most accurately a secular form of Muslim creative activism that enrols a wide intra-Muslim constituency through the event programme of Macfest, but that is indivisible from a transnational geopolitics of identity and belonging within an elite educated, middle-class Pakistani diaspora. Established in her professional life, Qaisra is well-networked and has already gained recognition, symbolised proudly by meeting Melvyn Bragg in the House of Lords, UK Parliament.

Manchester Writing Group

In the final example I have selected for the chapter there is a more pronounced juggling of creative and civic roles. Contributing to new writing on vernacular creativity that emphasises how creativity can and does take place in the lived everyday (Gilbert et al. 2019), I extend this to include thinking about religion and faith. A balancing act between creative and civic roles asks us to look differently at what

creative activism might entail, to see quieter, humbler moments alongside those that are large-scale, demonstrative or spectacular. Some of the instances of creative activism I have discussed above pointed towards a clear distinction between cultural production and activist work, such as with Qaisra where one career followed the other. But in most cases the two were entwined from the start, giving rise to a constellation of activity with a common purpose. Scales of belonging were relevant for many artists who might work across different groups and constituencies, such as activities in the local neighbourhood and those that were deliberately supra-national and non-territorial.

For instance, one poet, 'Safa', helped to found the Manchester Writing Group, a space for Manchester-based writers to meet and discuss their work. Not exclusive to Muslims, the Manchester Writing Group was nevertheless intended as somewhere that Muslims would feel at home, to give a sense of belonging and safety. In this interview it was raised there was a need for a space where Muslim writers would not feel afraid or misunderstood. The Manchester Writing Group offers a way of creating a social bond and a bridge that enables Muslim writers to be out in the 'mainstream' as both religious and creative subjects. 'Safa' spoke about her need to openly speak as a Muslim woman. 'Safa' explained this openness was a new direction for in the past she was concerned about whether identifying her religious faith as a writer was self-labelling and restrictive for reaching a wider public. She explained this concern stemmed through whether non-religious people reading her work would say 'how dare you talk about God, how dare you subject us to this?' In fact this line of critical thinking started to make 'Safa' change the language and subject of her work 'to remove' religion and faith, but she found that she wanted to talk about her beliefs. 'Safa' thereby raises the psychosocial demands of performing as a Muslim writer in Britain, where if the work is about religion or politics, she worries 'will the audience think "is she an extremist?"'

Departing from post-modernist, post-structuralist, post-colonial, and feminist approaches where emphasis is given to fluidity and contradiction in identity formation, such as new ethnic identities (Hall

1990, 1993; Mohanty et al. 1991) and hybrid transnational identities (Appadurai 1988; Bhabha 1990), 'Safa' raises the spiritual need for constancy. Explaining this further, 'Safa' reflected on her own observations in creative fields, where Muslim artists felt the need or desire to 'fit' into mainstream spaces, which then begins to change the person, and sometimes their religiosity. Echoing other creatives in the study, there is often an 'identity crisis'. Instead 'Safa' believes in integrity to the art and to oneself, where creative expression is an extension of faith, not a remaking of religious identity. Respectful of the reasons for why an identity crisis might happen for a British Muslim artist, 'Safa' nevertheless sought unity across her own life. She worked as a counsellor, on charity boards, as a volunteer chaplain, poet, artist and in radio at the British Muslim Heritage Centre, whilst looking after her children. As a sign of the respect 'Safa' has garnered and her distinction, she was asked to speak in front of 4000 people for Manchester's Women's Day in March 2008 by Manchester City Council.

Muslim creative activism in this example takes the form of doing a good deed – a form of sadaqah, or charity. For as 'Safa' discusses there are other things one can do apart from sending money abroad, running a soup kitchen or giving out warm clothes. Activism can take various forms including mobilising a positive message from various mediums and to cross boundaries of faith and non-faith communities. According to 'Safa's' vision, creativity is recognised as a means for a wider platform to enact positive change; a form of faith-based activism; or pillared activism, following DeHanas (2016). As a Muslim in the lived everyday, 'Safa' thinks: how can I represent my faith in the best way possible? Story-telling is crucial. Her stories will often contain a journey from darkness into the light, which serves as a moral and religious allegory, but one that is also grounded in everyday well-being. In 'Safa's' words: 'I always want to have a positive ending – so that the person seeing or hearing the work can take something positive away with them.' The social, caring and creative dimensions align in gestures towards world-building. Through her own love of words, she is 'compelled to reach out to those struggling and less fortunate' and work as an

activist for freedom, justice and peace. Distinguished by a sense of religious duty to contribute positively to the lives of others, 'Safa' shows humility that also involves not putting herself forward. 'Safa' does not position herself as a leader, but has been told by others that she is (and is well known across civic and creative circles across the city for her manifold contributions).

Conclusion

This chapter introduced the creative and activist roles of Muslim women producers in UK cultural and creative industries as a distinctive, emergent form of Muslim creative activism. It considers how Muslim women are living in geopolitical contexts where Islamophobia, racism and sexism can shape access to public space and occupational choices. Illuminated by feminist geopolitics I show how Muslim women are using a range of mediums, digital media, events such as festivals and creative writing as a way of simultaneously creating new spaces and representations of Muslim femininities whilst disrupting older notions and established norms. It adds conceptual nuance to how women and youth are systematically gaining visibility within discourse and debates on Islam and modernity, and contemporary faithful Muslim lifestyles. Women's politicised activity not only targets mainstream political spheres or Islamic religious spheres, but instead is operational through multiple, often informal channels. These represent the ideal of intra-Muslim women's unity, and in some cases external markers of recognition for a successful career, where Muslim identity and womanhood are master keys.

Considering the work of digital films, festivals and writing groups supports the insights of Harris and Roose (2013) on reconceptualising civic action to include contemporary post-traditional lifestyles. But, significantly, the gendered dimension of this chapter on Muslim women's creative activism highlights continuity as well as change. There is a continued commitment to social reproduction of Muslim women as an imagined community, and education roles more broadly, in care and teaching duties that are carefully balanced with the cultural work produced. Although secular and

post-feminist ideals form part of this scene, or cultural ecology, more common are Islamic-informed ideals of da'wa and sadaqah. Modesty and education position the worth and ultimate purpose of the creative work as communal, not individual. Whether by degrees performative or natural, with a range of piety across the wider study, the presence of Islamic ideals as guiding principles or ways of understanding the meaningfulness of labour point towards a more-than-economic framework for understanding the growing Islamic cultural industries, although the extent to which Islamic-ness is maintained within commercial industry has been questioned elsewhere (Lewis 2015; Gökarıksel and Secor 2009, 2010b). The creative and digital economy are recognised as ambivalent, ethical spaces, where there is continued economic exclusion and issues with extraction of identity for commercial gains. However, it does offer hopeful spaces. There is the opportunity for launching new work, for greater autonomy, and building alliances and solidarity. More than about the unity of Muslims, or even Muslim women, the kinds of Muslim creative activism I have discussed foreground the desire for dignity and recognition in Britain, not a rejection of the West or belonging.

Notes

1. Muslim women have often worked as teachers in respectable professional roles that nurture social reproduction.
2. The wider book focuses on black minority religious youth in London (Bangladeshi, mostly Muslim, and Caribbean, mostly Christian).

9

CONCLUSION

The subject of Muslim women and employment has attracted considerable attention as statistically participation is lower than the UK average; elsewhere in European countries the story of economic marginalisation is similar. In this book I have taken a longer historical view to contextualise in-depth qualitative research in order to better understand the changing roles of British Muslim women in work. There is some evidence of Muslim women entering the labour market in Britain as ayahs (or nannies) from the early eighteenth century and working in factories and through flexible specialisation, such as home-working on garment sewing, after the Second World War. Stories of Muslim women in work, however, have been obfuscated by a focus on men as the primary economic subject, and the very fact some of this work was 'hidden' in the home (and devalued as 'women's work'), combined with the overlooking of religion as an important index of identity and inclusion. As Avtah Brah (1993) has argued, traditional gendered division of labour has never fully explained relationships with work, nor have culturalist understandings of women as domestically bound. Muslim women's engagement in the labour market needs to also be understood as racialised and in relation to region and location. Home-working reflected what work was available for women, alongside what could flexibly be organised

around childcare, with concentrations in migrant South Asian communities as much about word-of-mouth networking rather than culture and patriarchalism per se (Brah 1993). In this book I have considered gendered and racialised dimensions within the transitions of cultural labour, and how they interrelate with the privileging of religious or Muslim identities especially evident with younger generations.

Tracing stories of educational aspiration and increasing workforce labour by British Muslim women in many ways mirrors wider structural and attitudinal shifts to women in work in Britain over the twentieth and twenty-first century. More women entered further and higher education and pursued waged labour for longer periods over the life course. Certain continuities exist, too, in the kinds of sector worked in, such as textiles and garment-making. Although the framing of the new economy in the knowledge-based and creative industries has transformed how we talk about work, expectations of the sense of purpose it will bestow on our lives, the type of jobs available, and how and where they are performed. In this book I expand the field by investigating the growth of religion as a primary identity marker and how the turn towards exploring faith, especially amongst younger Muslims in Britain, is crucial to understanding the appeal of cultural production as a seemingly malleable space in which to recontour who they are, and for agentic force as a minority in the West. Less hopefully, the creative turn might in fact represent enforced labour for some, where wages are low, but there are poor alternatives.

Through a major study of Muslim women in the cultural and creative industries, the book therefore brings together two areas of research that have hitherto not been considered together: research on religion and gender in the lived everyday; with access and inclusion within the cultural and creative industries. In some sub-sectors of the cultural and creative industries lower barriers to entry around educational level might appeal given that there is not a fair return on higher education. Muslims are slightly more likely to obtain higher education degrees (Social Mobility Commission 2017), but Muslim

females aged 18–24 years are much more likely to be economically inactive in comparison to all females (Elahi and Khan 2017; Karlsen and Nazroo 2015). In this book I write about the complexity of reasons behind the findings of multifarious reports that Muslim women are economically excluded and the kinds of important hidden labour that might be routinely performed and that are crucial for the economy: caring duties (intensified by high cost of childcare); working in family-owned businesses; and volunteering for charities (see Miaari et al. 2019). Significantly, I write about the importance of understanding intra-Muslim and gendered difference in relationship to discrimination and indexes of exclusion, with sharp distinctions between those who are fluent in English, born in the UK, white (or lighter skinned) and black Muslims, and life stage.

British Muslims in the Cultural and Creative Industries

The 'cultural and creative industries' is a hybridised construction that brings together traditional areas of culture and the arts with economic growth areas such as digital and gaming. A small field of studies of Muslim labour have focused on certain sub-sectors, particularly fashion with some emerging on digital media; however, this book set out with a broader ambition to consider the roles of Muslim women in Britain in the expanded context of creative arts and design education and work lives in multiple sub-sectors of fashion, media and visual arts. The wider framing acknowledges the point that racialised distinctions begin with education, and that art school and the professional world are often enmeshed: with careers launched whilst at art school; time investment in developing alumni and professional networks; and the potential bridges into industry artist-tutors can offer. The broader context also seeks to 'join the dots' between the transitions in representation evident across the three sub-sectors, and to understand more holistically how Muslim women were contributing to this change. The visibility and size of modest fashion has grown exponentially in recent years into a truly globalised industry, from Indonesia, to Turkey, to the US, and has been adapted by mainstream luxury and high-street fashion

brands. Demystifying the glamour of the industry, greater exposure of supply chains, from Uighur Muslims picking cotton and forced labour in textile factories that supply up to 40 per cent of global cotton used in fashion, to the Rana Plaza collapse in Bangladesh, and 'at home' in Leicester and Manchester's dysfunctional factories, has revealed modern slavery and unsafe conditions, even if consumer habits are yet to turn away from fast fashion and e-commerce. While there is some coverage of a handful of prominent designers and models, I trace the labour experiences of women often hidden from view: small brand owners, tutors, designers and tailors. I identify the distinctions and status hierarchies between working in textiles, 'cut and sew', and what is often termed 'proper fashion', such as buying and design work. In doing so, I expand knowledge on how these distinctions inform racialised notions of ethnic/Western fashion, and manual/creative labour. Racialised division of labour is evident in creative arts and design courses where I write about direct discrimination that stratifies access around attending community college (further education) or fashion college (higher education).

I looked at the growth areas of digital and lifestyle media where Muslim women are much more than figureheads, often producing and presenting content for other Muslim women, such as *sister-hood*, *Amaliah*, *Sisters' Hour*. I consider how these platforms are intended as a unifying post-secular space that promotes an ordinary and accessible image of Muslim women, but how the ideal is challenged by intra-Muslim and non-religious public scrutiny that impacts upon the aspirations of producers and presenters. I identify how British Muslim media workers have received death threats, and attacks due to issues of race and piety, or criticism for complicity by working in a sector perceived as anti-Muslim. I then looked at visual arts and public galleries mapping the rise in Islamic-inspired contemporary art. Here I considered the work of Sara Choudhrey and Zarah Hussain, and their roles in establishing a new genre, digital Islamic art, that explodes old binary arguments about the intractability of tradition and modernity. I consider persistent prejudices around religion and particularly Islam in the Western art world considering

the preferred secular categories of nationality/ethnicity and region for organising exhibitions. I frame the curatorial movement around anti-racist and de-colonialism strategies, including group exhibitions and re-interpretation strategies by Muslim women. Although often very different, in terms of history, evolution, form, business models and pathway to entry, women in the study usually worked across one or more creative sub-sectors, undertook civic and cultural work, waged and unwaged labour, such as volunteering. I therefore argue for the cultural and creative industries to be viewed as a cultural ecology, comprising discrete but overlapping sub-sectors that enrol value in multiple, sometimes conflicting ways, with some irreducible tensions, but where secularism and religious belief coexist.

A positive Muslim identity is amplified by many Muslim cultural producers and artists across the sub-sectors in this study. By this I refer to both the privileging of religion and the deliberate decision to represent Muslim women in a positive light; with patterns of strength, confidence, high achievement, piety and beauty. I have chosen the term British Muslim given its growing popularity and connections with activism (Morris 2018). But in the book I have also discussed a re-scaling of identities and affiliations, including a downgrading of nationalised identities for globalised, cosmopolitan or city identities (Simonsen and Koefoed 2020). I have shown examples where migration histories and connections with other countries and places have been continued, and strengthened, by transnational cultural production, and supply chains, for example, where a woman of South Asian heritage ('Saila') was conflicted and troubled by the deliberate condescending treatment of factory workers in India by her white British design company based in London.

The connection between cultural production and activism resonates with the idea of diasporic communities as 'mobilised groups' (Werbner 2004). Political activism from the 1970s in Muslim women's organisations has supported the international plight of Muslim women, from Palestine, Chechnya, Kashmir and later Bosnia, revealing multiple affinities, memberships and sometimes citizenships. Werbner described a gendered criticism of women-led

charity work in the past, whereas today there is a thriving presence of Muslim women leading charities, think tanks and cultural and academic projects, as I have alluded to. Regarding the turn towards religion in politics of identity together with the forming of a confident women's voice, I have discussed a politicised nature to certain examples of creative work, where Muslim women through a wide array of mediums are giving articulation to gendered difference in public and online spheres. Patterns in topics arising include decrying controls on women's bodies by men and by Western-liberal society, intra-Muslim shaming of women by men and other women, freedom of expression, including the use of figurative form or of the body or voice 'un-veiled' in public space, intersectional and racialised hierarchies and exclusions within Islam and wider Christian secular society. The turn towards DIY culture and creative Muslim activism can be viewed as part of an emergence of post-traditional lifestyle especially amongst younger people. As Harris and Roose (2013) have written cultural production and consumption are important arenas for understanding the changing contours of Muslim activism, where there can be an interaction between tradition and modernity that helps facilitate youth participation. For instance, around discussion of modest fashion by hijabi bloggers, or in exhibiting artwork explicitly as Islamic or religious art.

Religion in Society and Culture

Overarching ideas of society, culture and government are discussed in this book in relation to equality and living with difference. I identify how changes in legislation and law around racism and religious protections have politically mobilised, and, in turn, been mobilised by some Muslims, especially those of British Pakistani heritage. What has been under scrutiny is the key question of how religion and faith as characteristics of social identity and difference are integrated fairly and evenly into the public sphere. As discussed above and at some length in this book, there is continued strength of feeling around the history of law where it is believed that Muslims have not been given the same protections as some other religions, or as people who are

Christian or non-religious. These arguments centre upon the Race Relations Act of 1976 where religion and faith were not protected except unevenly through case law successfully challenged by Jews and Sikhs, the fact blasphemy law only covered Christianity, and then was repealed altogether in 2008, and that the Equality Act 2010 has certain limitations for religion and faith that mean they are not treated the same as other protected characteristics. With the growth of Islamophobic attacks on Muslims since 11 September 2001 over time there was a growth in anger that the law under-protected the most vulnerable group in Britain. One area that is often overlooked, perhaps because it remains divisive amongst the different Muslim communities of Britain, is the role of religion within culture and the arts, and the wider cultural and creative industries.

There are two sides to the conflation of the cultural and creative industries: that which is publicly funded and that which is commercially funded. There is ongoing debate about the wider societal significance of publicly funded culture. Perhaps it is always narrow and more conservative. However, also relevant is the social contract of public funding as a sign of justice, recognition, respect and support by the state. Significant here is the suspicion and turning away from central government and its policies by some younger Muslims after growing up within a hostile environment, most controversially the UK government's Prevent programme. Government funding might always be regarded as coming with ties that are compromising; however, a de facto removal of religion as a criterion of inclusion could also prove damaging. I write about the contested discourse and policy strategies around diversity, including diversity funding, where minority cultural producers and artists might feel they have stronger creative controls placed on them than their white counterparts; where inclusion is (wrongly) seen as counteracting excellence; and where after decades of talk there is still very little in the way of ethnic diversity or women's leadership across most sub-sectors of the cultural and creative industries.

The dual dimension to evaluate is the huge growth reported of the Islamic cultural industries, as part of the wider Islamic global

economy. Britain is ranked as a leader for Muslim lifestyle in global Islamic industries. Clearly there is a commercial marketplace for halal or goods otherwise targeted to Muslim spending, which I have discussed in relation to the growth of modest fashion. But there is a bigger question, perhaps, on how the two meet. Grey (2016) and Saha (2017a, 2017b) have argued for greater nuances around diversity and inclusion that require moving beyond a demography and representation approach and consideration of the psychosocial effects of working as a minority producer. I have written about how different artists and cultural producers in art school and within creative fields find their cultural work (or symbolic forms) guided towards 'identity-work', which risks the reproduction of certain stereotypical tropes, or they can be typecast.

Indeed drawing on the work of Grey and Saha it seems pertinent that despite the consumer potential of Islamic cultural forms or work by Muslim producers and artists, media, publishing and the arts there are still the same few familiar names and faces that tend to be represented. In Britain the 'acceptable' face of Muslim women for primetime, mainstream visibility might be Nadya Hussain, winner of the *Great British Bake Off*, or Dina Torkia, hijabi fashion blogger and writer, who has appeared on the front cover of *Vogue*. For Saha this is a matter of cultural distribution where investment is required into the understanding of different audiences, but where an unwillingness to change an audience base, even where there are strong market rationales, suggests an alternative agenda: the preservation of white hegemony, in regards to goods, services and jobs. The increasing profiles of Muslims within the cultural and creative sectors and some cross-over success stories detailed in the recent book by Lewis and Hamid (2018) suggest that there might be conditions for this balance to continue to shift. In the course of the book, I have deliberately complicated the notions of 'mainstream' and 'minority' cultural spaces as pure and discrete, identifying where they materially interpolate (for instance mobilities of workers, and audience flexibility around consumption practices, ideas and styles, sponsorship, amongst other things). While mainstream and minority spaces

overlap in multiple important ways, I write about how these binary categories are still symbolically reinscribed by Muslim producers, evoking spatialised hierarchies of the core and the periphery, insider/ outsiderness, and what that might entail psychosocially and spiritually for those who 'remain', or 'cross-over'.

The question of representation, particularly by the media and in public life since 11 September 2001, is a key area of concern for Muslims in British society (Ansari 2002). In education, mosque construction and with prayer facilities in public buildings, Muslims have effectively organised to address needs, beliefs and practices. Ansari writes that 'Space in public life has been "stretched" to include Islam, and facilities now exist in Britain enabling Islam to be practised in diverse ways' (2002: 31). There has been some documentation around the removal from public view of works that represent the figure of the Prophet Muhammad, and this therefore raises questions of freedom of speech, thought and expression together with Islamic doctrinal concerns around blasphemy. It remains to be seen whether there will be challenges made under the Equality Act 2010 to the full inclusion of religion and religious needs, expressions and practices in cultural policy, including monitoring who receives public funding.

Reframing the British Cultural and Creative Industries: On Geopolitics and Post-colonialism

This book revisits the well-worn narrative of the rise of 'Cool Britannia' in the globalising of the creative industries and creative arts genius spawned by British art school, placing both industry and institution within a broader historical context of empire and colonialism. The imaginaries of British creative leadership might more accurately be viewed as a whitewashed and secularising narrative in the promotion of a flat earth, one-world view that the world and its spaces are traversable (Mufti 2016). I write about the establishment of British-Indian art schools in Indian cities as an explicit form of colonialism for the transmission of European ideals on form and beauty, and extraction of material goods. In terms of knowledge transmission I consider the training of Western teachers and sending

them to India, and the training of international students in art and architectural school in Britain as twinned processes that are aspects of colonial and post-colonial practices. Post-colonial theorisation is helpful in revealing the limitations of a vantage point, or 'world-view', that is Eurocentric and Anglophone. By reflecting on imperialism and migration, I have added weight to the turn towards considering post-colonialism at home. Recent publications have argued how colonialism still actively shapes attitudes towards migrants and minorities within Britain, and their rights, employment prospects and wealth (see El-Enany 2020; Gilroy 2013). Concerns around aesthetic and racial hierarchies in culture and the arts have been framed as a standpoint of 'the West and the rest' that exist within settler and imperial nation-states. For example, in literary studies Jameson (Eagleton et al. 1988: 49) wrote on the 'internal Third world voices' such as in US black women's literature, where; 'when the other speaks, he or she becomes another subject' . . . 'whence the turn of what are still largely Western theories of imperialism in a new direction, toward the new other, and towards the structures of underdevelopment and dependency for which we are responsible'. I write about the experiences of different Muslim artists at art school and how a shared sense of marginality in the art canon and the institutional whiteness ignited a deeper geopolitical and post-colonial interest. Pedagogical and everyday ways in which marginalism was reproduced are observed in a standard curriculum involving life drawing, drinking cultures, with professional networking encouraged in bars and pubs, and politics of representation around tutors encouraging more 'identity-work', and other (white) students critiquing action around a politics of representation. It airs the concern raised elsewhere in relation to black art by Paul Gilroy that to move beyond a 'corrective inclusion' approach to the history of modern art leaves a dominant idea of artistic creativity centred on a white Western canon in place; 'we may discover that our story is not the other story after all but the story of England in the modern world' (1990: 52). Although recently the critical language of anti-racism has become mainstreamed – and there are some advancements, such

as that British Asians are now widely seen as settled, rather than migrants (Malik and Dudrah 2020) – the often hidden relationship of religion to ethnicity and race within the secular art world and Western modernity, means Islam and Muslims in contemporary art are now arguably the 'ultimate other'.

A repositioning of knowledge practice can recontour the landscape of culture and the arts and cultural production to include faith and religion. I do not seek to take a position on debates around the correct place of religion within the state, but restate here that I am non-religious and do not have a 'stake' in activism that seeks more religious rights. In this book I have in various ways explored and acknowledged post-secularism within culture and the arts, and the empirical actualities of a post-secular creative landscape, as I have observed them. Post-enlightenment separation of the state and religious doctrine has been largely viewed as bringing religious scepticism and humanism; however, the realities of the role of religion within the state, culture and society of course reveals far greater complexity. I have identified how religious faith and the dominant secular world coexist in the lives of Muslim artists in Britain, and their narratives of creativity. There are tensions between creative controls on the one hand, of the need to perform 'identity-work', and on the other hand the fear of being accused of radicalism or extremism if the topic of a work is religious, or it engages critically with British identity, nationality and politics. By contrast I have written about hesitancy, apathy, even hostility towards religious faith as an explicit guiding force and category of contemporary modern or post-modern artwork by non-religious arts professionals. Experienced by some artists in their treatment by curators, I explained how the marginalisation, even banishment, of religion and faith is more explicit in the relegation of Islamic art to the category of 'religious art' rather than situating Islamic inspired art without qualification within contemporary art discourse. Here there is a double exclusion of Muslim material culture and Muslim artistic identity. I write how preferred terms for work by Muslim artists has been organised around more palatable secular terms of

ethnicity or area, although Islamic religion has been aestheticised and sensationalised in art marketing, addressing a mostly majority non-Muslim and white art world. The huge diversity of the Muslim world is emphasised with distinctions in Britain made between the market strength of Middle Eastern art markets and Arab artists, and the demographic weighting of South Asian Muslims who have had recent strong involvement in British Museum/Manchester Museum's South Asian galleries but less of a visible presence in the art market. Although I note more recently with the emergence of digital Islamic art movement, through the work of Zarah Hussain and Sara Choudhrey, this could be changing. Crucial to this discourse is intra-Muslim difference and fragmentation around attitudes towards the representation of the human and animal form. Widely considered prohibited due to the teachings of the hadith, in fact the history of artistic development and the different spaces in which works are shown (religious or secular) reveal far greater nuance around the patronage and display of human and animal life. More recent contemporary art exhibitions have not shied away from Islamic religion and Muslim belief as organising principles in their curation, including an exhibition that I co-curated, which might well suggest a new direction for practice.

Rethinking Motivations and 'Good Work'

I have written about the need to think in a more plural way about the status of cultural work as 'good work'. It has been found that there are high ratings on subjectively framed ideas of career success, such as cultural work as rewarding (Banks and Hesmondhalgh 2009), and emphasis is given to social status and high desirability, even though culture and the arts is seen to entrench inequality (Brook et al. 2020). However, the fact that creative arts and design reports the highest proportion of white students of any discipline – 82 per cent, with only 2 per cent identifying as Asian (HESA 2018/19) – raises the social and cultural politics of 'good work'. In other words, is cultural work regarded as 'good work' outside the relatively privileged, white middle classes?

I identify that the status of cultural occupations as 'good' is contingent upon style and form, whether work is displayed in a religious or secular space, time and region, class and financial security. Decision-making about further education and higher education, and occupations, often involves parents and extended family, close friendships and even wider communities. Across different backgrounds, South Asian, Arab and African, women told me high status and family preference was for a narrow range of professions: medicine, law, engineering then teaching (the same ones were repeatedly cited). It was talked about as something distinctive to their culture; however, given that the answers cut across the varied sample group, I discuss the reasons given for the appeal as shared: good remuneration, contribution to society, availability of work opportunities, clear pathways to promotion and existing familiarity with the occupation. It was also raised as a concern that children would lose confidence through being the only minority in majority white cultural spaces, with examples given of attending acting classes or art school. Occupational pathways and jobs with ethnic and religious diversity in this way were seen as safer options where there was less chance for institutional whiteness and racism. I show how some women discussed the ways cultural work was perceived by their parents and by wider community networks as having 'no future' and implying that someone is 'lost'.

I have extended the field of knowledge by showing how higher levels of gender equality in education, with the expectation that daughters will attend university, and the lessening of importance placed on marriage, has actually led to stronger concerns about what course is studied and about occupation, meaning that the women in the study may need to demonstrate they can be financially secure and independent. Most of the women of different generations framed the decision to pursue cultural work as unusual amongst their peers, and highlighted perceptions that their families were atypical. This was perceived variously as freedom in a diaspora without interference from extended family to please and shape choices, or because all children were daughters and there were no expectations beyond obtaining a degree, or because parents or grandparents themselves had

creative interests, expertise or employment. Although the women in the study might be viewed as elite, for most attending art school was discussed as beyond a horizon of possibility. It was viewed as 'not for them' until the potential to apply was introduced by someone else or through serendipitous encounters. Outside of familial support, bridges to studying and pursuing art were through friendship networks, supportive teachers, school visits to galleries and museums, and everyday curiosity triggered by encountering art colleges within the urban landscape.

Religious faith and women's development are stressed as important drivers for entering cultural labour and motivating actors within the sector. These primary motivations can ease the experience of hardship such as poor pay, discrimination for ethnic, racialised and credal differences, the losing of faith and faith identity, and judgements incurred by juggling work with the roles of mother and nurturer. Cultural work was viewed as good work where it has social value, and, moreover, where it is given external recognition such as awards. More sophisticated interrelational understanding of gender and religion, and how they interact with ethnicity, racialisation, class, geography and migration histories within commercial and publicly funded spaces can offer clearer insights into the lives of women workers in the growing Islamic cultural industries and wider society. Research commissioned by the Equality and Human Rights Commission highlights that only a minority of UK-based surveys have asked questions which might contribute to an understanding of religious discrimination and even fewer ask about religious discrimination openly. Until now there has been almost no research on religion and faith and their inclusion in the arts and cultural sectors, which adds weight to the argument their significance is not understood. In this book I expand the field through historically informed in-depth qualitative study that provides detail and nuance into the experiences of women working in the cultural and creative industries, and how religion and faith interrelate with other indexes of difference, reshaping their work lives and the ever changing morphology of society, culture, and public life.

APPENDIX: INTERVIEW TABLE

Sub-sector/role	Name/ 'pseudonym'	Where interviewed	Date
Media and Digital: Presenter and Producer Digital TV	Nadia	West Yorkshire	August 2016
Media and Digital: Presenter and Musician	Sakinah	West Yorkshire	August 2016
Media and Digital: Magazine; TV; Film/ Producer	Deeyah	Telephone (based in London)	July 2016
Media and Digital: Radio presenter and Other (Comedian)	'Sultana'	Manchester	December 2018
Media and Digital: Producer and presenter	'Mia'	Manchester	July 2017
Media and Digital: Former journalist and researcher	'Tiymah'	Telephone (based in Edinburgh)	December 2017
Media and Digital: Content producer, Entrepreneur and Spoken word artist	'Amal'	Telephone (based in London)	August 2017
Media and Digital: Entrepreneur and Textiles in Legal Technology	'Rai'	Manchester	November 2017
Fashion and Textiles: Designer and Tutor	Aamira	Luton	April 2016

Sub-sector/role	Name/ 'pseudonym'	Where interviewed	Date
Fashion: Designer	Deniz	Rotterdam	September 2016
Fashion and Textiles: Designer and small modest fashion business owner	'Wafiza'	Leicester	November 2017
Fashion and Textiles: Designer	'Maia'	Manchester	Saturday 2018
Fashion and Textiles: Textile Designer	'Fatimah'	Manchester	January 2018
Fashion and Textiles: Designer and Tailor	'Clementine'	Oldham	July 2018
Fashion and Textiles: Co-owners of Textiles mill and education centre (2 people)	'Aashi' and 'Muhil'	Manchester	November 2018
Fashion and Textiles: Visual Arts: Textile Designer and Visual Artist	'Saila'	Manchester – London	January 2018
Visual Arts: Graphic Designer	'Sadia'	Greater Manchester	November 2017
Visual Arts: Artist	'Busara'	Manchester – London	October 2017
Visual Arts: Illustrator and artist	'Mona'	Manchester	December 2017
Visual Arts: Curator and diversity lead for major institution	'Sabina'	Manchester	January 2018
Visual arts: Artist	'Dinah'	Manchester	December 2017
Visual Arts: Photographer, Poet, Charity volunteer	'Safa'	Manchester	January 2018
Visual Arts: Artist, Textile Designer and Charity Worker	'Saba'	Manchester	February 2018
Visual Arts: Artist Film-maker	'Nina'	Manchester	February 2018
Visual Arts: Artist, Researcher and Translator	'Nazneen'	Manchester	June 2018

Sub-sector/role	Name/ 'pseudonym'	Where interviewed	Date
Visual Arts: Artist and Curator	'Yasmin'	Birmingham	July 2018 (informal)
Visual Arts: Artist, Researcher and Curator	Sara	London	July 2018
Visual Arts: Artist	Zarah	Cheshire/London	August 2018
Visual Arts: Artist	Azraa	Greater Manchester	September 2018
Visual Arts: Artist and Producer	'Arina'	Birmingham	November 2018
Visual Arts: Artist and Producer	'Farzana'	Manchester	December 2018
Other (Dancers); and students (2 people)	'Adeeba' and 'Asja'	Manchester	November 2018
Other (Fictional writer and festival product)	Qaisra	Manchester	July 2017
Stakeholder (academia) Vice Chancellor Arts and Humanities for a post 1992 university	'Amanda'	Manchester	October 2018
Stakeholder (Council Worker, Manchester City Council)	'Binita'	Manchester	November 2018
Stakeholder (Local councillor)	'Gulfsa'	Manchester	September 2017
Stakeholder Visual arts: Artist and director of South Asian arts company	'Riaan'	Manchester	October 2017
Stakeholder Visual Arts: Curator of leading south Asian arts gallery in major institution	'Derek'	Manchester	November 2018
Stakeholder Other (Charity); Producer of digital content and volunteer	'Asma'	Manchester	November 2018
Stakeholder Other (Charity); Event organiser and teacher	'Hayam'	Manchester	November 2018

Sub-sector/role	Name/ 'pseudonym'	Where interviewed	Date
Stakeholder Other (Charity and Events): Producer, Volunteer	'Selma'	Manchester	November 2018
Stakeholder Other (Charity and Events): Producer, Volunteer	'Alys'	Manchester	November 2018
Stakeholder Other (Charity and Events)	'Tamsin'	Birmingham	October 2016
Stakeholder Other (Charity and Events)	'Neelam'	Manchester	October 2016

BIBLIOGRAPHY

Abu-Lughod, L. (2002), 'Do Muslim women really need saving? Anthropological reflections on cultural relativism and its others', *American Anthropologist*, 104(3), 783–90.

Abu-Lughod, L. (2010), 'The active social life of "Muslim Women's Rights": a plea for ethnography, not polemic, with cases from Egypt and Palestine', *Journal of Middle East Women's Studies*, 6(1), 1–45.

Afshar, H. (1989), Gender roles and the moral economy of kin among Pakistani women in West Yorkshire, *Journal of Ethnic and Migration Studies*, 15(2), 211–25.

Afshar, H. (1994), Muslim women in West Yorkshire', in M. Maynard and H. Afshar (eds) *The Dynamics of Race and Gender: Some Feminist Interventions*, London: Taylor and Francis, London, pp. 127–47.

Ahmed, L. (1992), *Women and Gender in Islam: Historical Roots of a Modern Debate*, New Haven, CT: Yale University Press.

Ahmed, S. (2010), *The Promise of Happiness*, Durham, NC: Duke University Press.

Ahmed, S. (2012), *On Being Included: Racism and Diversity in Institutional Life*, Durham, NC: Duke University Press.

Ahmed, S. (2019), 'Converging identities, emerging discourses: Muslim female voices in British media', *ESSACHESS–Journal for Communication Studies*, 12 (24), 79–97.

Ahmed, S. and A. Dale (2008), 'Pakistani and Bangladeshi Women's Labour Market Participation', Cathie March Centre for Census and Survey Research CCSR Working Paper, <http://www.ccsr.ac.uk/resea rch/documents/2008-01.pdf>.

al-'Alam, R. (2003), 'Exclusive interview with Visual Dhikr artist', <www .mcb.org.uk/features/features.php?ann_id=154> (last accessed 19 September 2008).

Al-Azmeh, A. (1993), *Islams and Modernities*, London: Verso.

Alexander, C. E. (1996), *The Art of Being Black: The Creation of Black British Youth Identities*, New York: Clarendon Press.

Alexander, C. (2017), 'Raceing Islamophobia', in F. Elahi and O. Khan (eds), *Islamophobia: Still a Challenge for us All*, London: Runnymede Trust, pp. 13–17.

Alexander, A. C. and C. Welzel (2011), 'Islam and patriarchy: how robust is Muslim support for patriarchal values?', *International Review of Sociology*, 21(2), 249–76.

Amin, A. (2002), 'Ethnicity and the multicultural city: living with diversity', *Environment and Planning A*, 34, 959–80.

Anderson E. (2015), 'The white space', *Sociology of Race and Ethnicity*, 1(1), 10–21.

Anitha, S., R. Pearson and L. McDowell (2012), 'Striking lives: multiple narratives of South Asian Women's Employment, Identity and Protest in the UK', *Ethnicities*, 12(6), 654–775.

Ansari, H. (2002) 'Muslims in Britain', Minority Rights Group International, London, <https://minorityrights.org/wp-content/up loads/old-site-downloads/download-129-Muslims-in-Britain. pdf>.

Ansari, H. (2004), *The 'Infidel' Within: Muslims in Britain Since 1800*, London: Hurst & Co.

Anwar, M. (1979), *The Myth of Return: Pakistanis in Britain*. London: Heinemann.

Appadurai, A. (ed.) (1988), *The Social Life of Things: Commodities in Cultural Perspective*, Cambridge: Cambridge University Press.

Appiah, K. (2006), *Cosmopolitanism: Ethics in a World of Strangers*, New York: W. W. Norton.

Araeen, R. (2000), 'A new beginning: beyond postcolonial cultural theory and identity politics', *Third Text*, 14(50), 3–20.

Architectural Association's Archives, *Traces of Passage*, no. 28, 26 May 2016, <http://collectionsblog.aaschool.ac.uk/aa-archives-traces-of-pas sage/> (last accessed 20 December 2020).

Arnold, M. (ed.) (1911[1869]), *Culture and Anarchy: An Essay in Political and Social Criticism*, London: Macmillan.

Ashton, D. and E. Agusita (2020), 'Unexpected enterprises: remixing creative entrepreneurship', in S. Taylor and S. Luckman (eds), *Pathways into Creative Working Lives* (Creative Working Lives), London: Palgrave Macmillan.

Ashton, D. and K. Patel (2018), 'Vlogging careers: everyday expertise, collaboration and authenticity', in S. Taylor and S. Luckman (eds), *The New Normal of Working Lives*, Cham: Palgrave Macmillan, pp. 140–70.

Ashton, D. and K. Patel (2020), 'Girls' bedroom cultures', in *The International Encyclopedia of Gender, Media, and Communication*, Hoboken, NJ: John Wiley, 1–6.

Atif Imtiaz, S. M. (2011), *Wandering Lonely in a Crowd: Reflections on the Muslim Condition in the West*, Markfield: Kube.

Awan, I. (2014), 'Islamophobia and Twitter: a typology of online hate against Muslims on social media', *Policy and Internet*, 6(2), 133–50.

Aziz, S. (2018), 'Thanks, but a "Love a Muslim Day" isn't enough to counter Islamophobia', *The Guardian*, 4 April 2018, <https://www.the guardian.com/commentisfree/2018/apr/04/love-a-muslim-day-coun ter-islamophobia>.

Baer, H. (2016), 'Redoing feminism: digital activism, body politics, and neoliberalism', *Feminist Media Studies*, 16(1), 17–34.

Baker, C. and J. Beaumont (2011), 'Postcolonialism and religion: new spaces of "belonging and becoming" in the postsecular city', in Beaumont and Baker (eds), *Postsecular Cities: Space, Theory and Practice*, London: Bloomsbury, pp. 33–9.

Ball, L., E. Pollard and N. Stanley (2010), *Creative Graduates Creative Futures*, London: Institute for Employment Studies.

Banks, M. J. (2010), 'The picket line online: creative labor, digital activism, and the 2007–2008 Writers Guild of America strike', *Popular Communication*, 8(1), 20–33.

Banks, M. (2020), 'Persistent creativity: making the case, for art, culture and the creative industries', *International Journal of Cultural Policy*, 26(5), 709–10.

Banks, M. and D. Hesmondhalgh (2009), 'Looking for work in creative industries policy', *International Journal of Cultural Policy*, 15(4), 415–30.

Banks, M. and K. Oakley (2016), 'The dance goes on forever? Art schools, class and UK higher education', *International Journal of Cultural Policy*, 22(1), 41–57.

Beaumont, J., and C. Baker (eds) (2011), *Postsecular Cities: Space, Theory and Practice*, London: Bloomsbury.

Beaumont-Thomas, B. (2015), 'Major survey on UK arts diversity launched', *The Guardian*, 21 September 2021, <https://www.theguardian.com/culture/2015/sep/21/panic-survey-diversity-uk-arts-institutions> (last accessed 6 December 2021).

Begum, L., R. K. Dasgupta and R. Lewis (eds) (2018), *Styling South Asian Youth Cultures: Fashion, Media and Society*, London: Bloomsbury.

Behiery, V. (2015), 'Muslim women visual artist online organisations', *Hawwa: Journal of Women in the Middle East*, 13(3), 297–322.

Belfiore, E. (2020), 'Whose cultural value? Representation, power and creative industries', *International Journal of Cultural Policy*, 26(3), 383–97.

Bennett, T. (2001), *Cultural Policy and Cultural Diversity: Mapping the Policy Domain*, Policy Note 7, Strasbourg, Council of Europe.

Bennett, T., M. Savage, E. B. Silva, A. Warde, M. Gayo-Cal and D. Wright (2009), *Culture, Class, Distinction*, London: Routledge.

Bennoune, K. (2017), Special Rapporteur in the Field of Cultural Rights at the 34th Session of the United Nations of Human Rights Council, Office of the High Commissioner, Geneva: UN, <https://www.ohchr.org/en/NewsEvents/Pages/DisplayNews.aspx?NewsID=21423&LangID=E>.

Berger, J. (2008 [1972]). *Ways of Seeing*, London: Penguin.

Berthoud, R. and M. Blekesaune (2007), *Persistent Employment Disadvantage* (No. 416), Leeds: Corporate Document Services.

Bhabha, H. K. (1990), 'DissemiNation: time, narrative, and the margins of the modern nation', in *Nation and Narration*, London: Routledge, pp. 291–322.

Bhachu, P. (1985), *Twice-migrants: East-African Sikh Settlers in Britain*, London: Tavistock Publications.

Bianchini, F. (1999), 'Cultural Planning for Urban Sustainability', in L. Nystrom and C. Fudge (eds), *Culture and Cities. Cultural Processes and Urban Sustainability*, Stockholm: The Swedish Urban Development Council, pp. 34–51.

Bille, T., A. Grønholm and J. Møgelgaard (2016), 'Why are Cultural Policy Decisions Communicated in Cool Cash?', *International Journal of Cultural Policy*, 22(2), 238–55.

Birdwood, G. (1878), *Handbook to the British Indian Section*, London and Paris: Offices of the Royal Commission.

Blogosphere (February 2017), 'Dina Tokio: The Hijabi Blogger Breaking Stereotypes', Issue 12, <https://www.blogospheremagazine.com/shop /issue-12-print/>.

Bloom, H. (2014 [1994]), *The Western Canon: The Books and School of the Ages*, Boston: Houghton Mifflin Harcourt.

Blunt, A. (2007), 'Cultural geographies of migration: mobility, transnationality and diaspora', *Progress in Human Geography*, 31(5), 684–94.

Bolkhari, H. G. (2017), 'Aesthetic and concept of beauty in Quran', *International Journal of Arts*, 7(1), 1–5.

Bombay Gazette, 5 December 1896, 'Letter to the Editor', reprinted in *Journal of Indian Art and Industry* [JIAI], (1898), 61, 2.

Bourdieu, P. (1984 [1979]), *Distinction: A Social Critique of the Judgement of Taste*, Cambridge, MA, Harvard University Press.

Bourdieu, P., Darbel, A. and Schnapper, D. (1997), *The Love of Art: European Art Museums and their Public*, Cambridge, Polity Press.

Bourgoin, J. (1879), *Les Elements de l'Art Arabe: Trait des Entrelacs*, Paris: Firmin-Didiot.

Bowlby, S. and S. Lloyd-Evans (2009), 'You seem very westernised to me: place, identity and othering of Muslim workers in the UK labour market', in P. Hopkins and R. Gale, *Muslims in Britain: Race, Place and Identities*, Edinburgh: Edinburgh University Press, pp. 37–54.

Brah, A. (1993), '"Race" and "culture" in the gendering of labour markets: South Asian young Muslim women and the labour market', *New Community*, 19(3), 441–58.

Brah, A. and S. Shaw (1992), *Working Choices: South Asian Young Muslim Women and the Labour Market*, Department of Employment, Research Paper 91, London: HMSO.

Bridgstock, R. and Cunningham, S. (2016), 'Creative labour and graduate outcomes: implications for higher education and cultural policy', *International Journal of Cultural Policy*, 22(1), 10–26.

Bridgstock, R., B. Goldsmith, J. Rodgers and G. Hearn (2015). 'Creative graduate pathways within and beyond the creative industries', *Journal of Education and Work*, 28(4), 333–45.

British Fashion Council (2015), *High-end and Designer Manufacturing: A Report on Protecting Existing Resource and Encouraging Growth and Innovation*, London: British Fashion Council.

Brook, O., D. O'Brien and M. Taylor (2018), *Panic! Social Class, Taste and Inequalities in the Creative Industries Project report*, <https://createlon don.org/wp-content/uploads/2018/04/Panic-Social-Class-Taste-and -Inequalities-in-the-Creative-Industries1.pdf>.

Brook, O., D. O'Brien and M. Taylor (2020), *Culture is Bad for You: Inequality in the Cultural and Creative Industries*, Manchester: Manchester University Press.

Brooks, R. and G. Everett (2009), 'Post-graduation reflections on the value of a degree', *British Educational Research Journal*, 35(3), 333–49.

Brooks, R. and J. Waters (2011), *Student Mobilities, Migration and the Internationalization of Higher Education*, Basingstoke and New York: Palgrave Macmillan.

Brown, P., A. Hesketh and S. Williams (2004), *The Mismanagement of Talent: Employability and Jobs in the Knowledge Economy*, Oxford: Oxford University Press.

Brydges, T. and J. Sjöholm (2019), 'Becoming a personal style blogger: changing configurations and spatialities of aesthetic labour in the fashion industry', *International Journal of Cultural Studies*, 22(1), 119–39

Bukodi, E. and J. H. Goldthorpe (2018), *Social Mobility and Education in Britain: Research, Politics and Policy*, Cambridge: Cambridge University Press.

Bulliet, R. W. (1979), *Conversion to Islam in the Medieval Period: An Essay in Quantitative History*, Cambridge, MA: Harvard University Press.

Busby, M. (2020), 'Schools in England told not to use material from anti-capitalist groups', *The Guardian*, 27 September 2020, <https://www .theguardian.com/education/2020/sep/27/uk-schools-told-not-to

-use-anti-capitalist-material-in-teaching> (last accessed 20 December 2020)

Byrne, B. (2014), *Making Citizens: Public Rituals and Personal Journeys to Citizenship*, Basingstoke: Palgrave Macmillan.

Byrne, B., C. Alexander, O. Khan, J. Nazroo and W. Shankley (2020), *Ethnicity, Race and Inequality in the UK: State of the Nation*, Bristol: Policy Press.

Cantle, T. (2012), 'Interculturalism: for the era of globalisation, cohesion and diversity', *Political Insight*, 3(3), 38–41.

Cesari, J. (2004), 'Islam in the West', in Birgit Schaebler and Leif Stenberg (eds), *Globalization and the Muslim World: Culture, Religion, and Modernity*, Syracuse, NY: Syracuse University Press, pp. 87–90.

Chakrabarty, D. (2000), *Provincializing Europe: Postcolonial Thought and Historical Difference*, Princeton, NJ: Princeton University Press.

Cheung, S. Y. (2014), Ethno-religious minorities and labour market integration: generational advancement or decline? *Ethnic and Racial Studies*, 37(1), 140–60.

Cheung, S. Y. and A. F. Heath (2007), 'Nice work if you can get it: ethnic penalties in Great Britain', in A. F. Heath and S. Y. Cheung (eds), *Unequal Chances: Ethnic Minorities in Western Labour Markets*, Proceedings of the British Academy 137, Oxford: Oxford University Press, pp. 507–50

Choudhrey, S. (2016). 'Digital Islamic art: the use of digital technologies in contemporary Islamic art in the UK', July 2016, Swindon: BCS Learning.

Choudhrey, S. (2018), 'Pigment to Pixel – An Investigation into Digital Islamic Art in the UK', unpublished doctoral dissertation, University of Kent.

Christopherson, S. (2008), 'Beyond the self-expressive creative worker an industry perspective on entertainment media', *Theory, Culture and Society*, 25(7–8), 73–95.

Citizens UK (2017), *The Missing Muslims: Unlocking British Muslim Potential for the Benefit of All*, Report by the Citizens Commission on Islam, Participation and Public Life, London: Citizens UK.

Coles, A. and K. MacNeill (2017), 'Policy ecologies, gender, work, and regulation distance in film and TV production', in D. Peetz and G.

Murray (eds), *Women, Labor Segmentation and Regulation*, New York: Palgrave Macmillan, pp. 211–31.

Connell, J. and C. Gibson (2003), *Sound Tracks: Popular Music, Identity and Place*, London: Routledge.

Conor, B., R. Gill and S. Taylor (2015), 'Gender and creative labour', *Sociological Review*, 63, 1–22.

Consilium and Arts Council England (2014), *Equality and Diversity within the Arts and Cultural Sector in England, Evidence Review*, London: Consilium, <https://www.artscouncil.org.uk/sites/default/files/download-file/Equality_and_diversity_within_the_arts_and_cultural_sector_in_England_0.pdf>

Consilium and Arts Council England (2018), *Equality and Diversity within the Arts and Cultural Sector in England, 2013–16: Evidence Review*, London: Consilium, <https://www.artscouncil.org.uk/sites/default/files/download-file/Consilium_Equality_Diversity_report_13112018.docx_0.pdf> (last accessed 20 December 2020).

Cook, I. (2004), 'Follow the thing: Papaya', *Antipode*, 36(4), 642–64.

cooke, m. (2002), 'Saving brown women', *Signs: Journal of Women in Culture and Society*, 28(1), 468–70.

cooke, m. (2007), 'The Muslimwoman', *Contemporary Islam*, 1, 139–54.

Crang, M. (1998), *Cultural Geography*, London: Routledge.

Crang, M. and D. P. Tolia-Kelly (2010), 'Nation, race, and affect: senses and sensibilities at national heritage sites', *Environment and Planning A*, 42(10), 2315–31.

Crang, P., C. Dwyer and P. Jackson (2003), 'Transnationalism and the spaces of commodity culture', *Progress in Human Geography*, 27(4), 438–56.

Create (2015), 'Panic!', *The Guardian*, 21 September 2015, <https://www.theguardian.com/culture/2015/sep/21/panic-survey-diversity-arts-culture-creative-industries> (last accessed 6 December 2021).

Creative Skillset (2012), *Employment Census of the Creative Media Industries*, <https://www.screenskills.com/media/1552/2012_employment_census_of_the_creative_media_industries.pdf>.

Crenshaw, K. (1991), 'Mapping the margins: intersectionality, identity politics, and violence against women of color', *Stanford Law Review*, 43(6), 1241–99.

Crewe, L. (2013), 'When virtual and material worlds collide: democratic

fashion in the gendered labor market within a craft industry in transition', *Environment and Planning A* 45(4), 760–80.

Crewe, L. (2017), *The Geographies of Fashion: Consumption, Space, and Value*, London: Bloomsbury.

Critchlow, K. (1999), *Islamic Patterns: An Analytical and Cosmological Approach*, Rochester: Inner Traditions International, pp. 24–5.

Cumming, L. (2009), *The Observer*, 1 February 2009), <https://www.theguardian.com/artanddesign/2009/feb/01/unveiled-saatchi-gallery-review-art>.

Dabbour, L. M. (2012), 'Geometric proportions: the underlying structure of design process for Islamic geometric patterns', *Frontiers of Architectural Research*, 1(4), 380–91.

Dahya, B. (1974), 'The nature of Pakistani ethnicity in industrial cities in Britain', in A. Cohen (ed.), *Urban Ethnicity*, London: Tavistock, pp. 77–118.

Dale, A., N. Shaheen, V. Kalra and E. Fieldhouse (2002), 'Routes into education and employment for young Pakistani and Bangladeshi women in the UK', *Ethnic and Racial Studies*, 25(6), 942–68.

DCMS (2008), 'Our Creative Talent: the voluntary and amateur arts in England', <https://culturehive.co.uk/wp-content/uploads/2013/04/Our-Creative-Talent.pdf>

de Certeau, M. (1988), 'Walking in the city', in *The Practice of Everyday Life*, Berkeley: University of California Press, pp. 91–110.

de Dios, A. and L. Kong (eds) (2020), *Handbook on the Geographies of Creativity*, Cheltenham: Edward Elgar Publishing.

DeHanas, D. N. (2016), *London Youth, Religion, and Politics: Engagement and Activism from Brixton to Brick Lane*, Oxford: Oxford University Press.

Demos (2015), *Rising to the Top*, <https://www.demos.co.uk/project/rising-to-the-top/> (last accessed 18 August 2018).

Department for Culture Media and Sport (DCMS) (1999). *National Strategy for Neighbourhood Renewal: Policy Action Audit: Report of the Policy Action Team 10: The Contribution of Sport and the Arts*. London: DCMS.

Department for Culture Media and Sport (DCMS) (2016), *Creative Industries: Focus on Employment*, Whitehall: UK Government.

Department for Culture, Media and Sport (DCMS) (2018/19) *Taking Part Survey, England: Adult Report*, Whitehall: UK Government, <https://

assets.publishing.service.gov.uk/government/uploads/system/uploads
/attachment_data/file/879725/Taking_Part_Survey_Adult_Report
_2018_19.pdf>

Department for Culture, Media and Sport (DCMS) (2000), *Centres for Social Change: Museums, Galleries and Archives for All*. Whitehall: UK Government.

DiAngelo, R. (2011), 'White fragility', *International Journal of Critical Pedagogy*, 3, 54–70.

Dikeç, M. (2005), 'Space, politics, and the political', *Environment and Planning D: Society and Space*, 23(2), 171–88.

Dixon, D. P. (2014), 'The way of the flesh: life, geopolitics and the weight of the future', *Gender, Place and Culture*, 21, 136–51.

Dixon, D. P. and S. A. Marston (2011), 'Introduction: feminist engagements with geopolitics', *Gender, Place and Culture*, 18, 445–53.

Dorling, D. and B. D. Hennig (2016), 'London and the English desert–the geography of cultural capital in the UK', *Cultural Trends*, 25(1), 35–46.

Dowler, L. and J. Sharp (2001), 'A feminist geopolitics?', *Space and Polity*, 5, 165–76.

Duffy, B. E. (2016), 'The romance of work: gender and aspirational labour in the digital culture industries', *International Journal of Cultural Studies*, 19(4), 441–57.

Duffy, B. E. and E. Hund (2015), '"Having it all" on social media: entrepreneurial femininity and self-branding among fashion bloggers', *Social Media and Society*, 1(2), 1–11.

Dunn, K. M. (2003), 'Using cultural geography to engage contested constructions of ethnicity and citizenship in Sydney', *Social and Cultural Geography*, 4(2), 153–65.

Dwyer, C. (1999), 'Veiled meanings: young British Muslim women and the negotiation of differences', *Gender, Place and Culture: A Journal of Feminist Geography*, 6(1), 5–26.

Dwyer, C. (2000), 'Negotiating diasporic identities: young British South Asian Muslim women', *Women's Studies International Forum*, 23(4), 475–86.

Dwyer, C. (2016), 'Why does religion matter for cultural geographers?', *Social and Cultural Geography*, 17(6), 758–62.

Dwyer, C. and P. Crang (2002), 'Fashioning ethnicities: the commercial spaces of multiculture', *Ethnicities*, 2(3), 410–30.

Dwyer, C. and P. Jackson (2003), 'Commodifying difference: selling EASTern fashion', *Environment and Planning D: Society and Space*, 21(3), 269–91.

Dwyer, C. and B. Shah (2009), 'Rethinking the identities of young British Pakistani Muslim women: educational experiences and aspirations', in P. Hopkins and R. Gale (eds), *Muslims in Britain: Race, Place and Identities*, Edinburgh: Edinburgh University Press, pp. 55–73.

Eagleton, T., F. Jameson and Said, E. (1988), *Nationalism, Colonialism and Literature: Modernism and Imperialism*, Derry: Field Day Theatre Company.

Edensor, T., D. Leslie, S. Millington and N. Rantisi (eds) (2009), *Spaces of Vernacular Creativity: Rethinking the Cultural Economy*, London: Routledge.

Edge, P. and L. Vickers (2015), *Review of Equality and Human Rights Law Relating to Religion or Belief*, Equality and Human Rights Commission Research report 97, Equality and Human Rights Commission.

Ekinsmyth, C. (2011), 'Challenging the boundaries of entrepreneurship: the spatialities and practices of UK "Mumpreneurs"', *Geoforum*, 42(1), 104–14.

Ekinsmyth, C. (2014), Mothers' business, work/life and the politics of "mumpreneurship"', *Gender, Place and Culture*, 21(10), 1230–48.

Elahi, F. and O. Khan (2017), *Islamophobia: Still a Challenge for Us All*, Runnymede Foundation, <https://www.runnymedetrust.org/uploads /Islamophobia%20Report%202018%20FINAL.pdf> (last accessed 15 February 2017).

El-Enany, N. (2020), *(B)ordering Britain: Law, Race and Empire*, Manchester: Manchester University Press.

Ellis-Petersen, H. (2015), 'Middle class people dominate arts, survey finds', *The Guardian*, 23 November 2015, <http://www.theguardian.com /artanddesign/2015/nov/23/middle-class-people-dominate-arts-sur vey-finds> (last accessed 6 December 2021).

Elshayyal, K. (2018), *Muslim Identity Politics: Islam, Activism and Equality in Britain*, London: Bloomsbury.

Entwistle, J. and E. Wissinger (2006), 'Keeping up appearances: aesthetic labour in the fashion modelling industries of London and New York', *Sociological Review*, 54(4), 774–94.

Equality and Human Rights Commission (2016), *Religion or Belief: Is the Law Working?*, <https://www.equalityhumanrights.com/en/pub lication-download/religion-or-belief-law-working>.

Essers, C. and Y. Benschop (2009), 'Muslim businesswomen doing boundary work: the negotiation of Islam, gender and ethnicity within entrepreneurial contexts', *Human Relations*, 62(3), 403–23.

Evans, S. L. and S. Bowlby (2000), 'Crossing boundaries: racialised gendering and the labour market experiences of Pakistani migrant women in Britain', *Women's Studies International Forum*, 23(4), 461–74.

Falah, G. W. (2005), 'The visual representation of Muslim/Arab women in daily newspapers in the United States', in G. W. Falah and C. R. Nagel (eds) (2005), *Geographies of Muslim Women: Gender, Religion, and Space*, New York: Guilford Press, pp. 300–21.

Falah, G. W. and C. R. Nagel (eds) (2005), *Geographies of Muslim Women: Gender, Religion, and Space*, New York: Guilford Press.

Fanon, F. (1952), *Black Skin, White Masks*, trans. Charles Lam Markmann, New York: Grove Press.

Faruqi, N. (2017), *Diversity: A Critical Engagement*, Clore Leadership Fellow Report, <https://www.cloreleadership.org/userfiles/documents /NQF_Diversity_ACriticalEngagement.pdf> (last accessed 29 November 2020).

Fessenden, T. (2011), *Culture and Redemption: Religion, the Secular, and American Literature*, Princeton, NJ: Princeton University Press.

Fielding, A. J. (1992), 'Migration and social mobility: south east England as an escalator region', *Regional Studies*, 26(1), 1–15.

Finlay, R. and P. Hopkins (2019), 'Young Muslim women's political participation in Scotland: exploring the intersections of gender, religion, class and place', *Political Geography*, 74, 102046.

Fitzgerald, D. (2004), 'Beyond "transnationalism": Mexican hometown politics at an American labour union', *Ethnic and Racial Studies*, 27: 228–47.

Flew, T. (2011), *The Creative Industries: Culture and Policy*, Los Angeles: Sage.

Flew, T. (2019), 'From policy to curriculum: drivers of the growth in creative industries courses in the UK and Australia', *Creative Industries Journal*, 12, 167–84.

Flew, T. and S. Cunningham (2010), 'Creative industries after the first decade of debate', *The Information Society*, 26(2), 113–23.

Fluri, J. L. (2009), 'Geopolitics of gender and violence "from below"', *Political Geography*, 28, 259–65.

Fraser, N. (2000), 'Rethinking recognition', *New Left Review*, 3(May–June), 107–20.

Froud, J. et al. (2018), 'Capabilities and habitat in industrial renewal: the case of UK textiles', *Cambridge Journal of Economics*, 42, 1643–69.

García, B. (2004), 'Cultural policy and urban regeneration in Western European cities: lessons from experience, prospects for the future', *Local Economy*, 19(4), 312–26.

Garratt, L., B. Harries, B. Byrne and A. Smith (2019), '"Divide and conquer". Anti-racist and minority organising under austerity', *Ethnic and Racial Studies*, 43(16), 20–38.

Gerbaudo, P. (2012), *Tweets and the Streets: Social Media and Contemporary Activism*, London: Pluto Press.

Gerbaudo, P. and E. Treré (2015), 'In search of the "we" of social media activism: introduction to the special issue on social media and protest identities', *Information, Communication and Society*, 18(8), 865–71.

Ghilardi, L. (2001), 'Cultural planning and cultural diversity', in T. Bennett, *Differing Diversities*, Strasbourg: Council of Europe, pp. 123–34.

Gilbert, D., and P. Casadei (2020), 'The hunting of the fashion city: rethinking the relationship between fashion and the urban in the twenty-first century', *Fashion Theory*, 24(3), 393–408.

Gilbert, D. et al. (2019), 'The hidden geographies of religious creativity: place-making and material culture in West London faith communities', *Cultural Geographies*, 26(1), 23–41.

Gill, R. (2007), 'Postfeminist media culture: elements of a sensibility', *European Journal of Cultural Studies*, 10(2), 147–66.

Gill, R. (2009), 'Creative biographies in new media: social innovation in web work', in P. Jeffcutt and P. Pratt (eds), *Creativity and Innovation*, London: Routledge, pp. 161–78.

Gill, R. (2010), '"Life is a pitch": managing the self in new media work', in M. Deuze (ed.), *Managing Media Work*, London: Sage, pp. 249–62.

Gill, R. and A. Pratt (2008), 'In the social factory? Immaterial labour, precariousness and cultural work', *Theory, Culture and Society*, 25(7–8), 1–30.

Gillespie, M. (1995), *Television, Ethnicity and Cultural Change*. London: Routledge.

Gilliat-Ray, S. (2010), *Muslims in Britain: An Introduction*, Cambridge: Cambridge University Press.

Gilroy, P. (2013), *There Ain't no Black in the Union Jack*, London: Routledge.

Gökarıksel, B. and A. J. Secor (2009), 'New transnational geographies of Islamism, capitalism and subjectivity: the veiling-fashion industry in Turkey', *Area*, 41(1), 6–18.

Gökarıksel, B. and A. Secor (2010a), 'Between fashion and tesettür: marketing and consuming women's Islamic dress', *Journal of Middle East Women's Studies*, 6(3), 118–48.

Gökarıksel, B. and A. Secor (2010b), 'Islamic-ness in the life of a commodity: veiling-fashion in Turkey', *Transactions of the Institute of British Geographers*, 35(3), 313–33.

Gökarıksel, B. and A. Secor (2012), '"Even I was tempted": the moral ambivalence and ethical practice of veiling-fashion in Turkey', *Annals of the Association of American Geographers*, 102, 847–62.

Gökarıksel, B. and A. Secor (2015), 'Post-secular geographies and the problem of pluralism: religion and everyday life in Istanbul, Turkey', *Political Geography*, 46, 21–30.

Gökariksel, B. and E. McLarney (2010), 'Muslim women, consumer capitalism, and the Islamic culture industry', *Journal of Middle East Women's Studies*, 6(3), 1–18.

Gonzalez, V. (2016), 'Beauty', in *Encyclopedia of Islam and the Muslim World*, 2nd edn, New York: Schirmer Books, pp. 158–63.

Government of India, Home Office (1898), Papers Relating to the Maintenance of Schools of Art in India as State Institutions from 1893–1896, no. 356. Calcutta: Office of the Superintendent of Government Printing.

Grabar, O. (1987), *The Formation of Islamic Art*, revised edn, New Haven, CT: Yale University Press.

Gray, H. (2016), 'Precarious diversity: representation and demography', in M. Curtin and K. Sanson (eds), *Precarious Creativity*, Oakland: University of California Press.

Grenfell, M. and C. Hardy (2003), 'Field manoeuvres: Bourdieu and the Young British Artists', *Space and Culture*, 6(1), 19–34.

Hage, G. (2002), 'Multiculturalism and white paranoia in Australia', *Journal of International Migration and Integration/Revue de l'intégration et de la migration internationale*, 3(3–4), 417–37.

Hall, S. (1990), 'Cultural identity and diaspora', in J. Rutherford (ed.), *Identity: Culture, Community, Difference*, London: Lawrence and Wishart.

Hall, S. (1993), 'Culture, community, nation', *Cultural Studies*, 7(3), 349–63.

Hall, S. (ed.) (1997), *Representation: Cultural Representations and Signifying Practices*, vol. 2, London: Sage.

Hall, S. (1999), 'Un-settling "the heritage", re-imagining the post-nation, Whose heritage?', *Third Text*, 13(49), 3–13.

Hall, S. M. (2011), 'High street adaptations: ethnicity, independent retail practices, and localism in London's urban margins', *Environment and Planning A*, 43, 2571–88.

Halliday, F. (1992a), *Arabs in Exile: Yemeni Migrants in Urban Britain*, London: I. B. Tauris.

Halliday, F. (1992b), 'The millet of Manchester: Arab merchants and the cotton trade', *British Journal of Middle Eastern Studies*, 19(2), 159–76.

Hammer, N., R. Plugor, P. Nolan and I. Clark (2015), *New Industry on a Skewed Playing Field: Supply Chain Relations and Working Conditions in UK Garment Manufacturing Focus Area – Leicester and the East Midlands*, Leicester: University of Leicester, Centre for Sustainable Work and Employment Futures.

Hargittai, E. and G. Walejko (2008), 'The participation divide: content creation and sharing in the digital age', *Information, Community and Society*, 11(2), 239–56.

Harris, A. and J. Roose (2014), 'DIY citizenship amongst young Muslims: experiences of the "ordinary"', *Journal of Youth Studies*, 17(6), 794–813.

Harvey, L. and A. Blackwell (1999), *Destinations and Reflections: Careers of British Art, Craft and Design Graduates*, Birmingham: Centre for Research into Quality.

Haw, K., S. Shah, and M. Hanifa (1998), *Educating Muslim Girls: Shifting Discourses*, Buckingham: Open University Press.

Hawkins, H. (2013), *For Creative Geographies: Geography, Visual Arts and the Making of Worlds*, London: Routledge.

Hawting, G. (1999), *The Idea of Idolatry and the Emergence of Islam: From Polemic to History*, Cambridge Studies in Islamic Civilization, Cambridge and New York: Cambridge University Press.

Heath, I. (2007), *The Representation of Islam in British Museums*, BAR International Series 1643, Oxford: Archaeopress.

Heath, A. and A. Mustafa (2017), 'Poverty and the labour market', in F. Elahi and O. Khan, *Islamophobia: Still a Challenge for Us All*, Runnymede Foundation, pp. 25–30, <https://www.runnymedetru st.org/uploads/Islamophobia%20Report%202018%20FINAL.pdf> (last accessed 15 February 2017).

HEPI (Higher Education Policy Institute) (2017) 'A crisis in the creative arts in the UK?', <https://www.hepi.ac.uk/wp-content/uploads/2017 /09/A-crisis-in-the-creative-arts-in-the-UK-EMBARGOED-UNTIL -7th-SEPTEMBER-2017.pdf>.

Herbert, D. and M. Gillespie (eds) (2011), Editorial, special issue on religion, media and social change, *European Journal of Cultural Studies*, 14(6), 601–9.

HESA (Higher Education Student Statistics) 2018/19, <https://www.hesa .ac.uk/news/16-01-2020/sb255-higher-education-student-statistics/sub jects>.

Hesmondhalgh, D. (2019), *The Cultural Industries*, 4th edn, London: Sage.

Hesmondhalgh, D. and S. Baker (2010), '"A very complicated version of freedom": conditions and experiences of creative labour in three cultural industries', *Poetics*, 38(1), 4–20.

Hesmondhalgh, D. and S. Baker (2013), *Creative Labour: Media Work in Three Cultural Industries*, London: Routledge.

Hill, L. (2015), 'Arts salary survey reveals stark gender pay gap, *Arts Professional*, <www.artsprofessional.co.uk/news/arts-salary-survey-reve als-stark-gender-pay-gap> (last accessed 2 October 2017).

Holland, J. (2007), 'Inventing adulthoods: making the most of what you have', in H. Helve and J. Bynner (eds), *Youth and Social Capital*, London: Tufnell Press, ch. 2.

Holloway, J. (2011), 'Tracing the emergent in geographies of religion and belief', in C. Brace, A. Bailey, S. Carter, D. Harvey and N. Thomas (eds), *Emerging Geographies of Belief*, Newcastle upon Tyne: Cambridge Scholars Publishing, pp. 30–52.

Holloway, S. L. and H. Pimlott-Wilson (2014), 'Enriching children, institutionalizing childhood? Geographies of play, extracurricular activities, and parenting in England', *Annals of the Association of American Geographers*, 104(3), 613–27.

Homeworkers Worldwide (HWW) (2019), *The Greater Manchester Textile and Garment Industry: A Scoping Study*, Leeds: HWW.

Hooper-Greenhill, E. (2013), *Museums and their Visitors*, London, Routledge.

Hoover, S. and K. Lundby (eds) (1997), *Rethinking Media, Religion and Society*, Thousand Oaks, CA: Sage.

Hopkins, P. (2009a), 'Geographical contributions to understanding Islam: current trends and future directions', *Contemporary Islam*, 3, 213–27.

Hopkins, P. (2009b), 'Women, men, positionalities and emotion: doing feminist geographies of religion', *ACME: An International E-Journal for Critical Geographies*, 8(1), 1–17.

Hopkins, P. and R. Gale (eds) (2009), *Muslims in Britain: Race, Place and Identities*, Edinburgh: Edinburgh University Press.

Hopkins, P., L. Kong and E. Olsen (2013), *Religion and Place: Landscape, Politics and Piety*, Dordrecht: Springer.

Hopkins, P., K. Botterill, G. Sanghera and R. Arshad (2017), 'Encountering misrecognition: being mistaken for being Muslim', *Annals of the American Association of Geographers*, 107(4), 934–48.

House of Commons Women and Equalities Committee (2016/17), 'Employment opportunities for Muslims in the UK', London: UK Government, <https://publications.parliament.uk/pa/cm201617/cms elect/cmwomeq/89/89.pdf>

Hubbard, P. (2017), 'Enthusiasm, craft and authenticity on the High Street: micropubs as "community fixers"', *Social and Cultural Geography*, 20(3), 1–22.

Huq, R. (2007), *Beyond Subculture: Pop, Youth and Identity in a Postcolonial World*, Abingdon: Routledge.

Husband, C. (1998), Globalisation, media infrastructures and identities in a diasporic community, *Javnost – The Public*, 5(4), 19–33.

Hussain, S. (2017), 'British Muslims', in F. Elahi and O. Khan, *Islamophobia: Still a Challenge for Us All*, Runnymede Trust, <https://www.runnym edetrust.org/uploads/Islamophobia%20Report%202018%20FINAL .pdf> (last accessed 15 February 2017).

Hussain, Z. (2015), in Arts Council England Creative Diversity Hubs, film published online, <https://www.youtube.com/watch?v=4eqqf MDfbI8&feature=emb_title> (last accessed 6 December 2021).

Hussain, D. and S. M. McLoughlin (2013), 'United Kingdom', in J. S. Nielsen et al. (eds), *Yearbook of Muslims in Europe*, vol. 5, Leiden: Brill.

Hyndman, J. (2004), 'Mind the gap: bridging feminist and political geography through geopolitics', *Political Geography*, 23, 307–22.

Ibert, O., M. Hess, J. Kleibert, F. Müller and D. Power (2019), 'Geographies of dissociation: Value creation, "dark" places, and "missing" links', *Dialogues in Human Geography*, 9(1), 43–63.

Idriss, S. (2016), 'Racialisation in the creative industries and the Arab-Australian multicultural artist', *Journal of Intercultural Studies*, 37(4), 406–20.

Inge, A. (2016), *The Making of a Salafi Woman: Paths to Conversion*, Oxford: Oxford University Press.

Institute for Fiscal Studies – UCL Institute of Education (2020), 'Parents, especially mothers, paying heavy price for lockdown', 27 May 2020, <https://www.ifs.org.uk/publications/14861> (last accessed 6 December 2021).

Isar, Y. R. (2006), 'Cultural diversity', *Theory, Culture and Society*, 23(2–3), 372–5.

Islam Channel (2017), 'Muslimas leading the ways in social media', Tuesday 1 August 2017, <https://www.islamchannel.tv/video-category/womens-am/> (last accessed 4 August 2017).

Issa, R. (1997), 'Review of modern Islamic art: development and continuity', *Journal of Palestine Studies*, 27(4), 112–14.

Jackson, P. (1989), *Maps of Meaning*, London: Routledge.

Jackson, P. (2002), 'Commercial cultures: transcending the cultural and the economic', *Progress in Human Geography*, 26(1), 3–18.

Jacobs, J. M. (1996), *Edge of Empire: Postcolonialism and the City*, London: Psychology Press.

Jakubowicz, A. H., J. H. Collins and W. F. Chafic (2012), 'Young Australian Muslims: social ecology and cultural capital', in F. Mansouri and V. Marotta (eds), *Muslims in the West and the Challenges of Belonging*, Melbourne: Melbourne University Press, pp. 35–59.

Jansen, C. (2016), 'The Guerrilla Girls have data proving the art world needs more women leaders', *Artsy*, <www.artsy.net/article/artsy-editorial-the-guerrilla-girls-have-proof-that-the-art-world-needs-more-women-leaders> (last accessed 2 October 2017).

Jazeel, T. (2013), *Sacred Modernity: Nature, Environment, and the Postcolonial Geographies of Sri Lankan Nationhood*, Liverpool: Liverpool University Press.

Jeffries, S. (2020), 'They called her a crazy witch: did medium Hilma af Klint invent abstract art?', *The Guardian*, 6 October 2020, <https://www.theguardian.com/artanddesign/2020/oct/06/hilma-af-klint-abstract-art-beyond-the-visible-film-documentary>.

Jeldtoft, N. (2011), 'Lived Islam: religious identity with "non-organized" Muslim minorities', *Ethnic and Racial Studies*, 340, 1134–51.

Jiwa, M. (2010), 'Imaging, imagining and representation: Muslim visual artists in NYC', *Contemporary Islam*, 4(1), 77–90.

Jones, O. (1856), *The Grammar of Ornament*, London: Day and Son.

Joseph, S. and A. Mirza (2011), The colourful Conservative, *Emel*, issue 79, 4 April 2011, <https://www.emel.com/article?id=99&a_id=2332&c=32> (last accessed 10 November 2021).

Julius, A., M. Quinn and P. Schofield (2020), *Bentham and the Arts*, London: UCL Press.

Kalra, V. (2000), *From Textiles Mills to Taxi Ranks: Experiences of Migration, Labour and Social Change*, Aldershot: Ashgate.

Kandiyoti, D. (ed.) (1996), *Gendering the Middle East: Emerging Perspectives*, London: I. B. Tauris.

Karlsen, S. and J. Y. Nazroo (2015), 'Ethnic and religious differences in the attitudes of people towards being "British"', *The Sociological Review*, 63(4), 759–81.

Khattab, N. (2009), 'Ethno-religious background as a determinant of educational and occupational attainment in Britain', *Sociology*, 43(2), 304–22.

Khattab, N. (2018), 'Ethnicity and higher education: the role of aspirations, expectations and beliefs', *Ethnicities*, 18(4), 457–70.

Khattab, N. and T. Modood (2015), 'Both ethnic and religious: explaining employment penalties across 14 ethno-religious groups in the UK', *Journal of the Scientific Study of Religion*, 54(3), 501–22.

Khattab, N., R. Johnston and D. Manley (2018), 'Human capital, family structure and religiosity shaping British Muslim women's labour market participation', *Journal of Ethnic and Migration Studies*, 44(9), 1541–59.

King, R. (2013 [1999]), *Orientalism and Religion: Post-Colonial Theory, India and 'The Mystic East'*, London: Routledge.

Knifton, R. and F. Lloyd (2017), 'Multisensorial dynamics: encountering

and capturing the intangible heritage of the Art School in Britain', *Studies in Material Thinking*, 17(Paper 6), 1–22.

Kong, L. (2000), 'Cultural policy in Singapore: negotiating economic and socio-cultural agendas', *Geoforum*, 31(4), 409–24.

Kong, L. (2001), 'Mapping "new" geographies of religion: politics and poetics in modernity', *Progress in Human Geography*, 25(2), 211–33.

Kong, L. (2020), 'From cultural industries to creative industries and back? Towards clarifying theory and rethinking policy', in A. de Dios and L. Kong (eds) (2020), *Handbook on the Geographies of Creativity*, Cheltenham: Edward Elgar Publishing, pp. 54–72.

Krippendorff, K. (2018), *Content Analysis: An Introduction to its Methodology*, Thousand Oaks, CA: Sage.

Larner, W., M. Molloy and A. Goodrum (2007), 'Globalization, cultural economy, and not-so-global cities: the New Zealand designer fashion industry', *Environment and Planning D: Society and Space*, 25(3), 381–400.

Laurie, N. (2010), 'Finding yourself in the archive and doing geographies of religion', *Geoforum*, 41, 165–7.

Lawless, R. (1997), 'Muslim migration to the north east of England during the early twentieth century', *Local Historian*, 27(4), 225–44.

Leitner, H. and P. Ehrkamp (2006), 'Transnationalism and migrants' imaginings of citizenship', *Environment and Planning A*, 38, 1615–32.

Leslie, D. and J. P. Catungal (2012), 'Social justice and the creative city: class, gender and racial inequalities', *Geography Compass*, 6(3), 111–22.

Lewis, R. (2007), 'Veils and sales: Muslims and the spaces of postcolonial fashion retail', *Fashion Theory*, 11(4), 423–41.

Lewis, R. (2010), 'Marketing Muslim lifestyle: a new media genre', *Journal of Middle East Women's Studies*, 6(3), 58–90.

Lewis, R. (2013), *Modest Fashion: Styling Bodies, Mediating Faith*, London: I. B. Tauris.

Lewis, R. (2015), *Muslim Fashion: Contemporary Style Cultures*, Durham, NC: Duke University Press.

Lewis, P. and S. Hamid (2018), *British Muslims: New Directions in Islamic Thought, Creativity and Activism*, Edinburgh: Edinburgh University Press.

Long, P. (2008), *Only in the Common People: The Aesthetics of Class in Post-war Britain*, Newcastle upon Tyne: Cambridge Scholars Publishing.

Luckman, S. (2018), 'Craft entrepreneurialism and sustainable scale: resistance to and disavowal of the creative industries as champions of capitalist growth', *Cultural Trends*, 27(5), 313–26.

Luckman, S. and J. Andrew (2018), 'Online selling and the growth of home-based craft microenterprise: the "new normal" of women's self-(under)employment', in S. Taylor and S. Luckman (eds), *The New Normal of Working Lives: Critical Studies in Contemporary Work and Employment*, Cham: Palgrave Macmillan, pp. 19–39.

McCaughey, M. and M. D. Ayers (2003), *Cyberactivism: Online Activism in Theory and Practice*, London: Psychology Press.

McCrudden, C., R. Ford and A. Heath (2004), 'The impact of affirmative action', in R. Osborne and I. Shuttleworth (eds), *Fair Employment in Northern Ireland a Generation On*, Belfast: Blackstaff Press.

Macdonald, S. J. (2003), 'Museums, national, postnational and transcultural identities', Museum Studies: an anthology of contexts, *Museum and Society*, 1(1), 1–16.

McDonald-Toone, E. C. (2019), '"Curating the region": exhibitions, geopolitics and the reception of contemporary and modern art from the Arab world and the Middle East', unpublished PhD dissertation, London: University College London.

McDowell, L. (2005), 'Love, money, and gender divisions of labour: some critical on welfare-to-work policies in the UK', *Journal of Economic Geography*, 5(3), 365–39.

McDowell, L. (2016), *Migrant Women's Voices: Talking About Life and Work in the UK Since 1945*, London: Bloomsbury Publishing.

McDowell, L. and S. Christopherson (2009), 'Transforming work: new forms of employment and their regulation', *Cambridge Journal of Region, Society and Economy*, 2(3), 335–42.

McGhee, D. (2008), *End of Multiculturalism: Terrorism, Integration and Human Rights*, Maidenhead: McGraw-Hill Education.

McGinty, A. M. (2012), 'The "mainstream Muslim" opposing Islamophobia: self-representations of American Muslims', *Environment and Planning A*, 44(12), 2957–73.

McGuire, M. (2008), *Lived Religion*. Oxford: Oxford University Press.

McRobbie, A. (1997), 'Bridging the gap: feminism, fashion and consumption', *Feminist Review*, 55(1), 73–89.

McRobbie, A. (2002), 'Holloway to Hollywood: happiness at work in the cultural economy', in Paul Du Gay and Michael Pryke (eds), *Cultural Economy: Cultural Analysis and Commercial Life*, London: Sage, pp. 97–114.

McRobbie, A. (2004), 'Post-feminism and popular culture', *Feminist Media Studies*, 4(3), 255–64.

McRobbie, A. (2009), 'Precarious work in the cultural industries', in B. Lange, A. Kalandides, B. Stober and I. Wellmann (eds), *Governance der Kreativwirtschaft: Diagnosen und Handlungsoptionen*, Bielefeld: Transcript Verlag, pp. 123–39.

Mahmood, S. (2001), 'Feminist theory, embodiment, and the docile agent: some reflections on the Egyptian Islamic revival', *Cultural Anthropology*, 16(2), 202–36.

Mahmood, S. (2006), 'Feminist theory, agency, and the liberatory subject: some reflections on the Islamic revival in Egypt', *Temenos-Nordic Journal of Comparative Religion*, 42(1).

Major, L. E. and S. Machin (2018), *Social Mobility: And Its Enemies*, London: Penguin UK.

Major, L. E. and S. Machin (2020), *What Do We Know and What Should We Do About Social Mobility?*, Thousand Oaks, CA: Sage.

Malik, K. and R. Dudrah (eds) (2020), *South Asian Creative and Cultural Industries*, London: Routledge.

Malik, S., C. Mahn, M. Pierse and B. Rogaly (eds) (2020), *Creativity and Resistance in a Hostile World*, Manchester: Manchester University Press.

Marinetto, M. (2003), 'Who wants to be an active citizen? The politics and practice of community involvement', *Sociology*, 37(1), 103–20.

Masood, E. (2006), *British Muslims: Media Guide*, London: British Council.

Mathur, S. (2005), 'Museums and globalization', *Anthropological Quarterly*, 78(3), 697–708.

Meghji, A. (2017), 'Positionings of the black middle-classes: understanding identity construction beyond strategic assimilation', *Ethnic and Racial Studies*, 40(6), 1007–25.

Meghji, A. (2019), 'Encoding and decoding black and white cultural capitals: black middle class experiences', *Cultural Sociology*, 13(1), 3–19.

Mercer, K. (1990), 'Black art and the burden of representation', *Third Text*, 4(10), 61–78.

Mercer, K. (1999), 'Ethnicity and internationally: new British art and diaspora-based blackness', *Third Text*, 13(49), 51–62.

Mercer, K. (2005), 'Iconography after identity', in D. A. Bailey, I. Baucom and S. Boyce (eds), *Shades of Black: Assembling Black Arts in 1980s Britain* (John Hope Franklin Center Book S), Durham, NC: Duke University Press.

Mernissi, F. (1987), *Beyond the Veil: Male-female Dynamics in Modern Muslim Society*, Bloomington: Indiana University Press.

Miaari, S., N. Khattab and R. Johnston (2019), 'Religion and ethnicity at work: a study of British Muslim women's labour market performance', *Quality and Quantity*, 53, 19–47.

Michael, B. (2016), 'Creating while female: how women artists deal with online abuse', *Vice*, <https://broadly.vice.com/en_us/article/creating-while-female-how-women-artists-deal-with-online-abuse> (last accessed 2 October 2017).

Migration Advisory Committee (2020), *Review of the Shortage Occupation List*, London: Migration Advisory Committee, <https://assets.publis hing.service.gov.uk/government/uploads/system/uploads/attachment _data/file/927352/SOL_2020_Report_Final.pdf>.

Milwright, M. (2017), *Islamic Arts and Crafts: An Anthology*, Edinburgh: Edinburgh University Press.

Mitter S. (1985), 'Industrial restructuring and manufacturing homework: immigrant women in the UK clothing industry', *Capital and Class*, 9(3), 37–80.

Mitter, P. (2008), 'Decentering modernism: art history and avant-garde art from the periphery', *Art Bulletin*, 90(4), 531–48.

Moallem, M. (2005), *Between Warrior Brother and Veiled Sister: Islamic Fundamentalism and the Politics of Patriarchy in Iran*, Berkeley and Los Angeles: University of California Press.

Modood, T. (1994), 'Establishment, multiculturalism and British citizenship', *Political Quarterly*, 65(1), 53–73.

Modood, T. (2006), 'Ethnicity, Muslims and higher education entry in Britain', *Teaching in Higher Education*, 11(2), 247–50.

Modood, T. (2016), 'Muslims, religious equality and secularism', in A. Berg-Sorensen (ed.), *Contesting Secularism: Comparative Perspectives*, London: Routledge, pp. 69–86.

Mohammad, R. (2005), 'Negotiating spaces of the home, the education system and the labour market: the case of young, working-class, British-Pakistani Muslim women', in G.-W. Falah and C. Nagel (eds), *Geographies of Muslim Women: Gender, Religion and Space*, London and New York: Guildford Press, pp. 178–200.

Mohanty, C. T., A. Russo and L. Torres (eds) (1991), *Third World Women and the Politics of Feminism*, vol. 632. Bloomington: Indiana University Press.

Moors, A. (2013), '"Discover the beauty of modesty": Islamic fashion online', in R. Lewis (ed.), *Modest Fashion: Styling Bodies, Mediating Faith*, London: I. B. Tauris, pp. 17–40.

Morris, C. (2018), 'Re-placing the term "British Muslim": discourse, difference and the frontiers of Muslim agency in Britain', *Journal of Muslim Minority Affairs*, 38(3), 409–27.

Mould, O. (2018), *Against Creativity*. London: Verso Books.

Mountz, A. and J. Hyndman (2006), 'Feminist approaches to the global intimate', *Women's Studies Quarterly*, Spring, 445–63.

Mufti, A. R. (2016), *Forget English!*, Cambridge, MA: Harvard University Press.

Mukhtasar Sahih Muslim (2000), Compiled by al-Hafiz Zakiuddin Abdul-Azim al-Mundhiri, 2 vols. Riyadh, Saudi Arabia: Darussalam.

Mulvey, L. (1989), 'Visual pleasure and narrative cinema', in *Visual and Other Pleasures*, London: Palgrave Macmillan, pp. 14–26.

Muslim Council of Britain (2015), *British Muslims in Numbers, A Demographic, Socio-economic and Health profile of Muslims in Britain drawing on the 2011 Census*, <https://www.mcb.org.uk/wp-content/uploads/2015/02/MCBCensusReport_2015.pdf> (last accessed 18 January 2021).

Mustafa, A. (2016), 'Active citizenship, dissent and civic consciousness: young Muslims redefining citizenship on their own terms', *Identities*, 23(4), 454–69.

Nagel, C. and L. Staeheli (2008), 'Integration and the negotiation of "here" and "there": the case of British Arab activists', *Social and Cultural Geography*, 9(4), 415–30.

Nagel, C. and L. A. Staeheli (2011), 'Muslim political activism or political activism by Muslims? Secular and religious identities amongst Muslim Arab activists in the United States and United Kingdom', *Identities*, 18(5), 437–58.

Najib, K. and P. Hopkins (2019), 'Where does Islamophobia take place and who is involved? Reflections from Paris and London', *Social and Cultural Geography*, 1–21.

Nasr, S. V. R. (1987), 'Towards a Philosophy of Islamic Economics', *The Muslim World*, 77(3–4), 175–96.

Naudin, A. (2018), *Cultural Entrepreneurship: The Cultural Worker's Experience of Entrepreneurship*, New York: Routledge.

Naudin, A. and K. Patel (2019), 'Entangled expertise: women's use of social media in cultural work', *European Journal of Cultural Studies*, 22(5–6), 511–27.

Nesta (2016), *A Manifesto for the Creative Economy*, London: Nesta.

Nesta (2019) 'Creative nation: local profiles', <https://data-viz.nesta.org.uk/creative-nation/>.

New Local Government Network (NLGN) (2016), *Securing a Resilient Future*, London: NLGN, <https://www.newlocal.org.uk/wp-content/uploads/Securing-a-Resilient-Future_FINAL.pdf>.

Newsom, V. A. and L. Lengel (2012), 'Arab women, social media, and the Arab Spring: applying the framework of digital reflexivity to analyze gender and online activism', *Journal of International Women's Studies*, 13(5), 31–45.

Noble, G. and S. Poynting (2010), 'White lines: the intercultural politics of everyday movement in social spaces', *Journal of Intercultural Studies*, 31(5), 489–505.

Nouraie-Simone, F. (ed.) (2014), *On Shifting Ground: Muslim Women in the Global Era*, New York: The Feminist Press at CUNY.

O'Brien, D., K. Allen, S. Friedman and A. Saha (2017), 'Producing and consuming inequality: a cultural sociology of the cultural industries', *Cultural Sociology*, 271–82.

O'Connor, J. (2011), 'The cultural and creative industries: a critical history', *Ekonomiaz*, 78(3), 24–45.

O'Connor, J. (2020), 'The creative imaginary: cultural and creative industries and the future of modernity', in A. de Dios and L. Kong (eds) (2020), *Handbook on the Geographies of Creativity*, Cheltenham: Edward Elgar Publishing, pp. 15–36.

O'Toole, T., D. N. DeHanas, T. Modood, N. Meer and S. Jones (2013), *Taking Part: Muslim Participation in Contemporary Governance Report*, Bristol: University of Bristol.

Oakley, K. (2006), 'Include us out – economic development and social policy in the creative industries', *Cultural Trends*, 15(4), 255–73.

Oakley, K. (2009), 'From Bohemia to Britart – art students over 50 years', *Cultural Trends*, 18(4), 281–94.

Oakley, K. (2014), 'Good work? Rethinking cultural entrepreneurship', in C. Bilton and S. Cummings (eds), *Handbook of Management and Creativity*, Cheltenham: Edward Elgar, pp. 145–60.

Oakley, K., B. Sperry and A. C. Pratt (2008), 'The art of innovation: how fine arts graduates contribute to innovation', <https://openaccess.city.ac.uk/id/eprint/6704/1/>.

Oakley, K., D. Laurison, D. O'Brien et al. (2017), 'Cultural capital: arts graduates, spatial inequality, and London's impact on cultural labour markets', *American Behavioral Scientist*, 61(12), 1510–31.

Office for National Statistics (2011), 2001 Census aggregate data (edition: May 2011), UK Data Service, DOI: http://dx.doi.org/10.5257/census /aggregate-2001-2. (This information is licensed under the terms of the Open Government Licence <http://www.nationalarchives.gov.uk/doc /open-government-licence/version/2>.)

Office for National Statistics, Social Survey Division (2018), *Annual Population Survey*, <https://www.ons.gov.uk/searchdata>.

Ogilvy Noor (2018), *The Great British Ramadan*, <https://ogilvy.co.uk/sites /ogilvy-prelive/files/The%20Great%20British%20Ramadan%20%28 Ogilvy%20Noor&29%29%20Summary.pdf>.

Oosterbaan, M. (ed.) (2014), Special Issue. 'Public religion and urban space in Europe', *Social and Cultural Geography*, 15(6), 591–682.

Pain, R. and L. Staeheli (2014), 'Introduction: intimacy-geopolitics and violence', *Area*, 46(4), 344–7.

Pamuk, O. (2007), 'My father's suitcase', *PMLA*, 122(3), 788–96.

Parekh, B. (2000), *Rethinking Multiculturalism: Cultural Diversity and Political Theory*, Basingstoke: Palgrave.

Patel, K. (2020), 'Diversity initiatives and addressing inequalities in craft', in S. Taylor and S. Luckman (eds), *Pathways Into Creative Working Lives*, Cham: Palgrave Macmillan, pp. 175–91.

Peach, C. (2006), 'South Asian migration and settlement in Great Britain, 1951–2001', *Contemporary South Asia*, 15(2), 133–46.

Perry, B., K. Smith and S. Warren (2015), 'Revealing and re-valuing cultural intermediaries in the "real" creative city: insights from a

diary-keeping exercise', *European Journal of Cultural Studies*, 18(6), 724–40.

Peterson, K. M. (2020), 'The unruly, loud, and intersectional Muslim woman: interrupting the aesthetic styles of Islamic fashion images on Instagram', *International Journal of Communication*, 14, 1194–213.

Pew Research Forum on Religion and Public Life (2011), 'The future of the global Muslim population: projections for 2010–2030', <https://www.pewresearch.org/wp-content/uploads/sites/7/2011/08/RisingRestrictions-web.pdf>.

Pham, M. H. T. (2015), *Asians wear clothes on the Internet: race, gender, and the work of personal style blogging*, Durham, NC: Duke University Press.

Platt, L. (2005), *Migration and Social Mobility: The Life Chances of Britain's Minority Ethnic Communities*, Bristol: The Policy Press.

Pollock, G. (1999). *Differencing the Canon: Feminist Desire and the Writing of Art's Histories*, Abingdon: Routledge.

Powell, R. J. (1997), *Black Art and Culture in the 20th Century*, London: Thames and Hudson, pp. 127–47.

Quinn, M. (2015), *Utilitarianism and the Art School in Nineteenth-century Britain*, London: Routledge.

Rafferty, A., C. Hughes and R. Lupton (2017), *Inclusive Growth (IG) Monitor 2017: Local Enterprise Partnerships*, Inclusive Growth Analysis Unit, York: Joseph Rowntree Foundation.

Ralph, E. and M. Gibson (2021), 'Too Muslim or not Muslim enough? Exploring identity negotiations for women visual artists in Australia', *Journal of Sociology*, <https://doi.org/10.1177/14407833211021499>.

Rancière, J. (2003), 'Politics and aesthetics: an interview', *Angelaki*, 8(2), 194–201.

Rancière, J. (2004), *The Politics of Aesthetics*, London: Bloomsbury.

Rancière, J. (2007), *The Emancipated Spectator*, London: Verso.

Rantisi, N. M. (2011), 'The prospects and perils of creating a viable fashion identity', *Fashion Theory*, 15(2), 259–66.

Rantisi, N. M. (2014), 'Gendering fashion, fashioning fur: on the (re)production of a gendered labor market within a craft industry in transition', *Environment and Planning D: Society and Space*, 32(2), 223–39.

Rashid, N. (2014), 'Giving the silent majority a stronger voice? Initiatives to empower Muslim women as part of the UK's "War on Terror"', *Ethnic and Racial Studies*, 37(4), 589–604.

Razack, S. (2008), *Casting Out: The Eviction of Muslims from Western Law and Politics*, Toronto: University of Toronto Press.

Reay, D., M. E. David and S. J. Ball (2005), *Degrees of Choice: Class, Race, Gender and Higher Education*, London: Trentham Books.

Reimer, S. (2008), 'Geographies of production II: fashion, creativity and fragmented labour', *Progress in Human Geography*, 1–9.

Reimer, S. (2016), '"It's just a very male industry": gender and work in UK design agencies', *Gender, Place and Culture: A Journal of Feminist Geography*, 23(7), 1033–46.

Reynolds, T. (2013), '"Them and us": "Black neighbourhoods" as a social capital resource among black youths living in inner-city London', *Urban Studies*, 50(3), 484–98.

Richardson, L. (2018), 'Feminist geographies of digital work', *Progress in Human Geography*, 42(2), 244–63.

Rigoni, I. (2006), 'Islamic features in British and French Muslim media', in E. Poole and J. E. Richardson (eds), *Muslims and the News Media*, London: I. B. Tauris, 74–86.

Robinson-Dunne, D. (2006), *The Harem, Slavery and British Imperial Culture: Anglo-Muslim Relations in the Late Nineteenth Century*, Manchester: Manchester University Press.

Rogaly, B. (2020), *Stories from a Migrant City: Living and Working Together in the Shadow of Brexit*, Manchester: Manchester University Press.

Rogers, A. (2017), 'Advancing the geographies of the performing arts: intercultural aesthetics, migratory mobility and geopolitics', *Progress in Human Geography*, Online First.

Rogoff, I. (2007), 'Academy as potentiality', <http://summit.kein.org/node /191> (last accessed 26 October 2010).

Rose, G. (2016), *Visual Methodologies: An Introduction to Researching with Visual Materials*, Los Angeles: Sage.

Roy, A. (2011), 'Postcolonial urbanism: speed, hysteria, mass dreams', in A. Roy and A. Ong (eds), *Worlding Cities: Asian Experiments and the Art of being Global*, Chichester: Blackwell, pp. 307–35.

Runnymede Trust (2017), *Islamophobia: Still a Challenge for Us All*, Runnymede Foundation <https://www.runnymedetrust.org/projects

-and-publications/equality-and-integration/islamophobia.html> (last accessed 11 June 2018).

Rushdie, S. (1988), *Satanic Verses*, London: Vintage.

Ryan, L., E. Kofman and P. Aaron (2011), 'Insiders and outsiders: working with peer researchers in researching Muslim communities', *International Journal of Social Research Methodology*, 14(1), 49–60.

Saha, A. (2012), '"Beards, scarves, halal meat, terrorists, forced marriage": television industries and the production of "race"', *Media, Culture and Society*, 34(4), 424–38.

Saha, A. (2017a), 'The politics of race in cultural distribution: addressing inequalities in British Asian theatre', *Cultural Sociology*, 11(3), 302–17.

Saha, A. (2017b), *Race and the Cultural Industries*, Cambridge: Polity Press.

Saha, A. and S. van Lente (2019), *Rethinking 'Diversity' in Publishing*, London: Goldsmiths Press, <https://research.gold.ac.uk/id/eprint/286 92/1/Rethinking_diversity_in_publishing_full_booklet_v2.pdf> (last accessed 18 January 2021).

Sahlins, P. (1994), *The War of the Demoiselles in Nineteenth-century France*, Cambridge, MA: Harvard University Press.

Said, E. (1978), *Orientalism: Western Conceptions of the Orient*, New York: Pantheon Books.

Said, E. W. (1985), 'Orientalism reconsidered', *Race and Class*, 27(2), 1–15.

Saifullah-Khan, V. (1976). 'Pakistanis in Britain: perceptions of a population', *New Community*, 5 (3), 222–9.

Salime, Z. (2014), 'New feminism as personal revolutions: microrebellious bodies', *Signs*, 40(1), 14–20.

Sand, O. (ed.) (2019), *Contemporary Voices from the Asian and Islamic Art Worlds*, Milan: Skira.

Scarfe Beckett, K. (2004), *Anglo-Saxon Perceptions of the Islamic World*, Cambridge: Cambridge University Press.

Schiller, M. (2016), *European Cities, Municipal Organizations and Diversity: The New Politics of Difference*, London: Palgrave Macmillan.

Schmidt di Friedberg M., V. Mamadoux and L. Johnston (2019), Call for Papers for: *Bridging Differences: East, West, Seas And Mediterranean Worlds*, 34th International Geographical Congress, Istanbul 17–21 August 2020.

Secor, A. (2002), 'The veil and urban space in Istanbul: women's dress, mobility and Islamic knowledge', *Gender, Place and Culture*, 9(1), 5–22.

Sedghi, A. (2013), 'The London art audit: how well are female artists represented?' *The Guardian*, 24 May 2013, <www.theguardian.com/news /datablog/2013/may/24/london-art-audit-female-artists-represented> (last accessed 2 October 2017).

Shabout, N. (2016), 'What's in a name? Contemplating the "Islamic" in the "contemporary"', in T. Stanley and S. Tuqan (eds), *Jameel Prize 4*, Istanbul: Pera Muzesi Yayini, pp. 12–19.

Shankley, W. and B. Byrne (2020), 'Citizen rights and immigration', in B. Byrne and C. Alexander et al. (eds), *Ethnicity and Race in the UK: State of the Nation*, Bristol: Policy Press, pp. 35–50.

Shiner, M. and T. Modood (2002), Help or hindrance? Higher education and the route to ethnic equality. *British Journal of Sociology of Education*, 23(2), 209–32.

Shirazi, F. (2016), *Brand Islam: The Marketing and Commodification of Piety*, Austin, TX: University of Texas Press.

Shohat, E. and R. Stam (2014), *Unthinking Eurocentrism: Multiculturalism and the Media*, London: Routledge.

Simonsen, K. (2008), 'Practice, narrative and the multi-cultural city: a case of Copenhagen', *European Urban and Regional Studies*, 15, 145–58.

Simonsen, K. and L. Koefoed (2020), *Geographies of Embodiment: Critical Phenomenology and the World of Strangers*, Thousand Oaks, CA: Sage.

Sinfield, A. (2007), *Literature, Politics and Culture in Postwar Britain*, London: A&C Black.

Skeggs, B. (2004), *Class, Self, Culture*, London: Psychology Press.

Sobande, F. (2020), *The Digital Lives of Black Women in Britain*, Palgrave Studies in (Re)Presenting Gender, Cham: Palgrave Macmillan.

Sobande, F., A. Fearfull and D. Brownlie (2019), 'Resisting media marginalisation: black women's digital content and collectivity', *Consumption Markets and Culture*, 23(5), 413–28

Social Mobility Commission (2017), *State of the Nation 2017: Social Mobility in Great Britain*. London: Government UK.

South Kensington Museum (1874), *Catalogue of the Objects of Indian Art Exhibited in the South Kensington Museum, Illustrated by Woodcuts, and by a Map of India showing the Localities of Various Art Industries*, London: G. E. Eyre and W. Spottiswoode.

Spivak, G. C. (1985), 'Can the subaltern speak? Speculations on widow sacrifice', *Wedge*, 7/8, 120–30.

Stallabrass, J. (2001 [1999]), *High Art Lite: British Art in the 1990s*, London: Verso.

Sutton, D. (2007), *Islamic Design: A Genius for Geometry*, New York: Wooden Books, Bloomsbury Publishing.

Tarapor, M. (1980), 'John Lockwood Kipling and British art education in India', *Victorian Studies*, 24(1), 53–81.

Tarlo, E. (2010), *Visibly Muslim: Fashion, Politics, Faith*. London: Berg.

Tarlo, E. and A. Moors (eds) (2013), *Islamic Fashion and Anti-fashion: New Perspectives from Europe and North America*, London: Bloomsbury.

Taylor, S. and S. Luckman (2020), 'New pathways into creative work?', in *Pathways into Creative Working Lives*, Cham: Palgrave Macmillan, pp. 267–81.

Taylor, M. and O'Brien, D. (2017), '"Culture is a meritocracy": Why creative workers' attitudes may reinforce social inequality', *Sociological Research Online*, 22(4), 27–47.

TellMama (2018), *Gendered Anti-Muslim Hatred and Islamophobia*, Faith Matters, London, <https://tellmamauk.org/gendered-anti-muslim-hatred-and-islamophobia-street-based-aggression-in-cases-reported-to-tell-mama-is-alarming/>.

Temple, Sir R. (1882), *Men and Events of My Time in India*, London: J. Murray.

ThomasReuters (2016), State of the Global Islamic Economy Report 2016/17, <https://ceif.iba.edu.pk/pdf/ThomsonReutersstateoftheGlobalIslamicEconomyReport20161.pdf> (last accessed 4 August 2017).

ThomasReuters (2019), State of the Global Islamic Economy Report 2019/20, <https://crescentwealth.com.au/featured/state-of-the-global-islamic-economy-report-2019-2020/#:~:text=The%20Annual%20State%20of%20the%20Global%20Islamic%20Economy%20Report%20highlights,world's%201.8%20billion%20Muslim%20consumers> (last accessed 30 January 2021).

Tolia-Kelly, D. P. and R. Raymond (2020), 'Decolonising museum cultures: an artist and a geographer in collaboration', *Transactions of the Institute of British Geographers*, 45(1), 2–17.

Tse, J. K. (2014), 'Grounded theologies: "Religion" and the "secular" in human geography', *Progress in Human Geography*, 38(2), 201–20.

Tufekci, Z. (2017), *Twitter and Tear Gas: The Power and Fragility of Networked Protest*, New Haven, CT: Yale University Press.

Tuhiwai-Smith, L. (20132 [1999]), *Decolonizing Methodologies: Research and Indigenous Peoples*, London: Zed Books.

Turner, B. (2008), 'Revivalism and the enclave society', in A. B. Sujoo (ed.), *Muslim Modernities: Expressions of the Civil Imagination*, London: I. B. Tauris, pp. 137–160.

Tyrer, D. and F. Ahmad (2006), *Muslim Women and Higher Education: Identities, Experiences and Prospects, A Summary Report*, Liverpool: Liverpool John Moores University and European Social Fund.

Umphress, E. E., K. Smith-Crowe, A. P. Brief, J. Dietz and M. B. Watkins (2007), 'When birds of a feather flock together and when they do not: status composition, social dominance orientation, and organizational attractiveness', *Journal of Applied Psychology*, 92(2), 396.

UNESCO (2007), The UNESCO framework for cultural statistics (Draft). Montreal: UNESCO Institute for Statistics.

UNESCO (2017), *The Right to Culture*, Paris: UNESCO, <http://www.unesco.org/culture/culture-sector-knowledge-management-tools/10_Info%20Sheet_Right%20to%20Culture.pdf> (last accessed 14 June 2021).

UNESCO (2018), *Re-Shaping Cultural Policies: Advancing Creativity for Development*, Paris, UNESCO, <https://unesdoc.unesco.org/ark:/48223/pf0000260592?posInSet=11&queryId=f573a765-> (last accessed 14 January 2021).

Vickers, L. (2016), *Religious Freedom, Religious Discrimination and the Workplace*, London: Bloomsbury Publishing.

Vinken, H. (2005), 'Young people's civic engagement: the need for new perspectives', in H. Helve and G. Holm (eds), *Contemporary Youth Research: Local Expressions and Global Connections*, Aldershot: Ashgate, pp. 147–58.

Virdee, S. (2006), '"Race", employment and social change: a critique of current orthodoxies', *Ethnic and Racial Studies*, 29(4), 605–28.

Ward, K. G. (1997), 'Coalitions in urban regeneration: a regime approach', *Environment and Planning A*, 29(8), 1493–506.

Warren, S. (2013), 'Audiencing James Turrell's Skyspace: encounters between art and audience at Yorkshire Sculpture Park', *cultural geographies*, 20(1), 83–102.

Warren, S. (2017), 'Pluralising the walking interview: researching (im) mobilities with Muslim women', *Social and Cultural Geography*, 18(6), 786–807.

Warren, S. (2018), 'Placing faith in creative labour: Muslim women and digital media work in Britain', *Geoforum*, 97, 1–9.

Warren, S. (2019), '#YourAverageMuslim: ruptural geopolitics of British Muslim women's media and fashion', *Political Geography*, 69, 118–27.

Warren, S. (2020). 'Whose culture? Spatializing the museum, migration and belonging in Manchester', in A. de Dios and L. Kong (eds) (2020), *Handbook on the Geographies of Creativity*, Cheltenham: Edward Elgar Publishing, pp. 234–48.

Warren, S. (2021), 'Pluralising (im)mobilities: anti-Muslim acts and the epistemic politics of mobile methods', *Mobilities*, 1–16.

Warren, S. and P. Jones (2016), *Creative Economies, Creative Communities: Rethinking Place, Policy and Practice*, London: Routledge.

Warren, S. and P. Jones (2018), 'Cultural policy, governance and urban diversity: resident perspectives from Birmingham, UK', *Tijdschrift voor economische en sociale geografie*, 109(1), 22–35.

Werbner, P. (1990), 'Economic rationality and hierarchical gift economies: value and ranking among British Pakistanis', *Man*, 266–85.

Werbner, P. J. (1997), *The Politics of Multiculturalism in the New Europe: Racism, Identity and Community*, Cham: Palgrave Macmillan.

Werbner, P. (2002), *Imagined Diasporas Among Manchester Muslims: The Public Performance of Pakistani Transnational Identity Politics*, Melton: James Currey Publishers.

Werbner, P. (2004), 'Theorising complex diasporas: purity and hybridity in the South Asian public sphere in Britain', *Journal of Ethnic and Migration Studies*, 30(5), 895–911.

While, A. (2003), 'Locating art worlds: London and the making of Young British Art', *Area*, 35(3), 251–63.

Woodhead, L. and R. Catto (eds) (2013), *Religion and Change in Modern Britain*, London: Routledge.

Woolf Institute (2020), *How We Get Along: The Diversity Study of England and Wales 2020*, Cambridge: Woolf Institute, <file:///Users/saskiawar ren/Downloads/How-We-Get-Along-Full-Report-Revised-Dec-2020 .pdf>.

Worth, N. (2016), 'Who we are at work: millennial women, everyday inequalities and insecure work', *Gender, Place and Culture*, 23(9), 1302–14.

Wreyford, N. (2015), 'Birds of a feather: informal recruitment practices and gendered outcomes for screenwriting work in the UK film industry', *The Sociological Review*, 63, 84–96.

Zeb Babar, A. (2017), *We are All Revolutionaries Here: Militarism, Political Islam and Gender in Pakistan*, New Delhi: Sage.

Zebracki, M. and J. Luger (2018), 'Digital geographies of public art: new global politics', *Progress in Human Geography*, <http://journals.sagep ub.com/doi/pdf/10.1177/0309132518791734>.

Websites

<http://islamicartsmagazine.com/magazine/view/a_pioneer_of_contempo rary_art_from_the_muslim_world/>

<http://www.mywf.org.uk/uploads/projects/borderlines/Archive/2007 /muslimwomen.pdf>

<https://news.artnet.com/exhibitions/security-threats-force-londons-va-to -remove-prophet-muhammad-artwork-232724>

<https://www.britishfashioncouncil.co.uk/uploads/files/1/BFC%20Initi atives/manufacturing%20report.pdf>

<https://www.newstatesman.com/culture/2014/11/end-british-art-school>

<https://www.theguardian.com/education/2020/sep/27/uk-schools-told -not-to-use-anti-capitalist-material-in-teaching>

<https://www.theguardian.com/inequality/commentisfree/2017/jul/05/co ol-britannia-inequality-tony-blair-arts-industry>

<https://www.theguardian.com/politics/2014/jun/30/david-cameron-a-lis ters-cool-britannia-party>

Film

Fares, J. (Director) *Moslems in Britain – Manchester* (1961) Documentary Film, United Motions Pictures sponsored by the Foreign Office, Government UK.

Lee, S. (Director) *Malcolm X* (1992), Warner Bros.

INDEX

Note: *italic* indicates images; n indicates notes